WOMEN ARE HEROES

A GLOBAL PROJECT BY JR

Text by Marco Berrebi

ABRAMS, NEW YORK

Contents

JR – The Biggest Art Gallery

JR owns the biggest art gallery on the planet. He exhibits freely in the streets of the world, catching the attention of people who do not usually visit museums. His work mixes art and action, dealing with commitment, freedom, identity, and limits.

After he found a camera in the Paris subway, he made a survey of European street art, photographing the people who express their messages using walls. Then he started to work on vertical limits, observing people and life from the forbidden underground and on the roofs of the capital.

In 2006, he created Portrait of a Generation, portraits of young people from the housing projects around Paris that he posted in huge format in the bourgeois neighborhoods of the capital. This illegal project became official when the City of Paris put JR's photos up on its own buildings.

In 2007, with Marco, he created Face2Face, "the largest illegal photo exhibit ever created." JR put up enormous photos of Israelis and Palestinians face to face in eight Palestinian and Israeli cities on either side of the Separation Barrier. The experts said it would be impossible. And yet he did it.

In 2008, he embarked on a long international trip for Women, a project in which he underscored the dignity of women who are often the targets of conflicts. Of course, it didn't change the world, but sometimes a single burst of laughter in an unexpected place makes you dream that change is possible.

JR creates "pervasive art" that spreads, uninvited, on the buildings in the Paris-area housing projects, on the walls of the Middle East, on the broken bridges of Africa, and in the favelas of Brazil. People who often live with the bare minimum discover something absolutely superfluous. And they don't just see it, they make it. Elderly women become models for a day; kids turn into artists for a week. In this artistic activity, there is no stage separating the actors from the spectators.

After the local exhibitions, the images are transported to London, New York, Berlin, and Amsterdam where people interpret them in light of their own personal experience.

As JR remains anonymous and does not explain his huge full-frame portraits of people making faces, he leaves a space for an encounter between the subject/protagonist and the passerby/interpreter.

This is the essence of JR's work: raising questions.

Participative Art, or ART 2.0

Sometimes a technological evolution indirectly initiates a major change in the cultural landscape. For example, the printing of the Gutenberg Bible with moveable type in 1454 helped parishioners draw their own religious opinions and later allowed Luther's Theses against the Church to be widely distributed. Without the printing press, Protestantism would have been a mere provincial dispute. The invention of photography in 1839 challenged painters, pushing them to no longer limit their work to the representation of reality. From 1874 on, a group of young painters, the Impressionists, began giving exhibitions in which they expressed their impressions. The first one took place in a photographer's studio.

The recent past has seen some incredible technological changes. Some have had a huge impact on our way of life and will certainly affect art.

The first factor leading to change is that everyone has become a potential artist who can make a great photo with a cell phone, improve it on a computer, and publish it on a blog. Anyone with a computer and Internet access can become an expert on anything in several hours. Artists do more than just produce an image or a painting; they create an entire story, which becomes the real work of art. The photo or the work is just a souvenir.

The second factor of change is the profusion of news images that we see and which link places with events. For example, the French suburbs are associated with demonstrations, the Middle East means war, Mumbai evokes memories of terrorist attacks. So artists move away from the the territory of the news by ignoring it, by reinterpreting it, or by caricaturing it.

The third factor is that during the last twenty years the convenience of speed has prevailed, facilitating the ease with which one can fly to the ends of the world, print and send documents, order groceries, et cetera. This opens opportunities for artists to become international and orchestrate exhibitions of their creations in various environments.

The fourth major factor is the general practice of debate about everything. Children challenge their parents at the dinner table, citizens support or oppose their presidential candidates on web forums, actors answer their fans via Internet sites, millions of people sign petitions about everything and anything. The artist is not alone. People around the world can be part of the creative process by adding comments and intellectual content to an initial piece.

A number of artists have already worked with some elements of Participative Art. JR does the complete loop. Armed with his camera, he seeks remote places, defines his project in partnership with the people, chooses the models in the streets or at their workplace, completes the installation with the support of the locals, and publishes his work in books and on the Internet. During his Women project, more than a hundred people accepted the invitation to be models and told their stories or helped organize the project. Thousands of others posted photos and short films on their blogs with their own interpretations of the work, while hundreds of thousands posted comments on blogs and forums.

This way of working challenges the common conceptions concerning art. From prehistoric times until now, the idea has been the same: The artist creates a work of art; the public discovers it and reacts. Sometimes, a model is involved.

With Participative Art, the process is different. Within a precise time frame, people change their daily routines to create an ephemeral art project that will evolve with the communities that complete the work and infuse it with their added intellectual value.

Responding to the current technological landscape, JR is at the forefront of this new movement, which promises to be a fascinating catalyst in the evolution of art.

"A Word to the Wise!"

I might never have met JR, because one of my rules is to never approach people whose work I like if I do not have a specific proposal to offer them. However, alerted by one of my students, I followed with curiosity the enigmatic appearance of Expo2Rue, where black-and-white images framed in red paint were plastered on the walls of Paris and were then quickly destroyed by inclement weather. Afterward, I didn't really follow up on it – until I saw Face2Face on the wall separating the Palestinian and Israeli territories, which I thought was incredibly relevant and daring, with the right motivation and a low-key style.

When the director of the French Cultural Center in Phnom Penh asked me to be artistic director of the first PPP festival, I was given the awesome opportunity of doing something with the symbolic wall of the French Embassy, a strategic space that is two hundred meters long and three meters high. But what would be a meaningful thing to do with it? I had been following JR's movements on a regular basis, among them his initiative in Morro da Providência, Rio de Janeiro's first favela, where the huge faces formed a fascinating image at night. I sent him an email. He accepted immediately. We had an email exchange but never met, and he invented two hundred meters of women's gazes for the wall of the Embassy as part of his Women project. That is how we finally met for the first time in Phnom Penh, when he, Emile (the Coordinator of the Women project), and a small crew were pasting up what was to become one of the crucial high points of the first festival of images in Cambodia. We liked each other from the outset and talked easily. It all seemed so natural. For JR, who never misses out on an opportunity to enrich his work, it was a development, unexpected only a few months earlier, of Women in Southeast Asia.

Since then, our dialogue has never stopped and we know it will continue because the bond is there, both lighthearted and serious.

Who is this JR anyway? What's this business about being an artist who doesn't fit in with the established norms, not even those that seem to be – or call themselves – the most "alternative" or "underground"? And what is he hiding behind that nom de guerre that is neither aggressive nor demonstrative? Perhaps it is hiding nothing. Perhaps JR is simply situating himself – where we don't know. Because one of his main personality traits could well be his spontaneous expertise in and innate cleverness at protecting himself, often jubilantly, from all possible labels. JR doesn't seem to fit into any of the usual pigeonholes in contemporary art. So much the better! This attests to his sense of freedom. In the end, figuring out who he is not might be an easier way to understand him.

Although he may not naturally identify with museum and gallery spaces (this doesn't mean he categorically rejects them either, as issues of necessity and pragmatism have to be taken into account, even if only to be subsequently mastered and bypassed), even if the city or cities, in all their diversity, chaos, and complexity, are his most natural places of expression, we must not try to categorize him – or reduce him – to a cliché, "pie in the face" category like "street art." The closest thing would be the Brazilian *pichadores*, although even there . . . His work has nothing to do with the fad for creating "murals," where painters decorate the urban environment in an attempt to do something "new" or "modern." JR doesn't sign his pieces. What appears is not his work, even though he has created it. On the walls are simply the faces of people who live nearby, enlarged images of them staged in a way to create meaning. Strangely enough, the gigantic size of the installations gives these individuals a space in which they suddenly exist. It is a question of scale, a fundamental aspect in all his work. His approach derives meaning through the people and cities he exposes – to use a quintessential photography term. The work is not simply about reading the

city as a rebus with signs to be decrypted (although it is that, too), but rather about proposing other signs that are normally dissimulated but are used here to highlight the inhabitants of areas that are reputed to be – and are in fact – difficult. The result is an increased sense of dignity, respect, and exchange all around, which is no trifle.

JR is an artist because he feels the need to speak out about the contemporary world, to question it where it hurts and where it hurts him. But he is also an artist of his times who understands that certain conventions from previous centuries and from the history of art are no longer operative or relevant. So he became an urban activist (the term he probably prefers for the time being). And he is perfectly conscious of the various stakes involved, the first of which, as an artist, is undoubtedly to give other people a means of expression. The dialogue is often difficult, involving a complex and subtle dialectic that requires time, explanations, a pedagogical component, conviction, and boundless energy. If JR prefers to initiate – or create – projects in countries in what is commonly known as the Third World, it is because the people there, with almost no access to museums or to education, openly question him about his approach. They often do not understand it at first, but after talking things over with him, they end up being convinced, and then they adopt it as their own and become proud of the project they have taken part in. JR generously (and quite naturally) lets them take over the process and also physically relinquishes the future possibilities resulting from his actions, such as a cultural center run by the inhabitants of the favela in Rio and the tarps printed with the faces of women from the shantytown in Kenya, which reinforce the roofs of the flimsy shacks of those who live there. This social dimension with multiple ramifications and levels has nothing to do with charity and is motivated by a vital sense of responsibility rather than any high-minded feelings. The artist can't solve the problems that need to be addressed by politicians, but he is there to highlight things that are unacceptable and are the result of political choices.

That said, JR is not a "political" artist. He does not deliver a message. He just puts his finger on the problem. It is precisely because he is a totally committed artist that he is engaging and convincing – and why those who are directly concerned, as well as those accompanying him, follow him and are committed. There is something incredibly luminous and coherent in this, without it being didactic. It comes from the action that needs to be taken, from the physical dimension of it all, from this fine new illustrated layer of skin that blends in with the material of the walls before time, the wind, the rain, or power-washing by the authorities scratches, bruises, tears, and erases it. But bits and pieces remain, or seem to anyway, sometimes minute, of what was fleeting, grandiose, fragile, and never permanent, yet essential. And photography, which was there at the very beginning to allow images to be set up in new spaces, records and returns to what it brought collective memory. This brings us back to the fundamentals, to the origin of fixed images.

This also brings us back to that boy in the heart of Paris, who, in the beginning, usurped the expression "A word to the wise!" and plastered it on the city's walls in an incongruous, insolent, and provocative gesture. Somehow, he also knew there was a need to shout it out and announce it to one and all, even though the town crier and his drum had long since vanished from the scene. But the question was: to announce what? That things were not going well. That in fact things were going really badly. And that it was time it was said and made known.

by Christian Caujolle

What Is JR Telling Us?

Art always takes on a material form: a painting hung on a wall, a symphony played by an orchestra, a statue exhibited in a garden, a photograph framed under glass, or a dance piece performed onstage.

And every work of art is infused with its own special story. That's what gives it meaning and makes an original more valuable than a copy. Whether explicit, implicit, or mysterious, the narrative associated with the work can fit into all the spaces the imagination can create.

Sometimes, it is the artist himself who inhabits the work of art, which will then be framed by his own experience. Nan Goldin's photographs tell the story of Nan Goldin's life. We perceive them as a no-holds-barred testimony of a certain milieu and era.

Often, it is what is being shown by the work of art that will open up the widest narrative space. It can be grasped directly or require an explanation to complete it. *Christina's World*, painted by Andrew Wyeth in 1948 and shown at the MoMA, depicts a woman in a pink dress lying in a field, at the far end of which stands a house. The woman is Christina, a victim of polio, dragging herself laboriously toward her house under the painter's window. The work is a superb graphic construction, but it is the story behind it – the struggle between beauty and death – that gives it such intensity.

In some cases, the "making of" explanation of the work gives it an added layer of meaning. When Robert Doisneau took his photograph of the kiss in front of the Paris town hall in 1950, it was presented as a spontaneous image and immediately many legends surrounded it. This is the poster that people in love give each other as a present. It was only in 1992, after

some impostors "recognized themselves" in the photograph, that Doisneau explained that the scene was actually staged.

Sometimes the work of art comes with its own story, whether the creator has chosen it or not. In 1972, Giorgio de Chirico had official process servers come to the Musée des Arts Décoratifs and declare that *Le Revenant*, dated 1917, signed by him, and authenticated by experts, was a fake. He died after a legal battle, and his wife dropped the claim. The story of this work of art, challenged by de Chirico even though he knew he had created it, invites us to reflect on what is true and false in art.

Of course, a work of art can also exist without any known or explicit meaning. It could be a graphic construction or music without lyrics, such as a jazz piece or a symphony.

JR's work always conveys a distinct narrative. The narrative is not about the pieces themselves, except when they are made with special materials.

It involves the artist to a certain extent, since JR is no longer really anonymous given that he exists as an artist through his work. Even if he does not reveal his identity so that people do not see his work through that prism and thus overshadow the identity of the local people involved in the projects, the continuity of his work establishes a strong artistic identity.

What JR's work shows is in fact people telling a story, their story. They are anonymous people in whom the media takes only a fleeting interest – when their village is on fire or their children are fighting a war. JR allows us to share their pain and their joy, their hopes and their regrets. "I am a businesswoman. I sell chips," says Judith in Kibera, Kenya, before proudly explaining that she buys potatoes that she then peels, cuts up, and fries

to sell. That's her world, and JR allows us to share this intimate moment with her.

JR's approach – "the making of" – to creating his art is a crucial element of his work. First of all, because it shows us a new way of working in which the real work of art is not what has been framed or pasted on a wall, but rather the act of taking the photograph and pasting it up. In this sense, his work is at times closer to that of a choreographer. Secondly, because a different approach can be observed for each project, but each time the same technique is used. Large black-and-white photographs create a mise en abyme in Paris, a parallel in the Middle East, and a tribute in Women. This project, which consisted of contacting women, raising their awareness about the artistic process, and involving them in it, was astonishing, and the resulting exchange was fascinating. JR recorded the women's narratives and reproduced them in a symbolic itinerary. In places where he identified persistent pain, he put up a huge poster as if to exorcise the pain or drown it in glue. After listening to the story of a woman forced to flee her village, he went past the swimming pool of a former luxury hotel in Monrovia, now a squat for refugees, and pasted the woman's eyes on the bottom of the pool. Was it to connect the woman's fate to that of the hotel so that this woman could metaphorically deal with her loss and move on? Was it the result of a conscious process or of intuition?

Each of JR's photographs is an "autonomous" work. It exists through its own aesthetic, with no need to be "explained." But the narrative gives it its emotional power.

JR and the Portrait Tradition

Large-format portraits of Brazilian, African, Cambodian, and Indian women. The faces of Jessie, Clara, Musu, Roberta, and Christina tell stories, their stories. The mega-images displayed in public places evoke the manipulation of which they are constantly victims. And passersby gaze wide-eyed at the violence of their situation.

Since his very first projects, JR has worked on sensation and desire, trusting his conscience to determine the subjects of his initiatives. For the Women series, women from all over the world were his material, his photographs were his working tools, silkscreen and pasting were his methods, and cities served as his exhibition venues. The finished product was a series of whole or fragmented portraits intended to raise consciousness. The dignified gaze of these women looking out at viewers passed silent judgment on their condition. This was an artist's tribute to communities of people who have been ignored and often mistreated.

It is an exercise linked to places (towns, streets, squares, suburbs, fallow land, walls, fields, skies) and to people (passersby, inhabitants, strollers, actors, spectators). They are activities that seek to create links and sometimes tensions – crossroads, dialogues, sharing, chafing, friction, and grating.

In all his projects JR strives to blend his portraits in with the permanent language of cities, and in his practice he uses the theatrical staging of historical elements. He plays with visual memory and with the impact on the unconscious of remnants of memories that resurface once they are in contact with certain places and visual stimuli. He skips the verbal stage of communication, impacting our memories with his portraits. His language short-circuits interpretations, categorization, and ideological explanations. His initiatives are reference points that replace the usual clichés. The collective memory has penetrated his work, and he is simply the transmitter.

His portraits have always had a powerful impact, even out of context. Fragmented images become a common memory, and people are struck by these colorless images. The identification is immediate and direct, and viewers see themselves not as spectators or critics, but rather as inside the images, clearly feeling they are involved in them and concerned by them.

As a result, the portraits of women without captions are highly charged with emotion. Their condition is clearly identifiable on their faces – at once alienated and free, distinctive, and universal.

But what really interests these women, over and above seeing their portraits aggrandized, is the idea that their portraits are traveling around the world. Removed from their original context, the portraits reclaim their aesthetic function and raise questions in the process, forcing the viewer to detect the nuances and traces of their appearance in a favela, on a train, and on arches, but also in faraway cities such as London, Paris, and Brussels. Their impact is no longer neutral, as people try to find out more in order to uncover clues connecting them to the original story of these enlarged faces. Looking at these portraits means they are reminded that a group has been sacrificed and that the condition of women is a very distinct one.

JR also does his part to promote solidarity. In Brazil he opened a cultural center in a favela in Rio.

Naturally, JR has connections with other artists, including Ernest Pignon Ernest, due to the proximity of their work; Christo and his wrapping of the Pont Neuf in 1985 (regarding which he said: "What interests me is changing people's perceptions about something they think they know."); George Rousse, who took over spaces in Madrid and Casablanca and transformed them in an intuitive way; Warhol and Basquiat, for their use of the street; and in photography, Doisneau, Cartier-Bresson, and Archibald Reiss, founder of the Institute of Forensic Science at the University of Lausanne.

But he prefers to speak about generations rather than influences. His generation grew up with advertising images, the media, films, television, and their mulitplicity. JR feeds on them yet has learned to see them in order to take his distance from them. His desire is to document the everyday occurrences in a different manner.

And of course, it is in the portrait tradition that his work has an effortless impact. For what more than JR's Women project embodies the definition Charles Baudelaire gave in 1868 of the portrait in his *Aesthetic Curiosities*: "A good portrait always appears to me as a dramatized biography."

by Françoise Docquiert

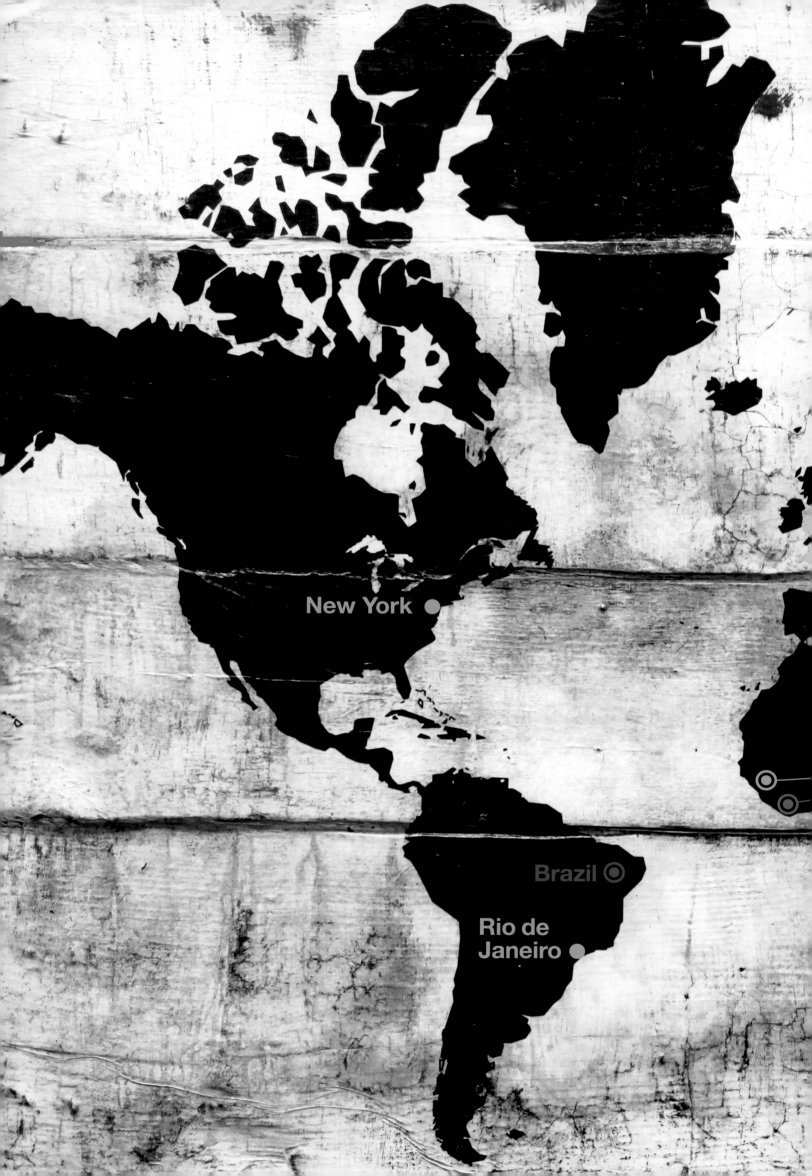

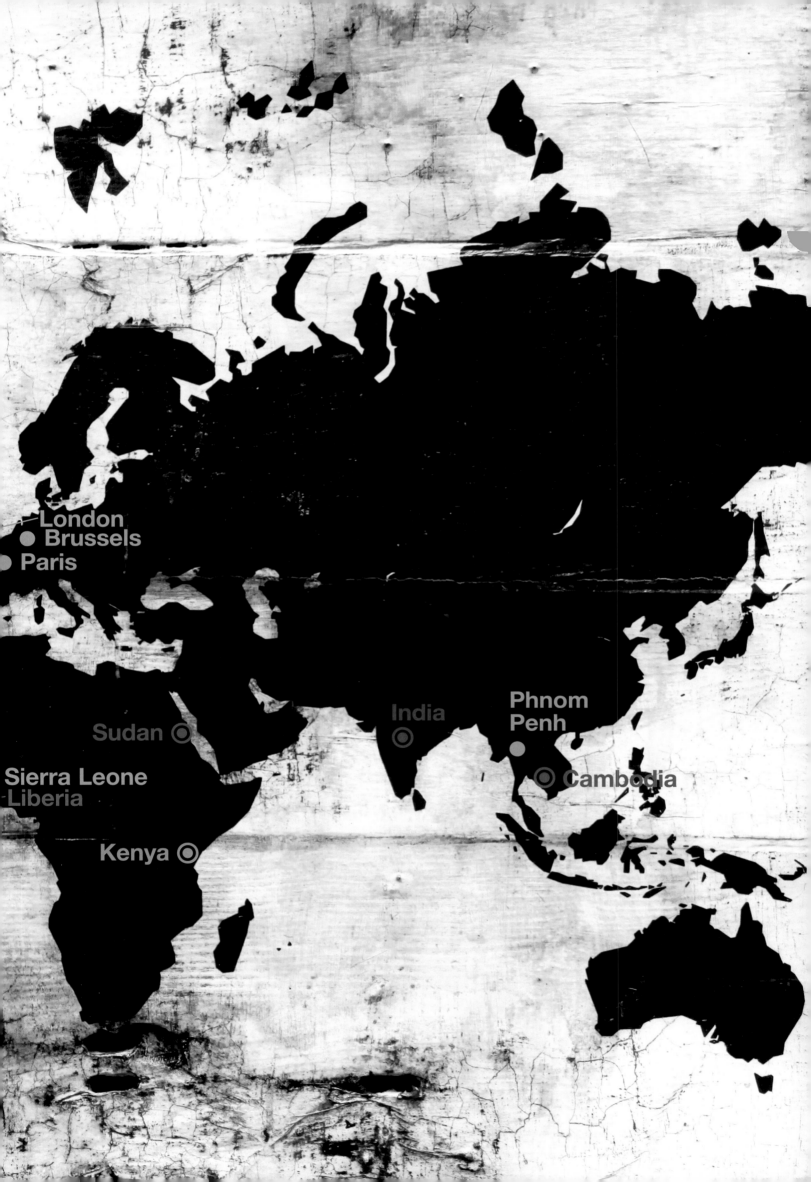

London
Brussels
Paris

Sudan ◎

India

Phnom
Penh

Sierra Leone
Liberia

Cambodia

Kenya ◎

ACTIONS

SIERRA LEONE

Women is a project with many images and few words. JR's intention is to underline the pivotal role of women in society and to highlight their dignity by photographing them in their daily lives and pasting their faces on the walls of their village and throughout the rest of the world.

When JR initiated the Women project and started listening to women in Sierra Leone, he didn't know what to do with all these words. It is impossible to understand why a man would rape his neighbor and kill her kids. It is difficult to figure out how somebody, culprit or victim, can cope with such a story. JR got an overdose of terrible stories of death, rape, and torture.

JR did not try to understand the reasons or the protagonists of the conflicts. He just observed the women and understood that they wanted to share their pain as a way to heal their wounds.

He just felt like doing what he does best: taking pictures and pasting them in a place where they make sense. He met women and asked them to tell their stories. They accepted as if they had been waiting forever for the opportunity to relive certain unforgettable scenes, to remind themselves that they were not guilty for the rape they endured or the killing of their relatives. Sometimes, there were no sentences, no words, just tears, lots of tears.

JR then asked the women if they would make faces for his project. Some preferred to pose silently in front of the camera, allowing us to read in their eyes everything they had been through. Others accepted, becoming models who switched within seconds from an expression of voiceless mourning to a loud laughter that they couldn't control. They wanted their spark of life to shine. To show that they survived it all, that they resist, and that they exist. They knew that making faces is something universal that would be understood in Europe, in America, and in their village.

Some women insisted on particular placement; they wanted their photos to be displayed in the middle of their village, as a public statement. Others preferred to have them pasted in another city. They were not ready to have their neighbors look at them. But they were all excited about the idea of having their photo pasted in other countries – as if some part of them would also travel, hidden between the paper and the ink.

Sierra Leone has the world's lowest Human Development Index rating, which takes into account life expectancy, literacy, and purchasing power. Many die of AIDS. The average life expectancy is slightly over forty years and one child in four does not reach the age of five years.

Having been torn apart for ten years by a bloody civil war, motivated by the desire to control the diamond mines, the country has been at peace since 2002 and is rebuilding its economy. In 2007, the government started taking measures to reduce violence and discrimination against women.

Having arrived at Freetown, Sierra Leone, during the night JR took a four-wheel-drive vehicle to Bo, the country's second-largest town, which looks like a big village with all its dirt roads. You get the feeling that life has started again here. Everywhere, you come across moped taxis, most belonging to former rebels, who exchanged their Kalashnikovs for mopeds during the period of disarmament. These men who pillaged the villages now drive the women back to their homes when they have finished working.

Marina Peter

"I am forty-seven years old. After the death of my father, I got married to a foreigner from Guinea. I gave birth to a son. Later, the man died and his family decided to get me married to his elder brother. So I got married to the elder brother and gave birth to six children.

During the war, my husband ran away to Guinea and left me alone with my children. During that time my mother collected me and the children and we went back to the village with the children. Then she died.

I want my children to be educated. The elder one has all the requirements for college but there is no money for me to send him to college. Whenever I think about that I can't feel very good. I am sad because of my son.

Any condition that God puts you in, you have to praise him. Even if it is not good for me, I have to praise God. Religion is very important to me. I pray to God to get transport to see my husband. I always think about that. I cannot sleep because of that."

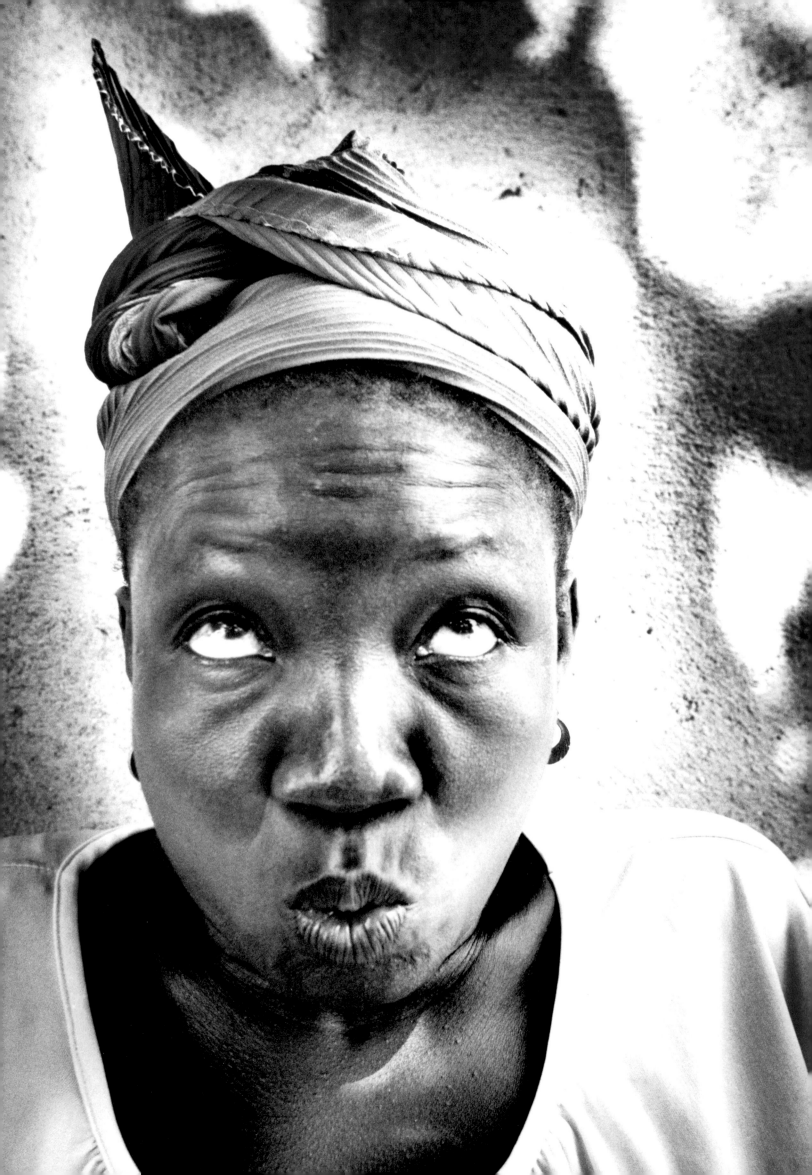

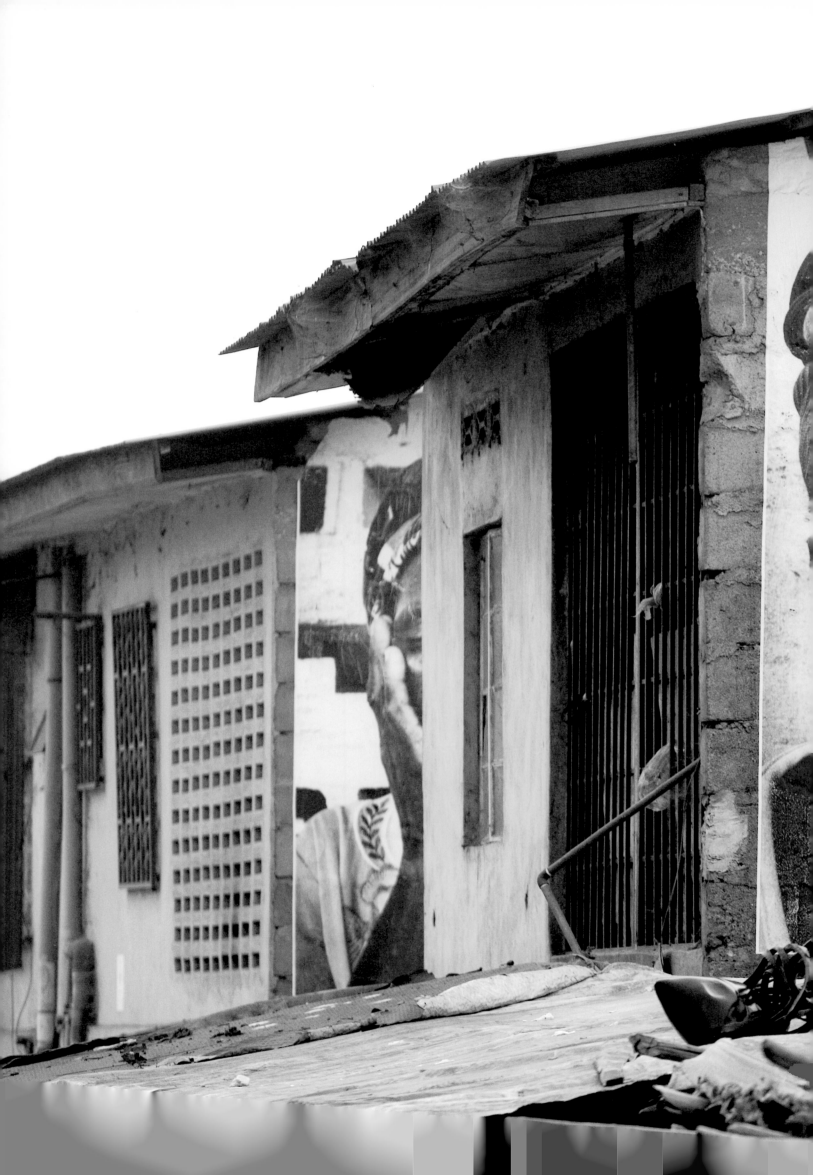

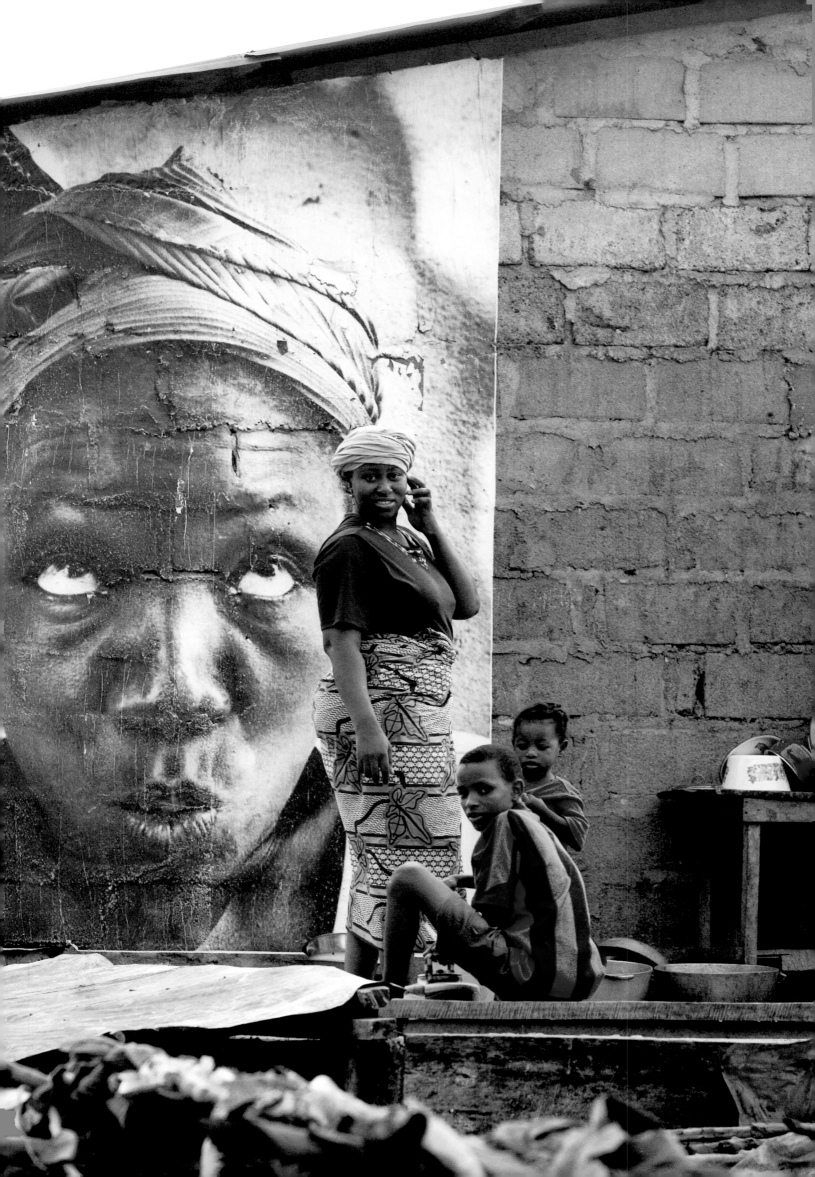

Hawa Munyan

"The attack happened one Saturday, when war was raging in my country, Liberia. I fled into the bush with four of my children and my husband, who died shortly after.

We joined up with a group of women who were also trying to flee. We were walking through the jungle when a group of rebels captured us. That night, five of them raped me. One of them killed my nine-year-old son, cutting his throat before my eyes. They forced me to laugh as I watched. I stayed there with ten other women for five days, during which I was continually raped. One night, we managed to escape. We gathered cassava for food. We spent nearly a month in the bush. Finally, we arrived on foot at the border with Sierra Leone."

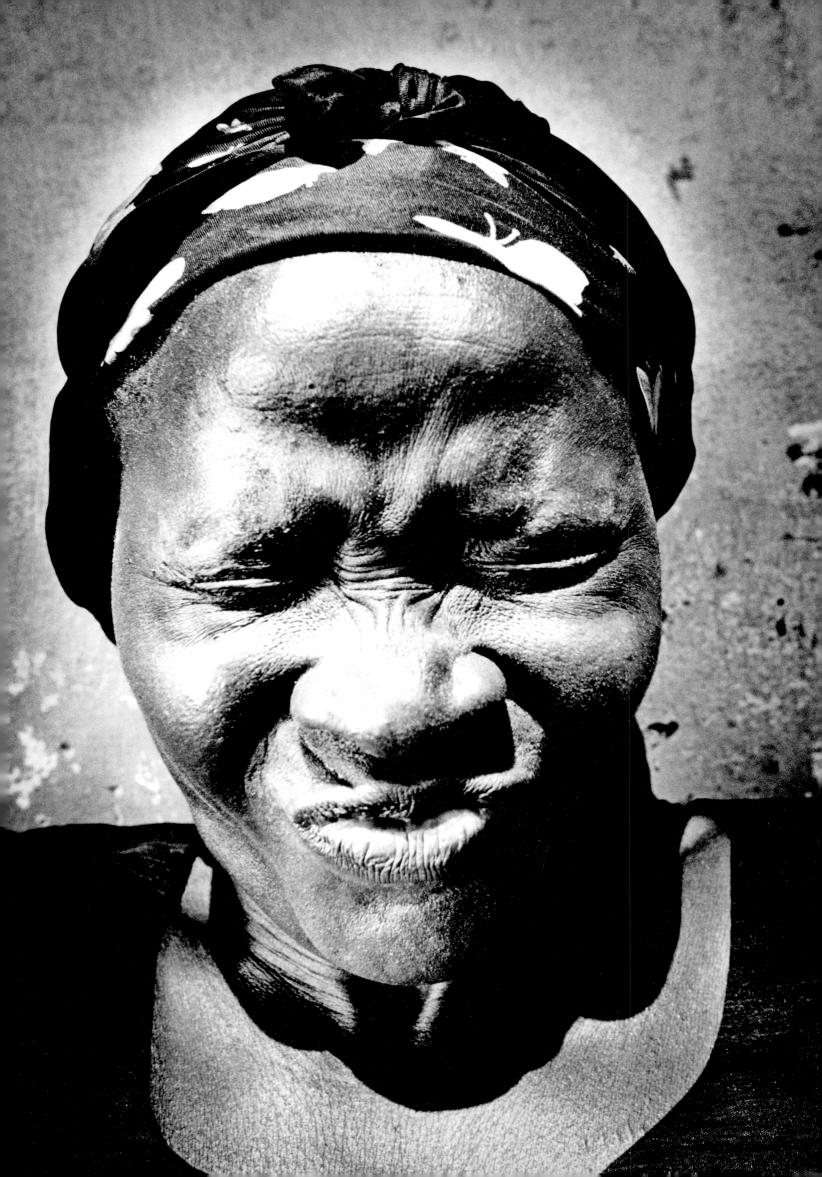

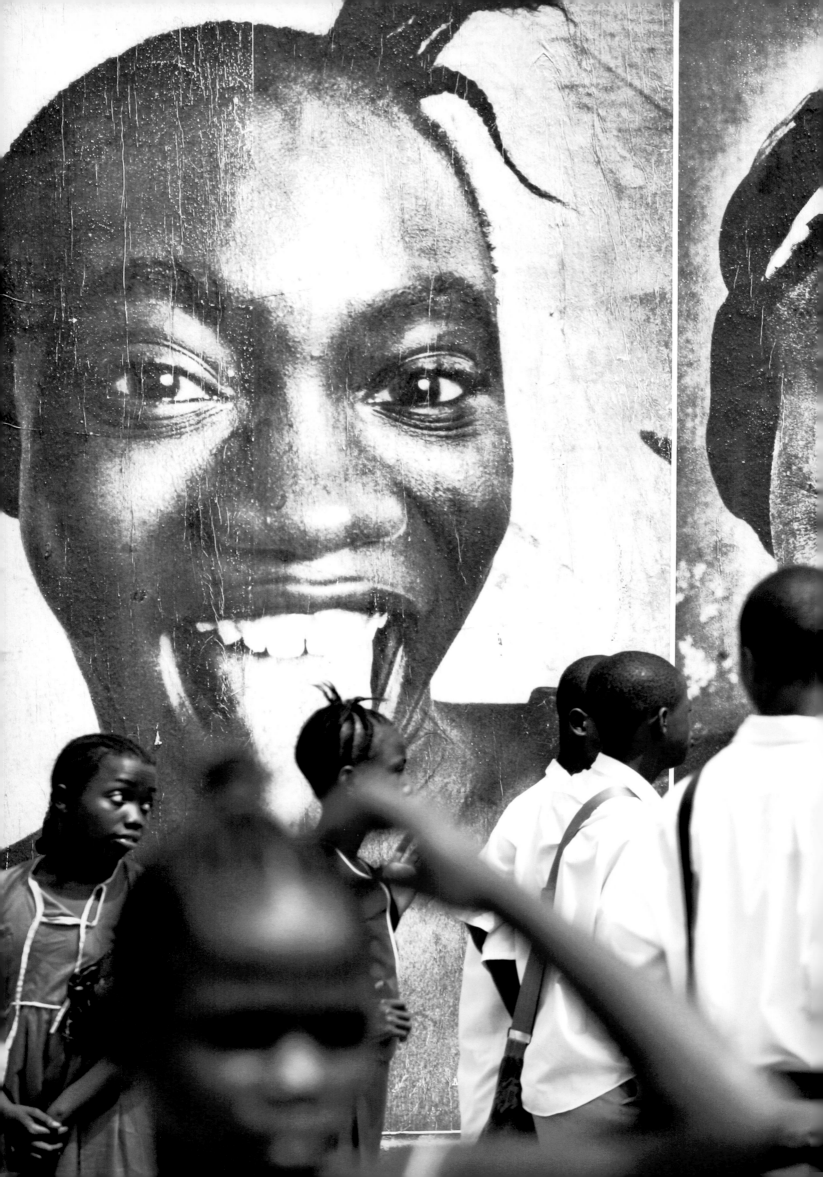

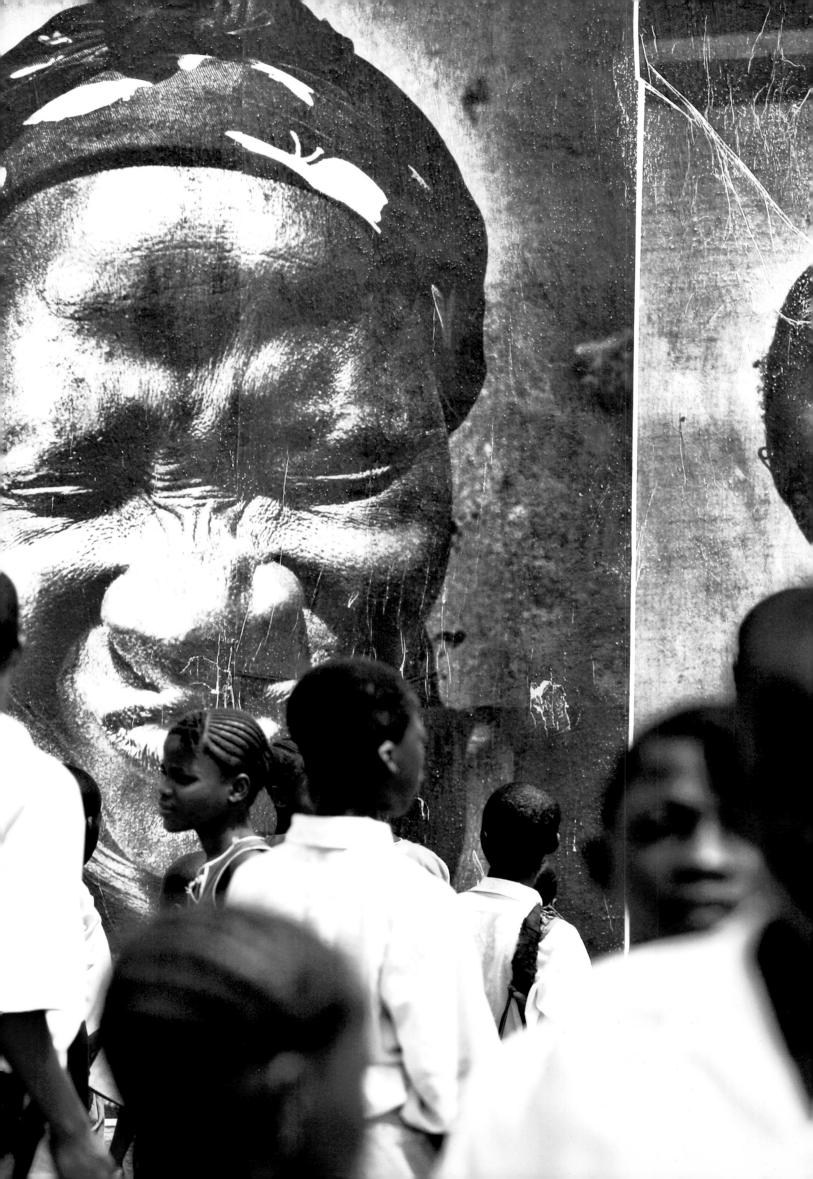

Baindu Gbembo

"I delivered ten children; seven are alive (five male, two female). I lost my first husband two years ago. My second husband has another wife. He doesn't want to see my children. There is no love for me; I am really suffering.

During the war I was with my first husband. I was pregnant. I gave birth in the bush because of the cold. We had no food to eat. We ran away to Kenema to find food.

Before the war my life was so nice. Now I am really suffering. I am praying to God to help my children to come out nice and to help me before I die because now I don't have the strength.

With my kids I sell palm oil for four hundred leones per pint. With that, we get us a living. When there is no palm oil, I beg to his relatives.

The best period of my life was when I was a kid, at the age of fifteen. My relatives did everything for me. But now I am alone. I do everything for myself and my children. Now I would prefer to be a child."

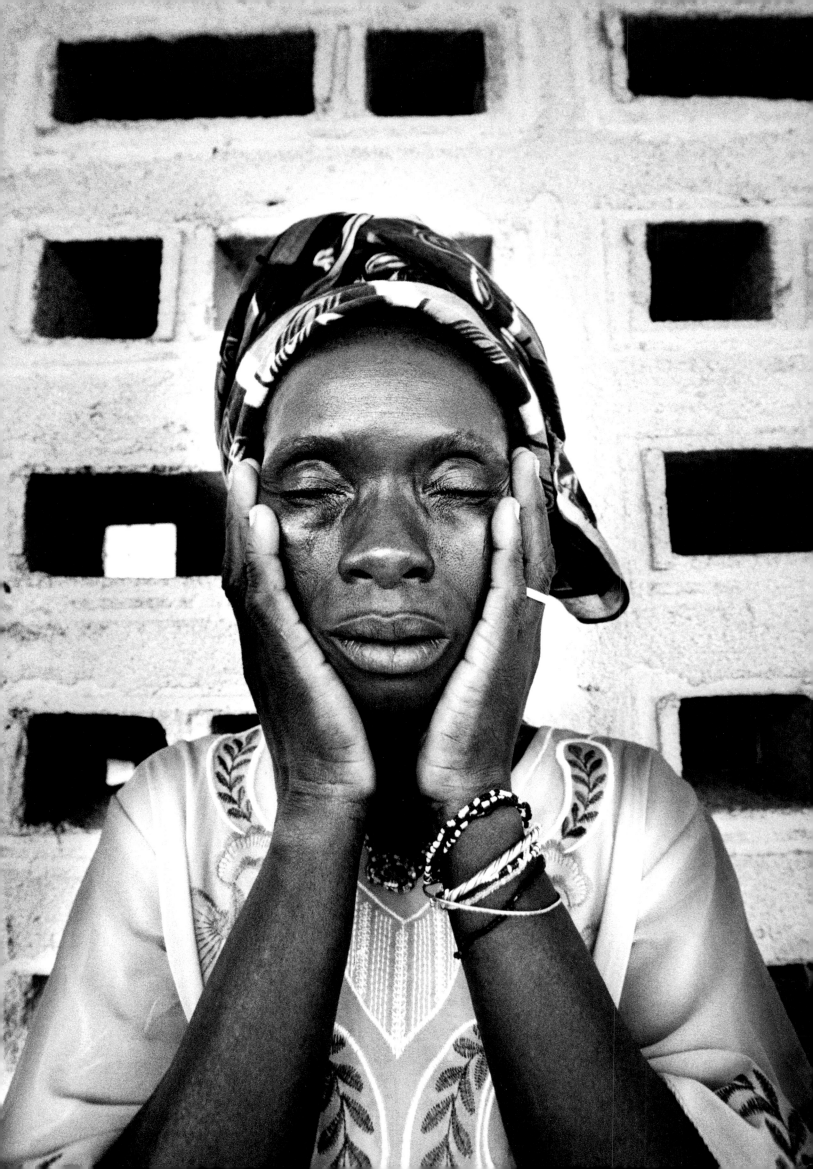

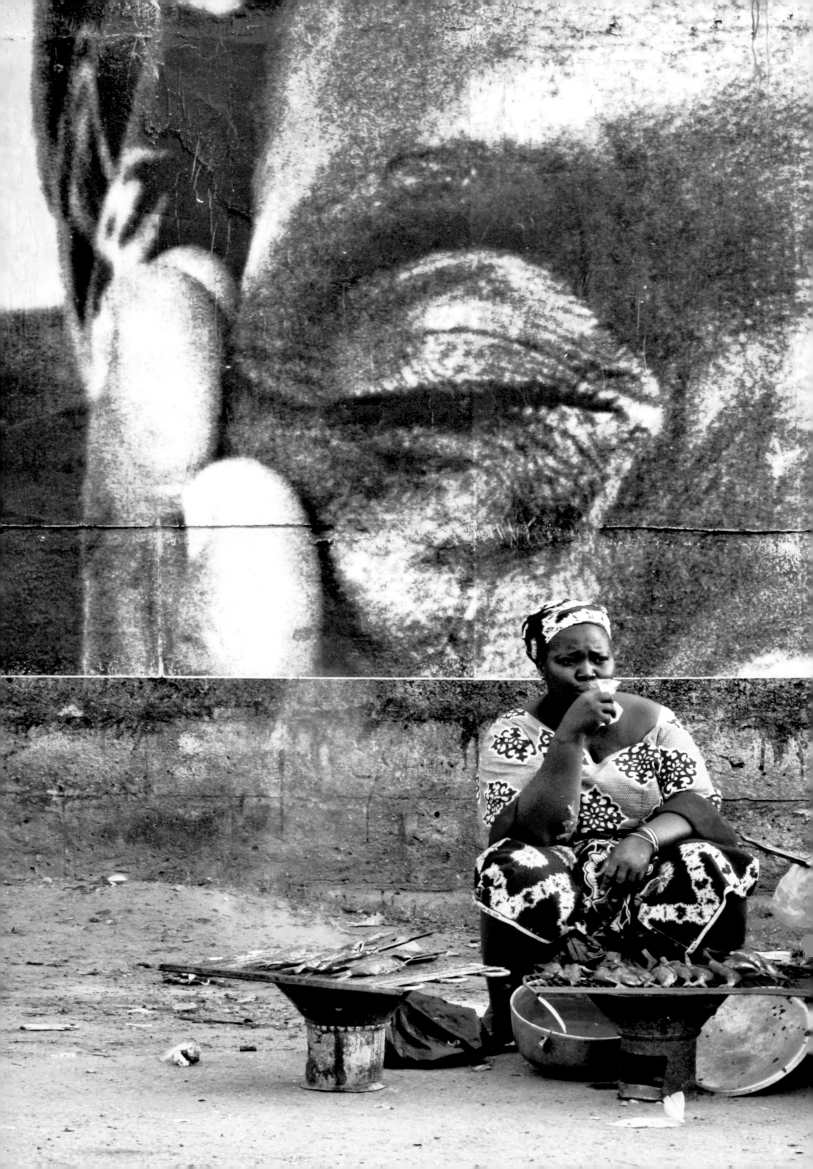

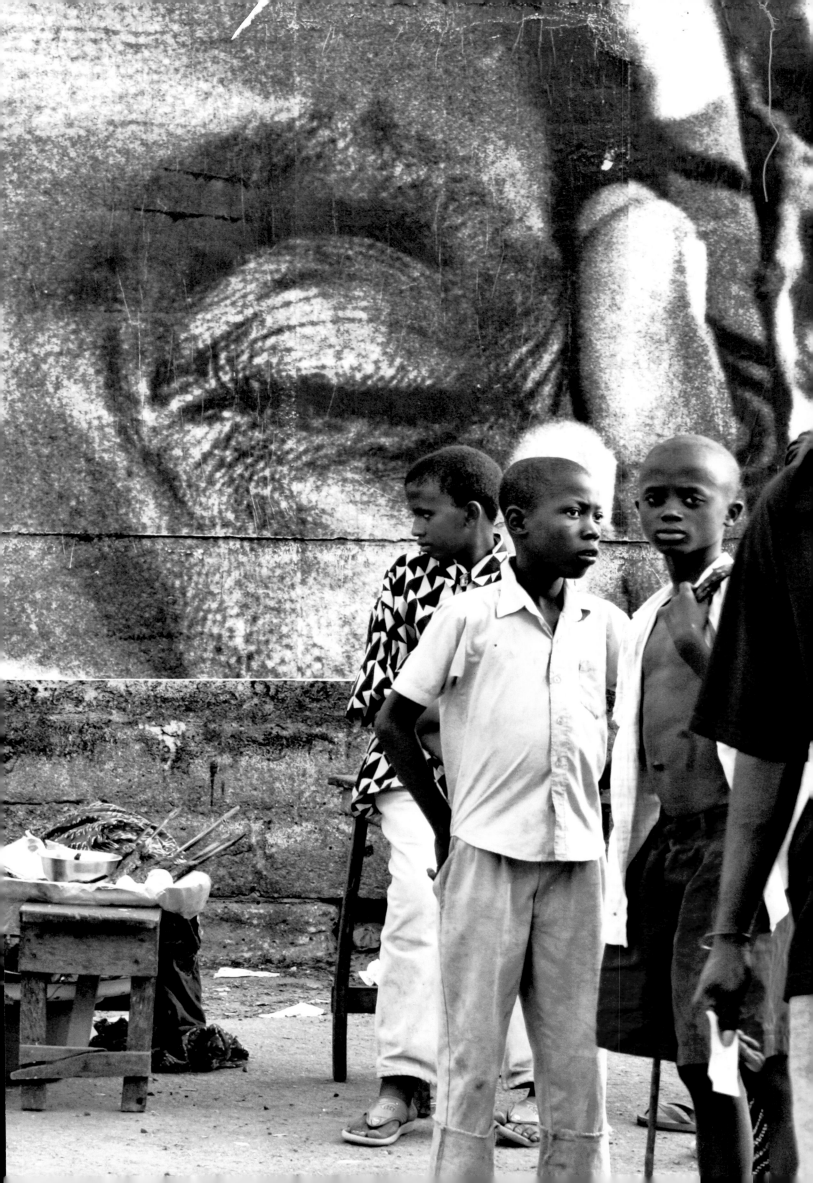

Musu Rogers

"Not long ago, I gave birth. My little girl is only six months old and weighs four kilograms. Her name is Kadiatu. She is my first child. The birth was very difficult. My uncle's wife was there to help me. When Kadiatu grows up, I'd like her to go to school, but we haven't much money. My father died when I was fifteen. I survive thanks to my mother, with whom we live. She is an example for me; I hope I will be as good a mother as she is. One day I hope to become a hairdresser."

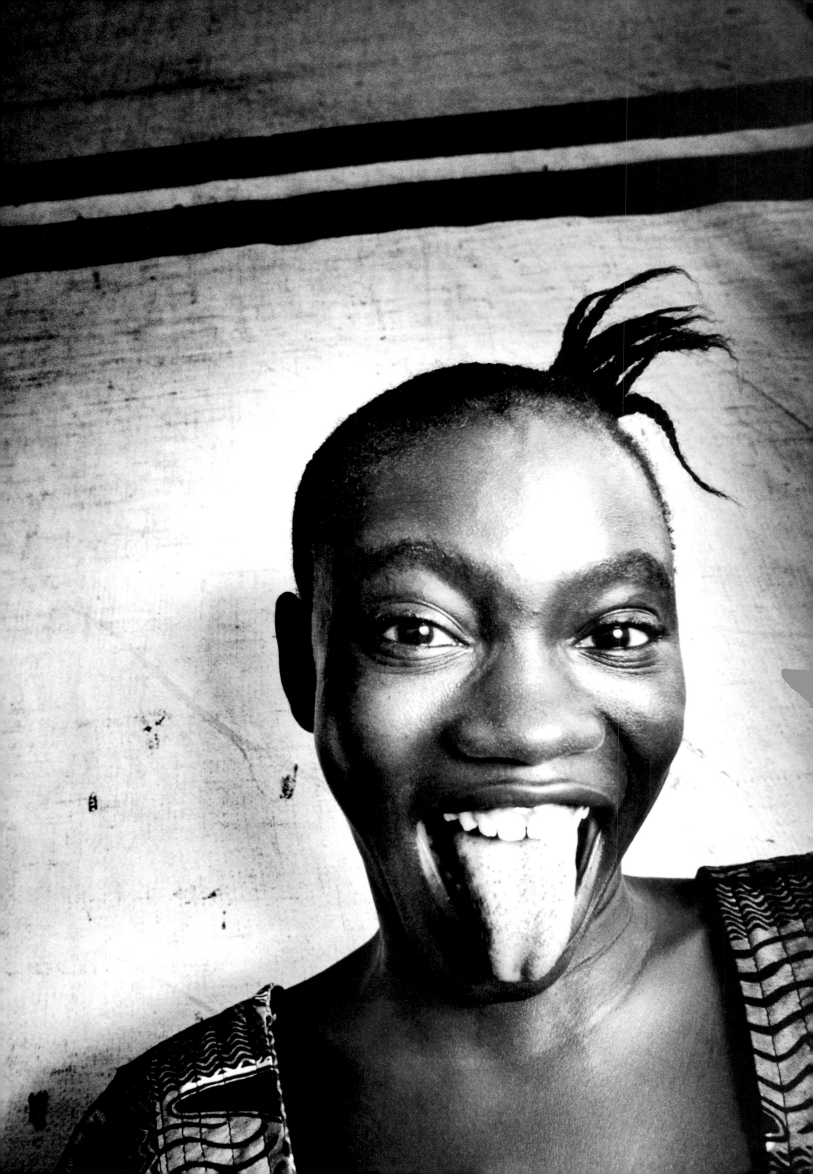

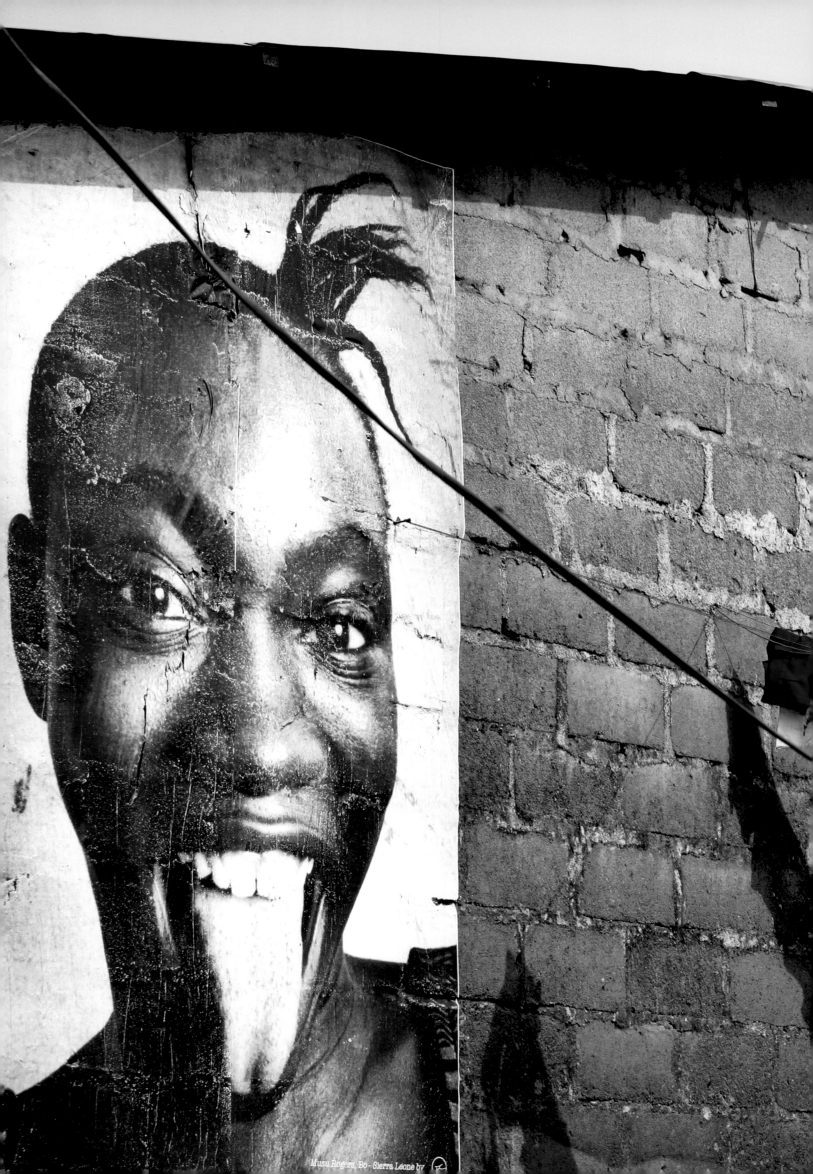

Musu Rogers, Bo - Sierra Leone by

Nyawo Gbotu

"I am thirty years old. I got married really young. I have five children from the same father. We were born in the same village.

The women that brought me up died in my childhood. And my mother and father didn't have money for me to continue my education. So I was taken back to the village. When I was in the village, not going to school, my children's father made a proposal to my family in order to marry me. I had to accept because my people didn't have the money to send me to school.

We had our first kid before the war in 1991. During the war we worked in the bush, just to survive. We lost everything; there was nothing, nowhere to sleep, no food, no shelter, no nothing.

The situation got worse when our little baby was sick again. Now we had to remove the big boy from school, send him back to the village, in order to bring this one to the hospital.

For the moment I am in the hospital with my baby, who is sick. Zachary is two months old. That's hard. I never went to school because my parents were poor. My wish is that my children will be educated. I want my son to become a doctor because he will be able to help the nation."

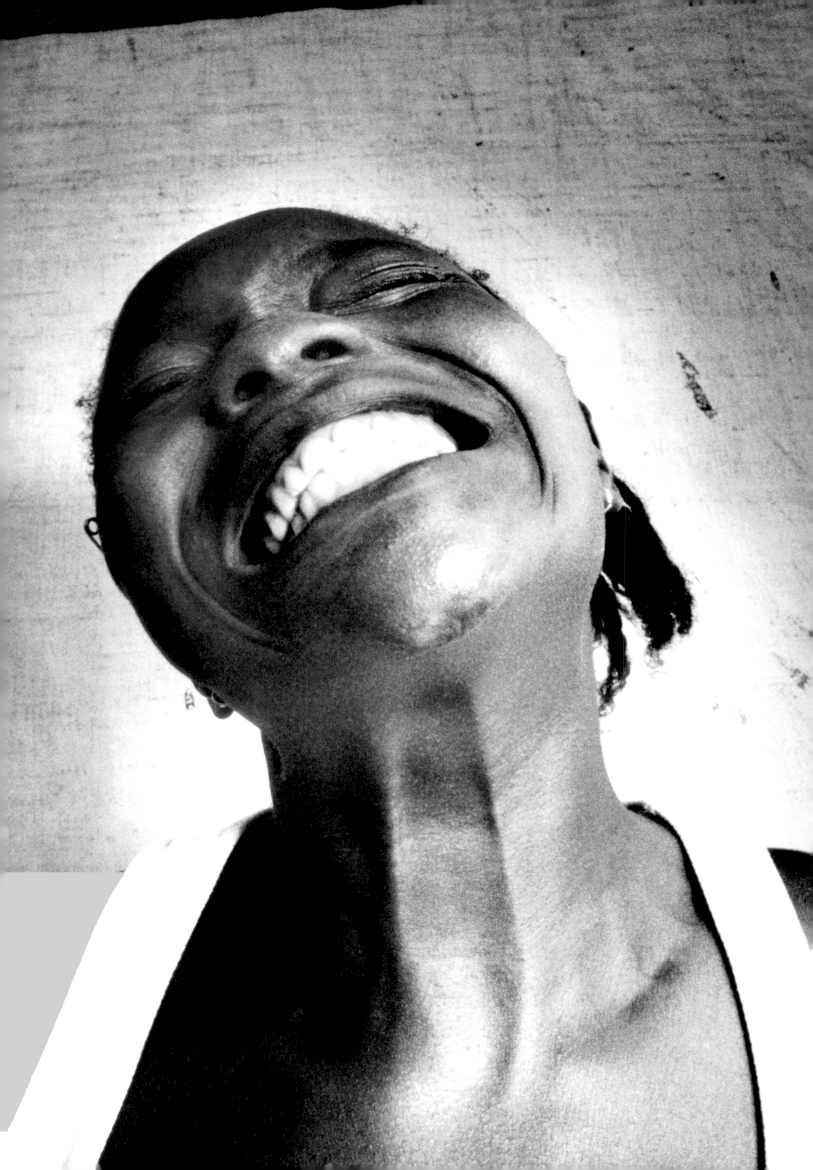

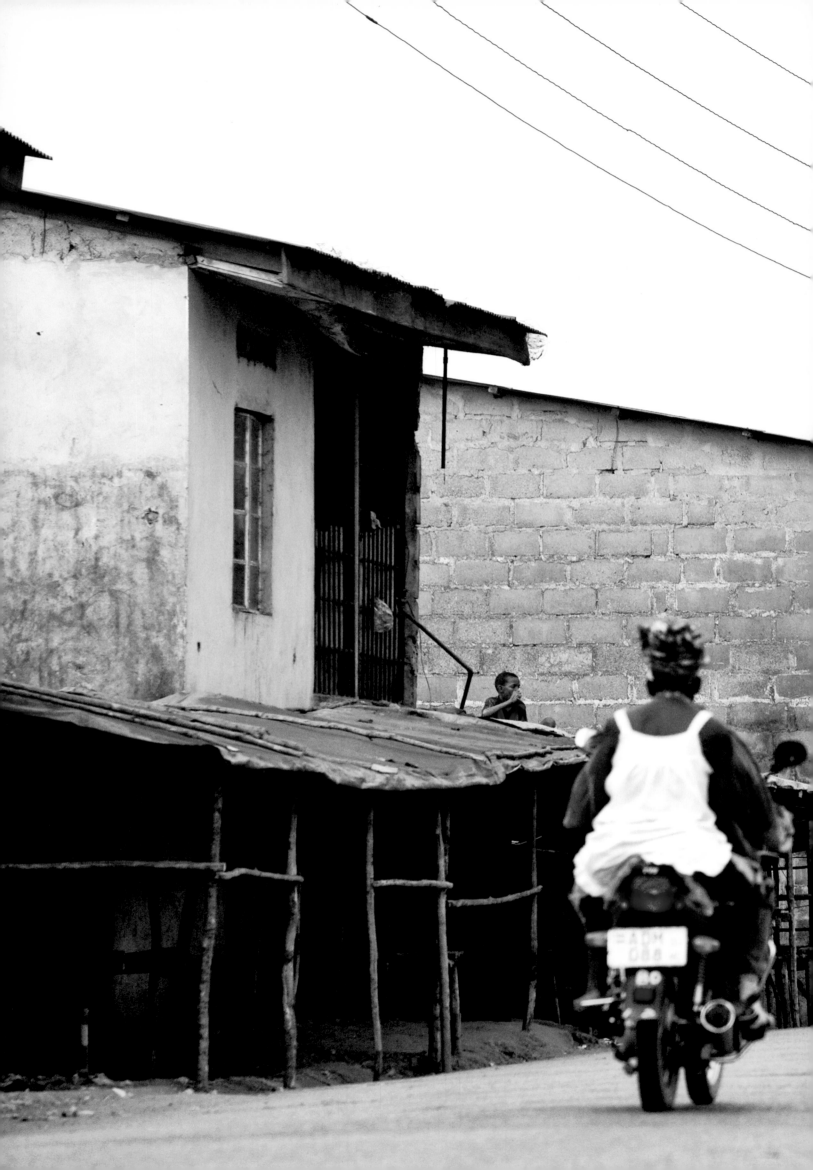

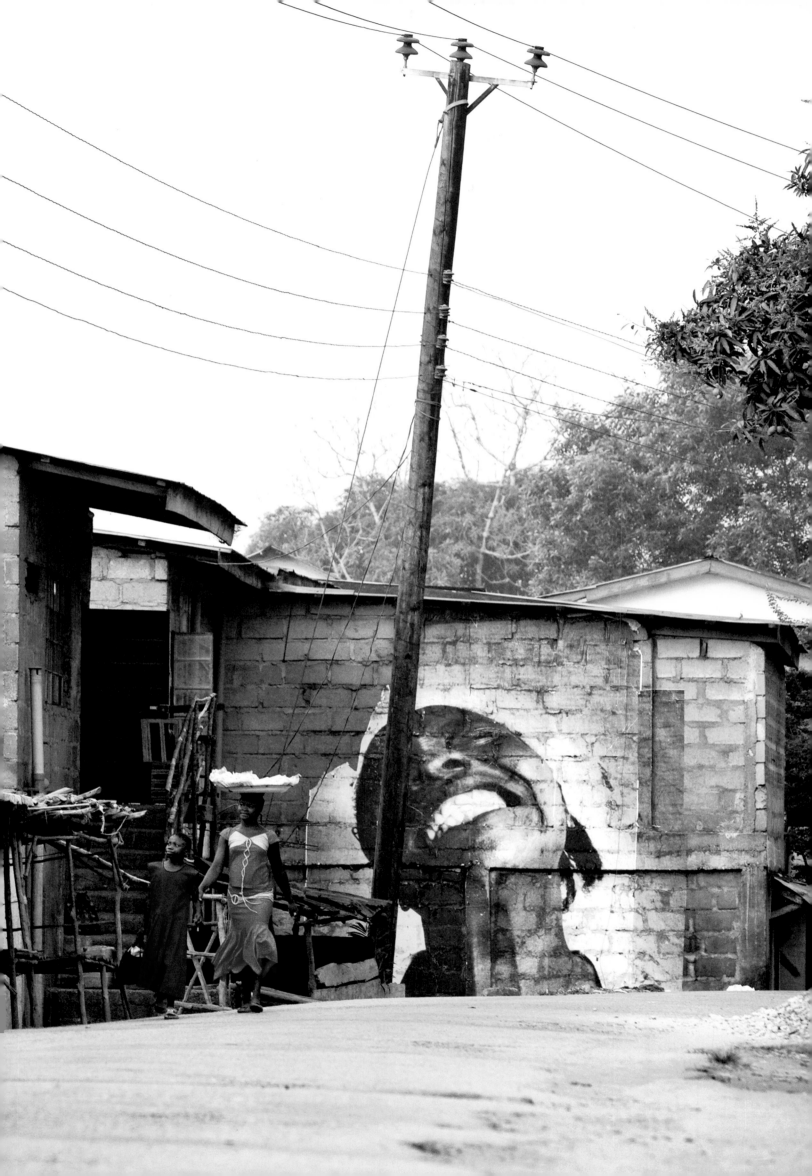

LIBERIA

The land that was once colonized by freed African slaves, Liberia takes its name from "Liberty." The first African nation to become an independent republic, in 1847, Liberia experienced periods of prosperity before having a devastating civil war and becoming one of the poorest countries in the world.

In 2005, Liberia became the first African state to elect a woman leader. Still fragile, the country is trying to reestablish its infrastructure and set up a development plan. In 2008, in a context of growing violence toward women, the government initiated a national action plan to protect them.

Monrovia, the capital, is a chaotic city. The presence of the UN is visible everywhere along the main roads, and things are still extremely tense. There is a curfew at nightfall, as the streets are dangerous.

In town, people look hard, their faces full of fear or violence. Marks of the fighting scar the people, the walls, blocks of flats, and lampposts. Tops of tower blocks are empty, yet the streets below seethe with people. Life is starting to look up . . .

After his first trip, during which he shot the portraits, JR went back to the region for the pasting. He was much awaited. Followed by a crowd of kids, he started to paste the portraits. Sara found her place on a broken bridge that is still necessary to cross the river. Manina stood on the remaining walls of a broken house. And in the empty and dry swimming pool of Monrovia are the eyes of Haya, with enough tears to fill it up to the edge.

During the pasting, the reactions were immediate, raw, and sometimes brutal. People were asking lots of questions. Why faces? Why women? Did they do something special? Why here? What does it mean? Why is it in black and white? Don't they have colors now in France? Are these women all dead? JR always explained what it was all about.

And often, those who understood shared it with the others in their own way. To someone asking what an art exhibition is, a man answered, "You have been here for a moment looking at the portraits, asking questions, trying to understand. During that time, you haven't thought about what you will eat tomorrow. This is art."

The women understood that JR was not a journalist. He was not taking pictures just to bring them to Europe. He was shooting and filming stories to display them in the village and everywhere else.

They trust JR and asked him to send a message in a bottle, not to write it. They asked for a single thing: "Let my story travel with you."

Cecilia Tubah

"I am thirty years old. I live in New Kru Town, Monrovia. I came to the clinic for treatment. There I saw a poster about rape: 'If you were raped before or are being raped, come and see us. We give free medical treatment and emotional support.' I went there and I told what happened to me.

In 1992 I was fifteen years old. The ECOMOG soldiers took me. They carried us in the bush to a rubber plantation. There we had to put our sack down on the ground. Then he started. There were six or seven girls. They kept us from six to nine o'clock in the night. Then he used a torch light. He pointed at my feet and said: 'You, move on, come.' So I went to him . . . He said: 'I will take you to your mom.' So I followed him. He said: 'I will not free you. Go inside and take off all your clothes and lie down on the bed.' He had a gun. I was scared . . . I was sitting there and then he came back. He said: 'Take off all your clothes.' I was so scared . . . I took off all my clothes . . . He pushed me on the bed and did it with me. After, I knew nothing about it. He was the first person in my life who did it with me. When he was finished my legs started shaking; I was cold. Then I started bleeding. I was scared; I did not tell my mom.

For fifteen years I did not tell the story to anyone, not even my husband. I decided to forget about this time in my life.

I consider myself a very strong woman. I had three children after the incident, and I have a little business. My children are in school. And I manage from the business to eat every day. So indeed, I am strong.

I have plans for the future. The plan is only for my children. Because I don't want my children to be on the street, stealing. I am preparing a foundation. I am trying to construct a house, and I have a bankbook to save money.

The best beauty is to wake up early in the morning and to see the children in good health, nobody sick. That's beauty for me. The message for all the women out there is that they should not lose hope."

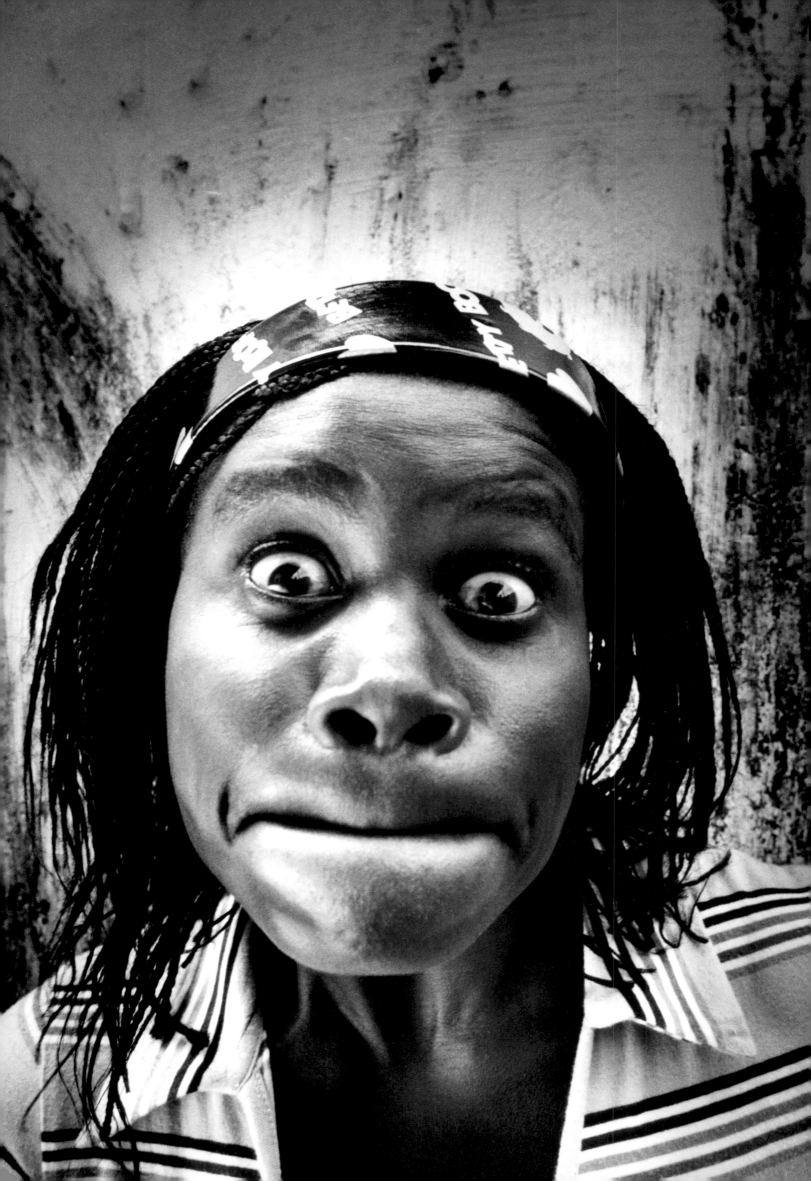

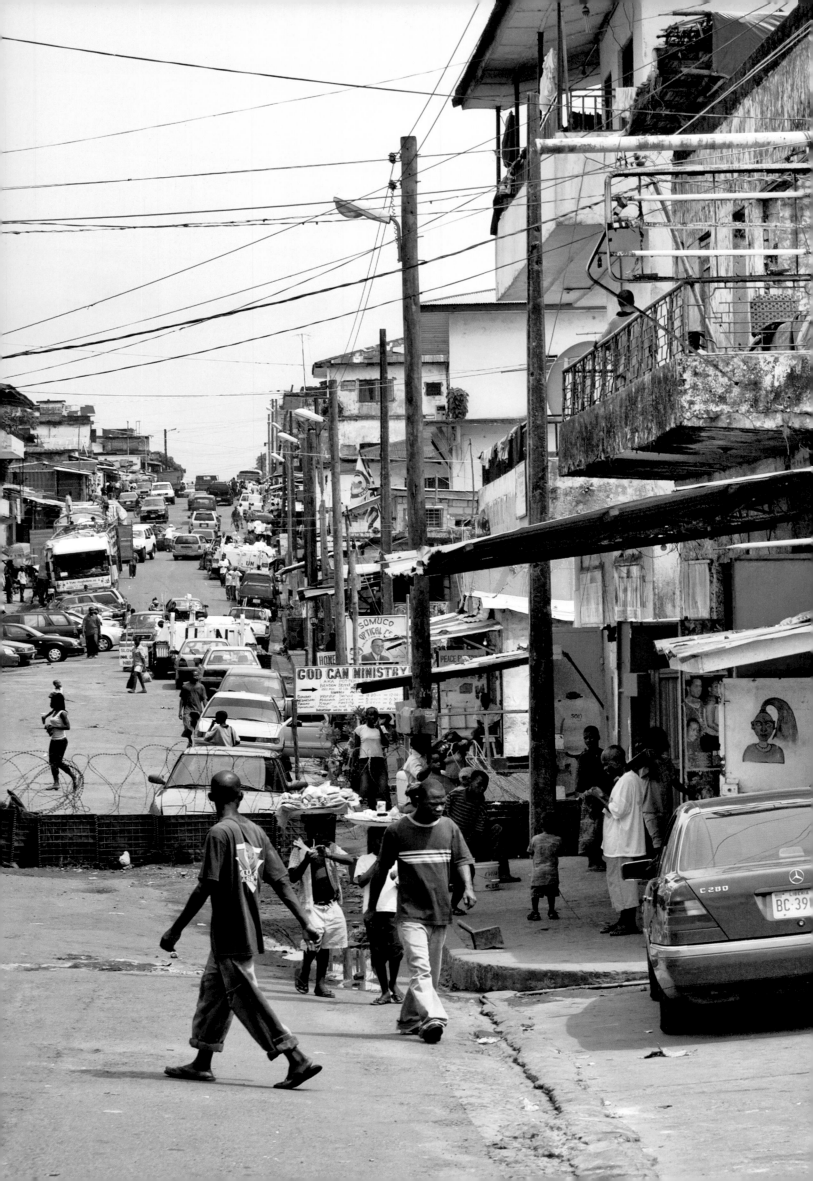

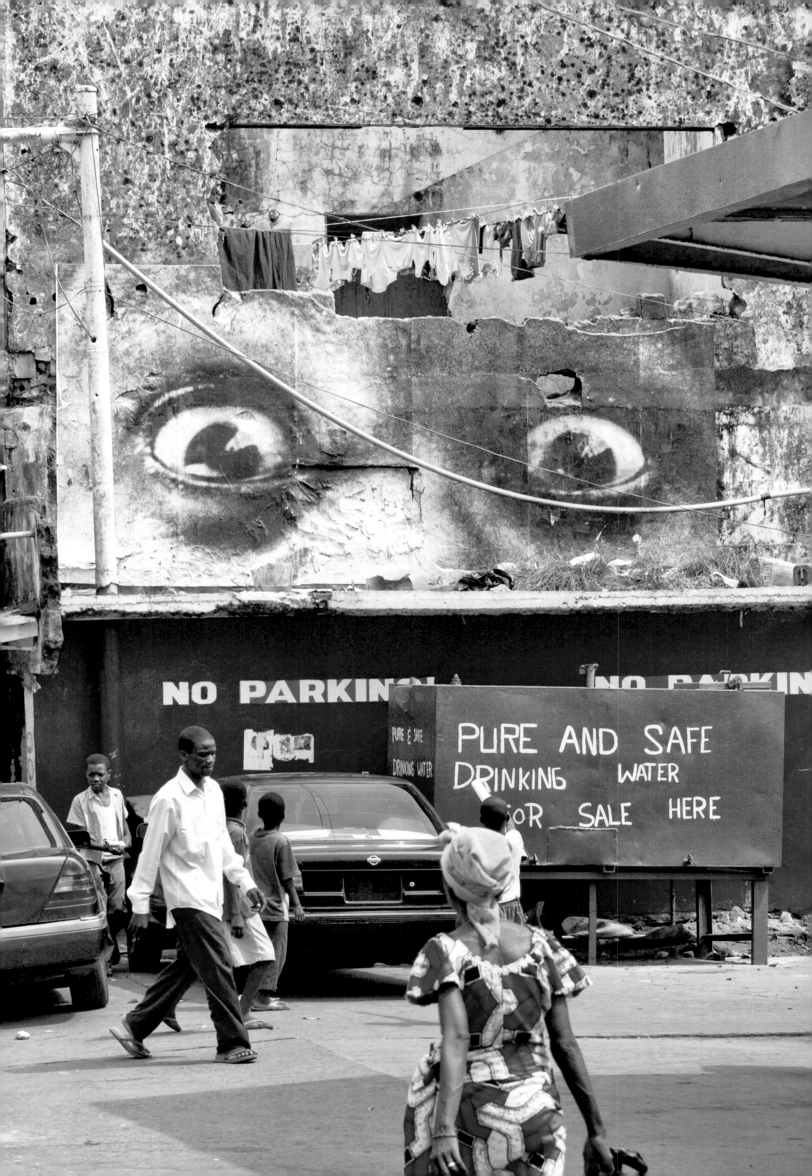

Haya Massaley

"I got married when I was fifteen. My husband had two kids. He disappeared during the war. I don't know what happened to him. So I met another man. His name is Sharim. We had two children. One died. During the war I went to Freetown.

I have four children in the hospital. Three are sick; one is not sick. Because of my children I can't go begging. I asked a woman: Let me live with you. The woman agreed. But one day the woman said that she had no sleeping place anymore. She didn't want to support me and my children. She put me outside. I had to take my boy with me to the hospital. If they discharge me tomorrow, I don't have a place to go . . .

Sometimes I wash people's clothes. They pay me forty or fifty dollars [Liberian]. Some people give me some clothes that I can wear because I have no money.

I think I am strong. But now I don't have anything to support the children. I have nothing to support them . . . I want to give the baby that I am breastfeeding to people for free, because I have nothing. I don't want another husband because I've already said 'I want you, I love you.' I don't have nobody to take care of myself.

When my children grow, they can help me.

The only thing I want right now is food. I want my children to get food, eat, get medicines, a place to live, and feel fine. Those are the things I want."

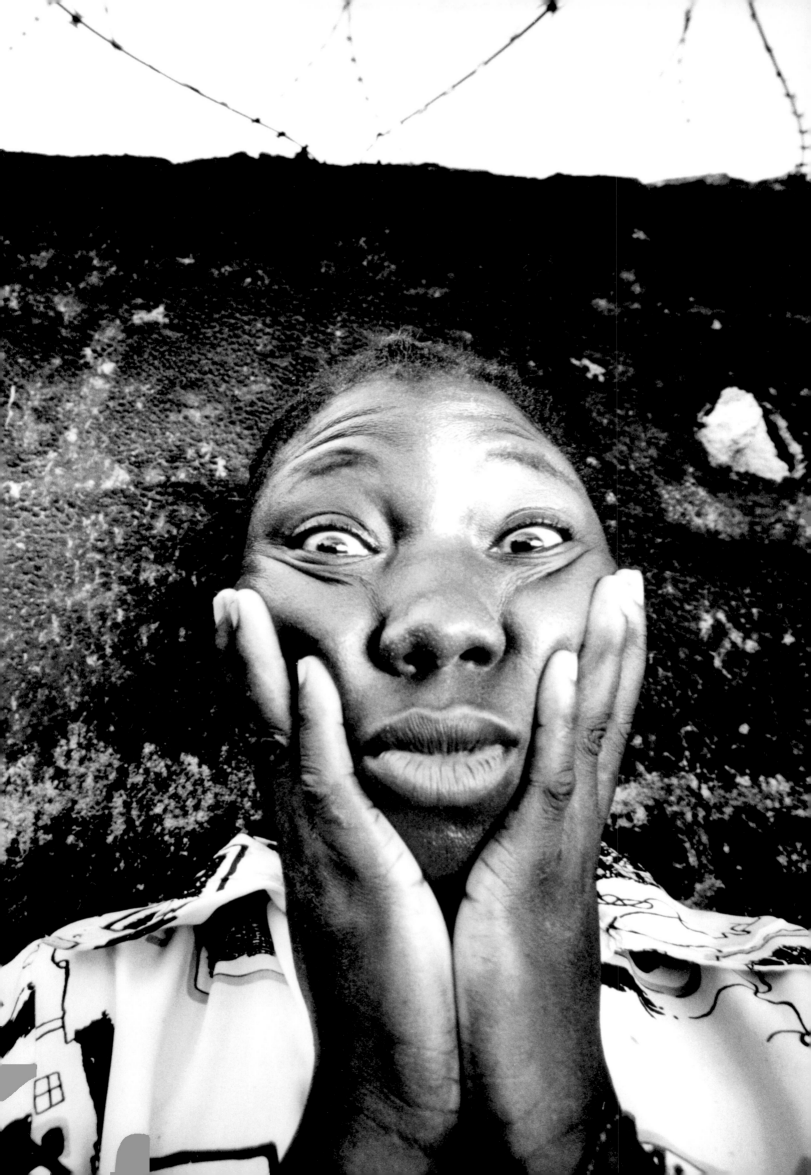

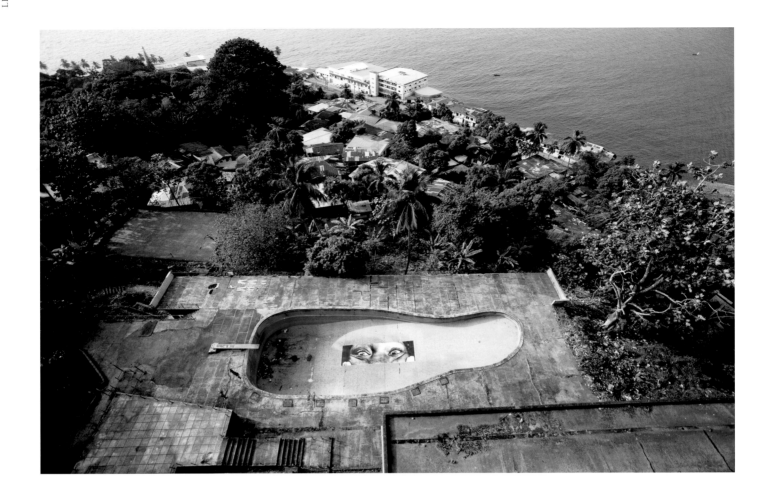

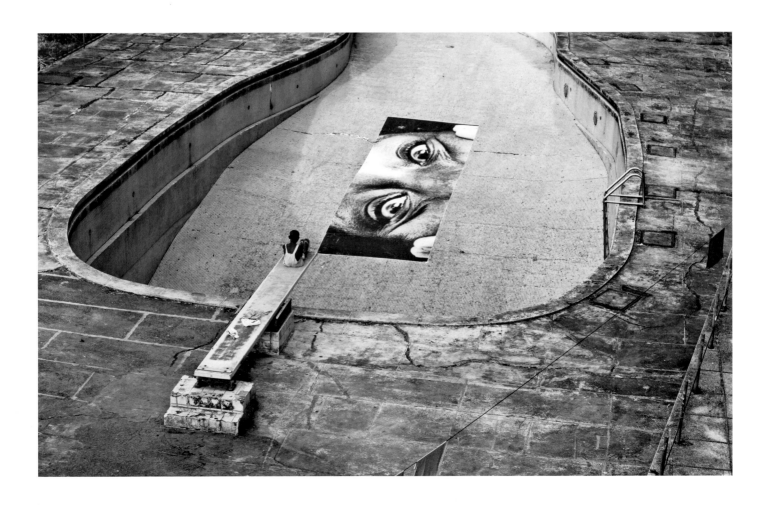

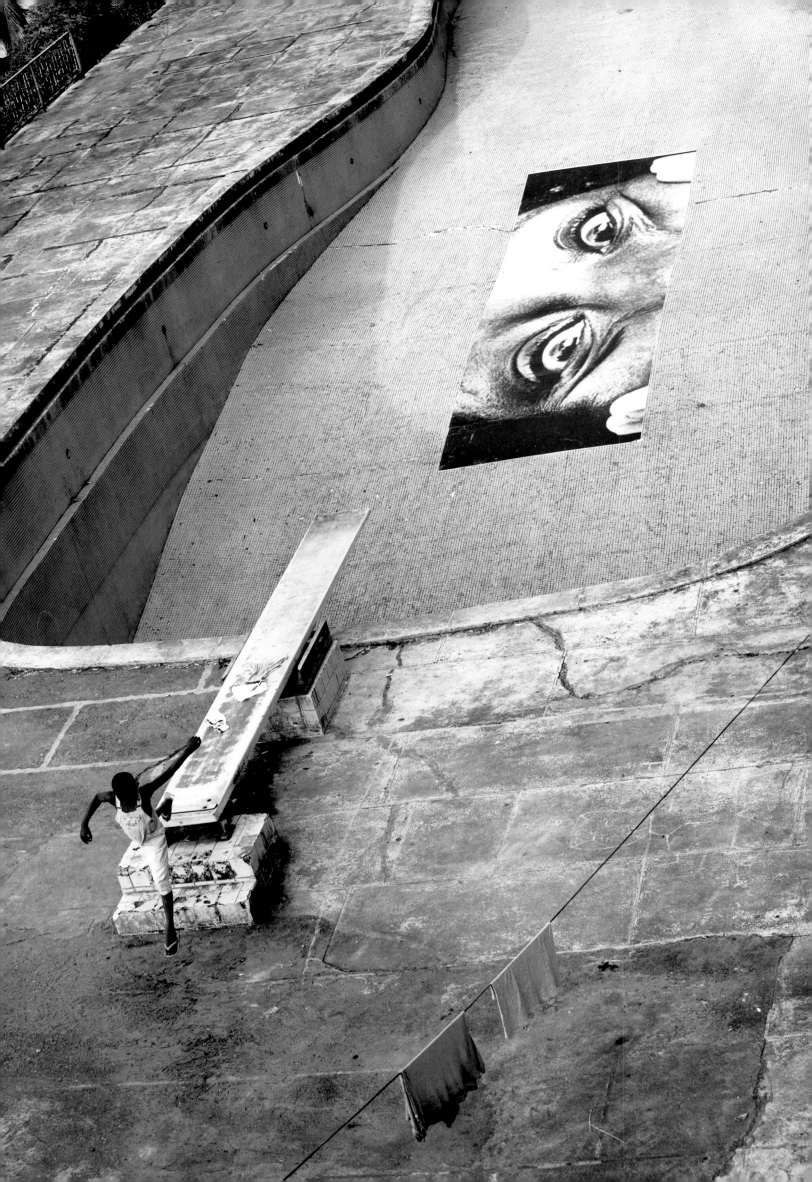

Jessie Jon

"I am around ninety years old. I had a happy life. A good husband. I tattooed his initials on my chest. Unfortunately, he died in 1976.

The worst day of my life is still buried deep inside my soul. I had two daughters before the war. But then the war started here and my daughter got pregnant. We started running away. But the belly of my daughter was very big and we had to rest. They asked: 'Is it a girl? Is it a boy?' They opened the belly and took the baby out of the stomach. They threw the baby in the water and they killed my daughter.

Then I ran away and walked alone in the bush . . .

The war killed my two daughters and my son. Now I have nothing. When I was young, I worked hard and I enjoyed. With my husband I was very happy. I enjoyed my life so much before the war.

I have a large family. One hundred and eight in total with my children, my grandchildren, and my great-grandchildren. I know all of them. I feel that I am now living in a better country thanks to Ellen, our president. She already did a lot for health and education. Women are better leaders. They don't want to fight again and again. The day she was elected, I was so glad that I danced."

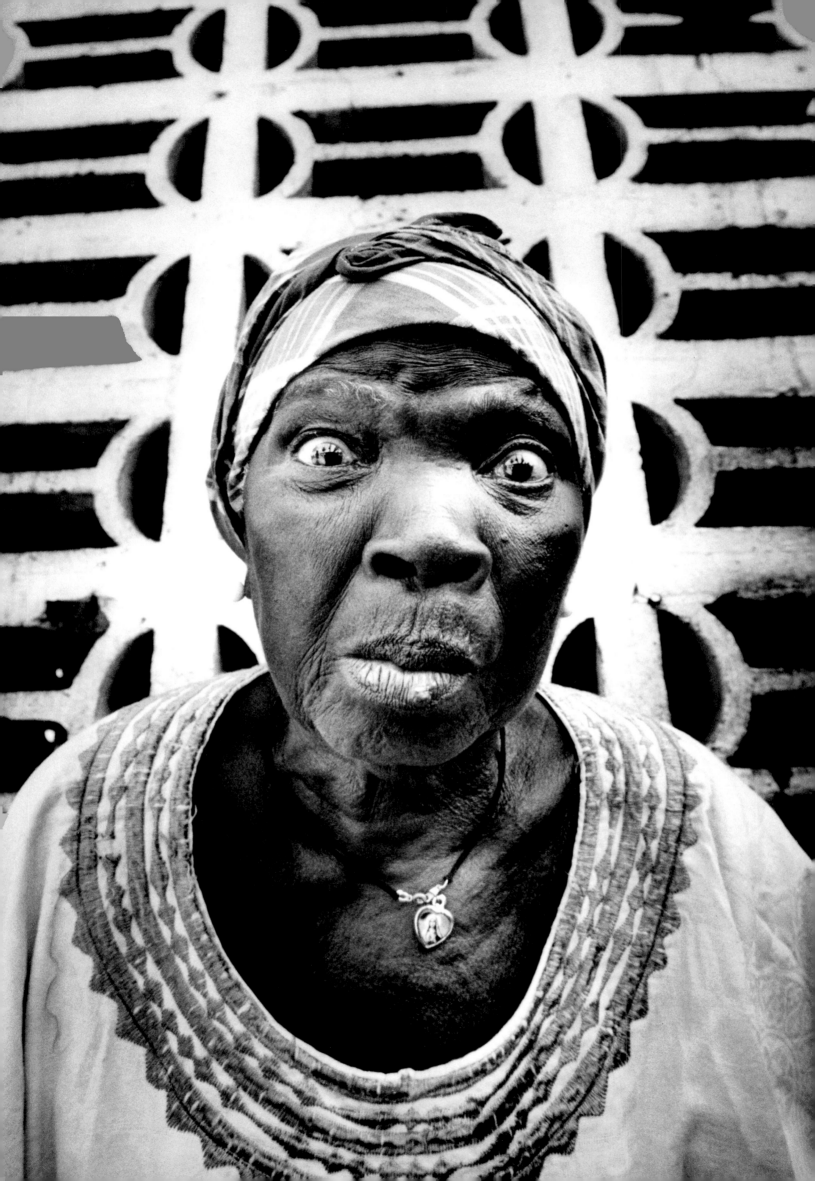

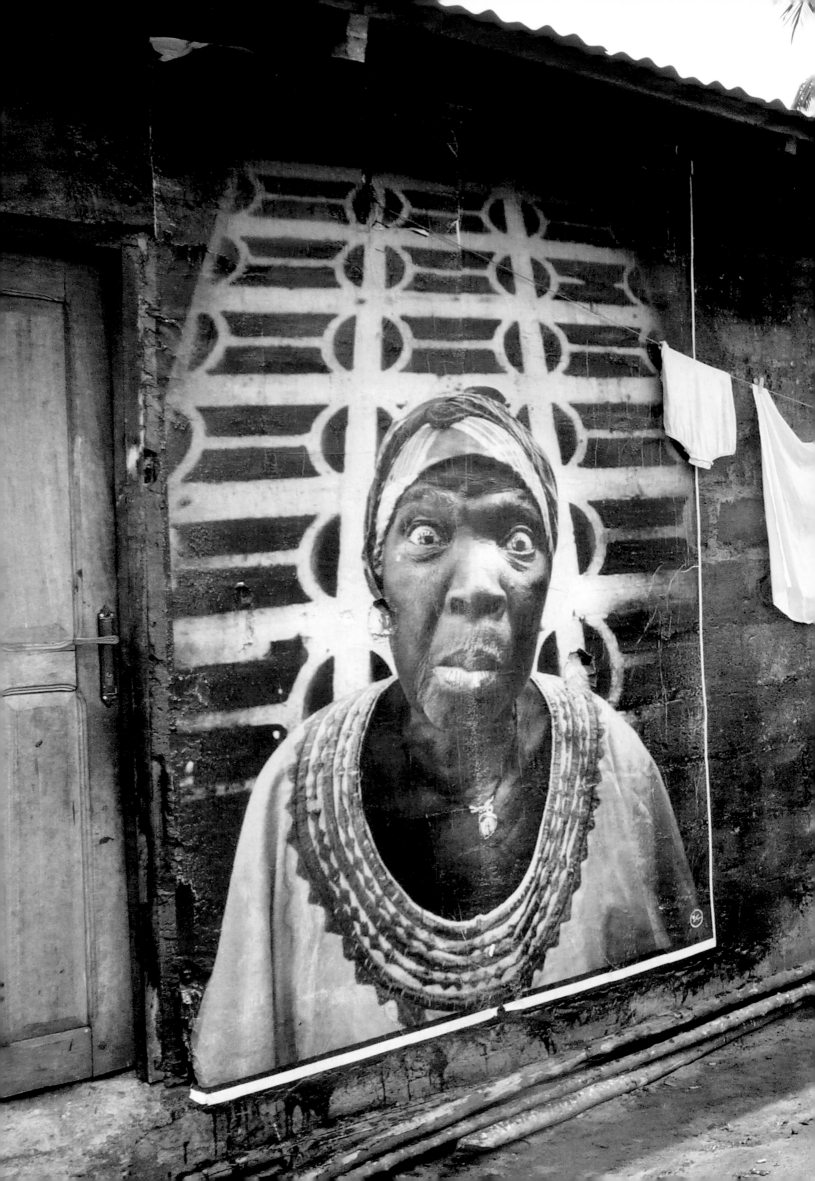

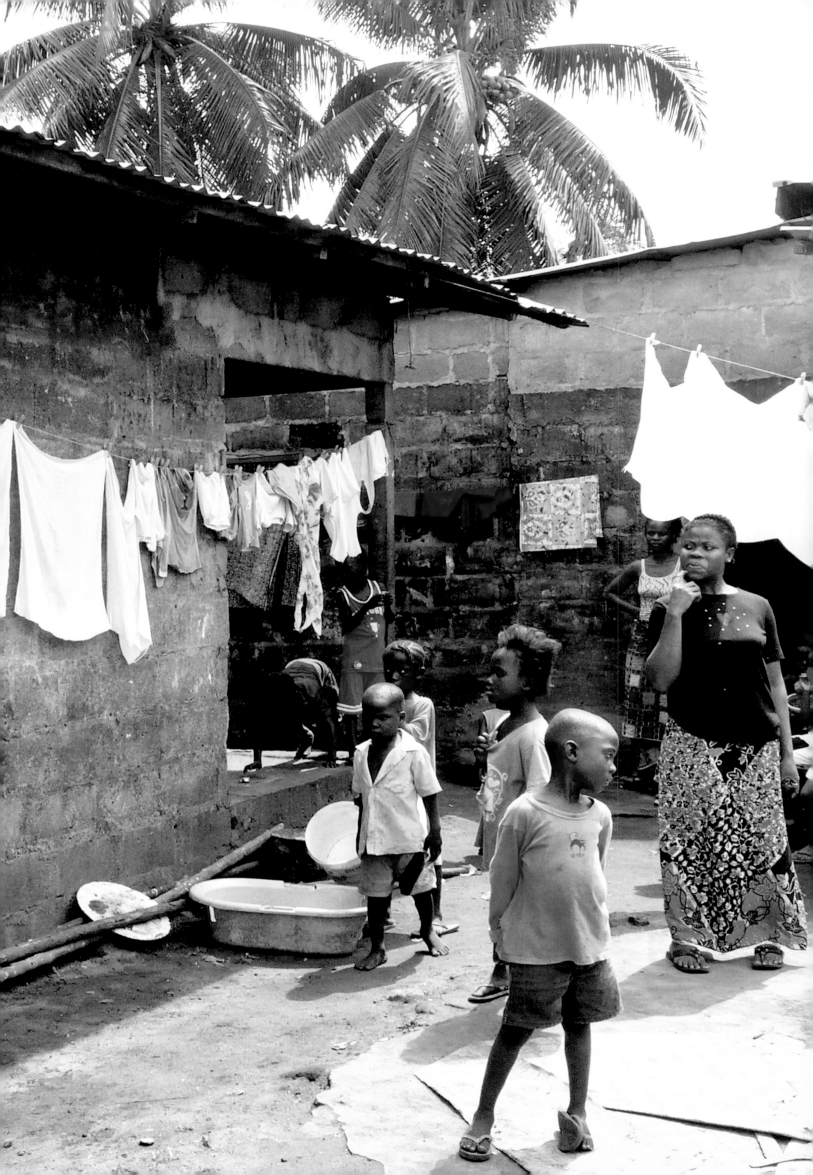

Marie Nyaci

"My husband was a teacher. When the war started, we ran away. We took the bushroad to hide in the forest. So we left the place where we were; we left the area and ran away.

Me and my husband, we had two children, a girl and a boy. They killed my oldest son and burned our house. My husband got sick two years ago and he died. When he was still alive it was better. He helped me a lot. He was a strong man. So there is only my daughter and myself here.

I don't feel happy in Monrovia. I survive but I have nobody to help me."

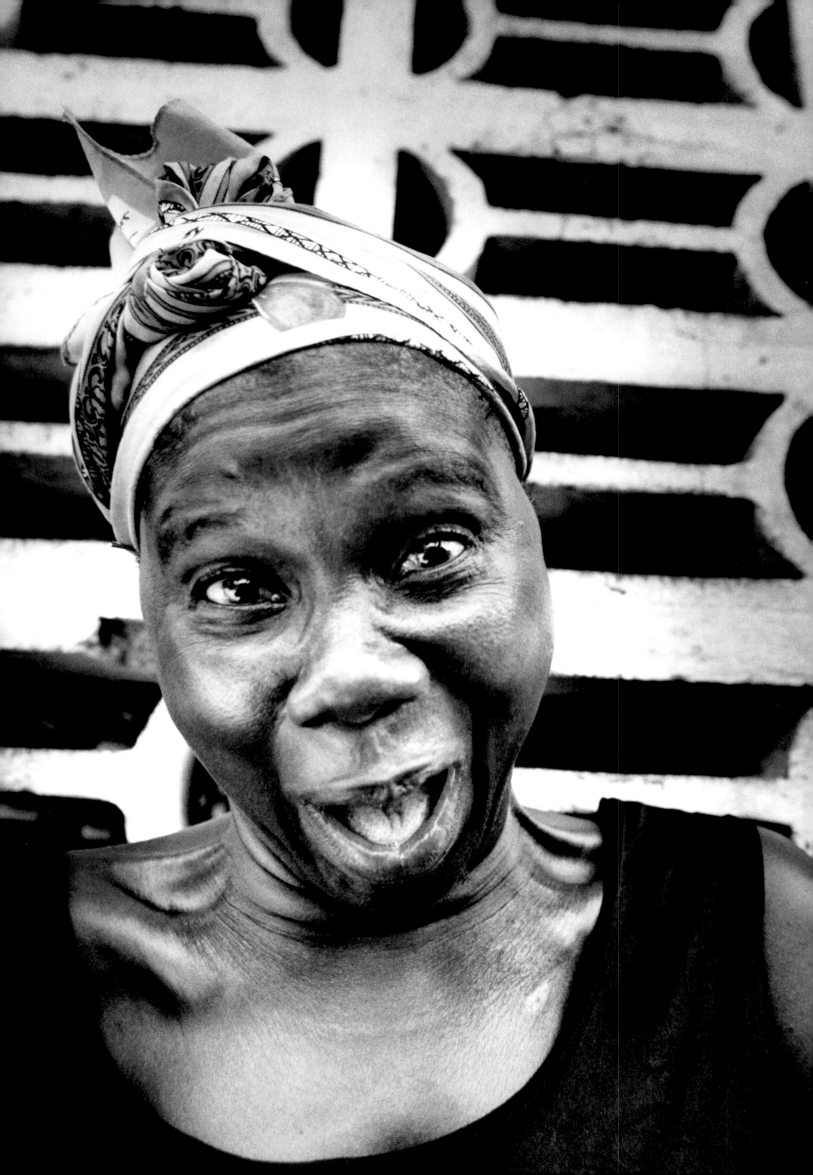

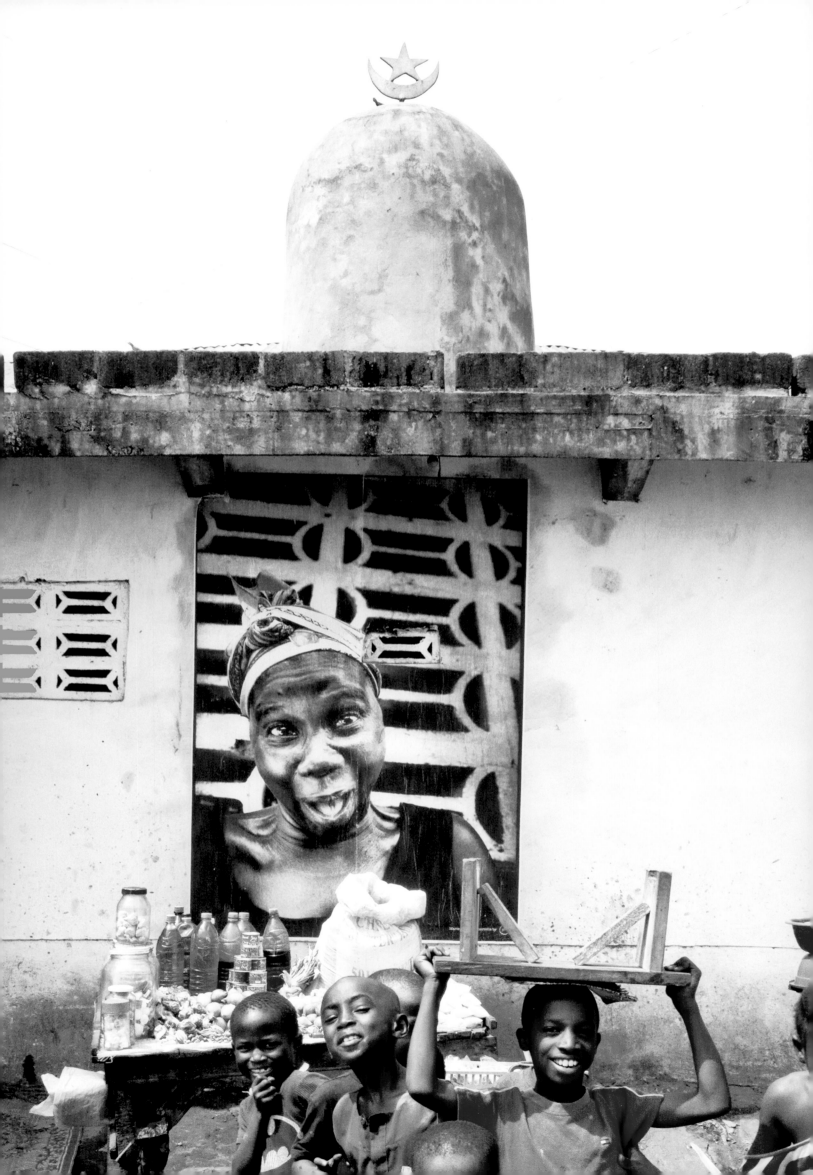

Rebecca Deman

"I am thirteen years old. I live in Monrovia. I was living with another lady who is not my aunt. Her name is Aunty Mary. I slept on the sofa.

One young man, Clarence, came every time [editor's note: to rape her]. I asked him to stop but he continued. I did not know that I was pregnant. It was a woman in the house who said it to me. Clarence said that he is not the father . . .

I am not feeling good. I want to keep the baby even if I am too young to have him. My brother didn't want me to have an abortion. I live with my brother for now; I have no more friends. And I do not know how long I have not seen my mother.

I like to see flowers and drawings. I want to become a nurse. I am afraid sometimes to have the baby. Because there is no father."

Sara Toe

"I had six children. During the war, we were living in the country. When they were on the highway, three of the children – three girls – were taken by the rebels. They took them to the bush. All three died there. My fourth daughter was pregnant. 'Is there a boy inside? Is there a girl inside?' The rebels opened her belly and took the child out. Then they ran away.

We stayed four months in the bush. We survived by eating cabbages. Until the ECOMOG came and took us from there. Then we went to Ghana . . . When I came back my house was broken and my son passed away. I am living with my only daughter now.

I am sad because I lost my big family. When I lie down I am thinking about that. I am grieving about those lost in the war."

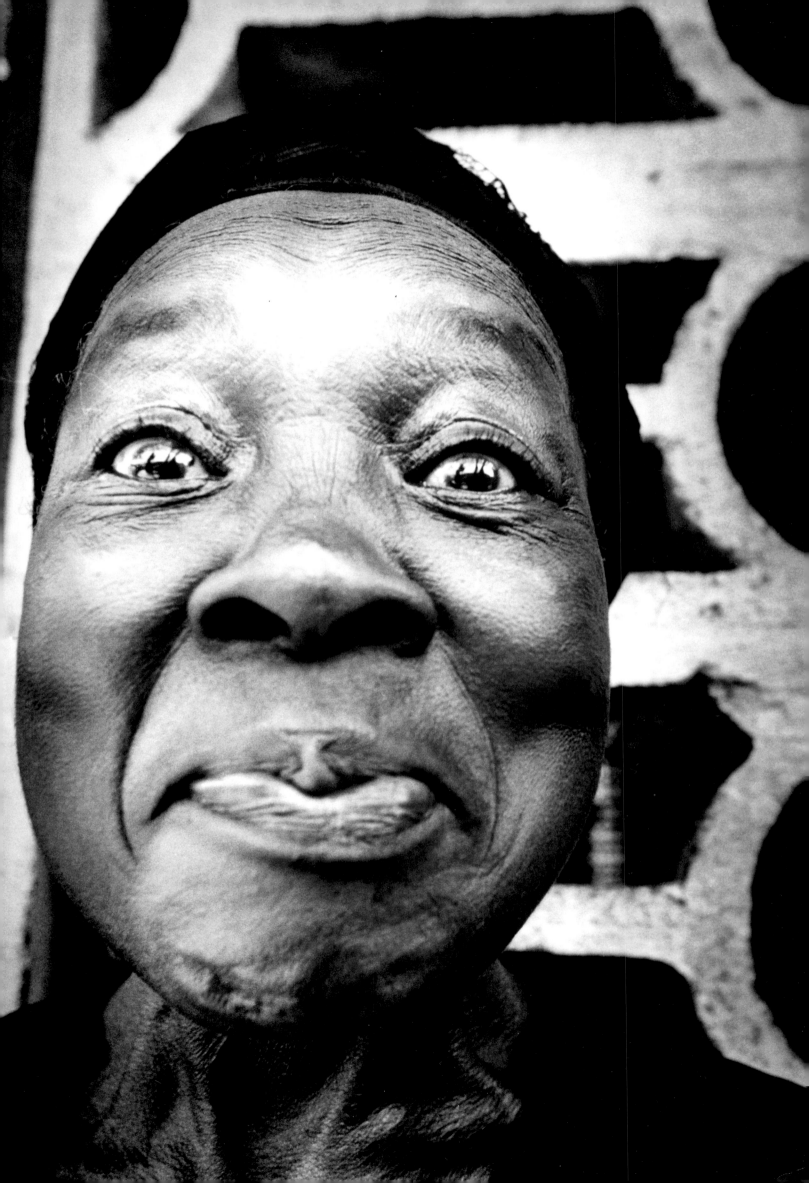

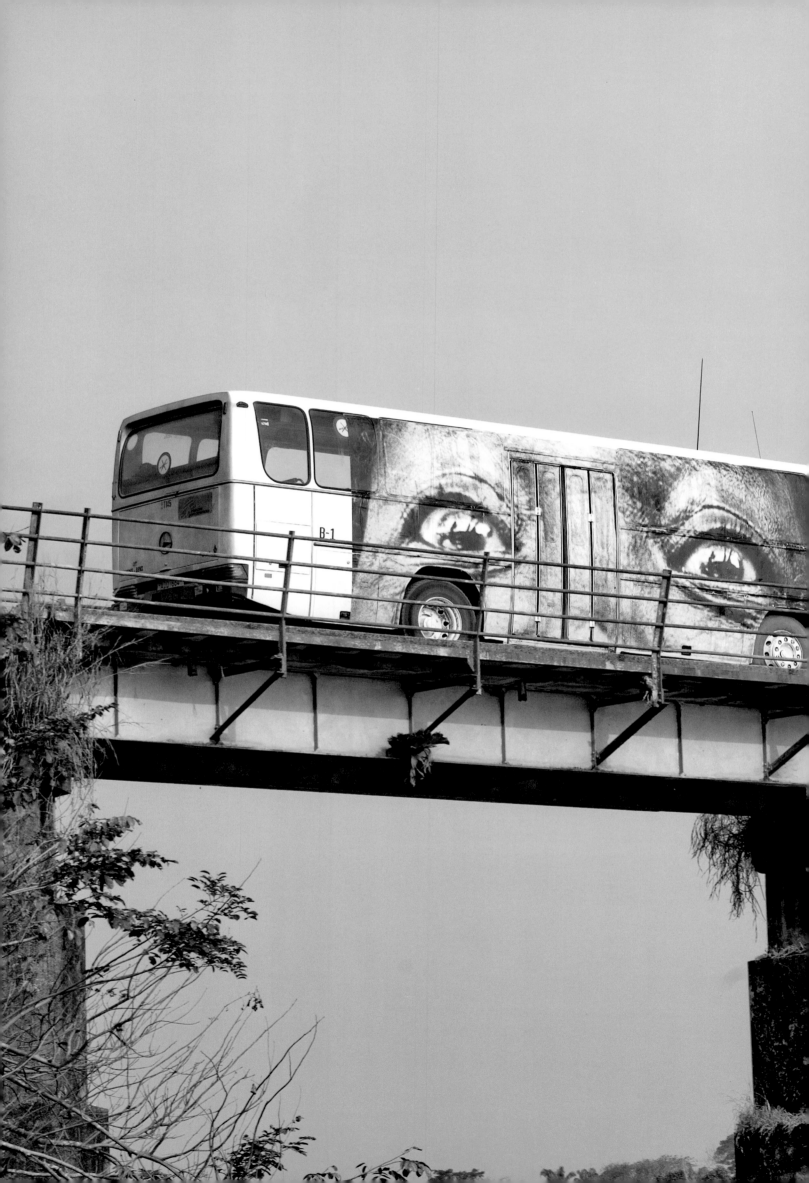

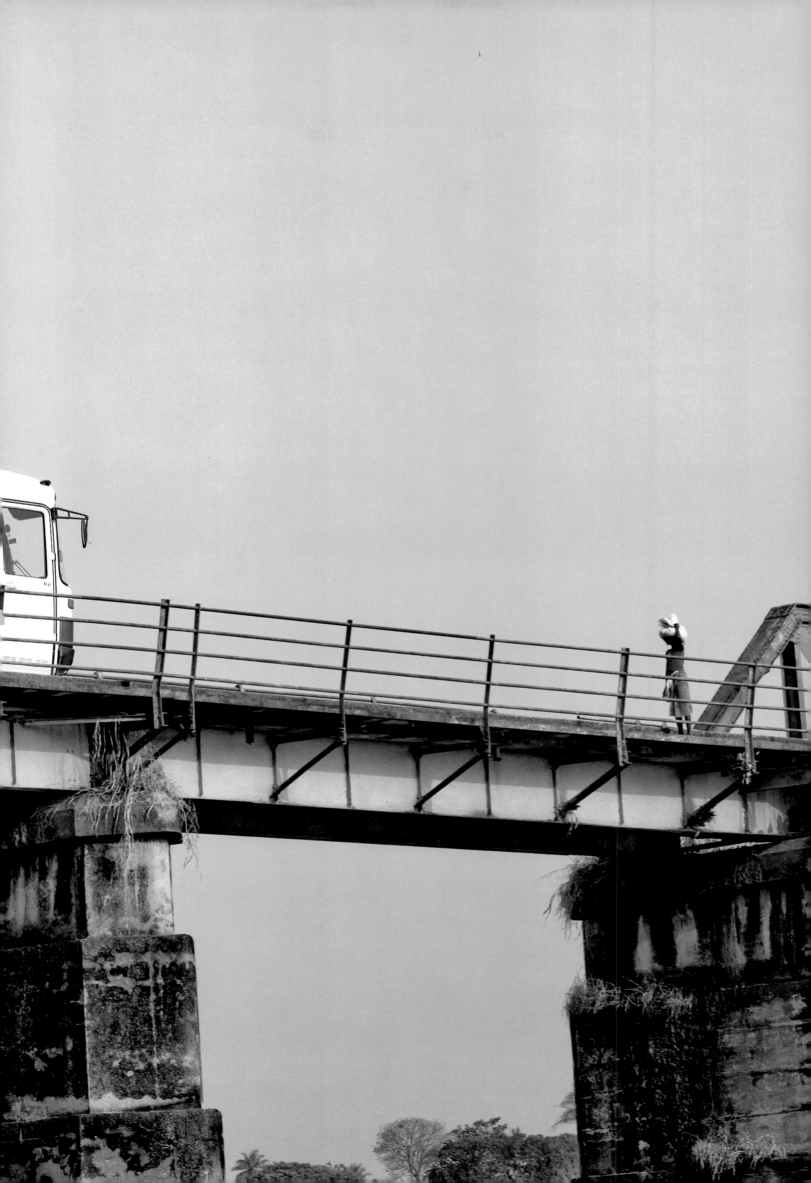

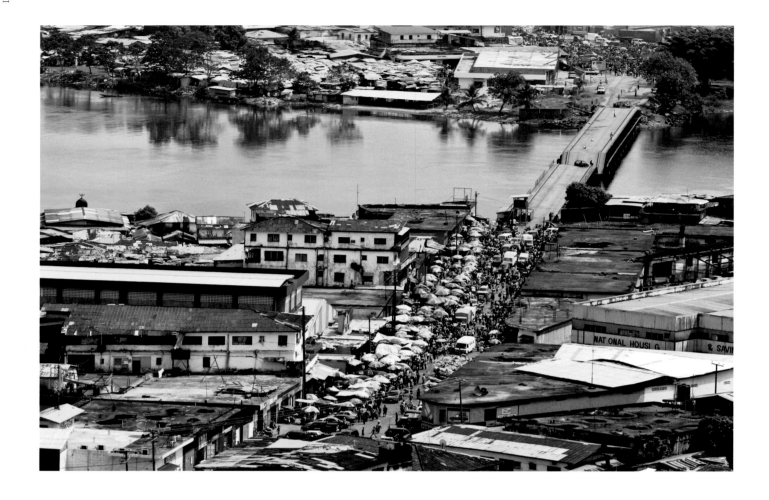

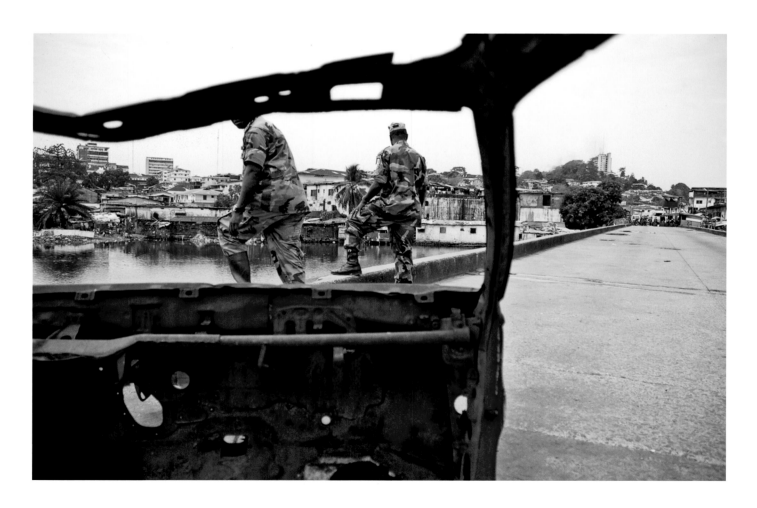

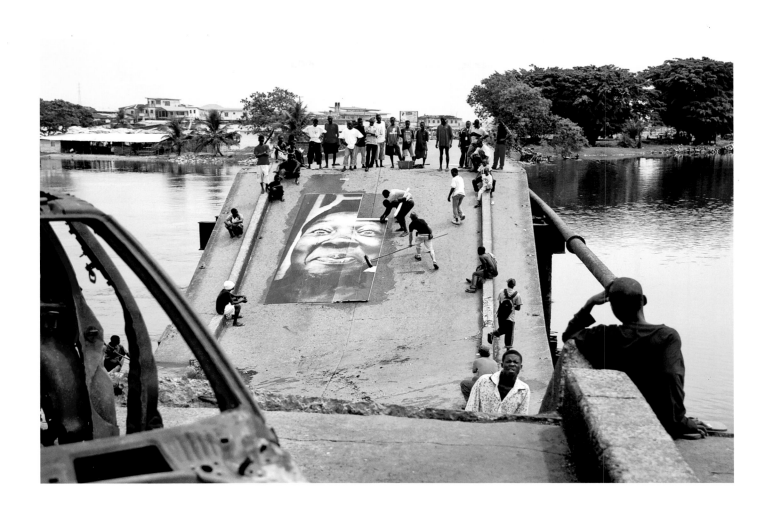
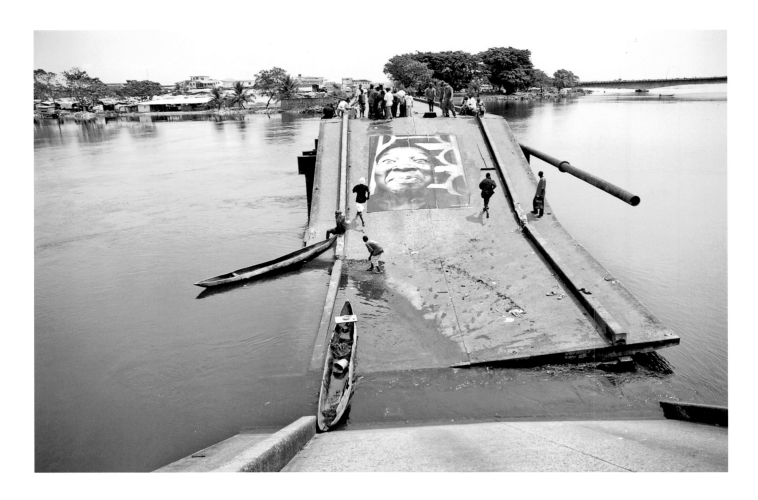

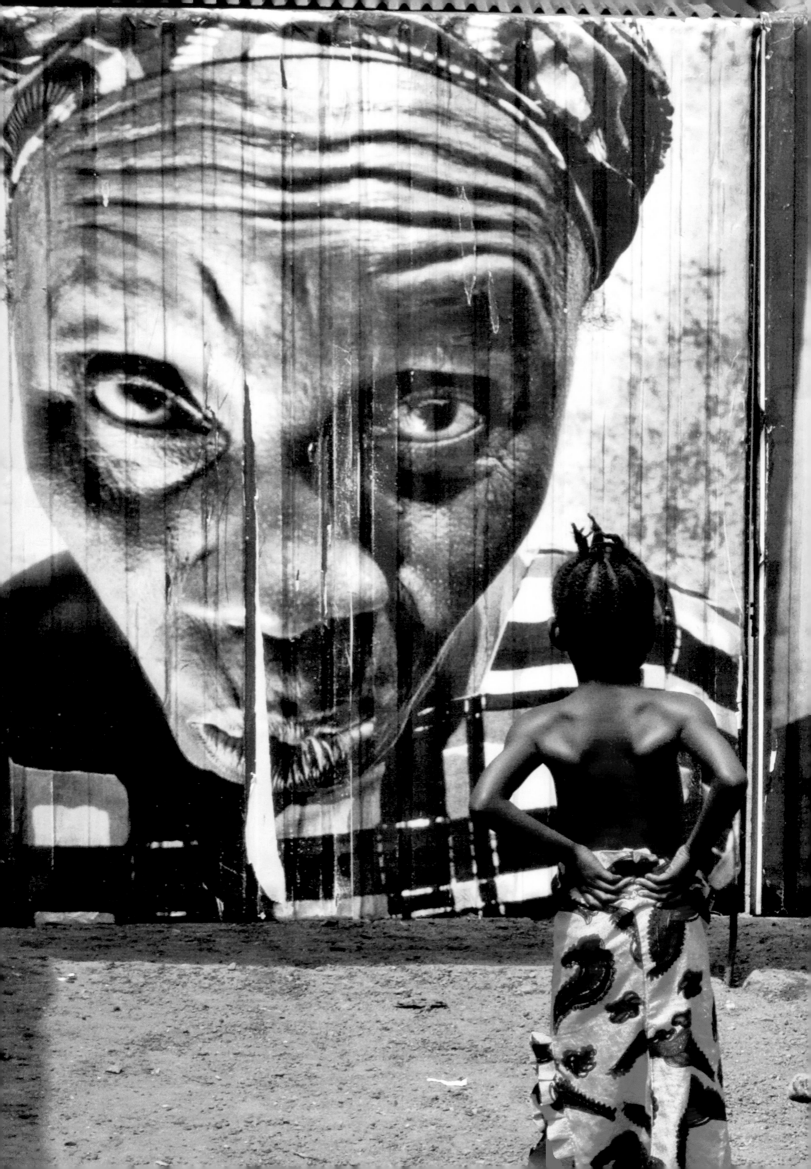

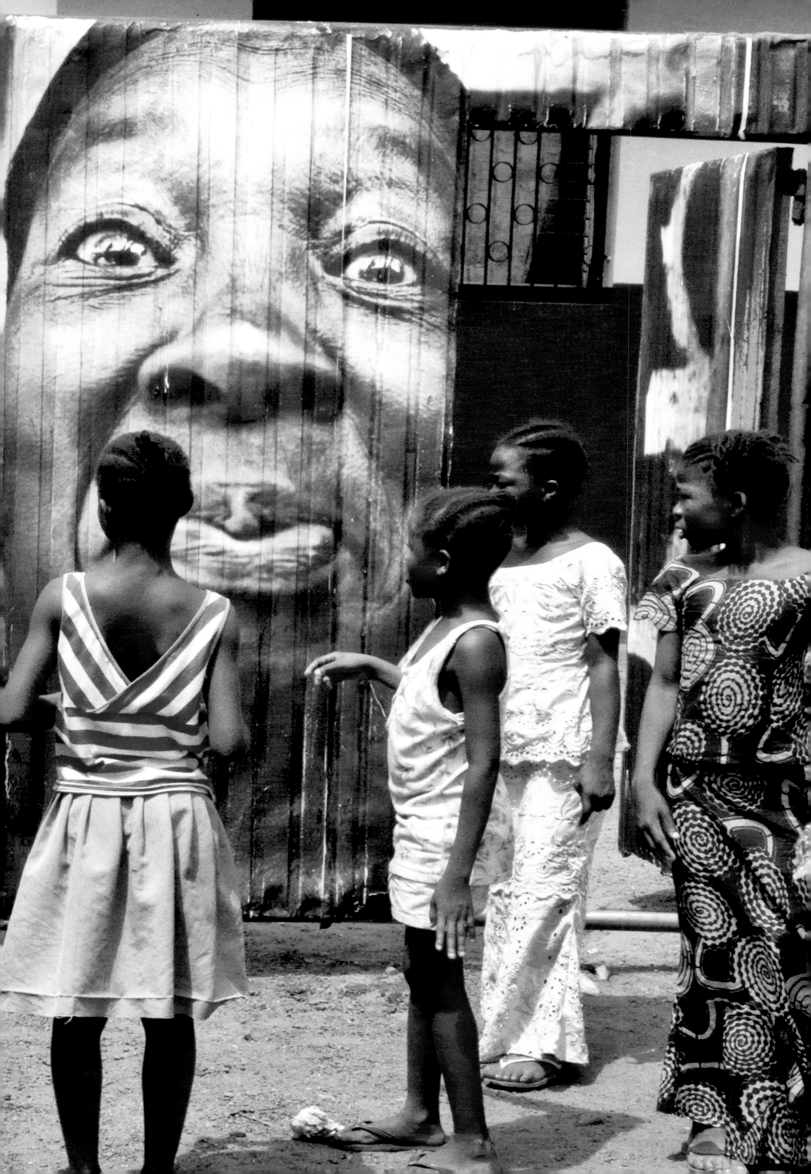

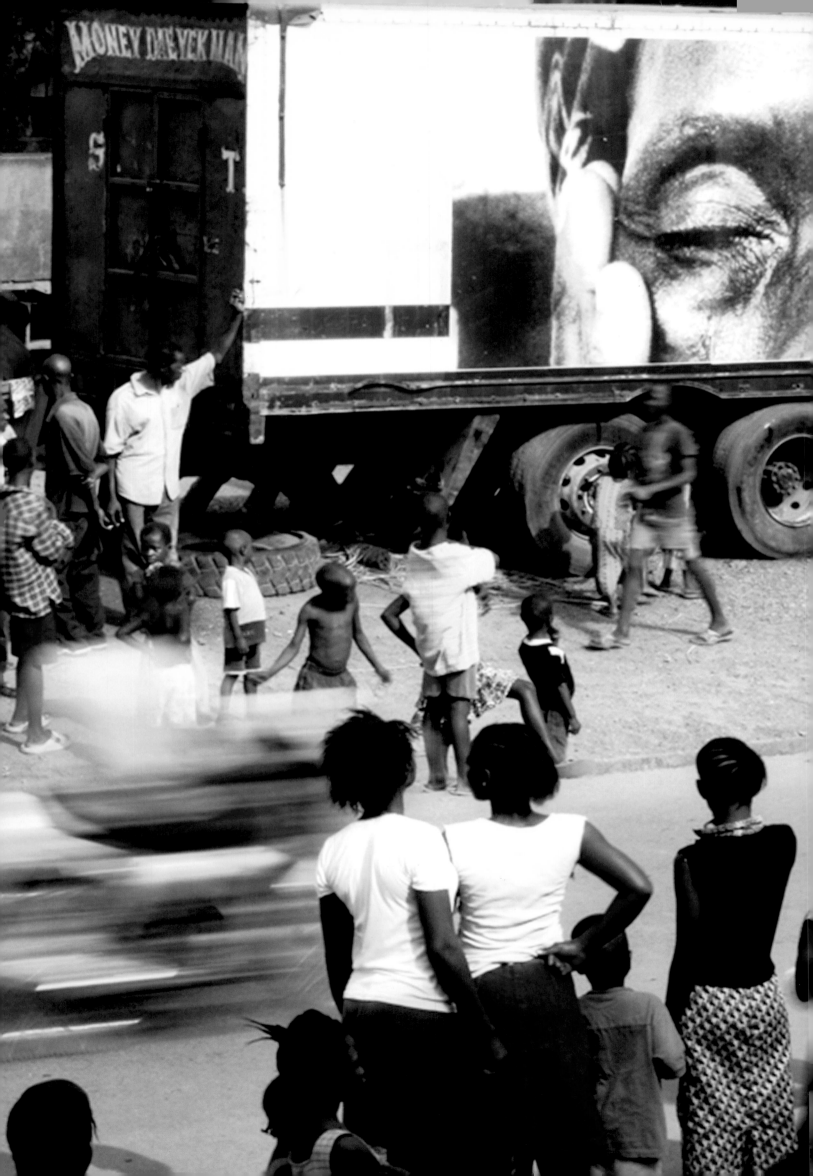

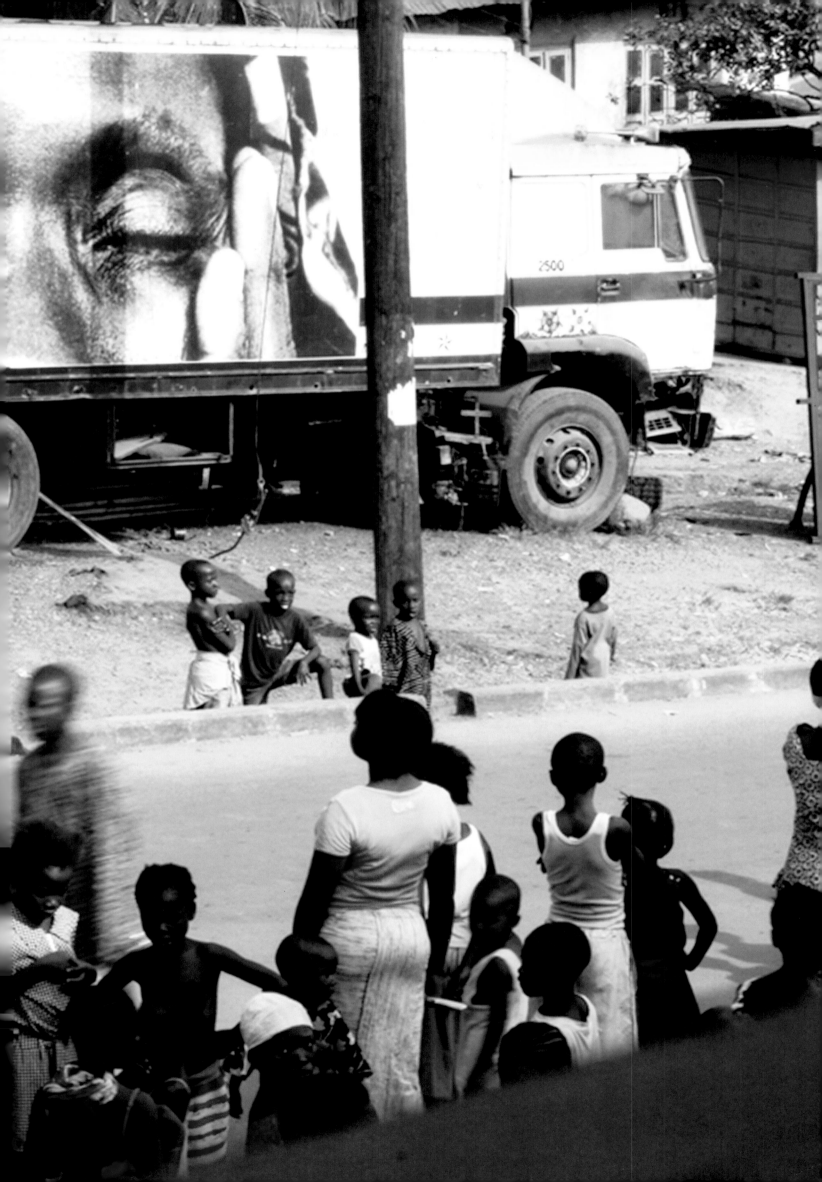

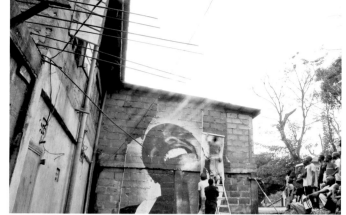

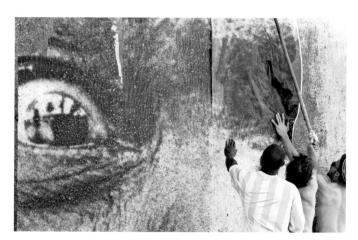

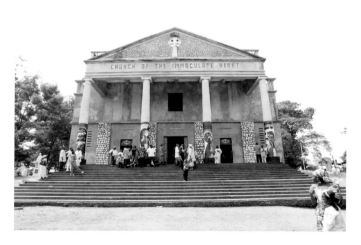

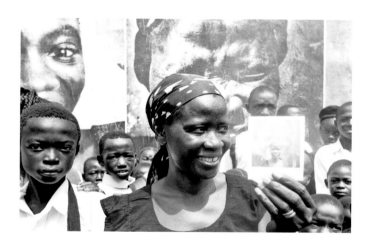

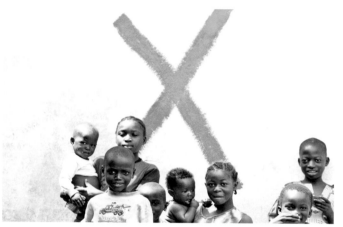

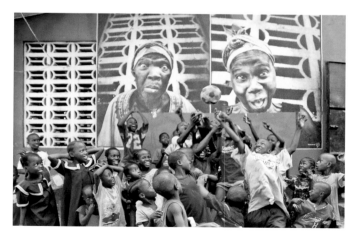

SUDAN

It has not been possible to organize a major exhibition in this country. Rather than fighting violence toward women, the powers that be obstruct nongovernmental bodies' efforts to this end. Women Are Heroes is also a project about exploring limits.

In southern Sudan, the village of Pibor is a dot that is difficult to find on the map. We slipped into a little humanitarian-aid plane to reach a zone in which people still go about naked. Of all the products of our Western culture, guns are the only things they know. Here, there are no walls, no buildings, just stifling heat. But as everywhere else in the country, women are at the heart of conflict, because they survive wars better than men; rape does not always kill.

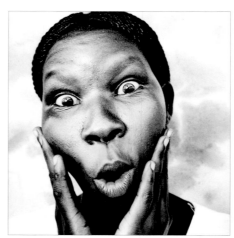

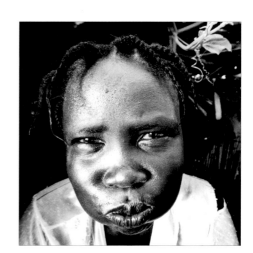

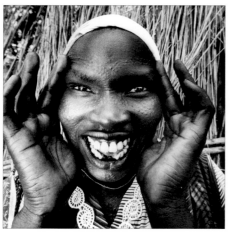

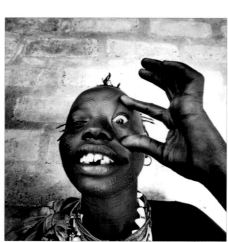

Dulekara

Jane

Lisa

Lojen

Natalina

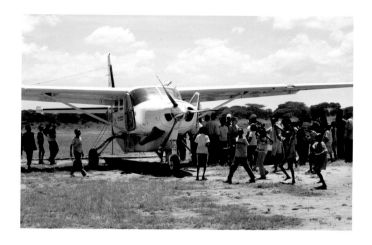

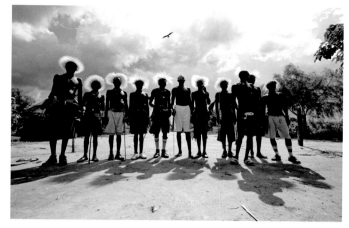

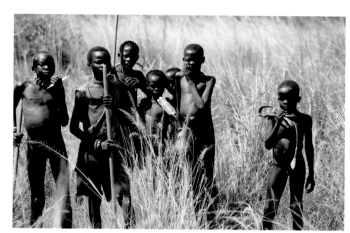

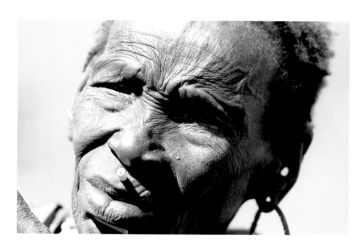

KENYA

Kibera is a district of Nairobi, hosting the biggest shantytown in East Africa. Between 700,000 and 1,200,000 people live in an area of two square kilometers.

JR went there for the first time in October 2007, to photograph and interview the women who became the first in the Women project, at the very heart of this "town within a town." The idea at the time was to use rooftops to mount this exhibition.

Then JR came up with the idea of an exhibition of portraits of women, with the lower parts of their faces attached to the hill alongside the railway. Their eyes would be stuck on a train that would move along the line. At certain times, the train would pass exactly at the spot where the faces were reproduced, looking like twenty-first century "exquisite corpses." People would wait for the moment when this happened, a little rendezvous.

A few weeks later, when the results of the December 2007 elections were announced, Kenya – which had been a relatively calm country – slid into violence, and Kibera counted its dead.

The choice of Kibera and the railway line that ran alongside this shantytown was symbolic. Nairobi had been built around the railway, the first in Africa. And during the events that followed the elections, as a sign of protest against the contested election of President Kibaki, rioters in Kibera tore up and overturned these rails leading to Uganda, the only country to recognize the reelection of the Kenyan president . . . Rumor also had it that Ugandan soldiers supported the Kenyan army in the west of the country, exactly where that railway line was leading.

In April 2008, the president nominated his principal opponent as prime minister, and Kenya became calm again. In January 2009, the project was relaunched, but needed reorganizing.

The conflict had been very violent, many houses had been destroyed, and the population still taking refuge in the north was gradually returning. A new period of research was needed before anything could be done. JR had to be sure that the women photographed still lived there, and above all that they were still willing to take part in the project.

During the first trip, interviews had dealt with their lives and struggles. There was nothing political. The problem now was that the situation had changed, and JR had to be certain that this artistic project, with its gigantic photos, wouldn't be misinterpreted in the tense situation that prevailed.

It was therefore necessary to talk to the local population and the women once more, to evaluate the feasibility of the project and the risks the women incurred. The support of the whole community was essential for the project to take place. No authorization seemed necessary, other than that of the aptly named Rift Valley Railways that JR had to convince in order to create his train installation, which was to cover an entire train with portraits.

Once the population had been motivated to take part in the project, JR began by mounting fairly heavy tarpaulins on the dwellings, to cover them. Houses in Kibera offer little protection: neither from rain, which turns the earth into mud; nor from heat, as corrugated-iron roofs become burning hot in the sun; nor from theft, because you can get in just by pushing a door that hardly closes; nor from the gaze of others, who see and hear everything that goes on inside. So if it no longer rained inside a house, that would already be something, but no one was really sure what would happen . . .

For the first time, vinyl was to replace paper. Everything would be printed in Nairobi. The printer refused to deliver the tarpaulins to Kibera and asked some of his workers to do so. The latter accepted, because they were from . . . Kibera. Back home!

The inhabitants helped install the tarpaulins, and the system worked well. The floors of the houses were now dry and the tarpaulins hanging beyond the roofs also acted as sunshades over the alleyways. Suddenly, everyone wanted a tarpaulin over his roof!

The other installation was on the train cars. The train was covered with portraits of women – Africans, Brazilians, Indians, Cambodians, and, of course, women from Kibera. The lower parts of their faces were pasted on more than 210 sheets of corrugated iron and placed below the train track.

On Friday, January 30, 2009, in the late afternoon, a train ran slowly along the embankment, revealing the setup. To ensure that it worked perfectly, the train engineer had become a member of the team. He slowed the train as it passed through Kibera.

The first to see the train arrive were children at the school where cameras had been set up. As if by magic, the eyes one could see coming from far away seemed to be looking toward the assembled crowd. They approached the faces they belonged to slowly and were suddenly part of those faces once more.

For a few seconds, JR became as powerful as an African witch doctor. But not really . . . here, everyone knew what he was up to. They had seen him create this, and many had taken part in the project. That day, all of Kibera became a village of witch doctors!

After these few magical seconds, the train went on its way, linking the eyes of one woman with the face of another, before leaving the eyes alone to survey the countryside through which they passed. Every morning, the eyes of the women of Kibera linger on the train, into which men of the shantytown are crammed as they go to work in the capital. The women remain; the men leave. But today it is the eyes of the women of Kibera that scan the skies, the towns, and the landscapes of Kenya.

The project was particularly demanding for the whole team. Despite heat, rain, long working days, nights that were too short, anxiety, and sickness, JR and his friends emerged from it with great pride. Because something lasting, other than tarpaulins and corrugated iron, remains in Kibera after this ephemeral artistic project.

Agnes Mark

"I am thirty-two years old, and I was born in western Kenya. I have lived in Kibera for the last five years. I moved here to look for a job after my husband passed away, so that I could buy some land of my own and take care of my four children. But I became very sick and am not able to work very much. Life is very hard for me, and I sometimes wonder what I have done wrong to deserve such bad luck.

During the postelection violence, I was here in Kibera. My memory isn't good because I am still affected, but what I can remember is this. The day had been full of chaos; there were demonstrations along the railway line and mayhem between the police and the people. The government sent in the GSU [General Service Unit]. There were many of them. It was around midnight when I heard a knocking at my door. I then heard a bang, and the police entered the house. The first question they asked me was where the boys were who were heaving up the railway line. I told them there were no boys in my house. They then asked where my husband was and if he had gone out to fight. I told them that he had died in 2003. One of the officers said that since I didn't have a husband they would now be my husbands. They slapped me, and I tried to tell them that I was [HIV] positive so that they would stay away from me. They didn't want to listen and raped me anyway. After the rape, they left, and for the next two weeks I treated myself with hot water. I first went to the clinic, where they gave me some medicine to treat myself, but it didn't work. I had a buildup of fluids, and they referred me to Kenyatta National Hospital. They drained the fluids from the vagina, and I was OK.

I think that women are very important in the community because they stabilize everything and families depend on them very much in the house. Men also have a role to play, as they are the security for women. If I were not a widow, then I would have protection against men coming into my house to attack me.

It was only three days ago that my neighbor beat me. I was talking to my children when my neighbor burst into my house and started arguing with me about how I was talking to my children. When I asked him to leave my house, he became angry and told me that I was speaking rudely to him. He punched me in the head and chest, and I fell to the floor. When I tried to stand up, my neighbor beat me again and then grabbed my neck and dragged me outside my house. I screamed, and some other neighbors came out of their houses and told him to let me go. So he left me alone, and I returned to my house with many injuries. I cannot turn my head and I have difficulty breathing because he punched me in the chest, but I do not have any money to go to the hospital for treatment. I want to go to hospital so that I can get a doctor's report and go to the police. I am frightened of my neighbor, and I want the police to help me."

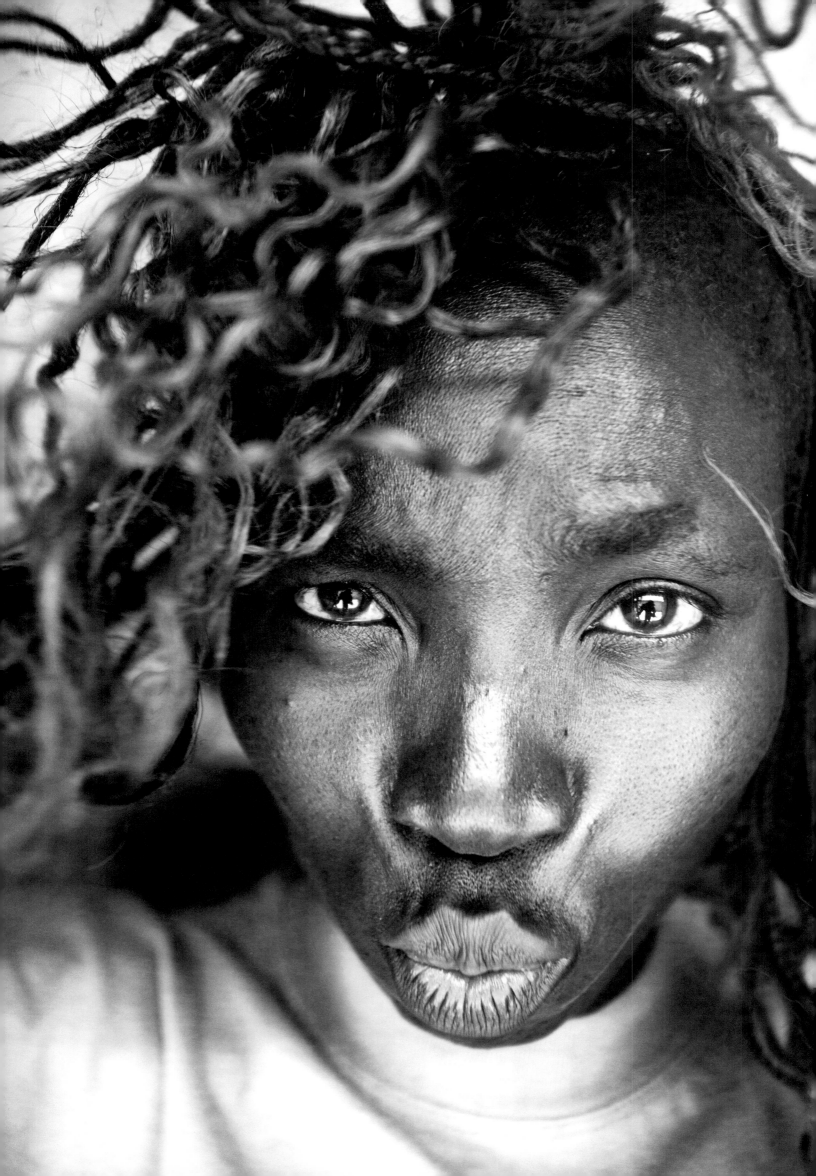

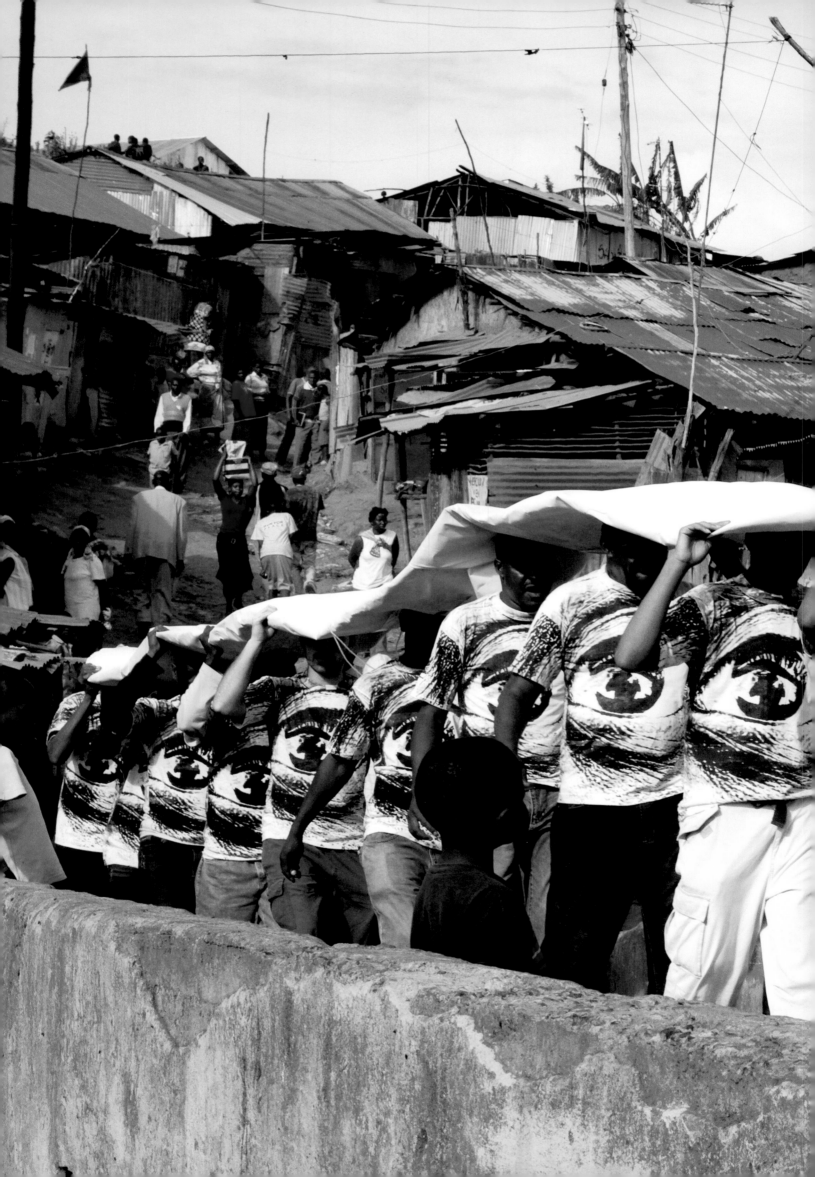

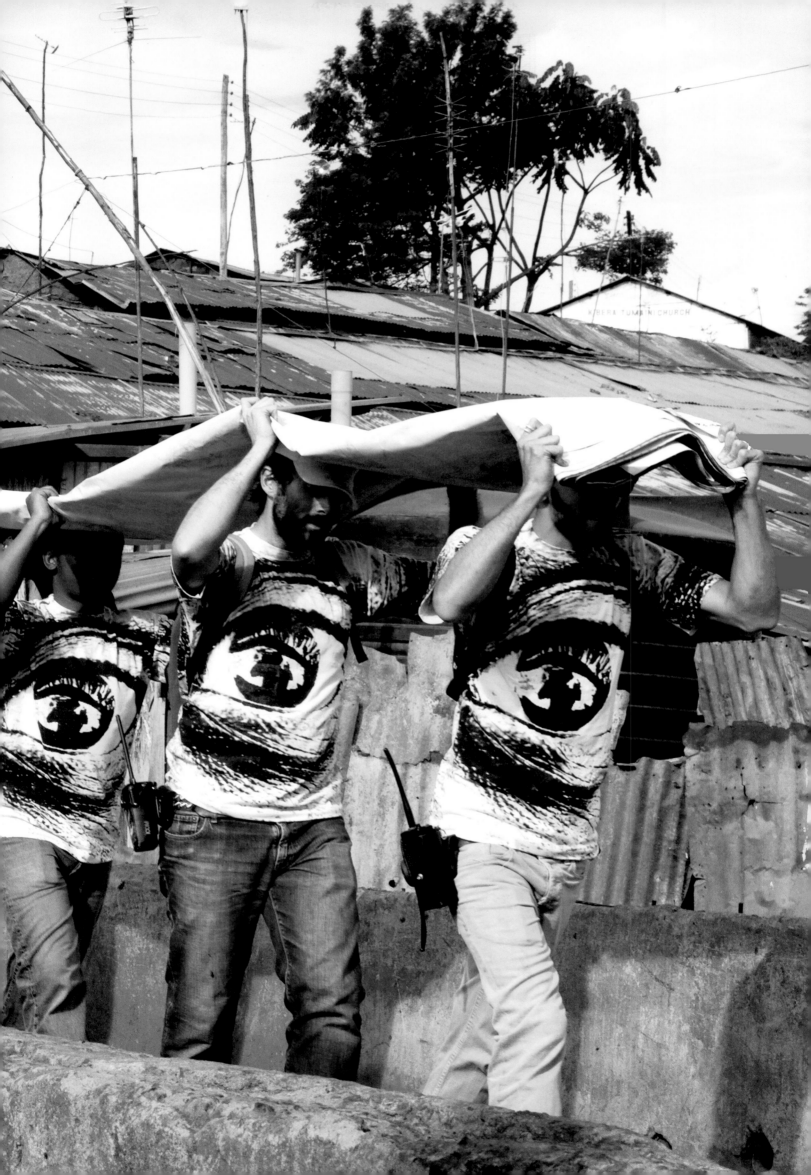

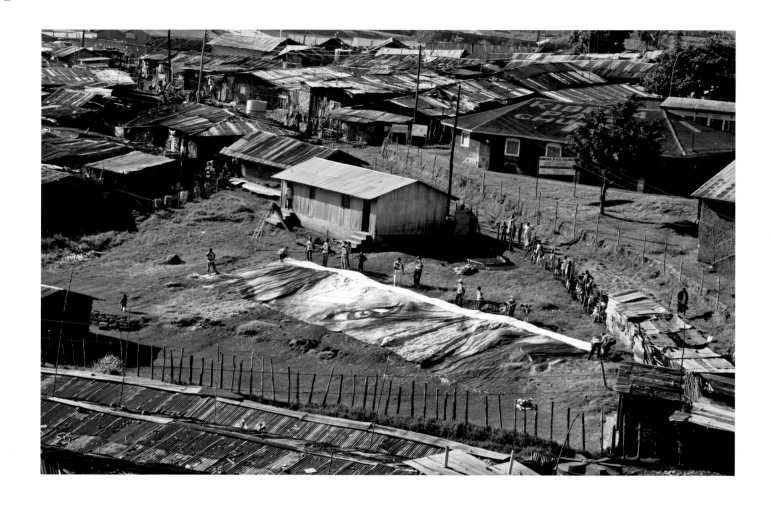

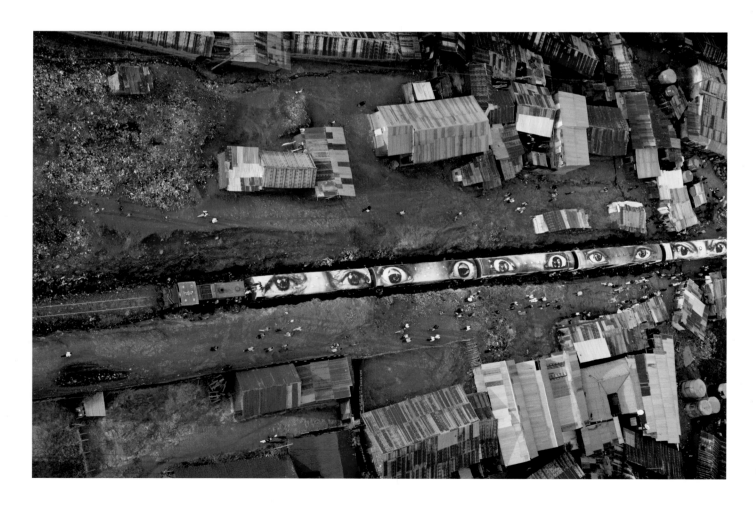

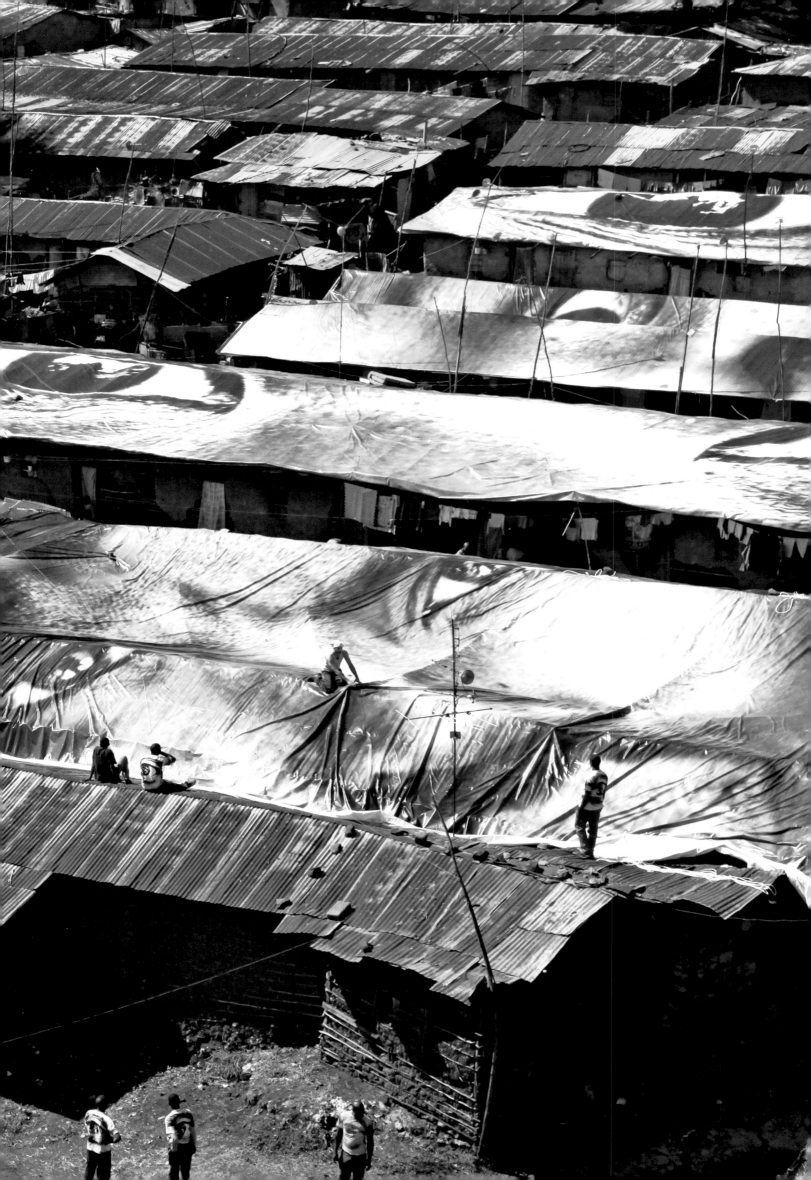

Grace Akoth

"I am twenty-seven years old, and I was born in Kisumu. I have lived in Kibera ever since I was married, which was nine years ago. After we got married, I had my first child within a year, but then I had difficulty getting pregnant and my husband started to beat me. After six years I had not given birth to another child, and his mother began to encourage him to marry another woman who could give him more children. Then God blessed me and sent a baby to me last year. It was a miracle. My youngest child is now one year old.

I have a job as a tailor, which I have had for the last four years. I work every day except Sunday, which is the only day that I have to rest. I try to help in the community by taking part in a merry-go-round with a group of women. There are about fifteen of us in the group and we each contribute ten shillings per day to the group. The money that is collected is then given to one of the women in the group, and we rotate the recipient each day.

I was living in Kibera during the postelection violence last year. It was very difficult for me because I was pregnant at the time and all the tear gas that the police threw into Kibera affected me. I think that it has also affected my baby because he has difficulty breathing now.

I was very happy to be involved in the project. The canvas that is on my roof helps to keep the rain out of my house, which is good. Before I had the canvas, I had a problem with leaks whenever it rained!"

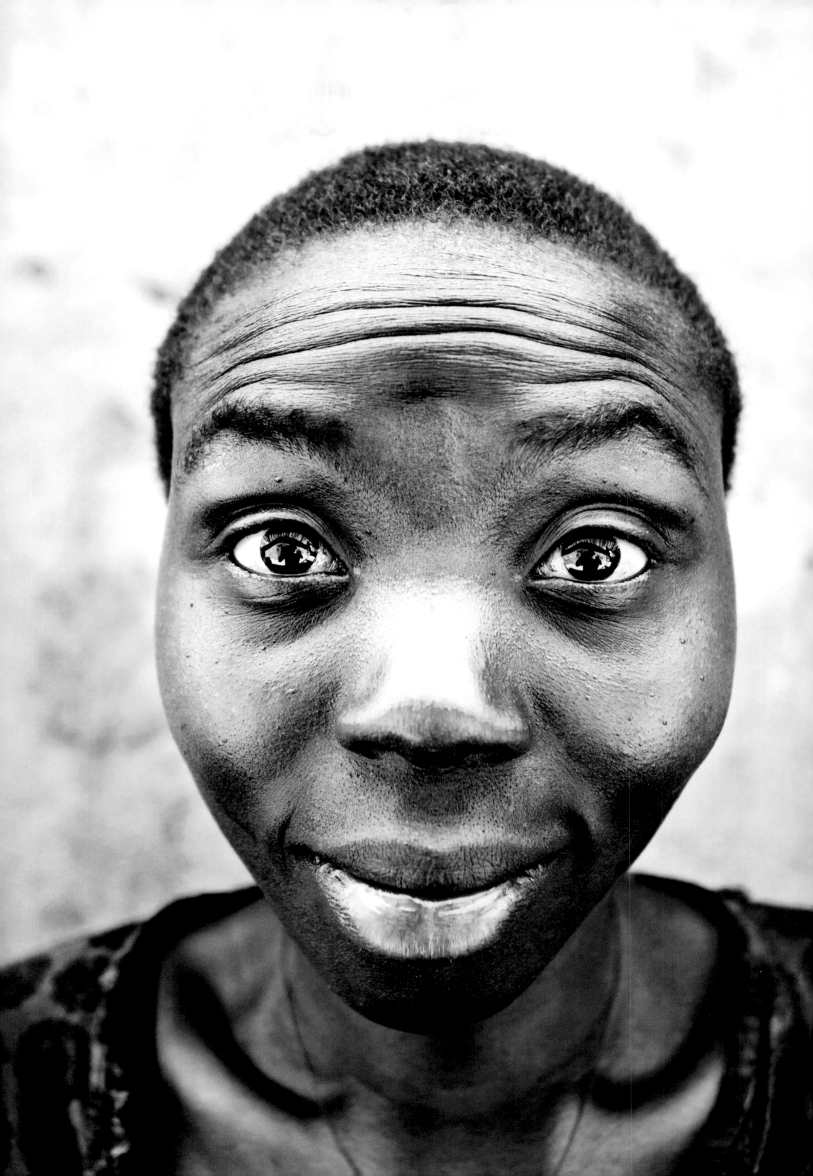

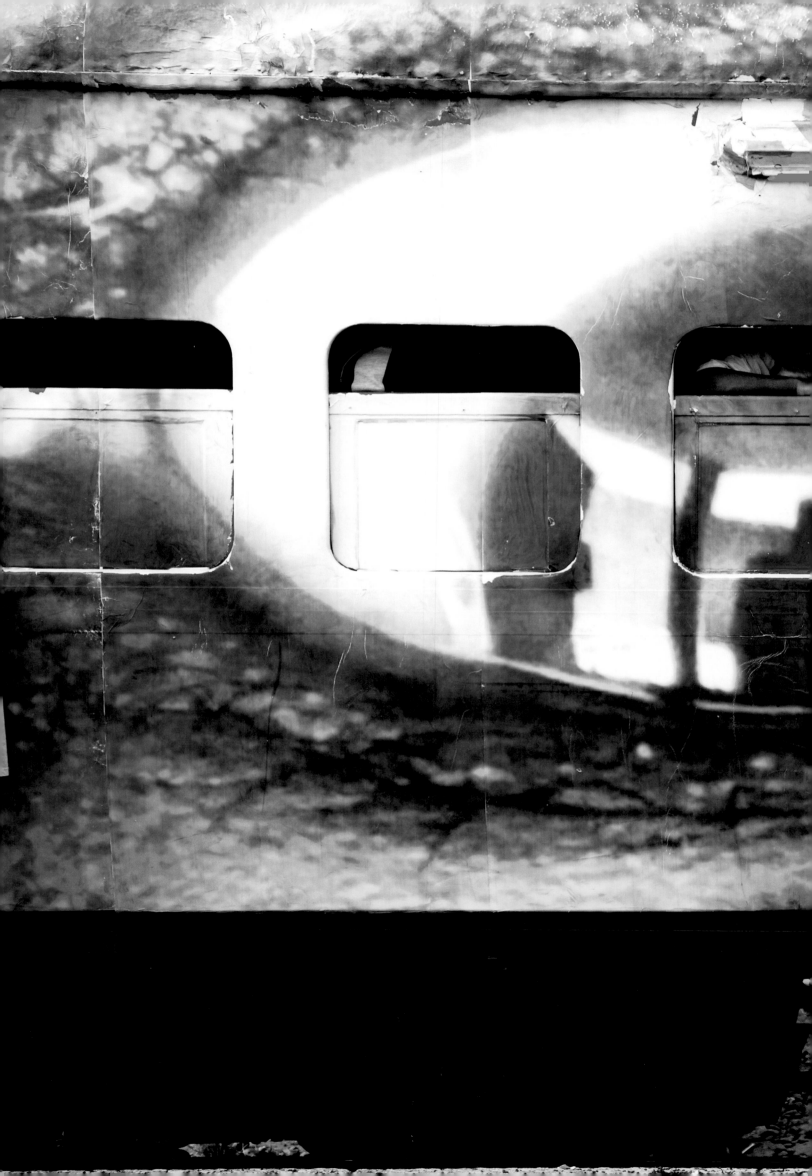

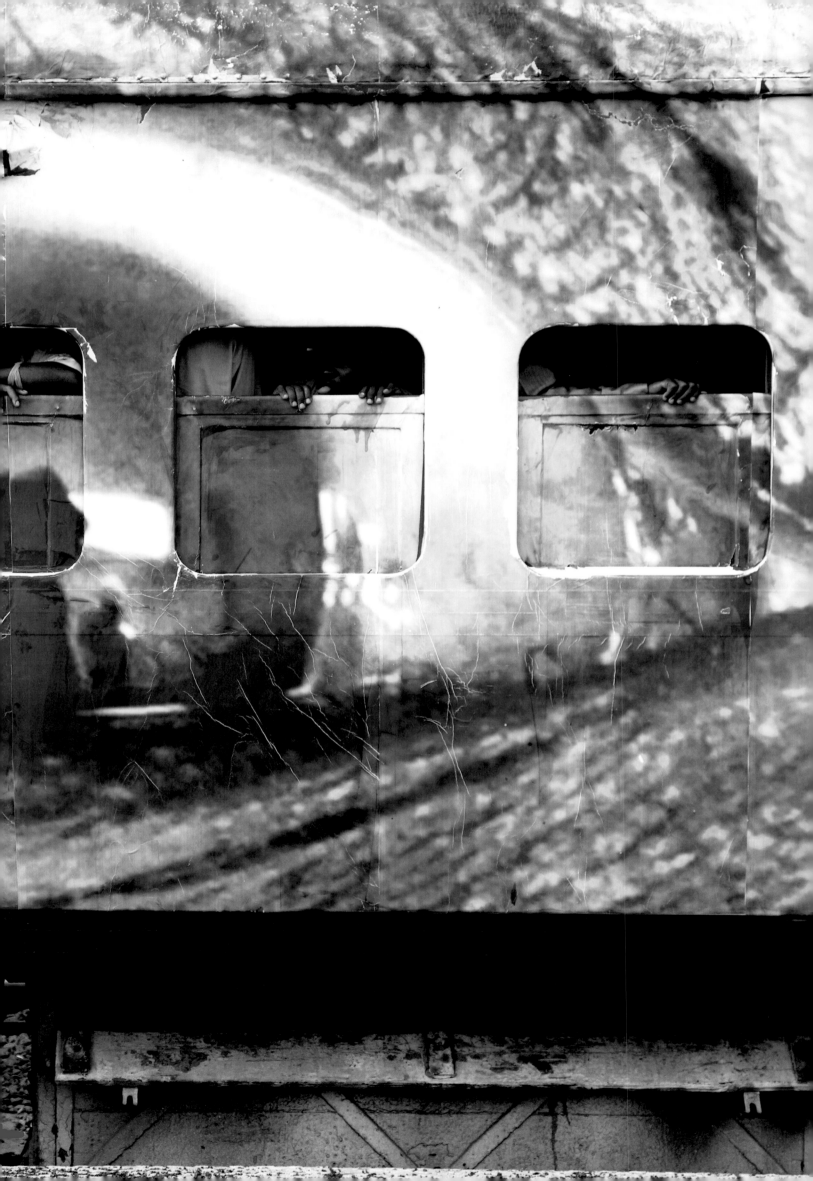

Jane Auma

"I am twenty-five years old. I was born in the Nigori district, and I have been married for eight years. After getting married, I gave birth to my first child – a little girl called Valentine – but she passed away when she was three years old. I now have three children. My eldest is four years old, the next one is three years old, and my baby is only four months old.

My husband and I decided to move to Kibera three years ago to look for work, as there was no good work for us in our village. I took a course to learn how to make dresses, and then I bought a sewing machine. I would like to start my own dressmaking business, but I don't have the capital I need to get started. So for now my husband and I make jewelery, which we sell locally to brokers. But this work is not very good because the brokers take a large percentage and pay us very little. Like, for example, the broker will sell this pair of earrings for 350 shillings, but

he only pays us 50 shillings. It is also very difficult to find a broker who is willing to buy a completed pair of earrings from us. Most of them prefer to buy the earrings in parts and will only pay eight shillings for them. So life is very hard for us, and we are not able to support our families in our village because we do not have enough money.

My daily routine is to look after my children, my husband, and my home. I usually clean the house, cook food for my family, and take care of my children every day. I also help my husband to make the jewelry that he sells. I think that both men and women are important in Kibera. If there were no women in Kibera, then the men would not survive, as most of them are drunkards! But life would also be impossible for the women if there were no men here, as many women are supported by their husbands."

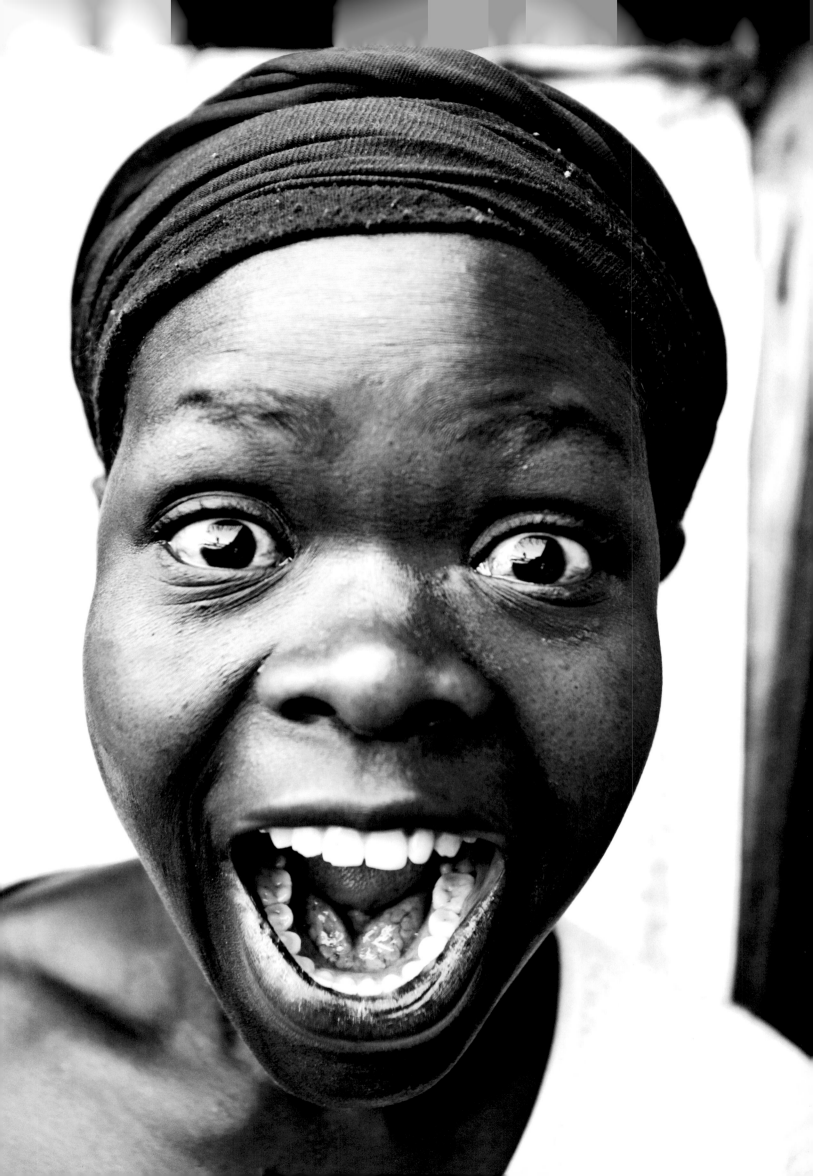

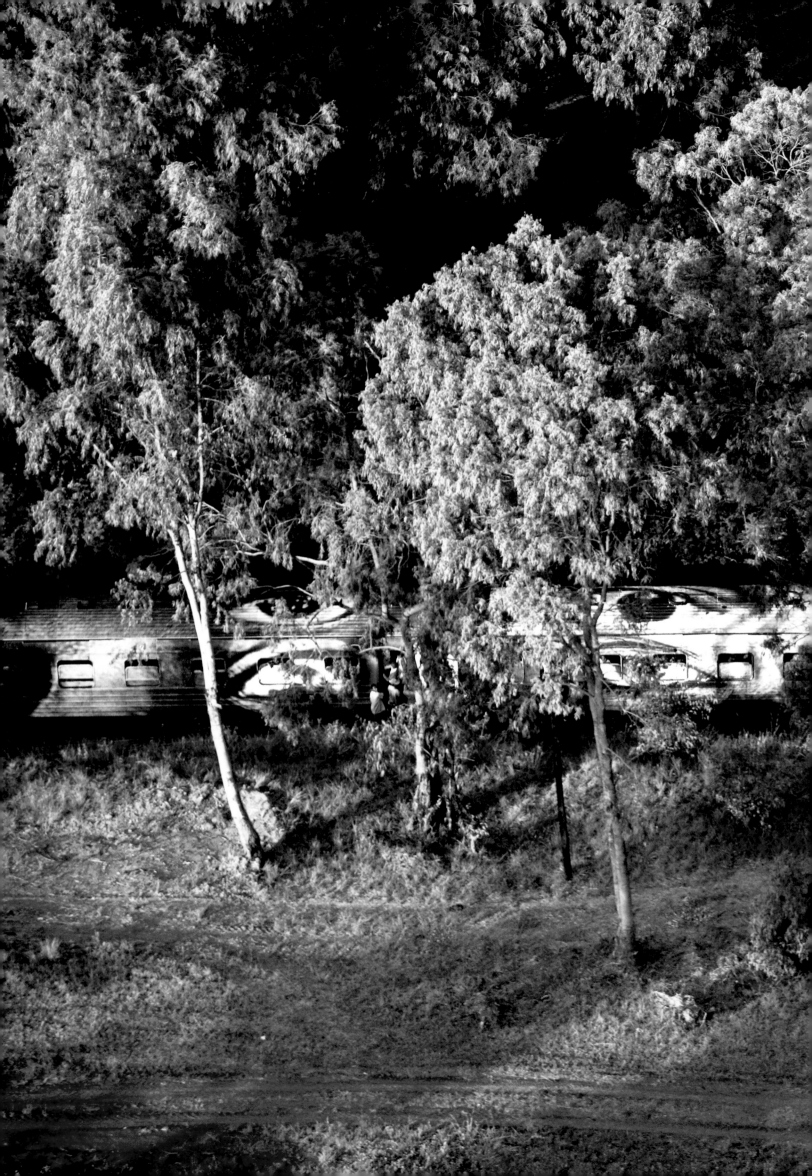

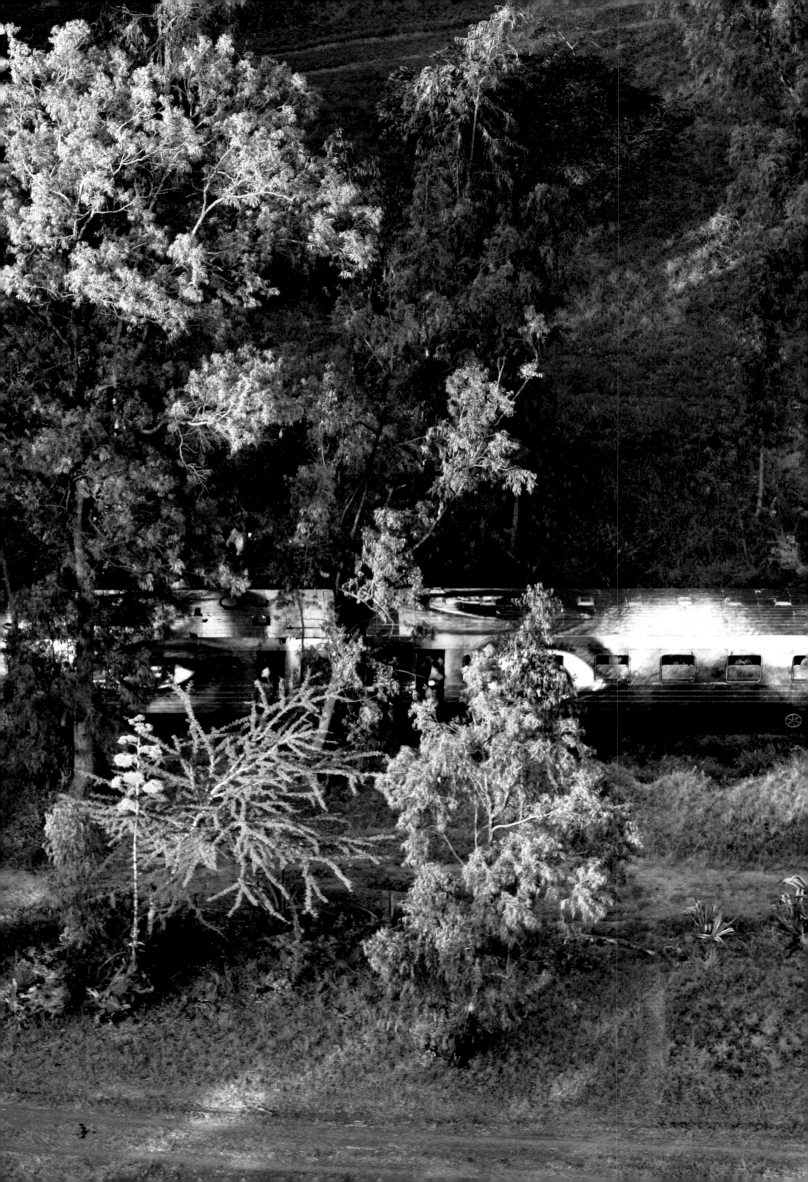

Jecinta Achieng

"I am nineteen years old, and I was born in Mombasa. I have not lived in Kibera for very long. I got married last year, and the man I married works in Kibera, so I moved here with him. We have lived here for less than a year. I gave birth to my first child last week, but my baby did not live for even a day. It was early in the morning on Thursday, April 19, that my baby was born, but by the evening the baby died. The next day she was taken to the mortuary, and we buried her on Monday.

Life here in Kibera is very difficult. I don't have a job, and at the moment I am very sick because I was injured during childbirth. So I cannot even go to fetch water or food and my husband has to work and look after me. He works at a joinery and earns 150 shillings for each day that he works, but he does not always have work each day. He is paid his earnings once a month, and we need to use most of the money to pay our rent.

Before I was sick I used to find casual work washing clothes for people or fetching water. People would pay me to fetch water for them because sometimes it is necessary to walk for many kilometers to find water. My parents know that I am living in Nairobi, and they think that I will find work here and be able to help them. So they ask me to send them money or sugar, and sometimes that forces me to go to look for work so that I can help them. If I wash clothes for someone and earn two hundred shillings, I can send half of the money to my parents. But if I do not find work, then I cannot help them.

There are some people who come to Kibera to try to help us. There is a project to help us grow our own vegetables. I volunteered for the project and was given a bag of soil and some seeds to grow. They showed us how to plant the seeds and told us that if the seeds grew, then we could keep the vegetables for ourselves. I planted the seeds and my vegetables grew, so even if I don't have money to buy food, at least I have those vegetables to eat.

The women in Kibera are very hardworking, and we were very happy when JR came to Kibera and told us that he wanted to do a project all about women. We think that the project will help us, and I am very proud to be involved because a lot of people are seeing my face. Already, the project has helped me because the canvas on my roof helps to stop the rain from getting inside my house!"

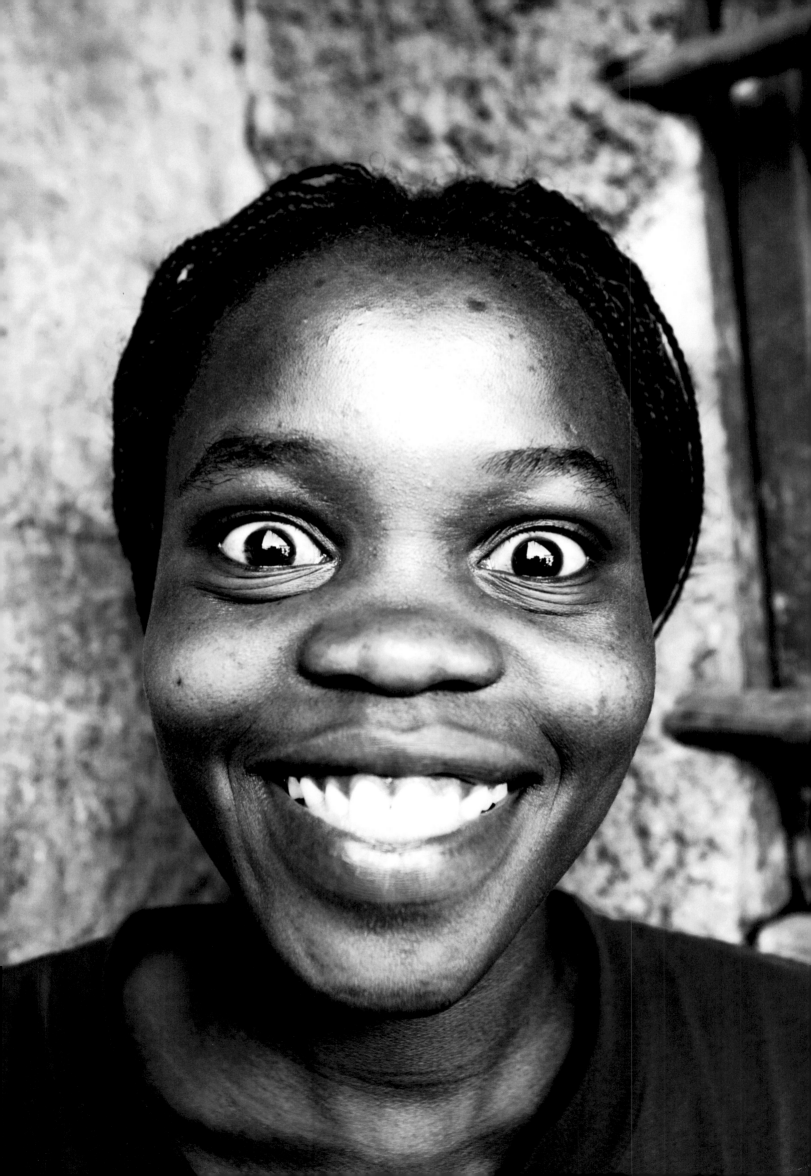

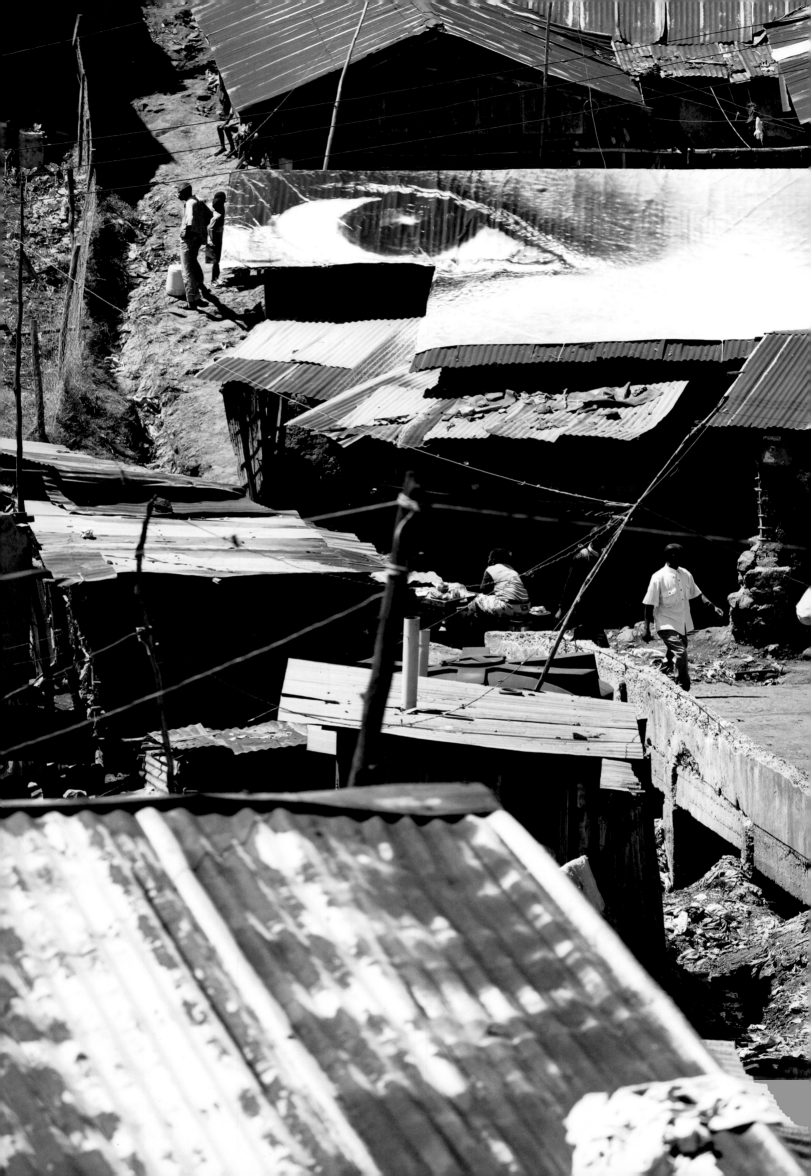

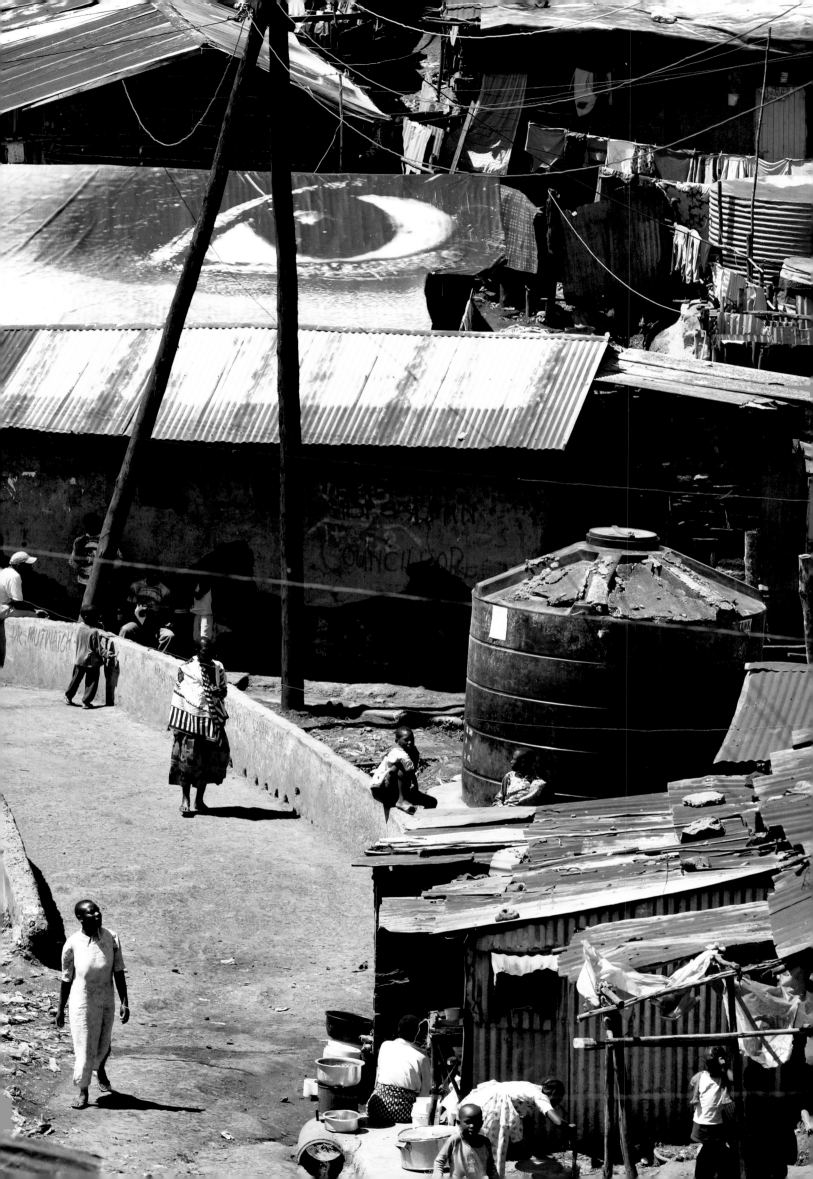

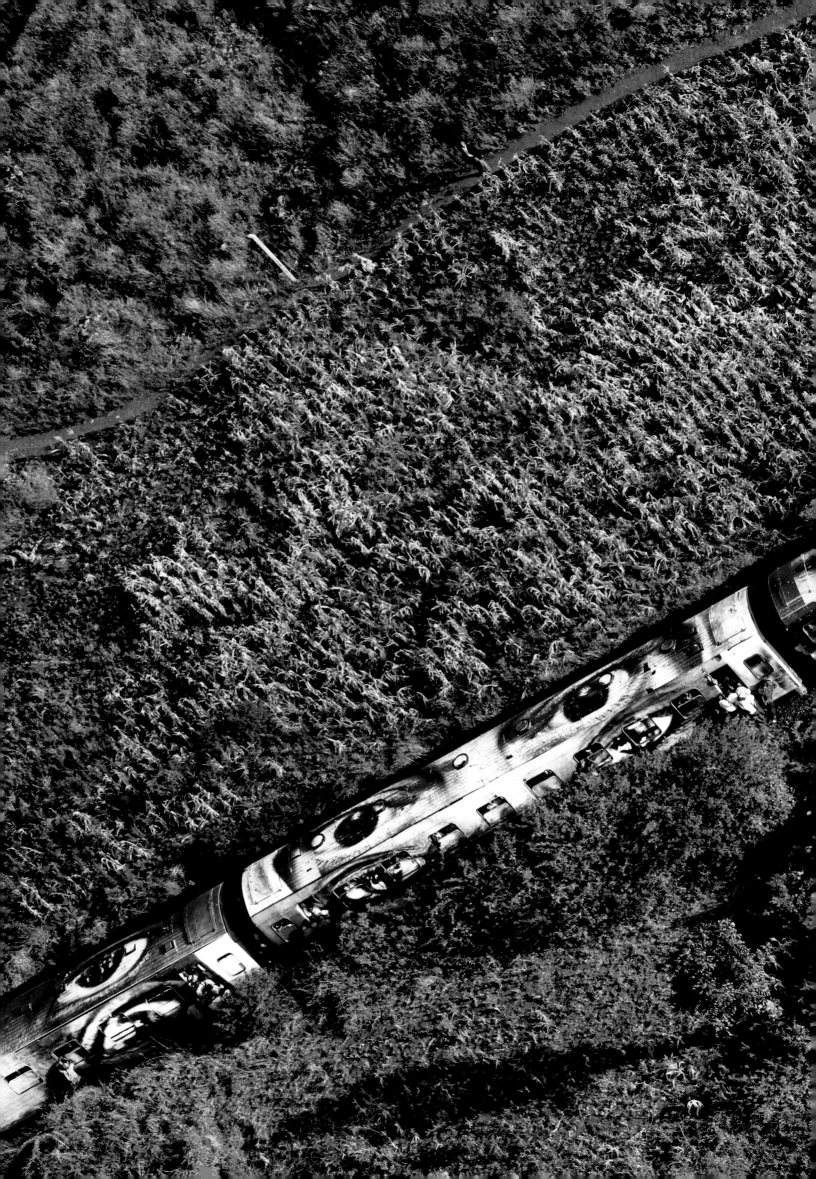

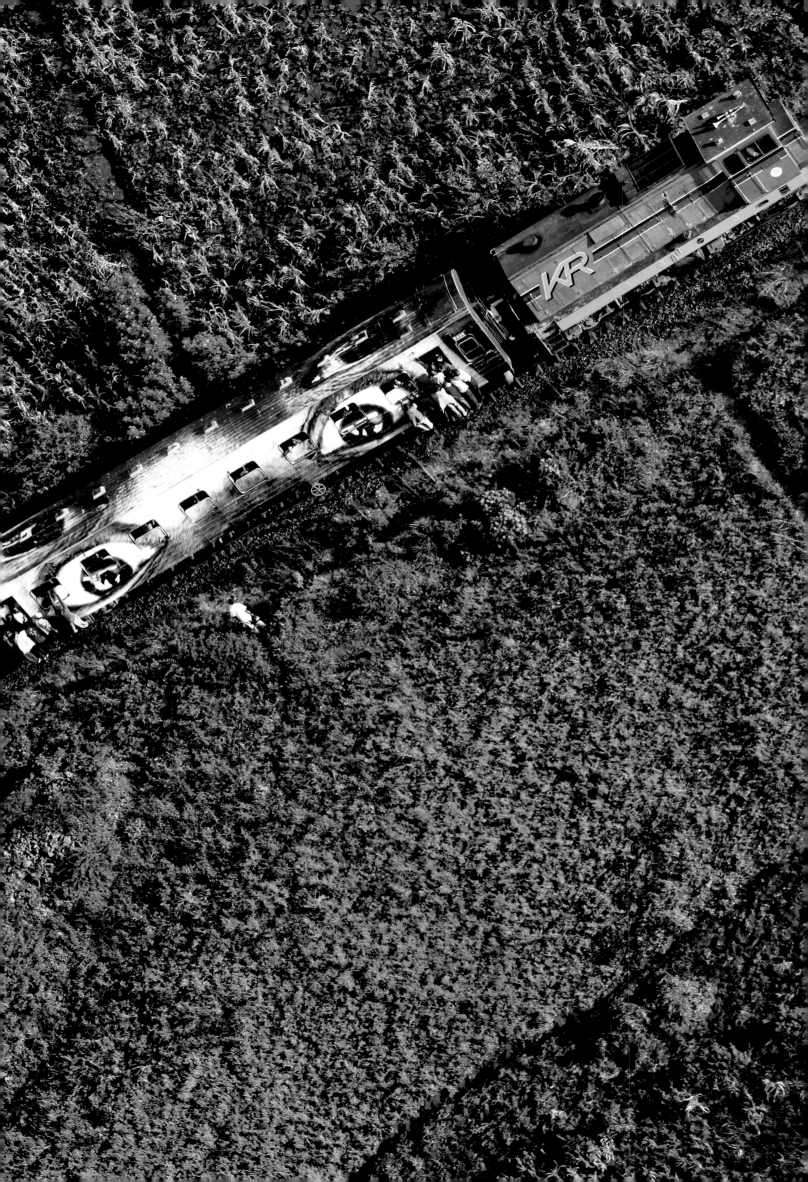

Ebby Kadenyi

"I am fifty years old and am suffering very much with many problems in my life at the moment. I worked as a housemaid for over thirty years, and then three years ago I was fired and have not been able to find any more work. I come from a very large family (my mother had thirteen children, and when you include grandchildren and great-grandchildren there are around fifty of us), and when I was working I looked after many of my family members, as most of my brothers and sisters are jobless.

I have worked for five Europeans in my life. I worked for the first family for twenty years, and then I worked for the next family for five years, and the third family for three years. The fourth family did not pay me properly. I worked for them for four and a half years before they went away to Australia, and they only paid me twenty thousand shillings for all of my work! When they left, they handed me to another family, but they asked me to leave after seven months because they said that they did not want to have someone living in their house that they did not know very well.

I moved to Kibera and the money was used up very quickly. I paid almost four thousand shillings in rent for the first four months. The remaining five thousand shillings went to food and to helping my parents. I have not been able to find any regular work since that money ran out. Sometimes I am able to earn some money by washing clothes for other Africans, but sometimes I simply have to go without food.

I now live with my sister and our children. My sister has seven children and I have three children, and we all live together in a small house. We must share all of the food that we are able to afford, so life is very difficult as there are so many of us to feed. My eldest child is twenty-nine years old and my second child is twenty, but neither of them are able to help me much as they are both jobless. My daughter struggles to find work so that she can help to feed the family. She wakes early every day and walks to the industrial area to look for casual work. Some days she is able to earn enough money to bring home some food for dinner.

I helped to educate four of my siblings because my parents did not have jobs and could not afford to educate us all. One of my brothers now has a good job as a teacher, but sadly he has become a drunkard and has forgotten about his family. If we go to him to ask for help, he just shouts at us and tells us to go away.

I would like to buy my own land so that I can care for my family. I began to buy some land when I had a job. I have already paid a large sum of money to the owner, but since I lost my job I have not been able to pay any more money to the owner. So he has recently threatened to sell the land to someone else who is able to pay in full."

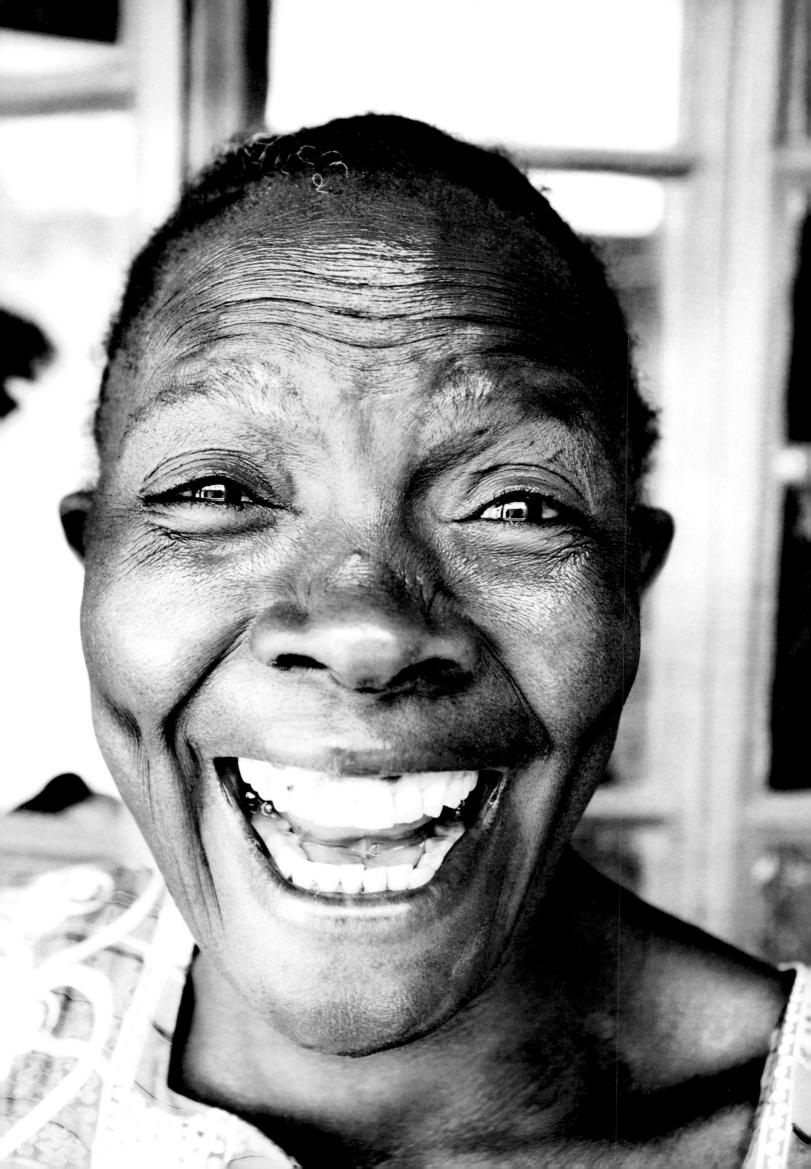

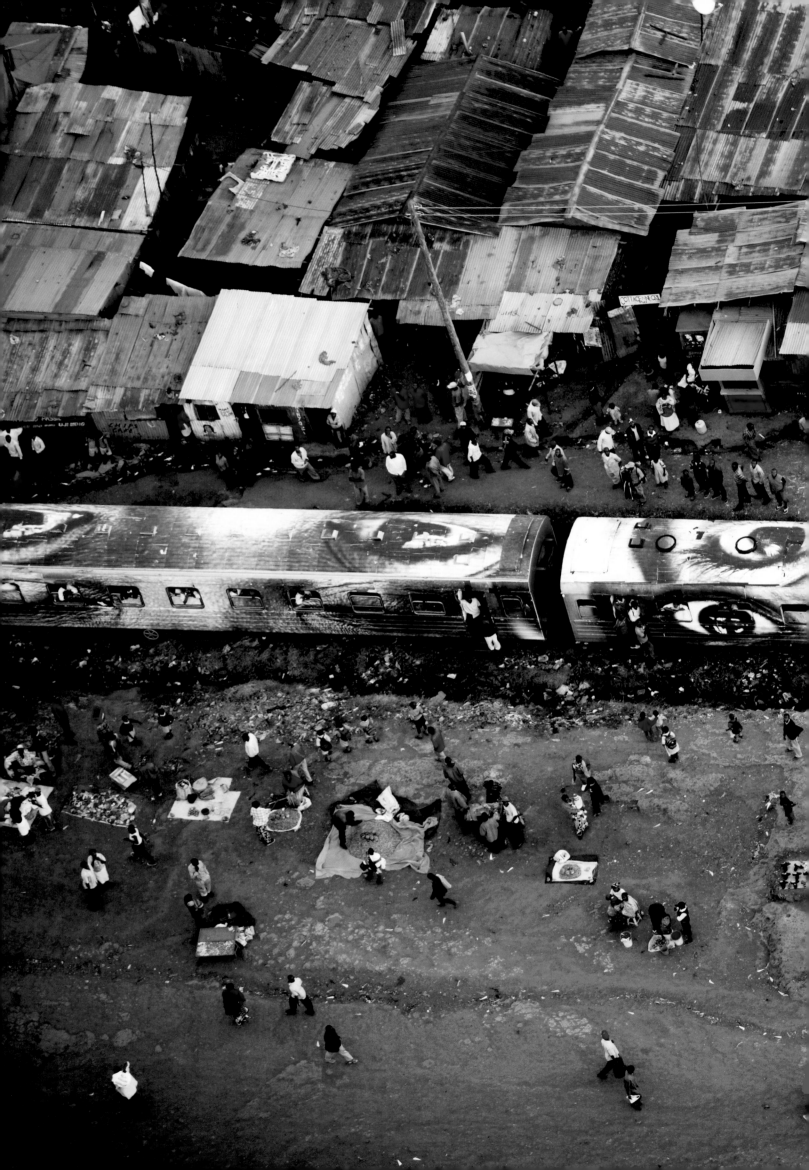

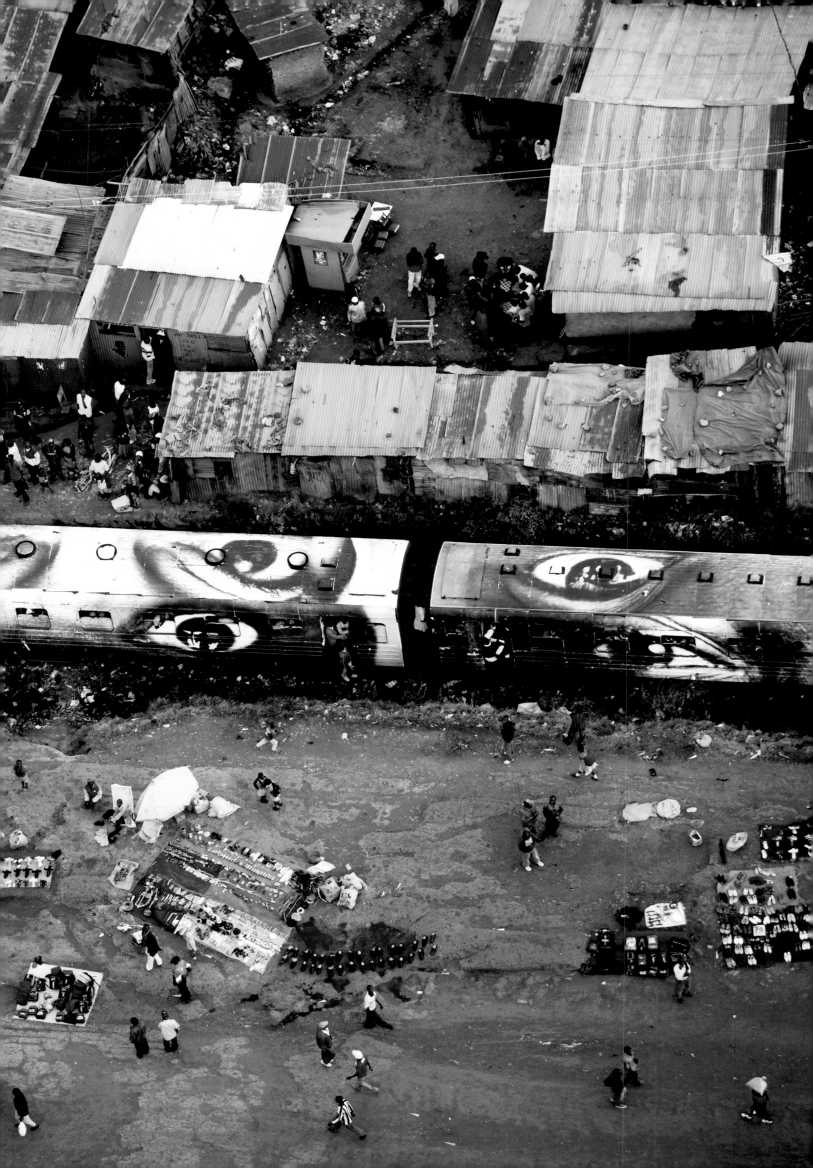

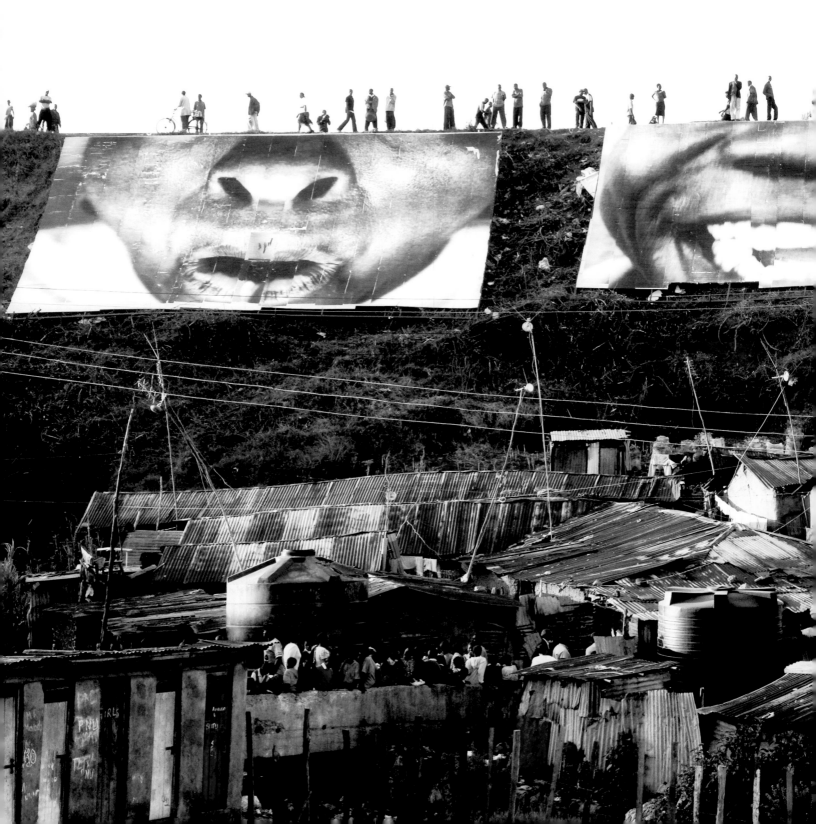

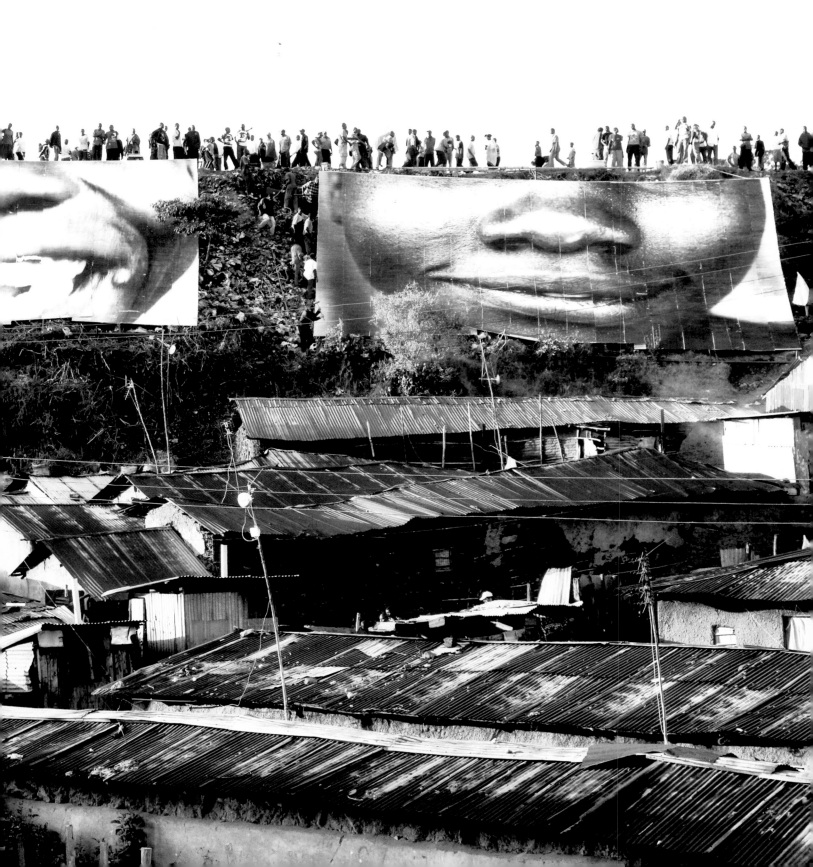

Zippy Vugutsa

"I was born in the year 1962 in western Kenya. I have five children and four grandchildren. I work as a volunteer in the community. I do home-based care on a voluntary basis concerned with HIV and AIDS. I have lived in Kibera for the last five years. I came to Kibera in 2004 due to the high stigma in my rural area, having contracted HIV from my husband at the time. When I tested positive in 2000, I was shunned by people and stigmatized. I could not even share utensils with family members. So I decided to come here. When I first arrived in Kibera, I felt that I was going to die the second minute, but then a friend of mine took me to AMREF [African Medical Research Foundation] and enrolled me in their program. I have undergone many counseling sessions and training, and now I am OK.

I am a single woman with children to care for. I have a daughter in secondary school, and paying her school fees is very difficult. Finding food for my children is a challenge and rent is a big problem.

My role in the community as a woman is to try and mobilize [HIV] positive women. Every Tuesday we have a session in the evening. We meet and share challenges that they are undergoing because of violence. I also try to encourage women and tell them that being HIV positive does not mean that it is the end of their lives. I do home-based care for those who are bedridden; I wash them in their houses. Some are not able to get out of bed so we do bed washing, and the biggest challenge I encounter when doing this is the lack of water even to wash a sick person.

During the postelection violence, I was here in Kibera. It was on December 30, 2007, in the evening, when Kibaki was announced as the winner, that they started the violence. People started burning houses, and many women were raped. The prevalence of HIV in Kenya has now gone up due to the raping. People killed others, and there was hatred between Luos and Kikuyuys and Luhyas. Many people lost their lives.

I was in my house. The following day we could not move. The violence was everywhere. There was looting, and people were stealing other people's possessions. We could not access our daily food because we could not move. It has affected my life because the prices of commodities, property, and rent have gone up.

My role appearing in JR's book will help other women who are in denial to accept themselves after reading the book. Even though there will be misconceptions about me, I don't care. I know my photo in this book will enable other women to accept themselves. I am not scared; I am comfortable about being in this book."

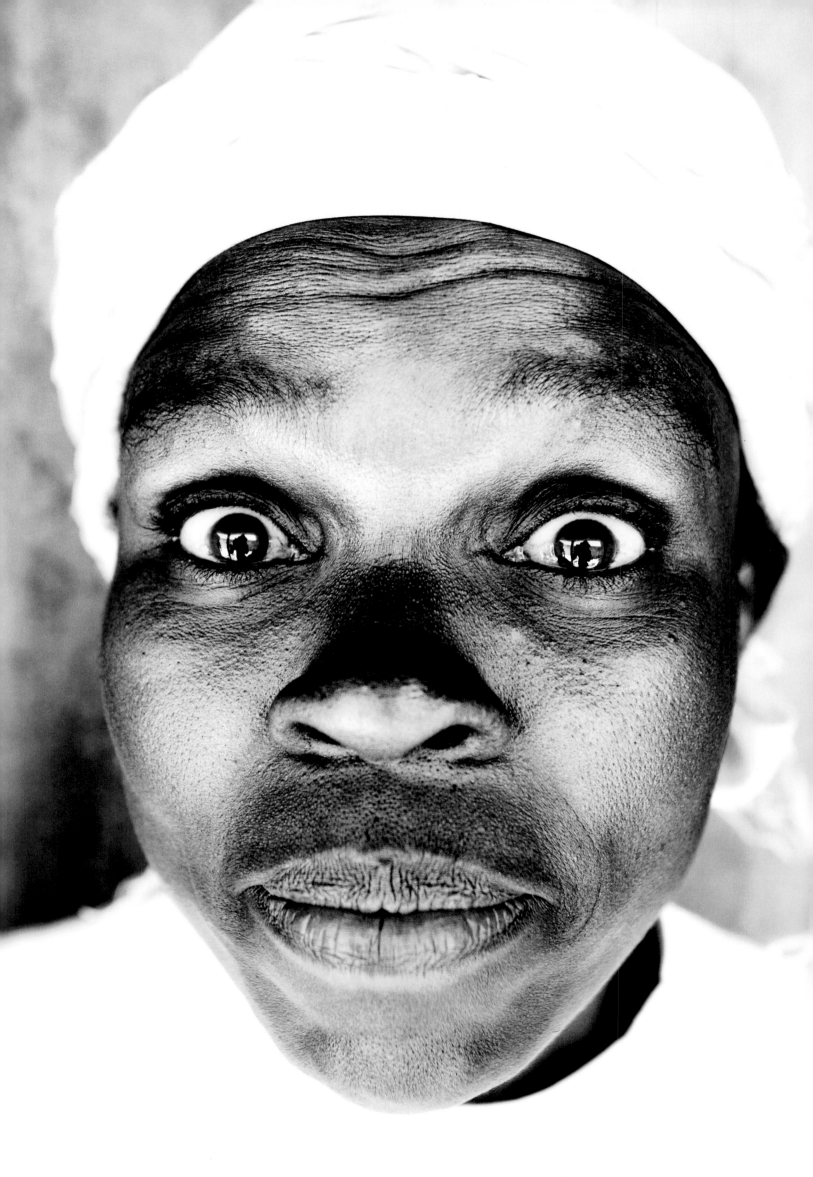

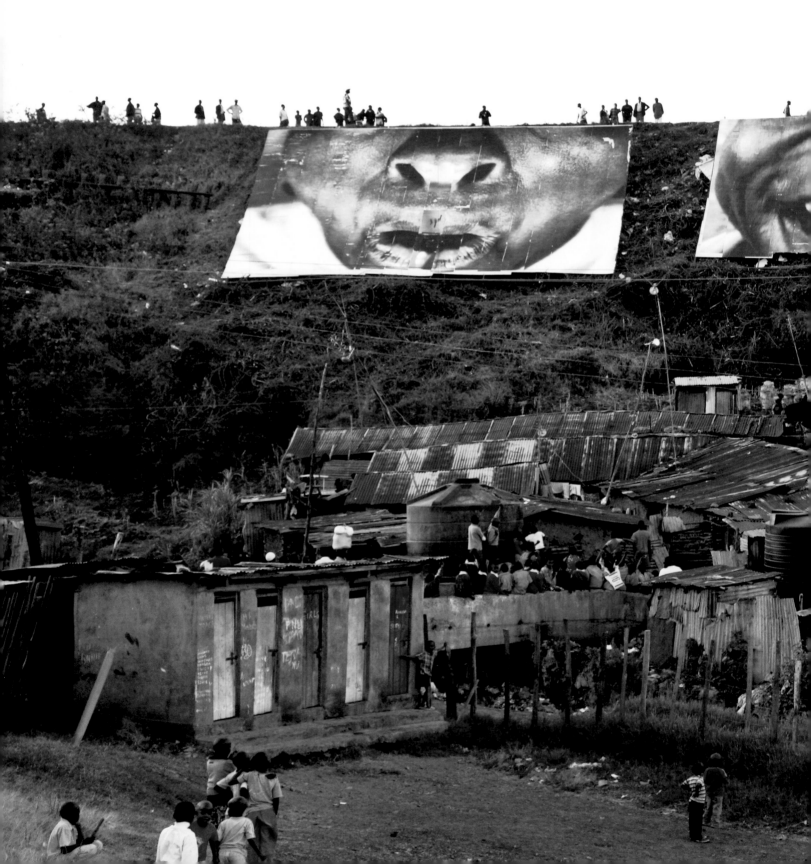

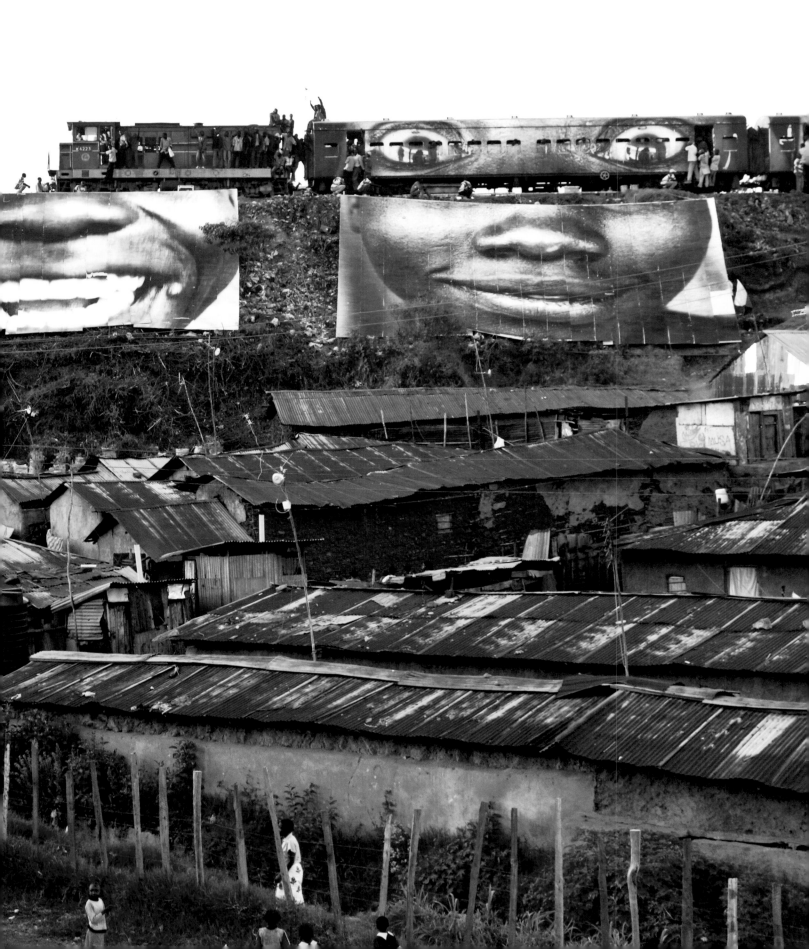

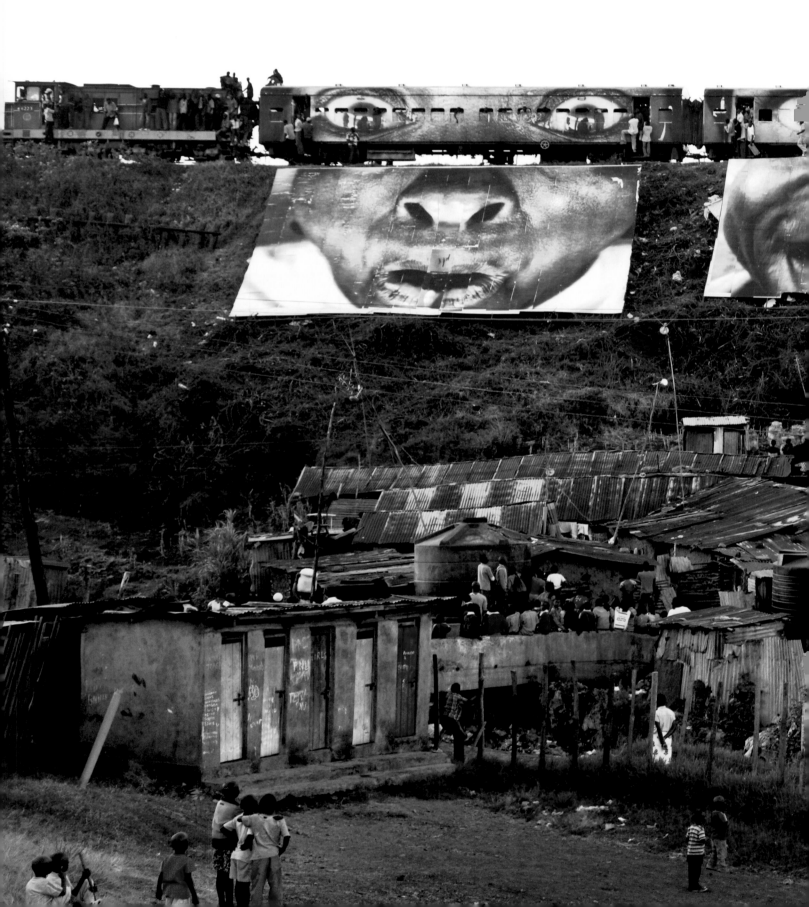

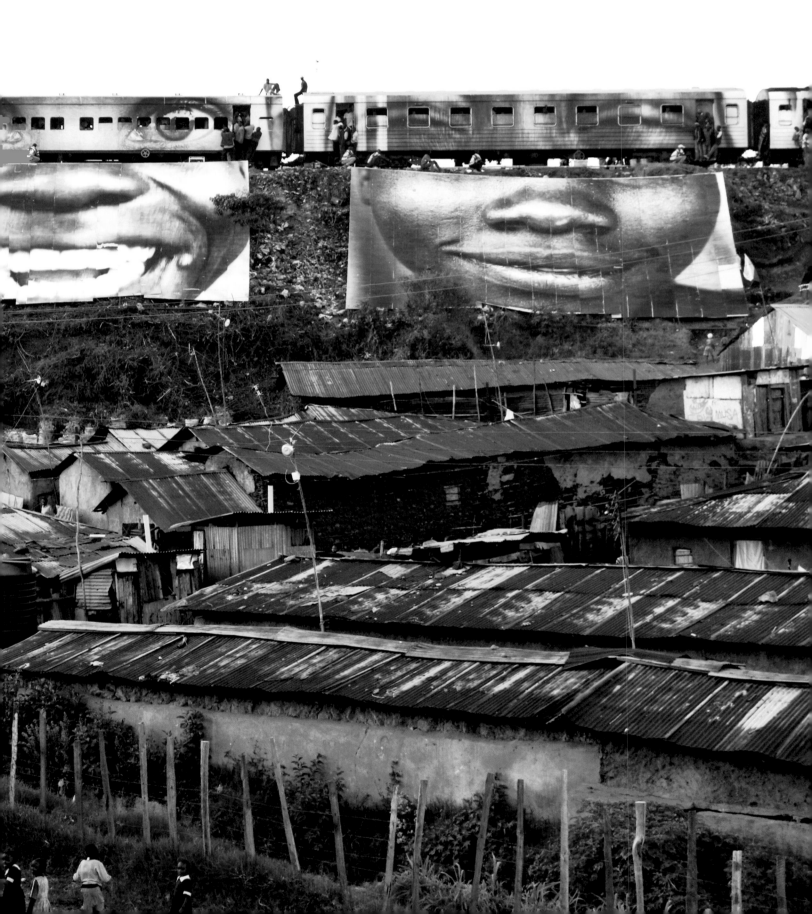

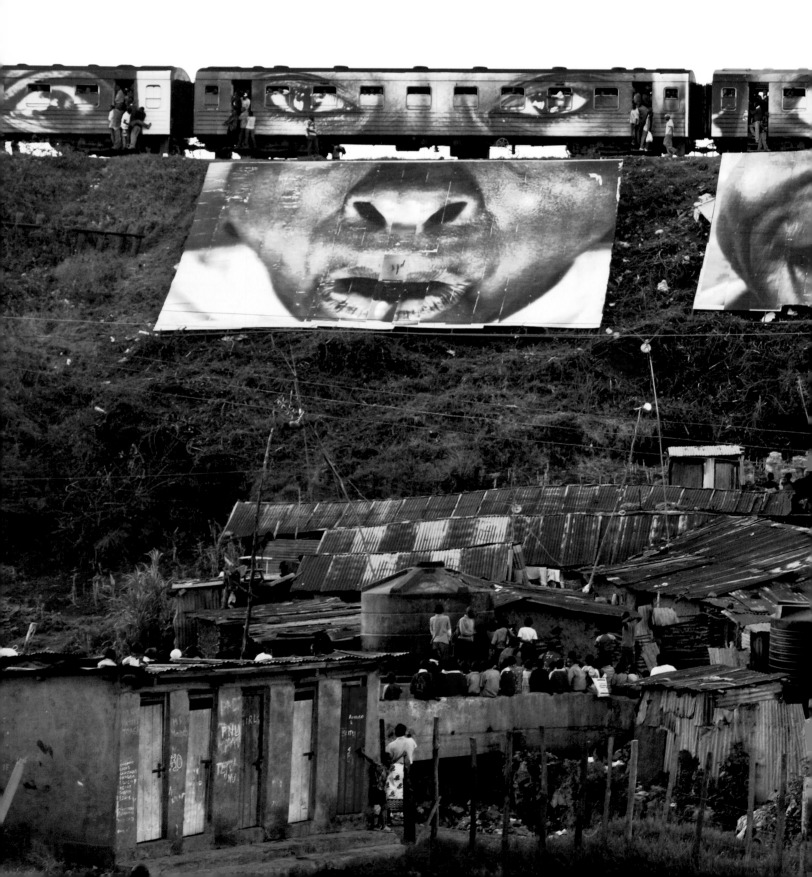

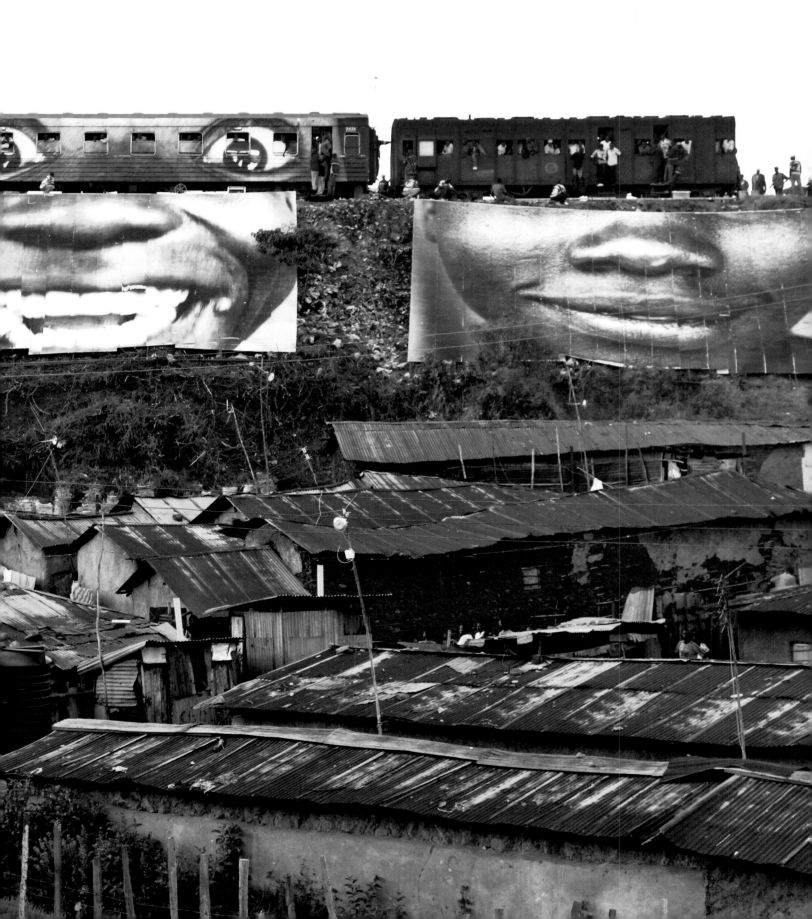

Oliver Anyika

"I am thirty-five years old, and I was born in Kakamega district. I have four children, and I am without a job.

I came to Kibera as a young girl in 1985 to look for work. I got married and lived with my husband for ten years. We had four children, and it was then when I came to realize that my husband was [HIV] positive and he had not told me. After that I continued with my life as normal, and I continued taking care of my kids, and I went to the VCT to know my status. Now I know what my status is: HIV positive.

I had a business. I used to sell clothes, chickens, and shoes, but because of the postelection violence, my business collapsed and I am now jobless. I was here in Kibera during the violence. When the announcement came that Kibaki was the winner, the fights and the violence started. We couldn't stay in the house. When the GSU [General Service Unit] came in, that's when we moved out and went to the showground [internally displaced persons camp] to seek refuge there. Staying in the showground was not a good experience because everyone was in one place. Boys, girls, men, and women were all together. We were not safe and there wasn't good shelter. I moved back after two months.

It has changed my life because during the postelection clashes I was raped by three policemen and my child's eyes were spoiled by the tear gas. Life has never been the same again. I face so much stigma. I got help from the humanitarians, and I got treated at the Nairobi Hospital, Kenyatta Hospital, and I have even had counseling. Now I am continuing with my life as normal.

There is nothing wrong about telling your story. If it is telling something so that you can heal somebody or can change somebody's life, this is good. There were many women who were raped, and they are still hiding the fact that they are HIV positive.

This project is good because most people are not writing about exactly what happened. They have showed pictures of what was happening, and you can't actually know something from the pictures. You will know people were rioting, but who knows what happened in the interior of Kibera?

Women should come out and state their problems, especially when we talk about raped women hiding. It has really affected them, and they don't go for medication or testing. My role as a woman is to improve my health, my children's health, and the health of my environment."

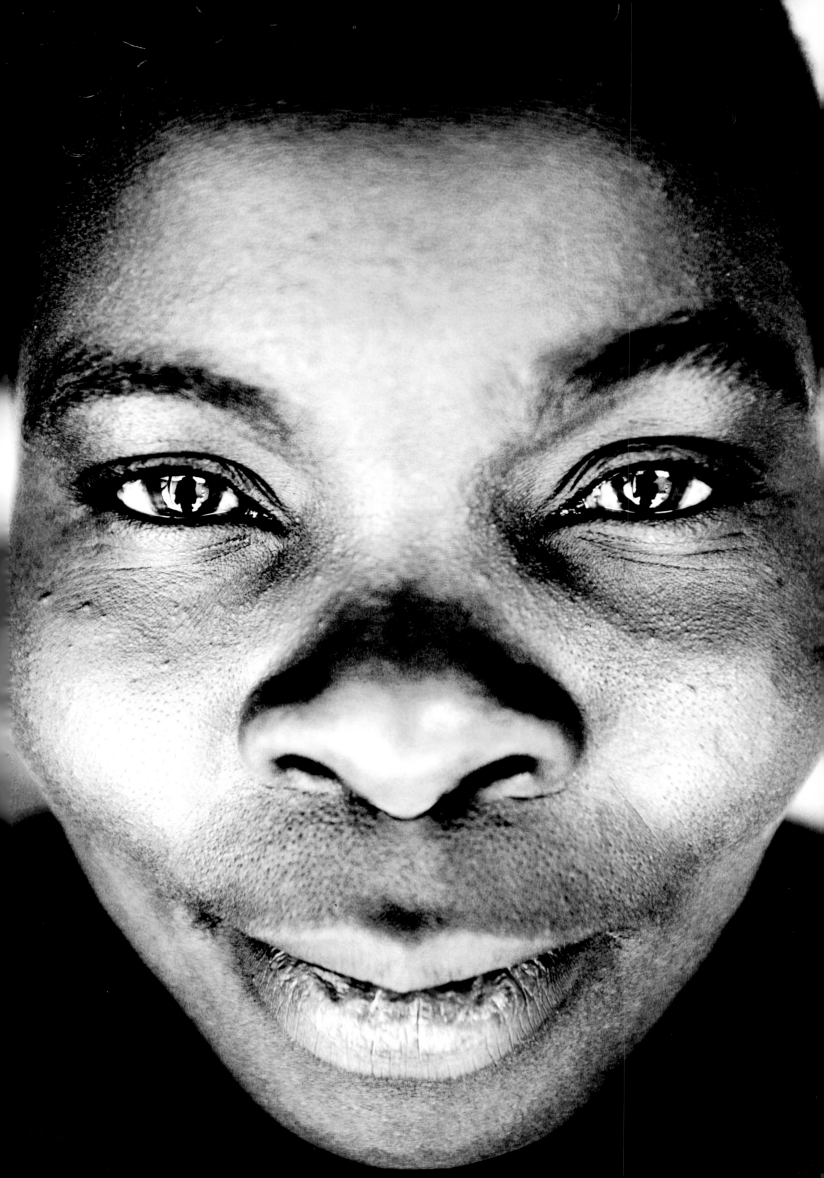

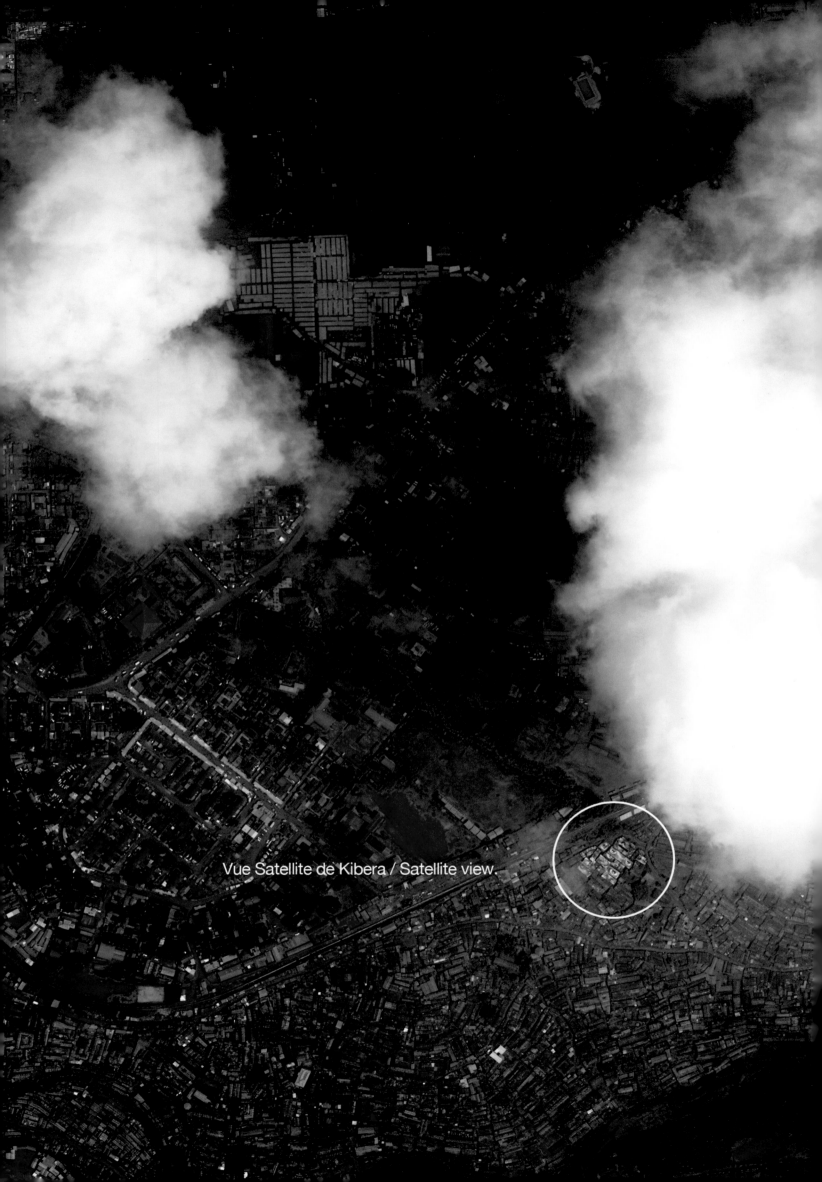

Vue Satellite de Kibera / Satellite view.

Judith Anyango

"I need my photo to be on that train so that everyone in this world or even in our country will want to know about me. Even if somebody is passing by, he will like to know: 'Who is she and what is she doing in her life?' That's what I am happy about.

I need to strengthen the message for women who just sit and wait for their husband. When they come to ask you questions, you have to answer them and some will get some experience from you.

I am a businesswoman. I go to the market, I pick some potatoes, I cut them into pieces, I deep-fry them, and when they are ready, I sell them. That's what we call chips. That's what I do, and I do it for my little Dennis.

If you are waiting for your husband to come back home, when your husband dies, you start from nowhere, you find life very difficult. And when you get used to what you are doing, you understand that life is so simple with or without a husband. That's why I am happy."

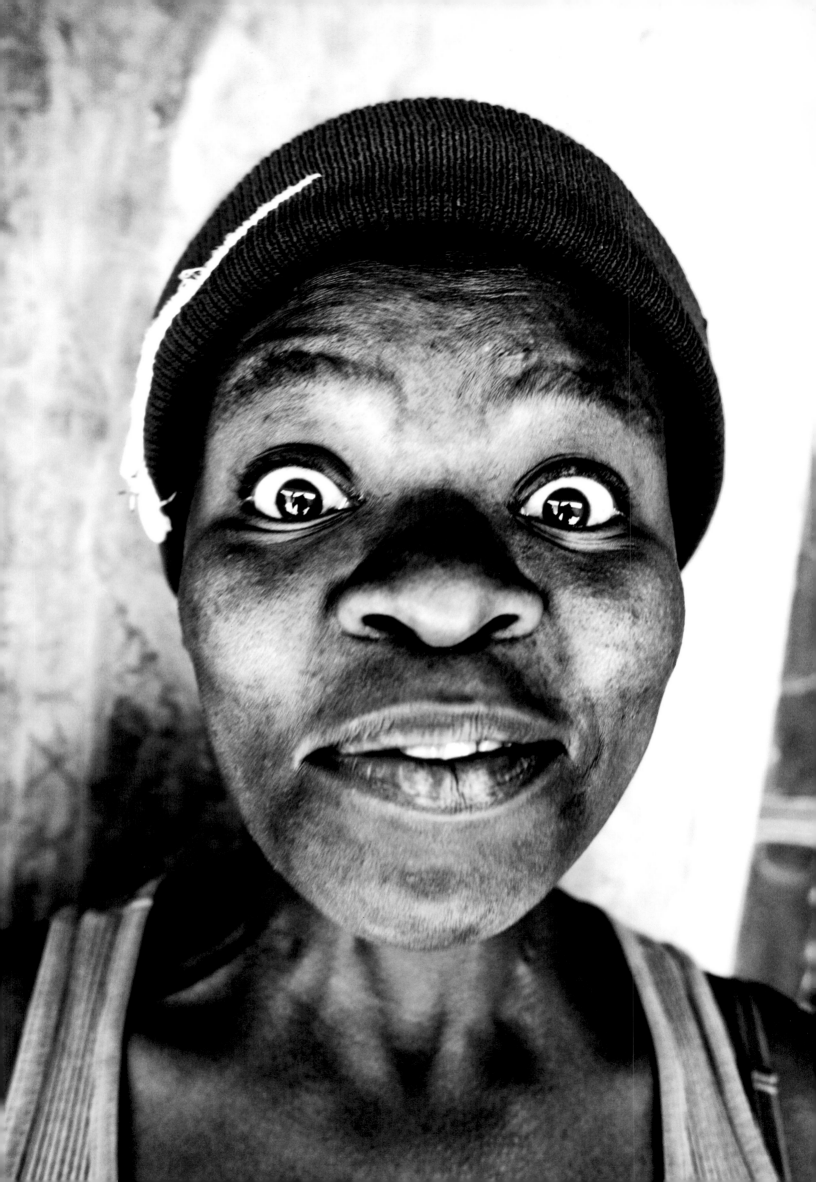

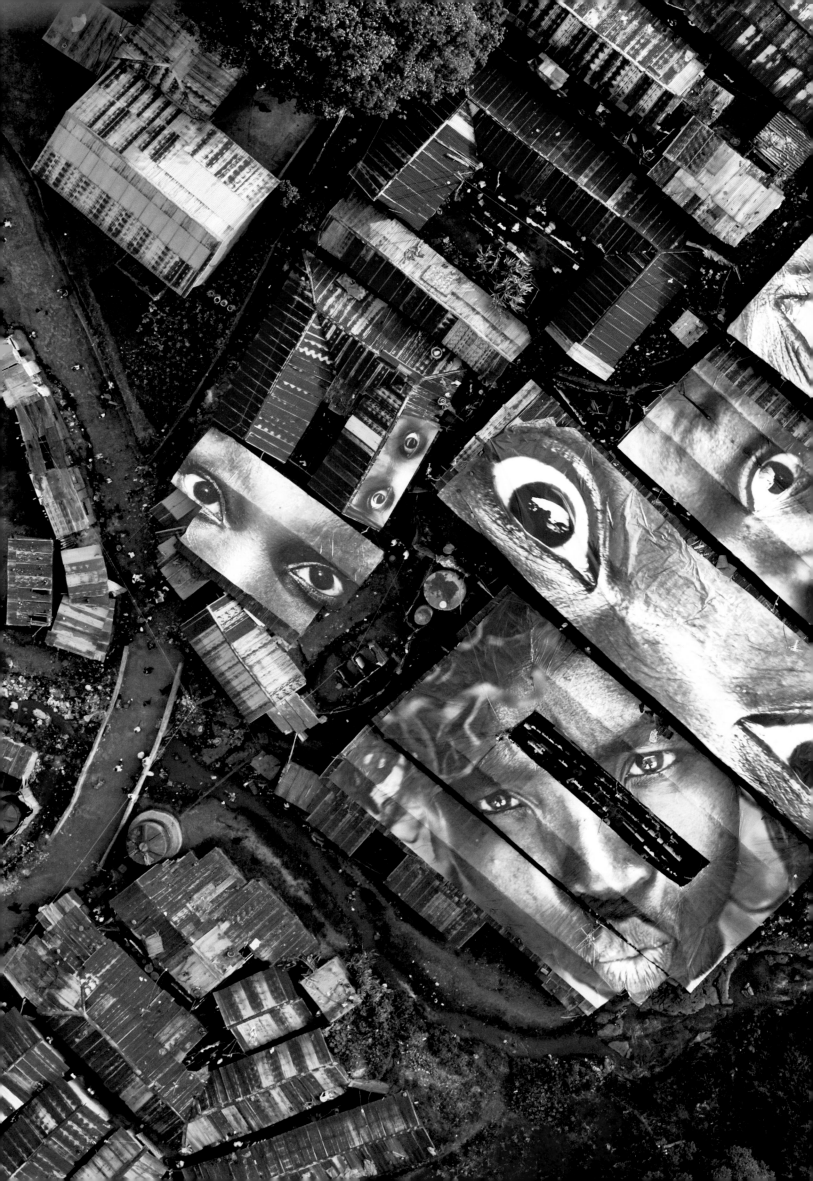

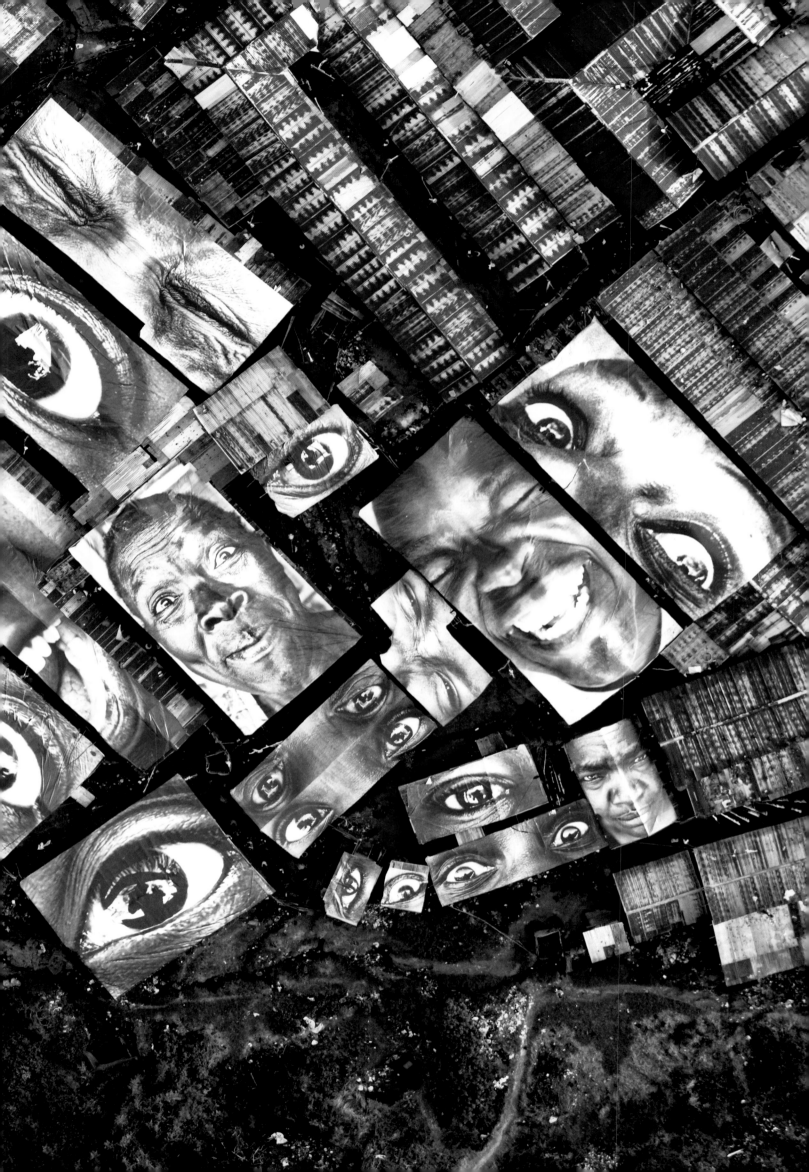

Phoebe Adhiambo

"I am twenty-three years old, and I have lived in Kibera ever since I was two. I am not yet married, and I do not have any children. I live with my parents and my family, and I am the eldest of ten children in my family.

Growing up in Kibera is very hard, especially for girls. When a young girl reaches adolescence, men begin to look at her as mature and beautiful, and many girls are seduced by men who want to sleep with them. A man may find a young girl and give her money and the girl may be tempted to go and stay with him. In Kibera, we call this 'come we stay.' It is when a man finds a girl and the girl agrees to go and live with him and sleep with him. Many girls who are seduced by men don't finish school, and then they find themselves either pregnant or infected with HIV and the man does not support them. It is very bad.

I come from a very poor family. There are ten children in my family, and we all rely on my mother to survive. My father is a drunkard and he does not care about us. If he gets any money he spends it on drinking and does not help us. My mother sells maize and nuts on the side of the road, and she uses the money to look after all of her children. I want to help my mother to support my family by starting my own dressmaking business. I have completed a course in dressmaking, but the problem is that I do not have any money to buy a sewing machine or materials to get started. I hope that someone will come and help me so that I can help to support my family and other children and orphans in the community.

I was here in Kibera when the postelection violence happened last year. There was so much fighting and killing because people wanted change and they didn't get it. I lost some friends and relatives because of the violence, and it also affected me because I rely on drugs to survive and was not able to access them at the time. For people like me, the violence had a big impact because we really suffered without the drugs that we needed.

I am very happy that this project shows how the women here are suffering and how they carry on their daily lives despite their problems. I think that this project will help the women of Kibera."

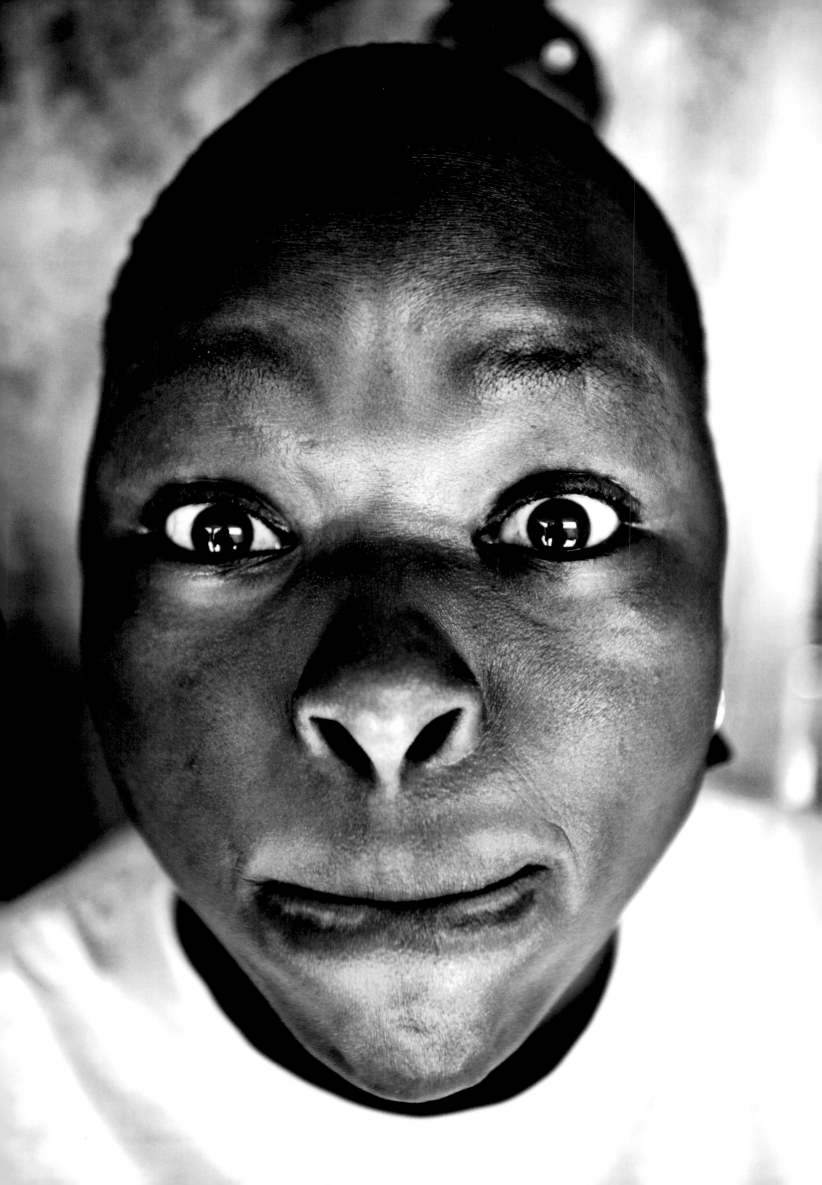

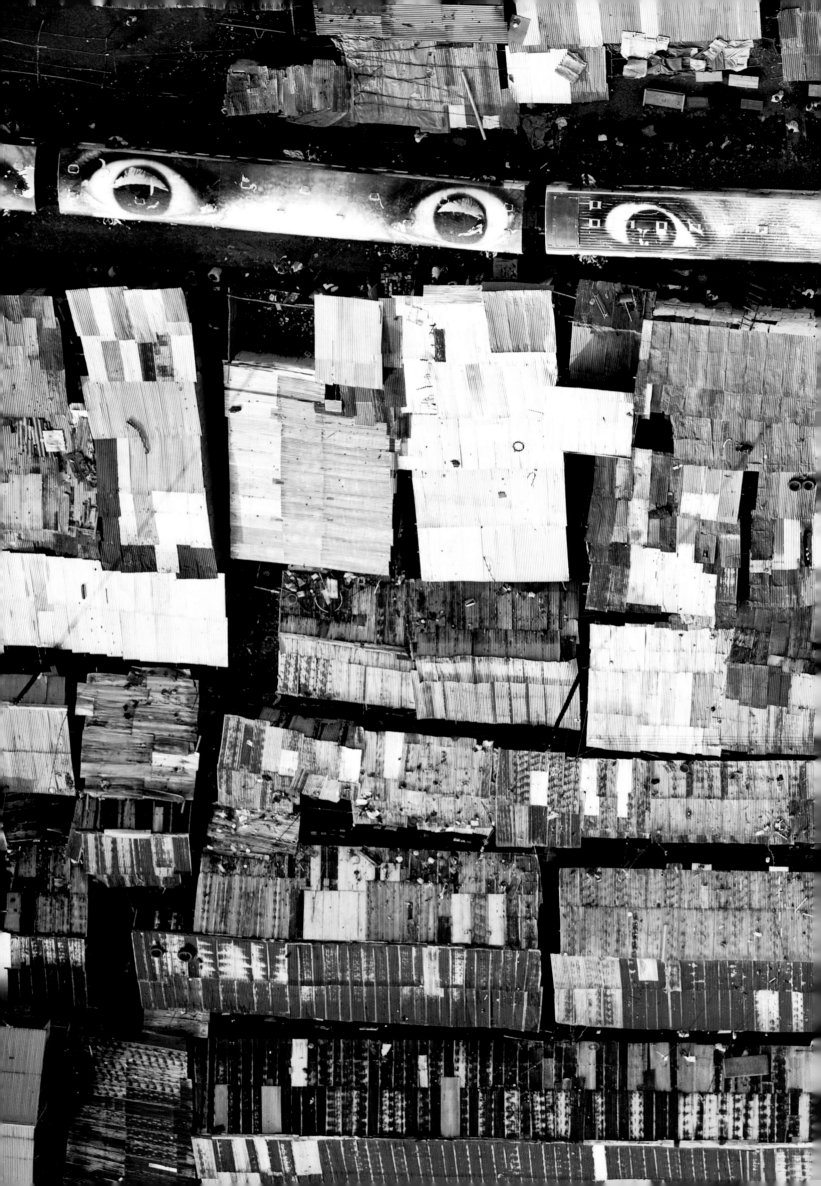

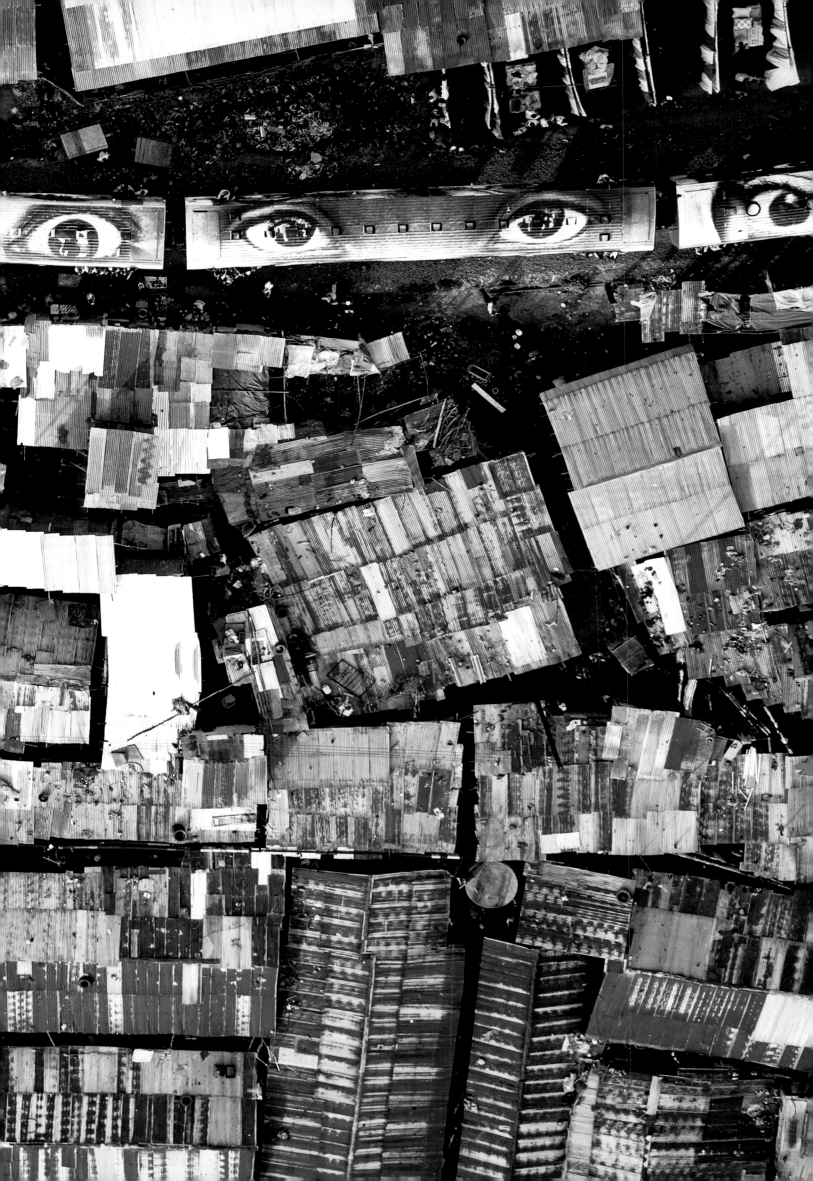

Angela Nzilani

"I am twenty-six years old, and I was born in the Makueni district. Three years ago I caught meningitis and suffered from it for three days before being admitted to the hospital. On the fourth day I lost my sight. My boss then fired me from my job as a cleaner and my husband left me. I had worked as a cleaner for two years and I think that I would have been capable of continuing to work despite my blindness, but there is a lot of stigma in the community against disabled people and I was not given the chance to try and continue.

When I lost my sight, the doctors told me that it may be possible to restore it, but I did not have enough money for the necessary operations. At the time I had two small operations to try to regain my sight, but I only regained one percent vision in my right eye. I can see nothing from my left eye. I continue to pray for a Good Samaritan to help me with the hospital fees so that I can try to regain my sight. For now I just go to clinics, where I receive help and support with my disability.

I have three young children, and life has been very hard ever since I lost my sight, my job, and my husband. I am proud to be a mother, and I try hard to take care of their needs. My cousin helps me to put food on the table for my children because she has a job. I am so grateful for her help as without it my children would have nothing. I would love to be able to open my own shop selling clothes so that I could provide for my children without having to depend on anyone

else for help. I do not want to find another man to take care of me. I do not want to depend on a man again. I just want to be alone, and I want to be independent.

I suffered during the postelection violence because the tear gas thrown into Kibera by the police affected my eyes and I had to return to the hospital several times for treatment. I also lost my small business because it was looted by rioters. I had to move out of my house to go and live with my cousin. When I was moving my belongings, some people came and told me that they would help me to carry my things, but they stole from me instead.

Every day, before I start my journey, I ask myself three questions: Where am I? Where do I want to go? How will I get there and how will I get back? Then I can start my journey.

The reason why I agreed to take the photos is that I accepted the fact that I am not able to see. The other thing is that I'll be happy when people are able to see this picture, and I would like to know how people see the fact that I am not able to see. That is really a happiness. The other thing is my family. I want to tell them: 'Look, I have accepted myself and this is how I am and I am ready to move on with this struggle that I'm not able to see.'

I understand from the explanation that the people who take these photos really don't have bad intentions. It's about the struggle of women, and women who are not able to see are also involved. So for me this is a happiness."

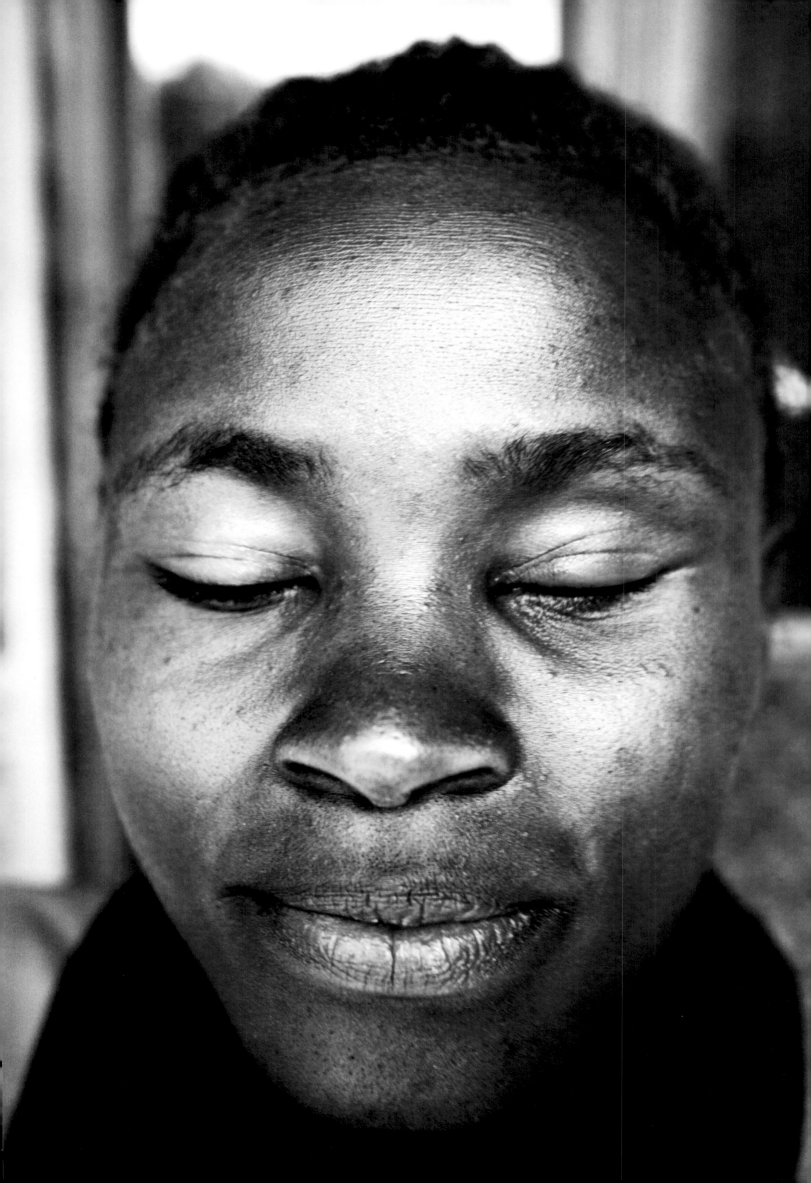

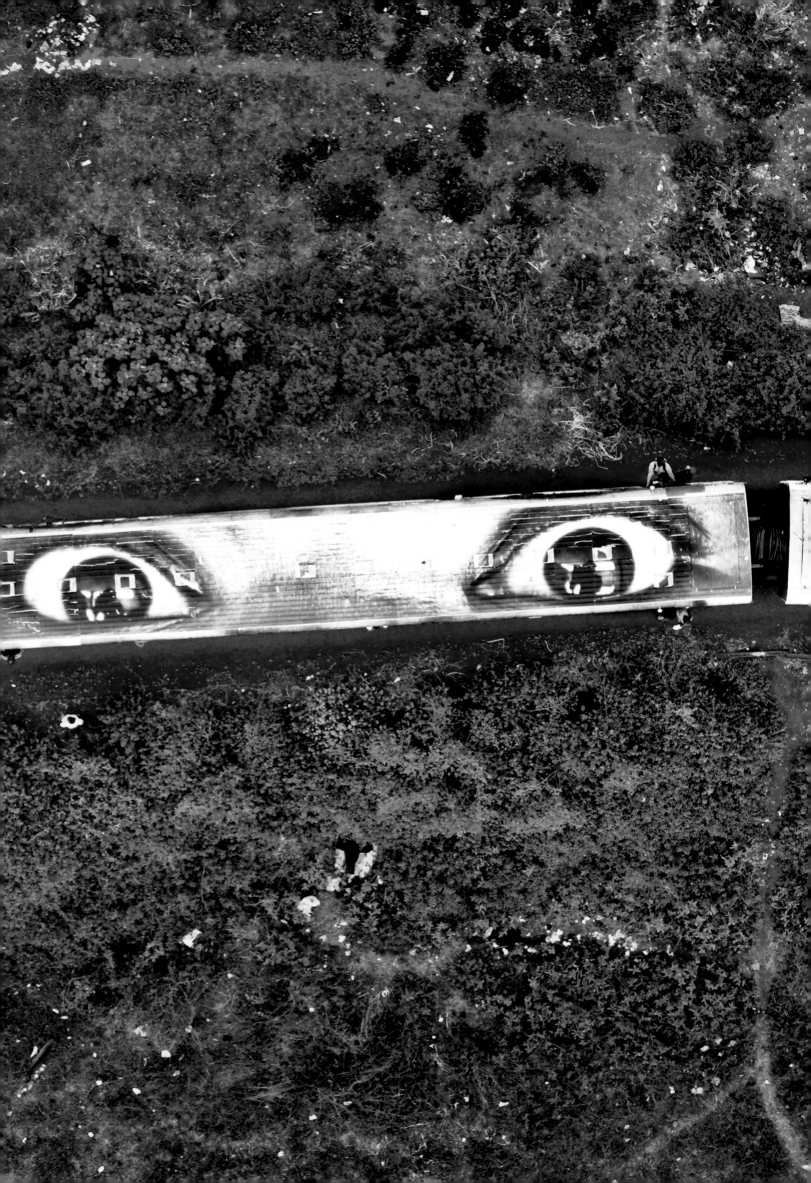

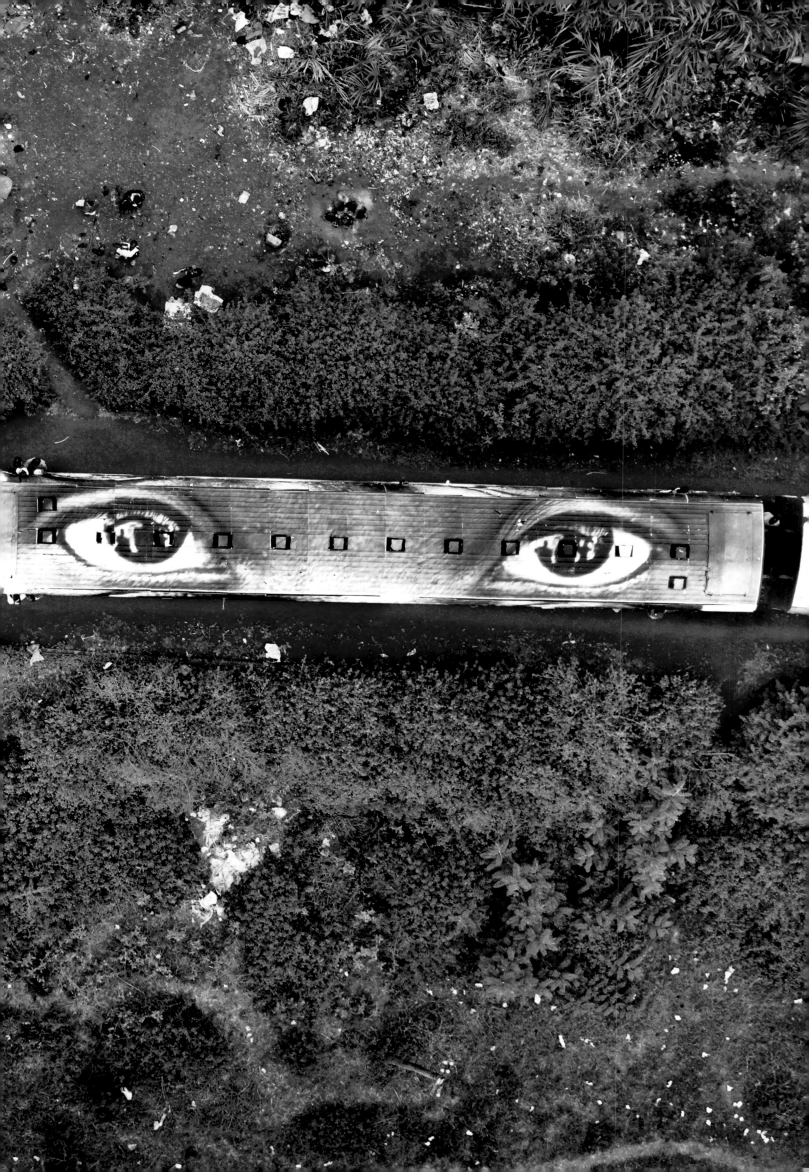

Elizabeth Kamanga

"I am thirty years old, and I was born in a place called Kakamega in the Western Province of Kenya. I am married, and I have two young girls aged five and three. I moved to Kibera when I was twenty years old to look for a good job. I had an aunt who lived here, and she encouraged me to come, telling me that I would find a good job here. I had just finished school, and I was excited at the prospects that I thought Nairobi would offer to me. I thought that I would come here and find a good job in an office. But I did not find the good job that I had hoped for. This makes me feel very sad because I think too many young people move from their rural homes to come to Nairobi thinking that it will provide them with a better life, only to be disappointed.

When I arrived in Nairobi, my aunt made me do all of her housework, and eventually I had to run away to try to find myself a better life. I did not want to work as a maid because I had finished school and I had a good education, but I opted to take a job as a maid to escape the things that I was facing in my aunt's house. I met my husband while I was working as a maid, so I do not regret my decision, but I want to advise young people in rural areas to think carefully before migrating to the city. Rural-to-urban migration is not good because it causes a lot of congestion in the slums, and most people do not find the better life that they are seeking.

My husband has a job, but he does not get paid very much money and his work is only casual, so I also have a kiosk where I sell vegetables so that I can bring home money for my family. On the days when I work in my kiosk, I have to get up very early in the morning to go to either Kikomba or Toi market to buy the vegetables that I will sell. I then return home to get my children ready for school and my husband ready for work. After they have left, I do all of the family work before breakfast, and then I go and open my kiosk. I don't usually eat lunch, so I work all day and close at 3 PM so that I can collect my children from school.

I also do some volunteer work as a community health worker here in Kibera. My role is to educate people about their lives, HIV, AIDS, and other sicknesses and disasters that affect them. I educate people about how to live a good and healthy life.

I think that women are very important in the community – we are the healers of Kibera. Women toil, and even when there is nothing, a woman will try. Women are very flexible, and they can do anything to earn a living and to sustain their families. Without women, I don't think that Kibera would be whole. Women are the ones who can really help the community and who will do anything to provide for their families. I also think that men are equally important because women rely on men just as men rely on women. So I think that both men and women are important to Kibera.

I hope that my photograph and my story will encourage and inspire other people. People will see that Kibera is not a good place but that we are living and we are coping with everything. I hope that people will be inspired by me."

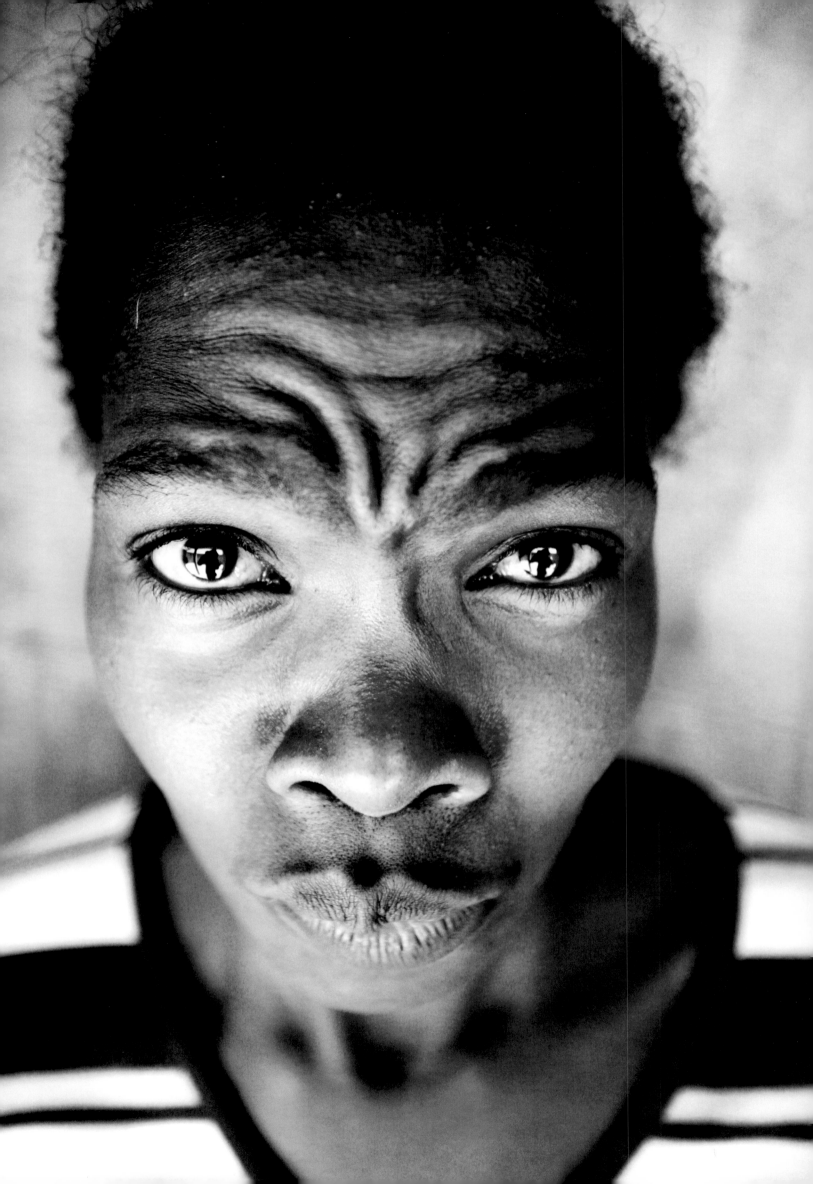

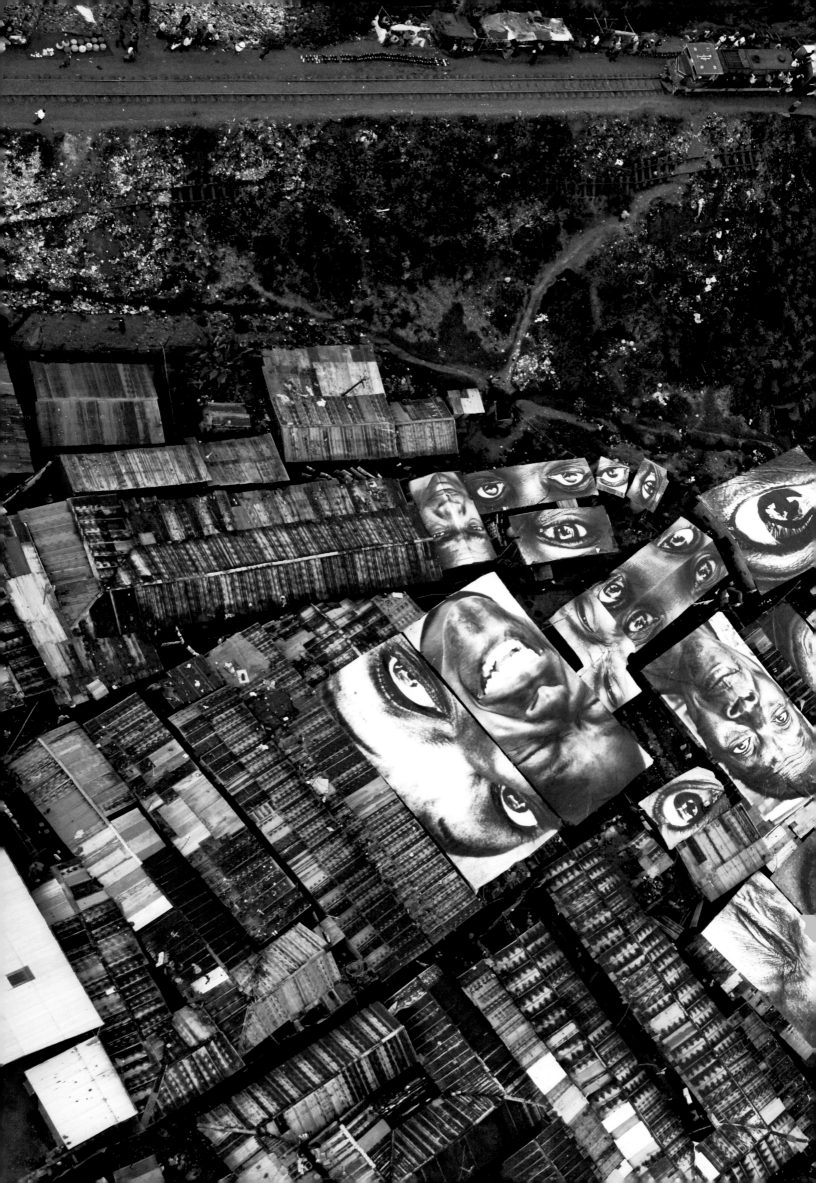

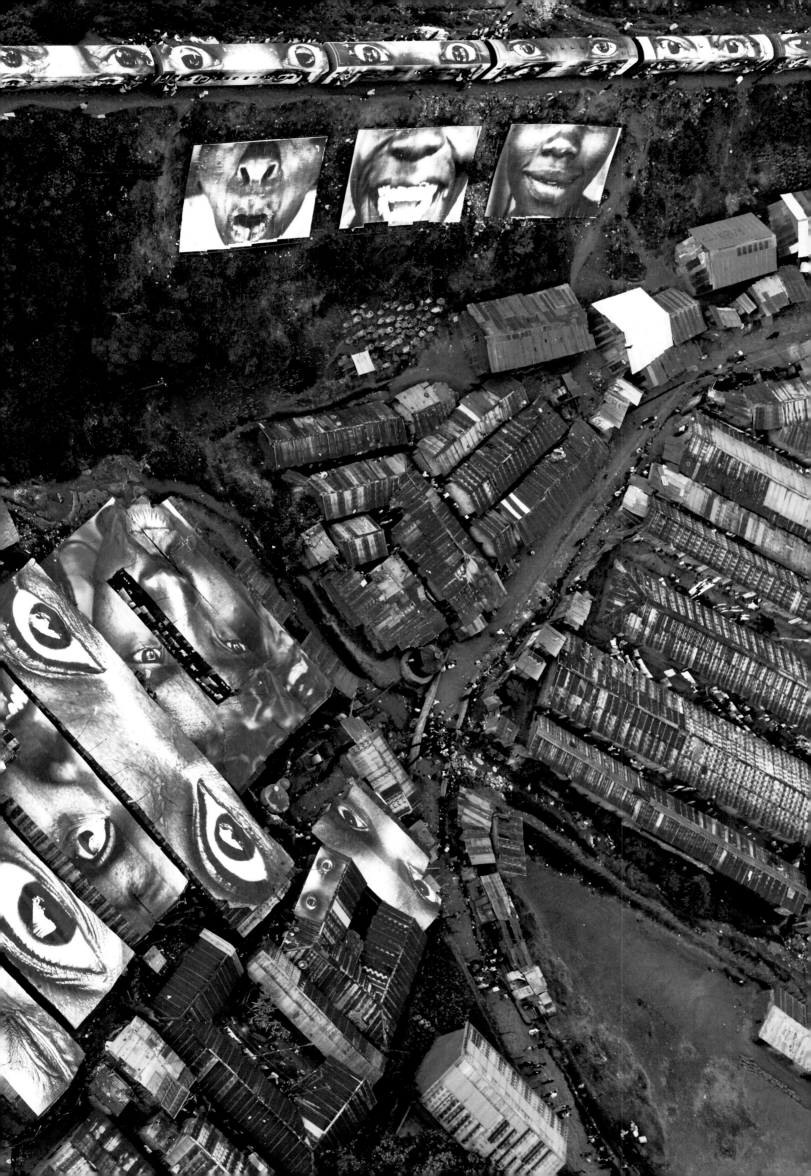

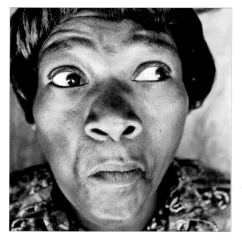
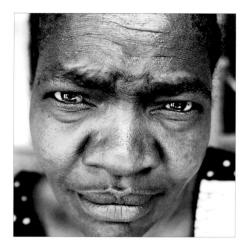
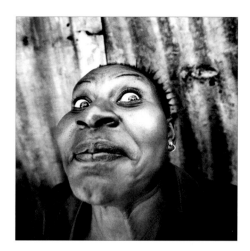
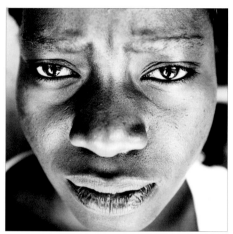
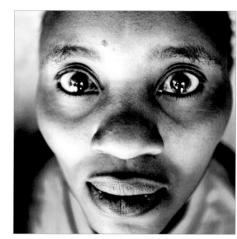
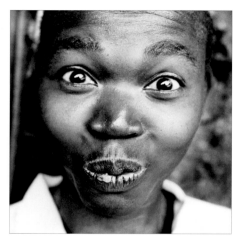
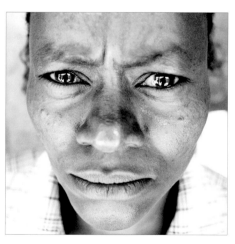
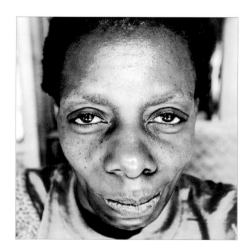
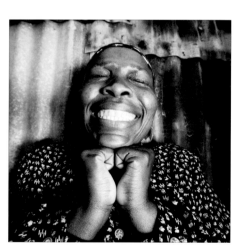
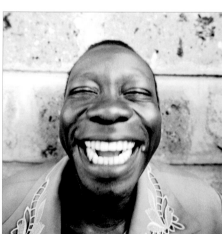

Veronica Kalunde

Joan Aloo Omiya

Bernadette Nekesa

Victorine Wambura

Rachael Wayiego

Gorety Aukior

Jane Wambui

Felistus Amina

Rispah Atemba

Phylice Kedogo

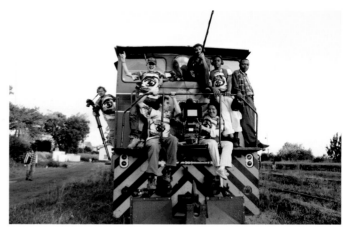

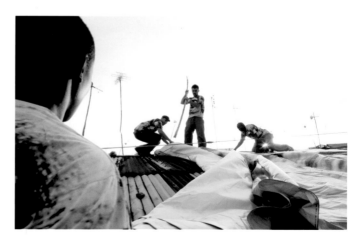

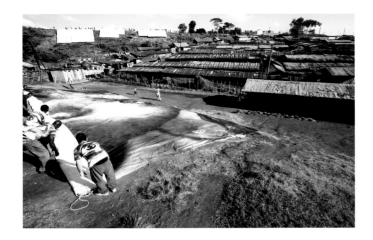
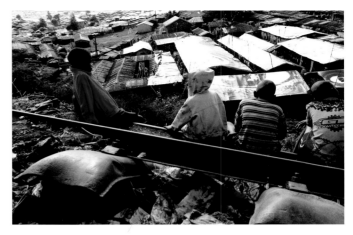
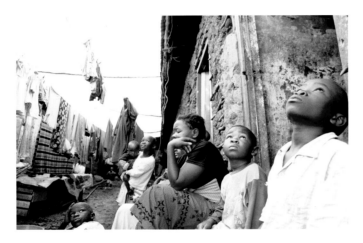
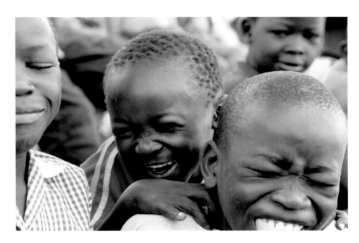

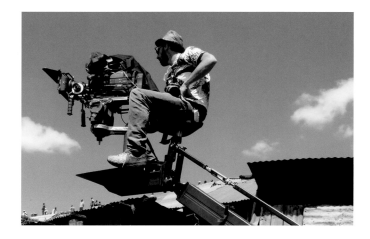

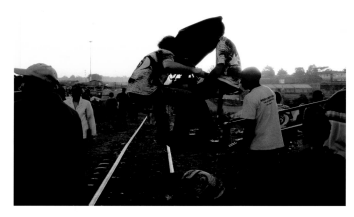

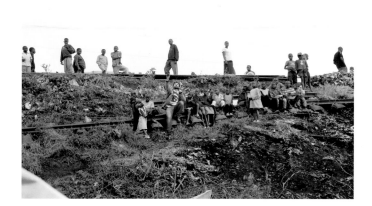

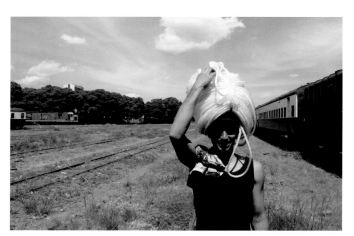

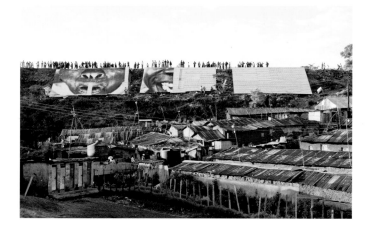

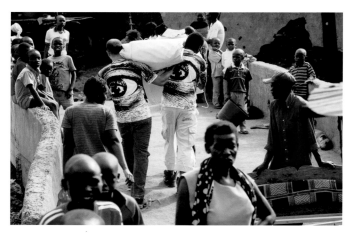

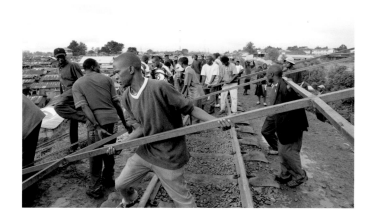

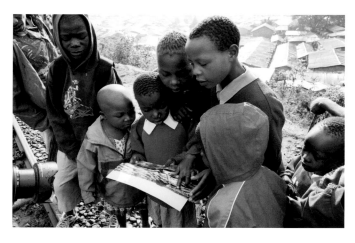

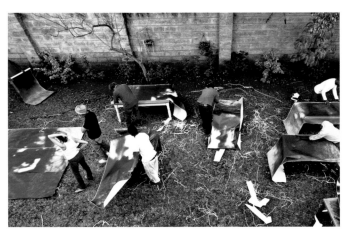

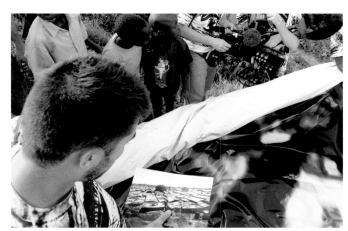

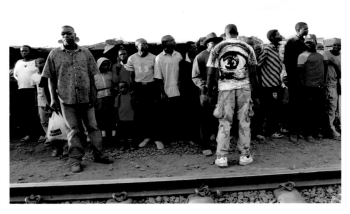

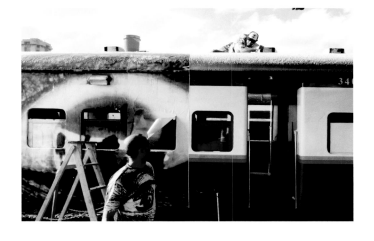

BRAZIL

Morro da Providência is a place that has become synonymous for violence in Rio de Janeiro. However, the reason this favela (shantytown) located in the center of Rio appeared on television screens in August 2008 wasn't the regular scenes of clashes between drug dealers and the police, but to present the art exhibition Women.

In order to pay tribute to those who play an essential role in society, but who are the primary victims of war, crime, rape, and political or religious fanaticism, JR pasted huge photos of the faces and eyes of local women all over the walls of the favela, suddenly giving a female gaze to both the hill and the favela.

"It's a project made of bric-a-brac, like the favela itself. We had to adapt to this world where the roofs of houses are made of plastic and children's revolvers are made of steel. We managed to get by in spite of the steep streets, the unsteady houses, the unpredictable electric cables, and the exchanges of gunshots where the bullets sometimes go through several houses at once," says JR.

JR shows that art can find a place anywhere, just like those flowers that sometimes emerge between slabs of concrete. "The inhabitants got a real buzz out of the project. On our last day there, they threw a little party for us. Even the big tough guys of the favela, with guns and bulletproof vests, were sad to see us leave," says JR. JR had arrived in the favela at an interesting moment: a few weeks earlier, some soldiers had captured three young people from Providência and handed them over to drug dealers from another favela, who executed them and cut them into pieces.

"Of course, we're not going to change the favela. Life will very quickly go back to what it was before, like after a murder or when the army was occupying, but I hope we opened a new perspective. I am sure that new initiatives will appear," says JR, who, in order to reassure himself, repeats phrases he heard in the favela, like the words of a teenager he met when he arrived, who told him, "I prefer to live for a year like a king than a hundred years as a slave," and those of another teenager, the day he was leaving, who said, "With a bullet, you can get one man; with a photo, you can get one hundred."

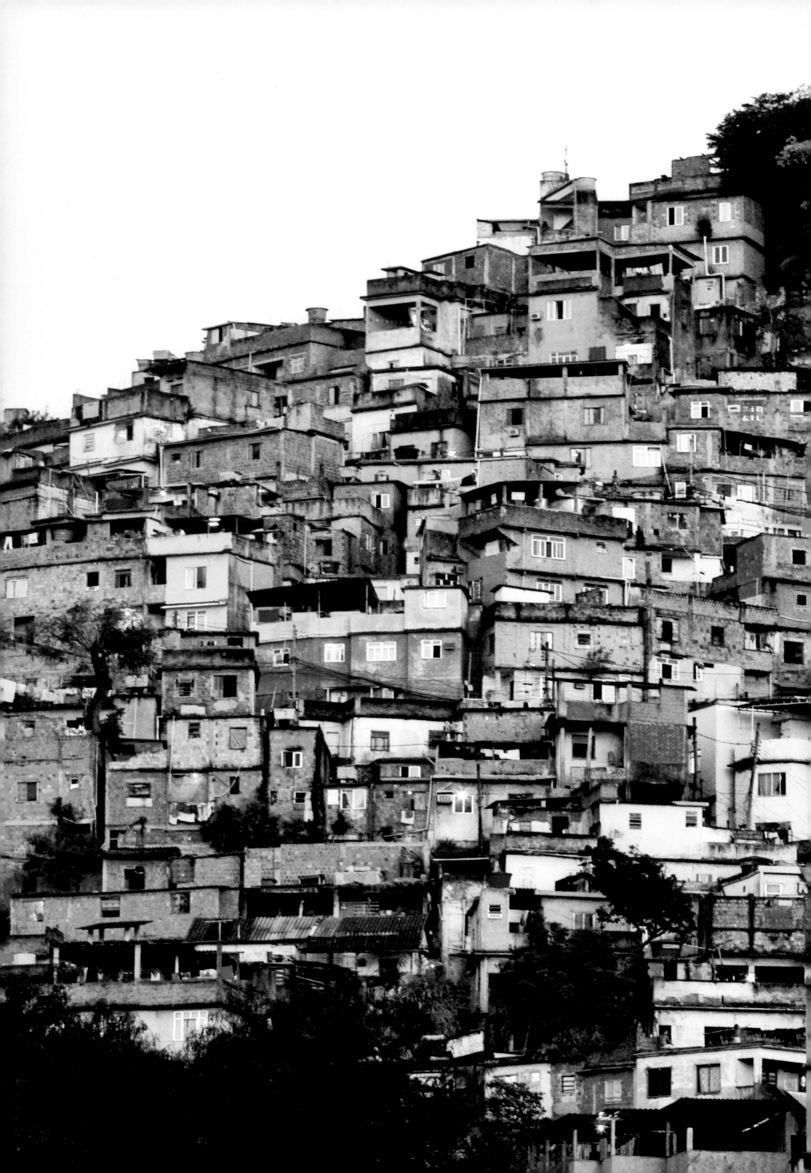

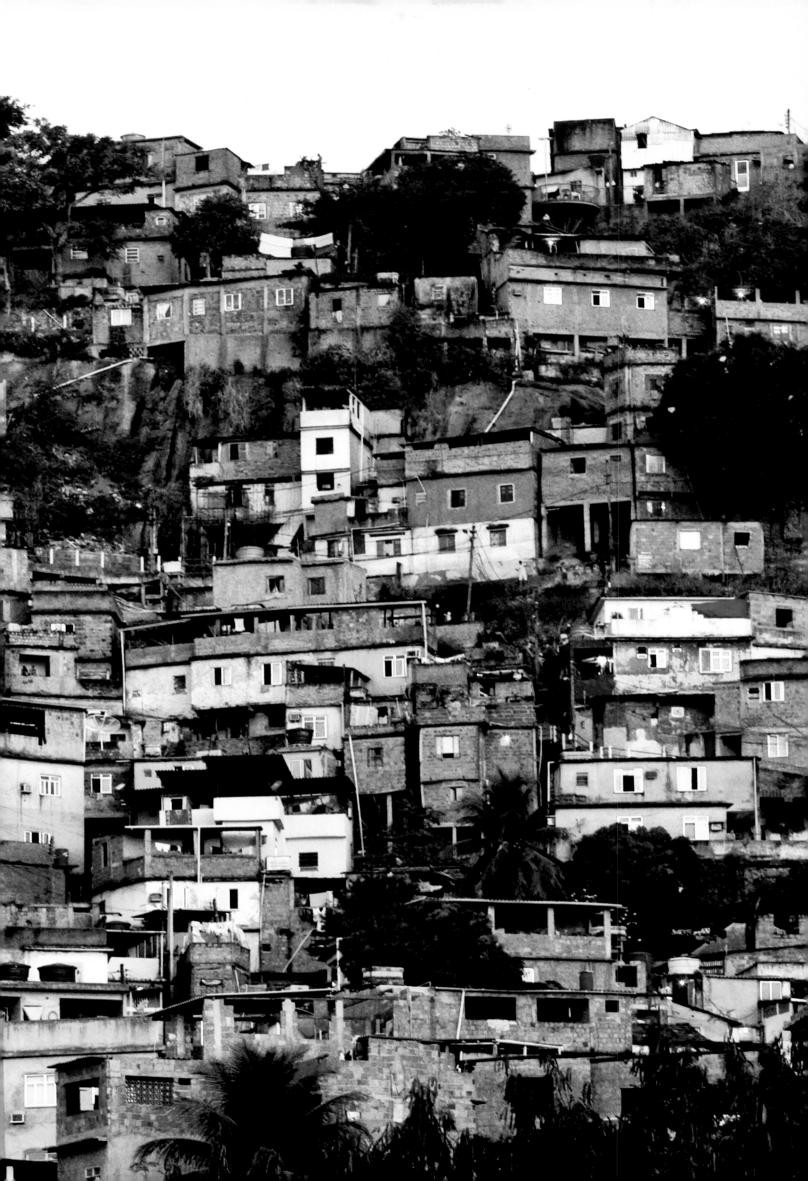

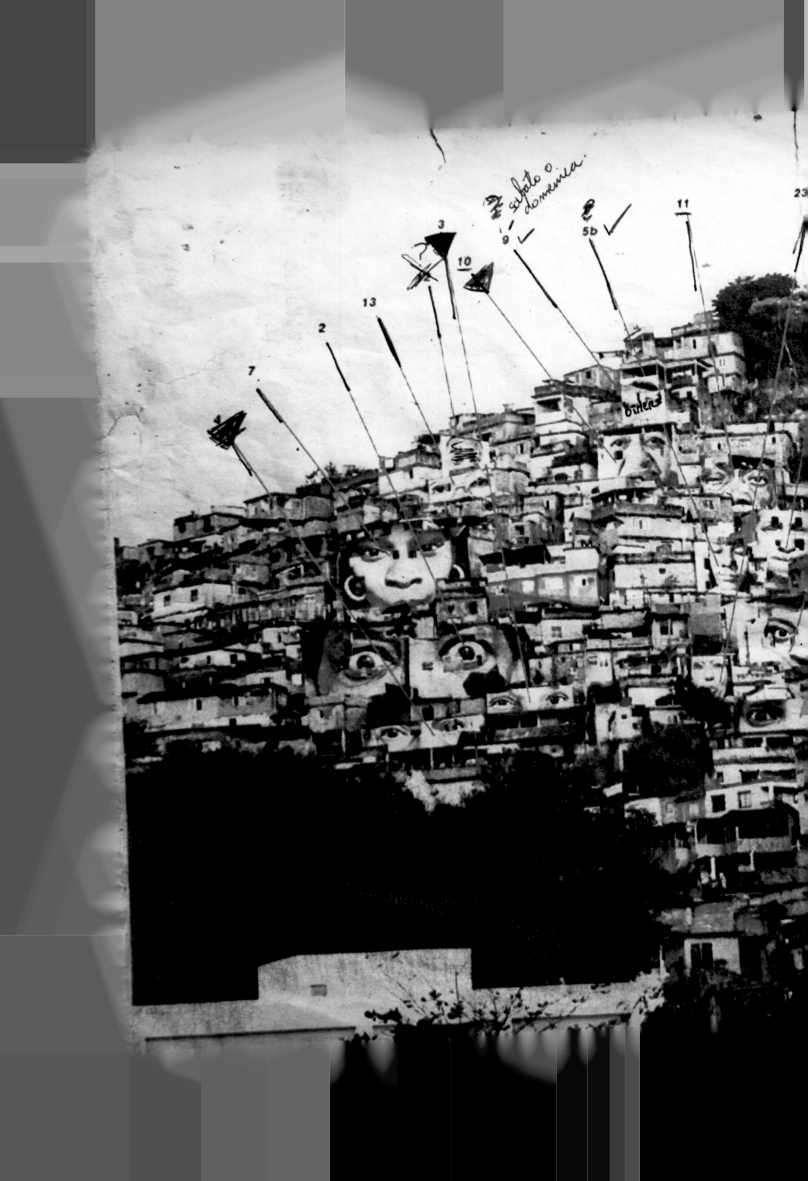

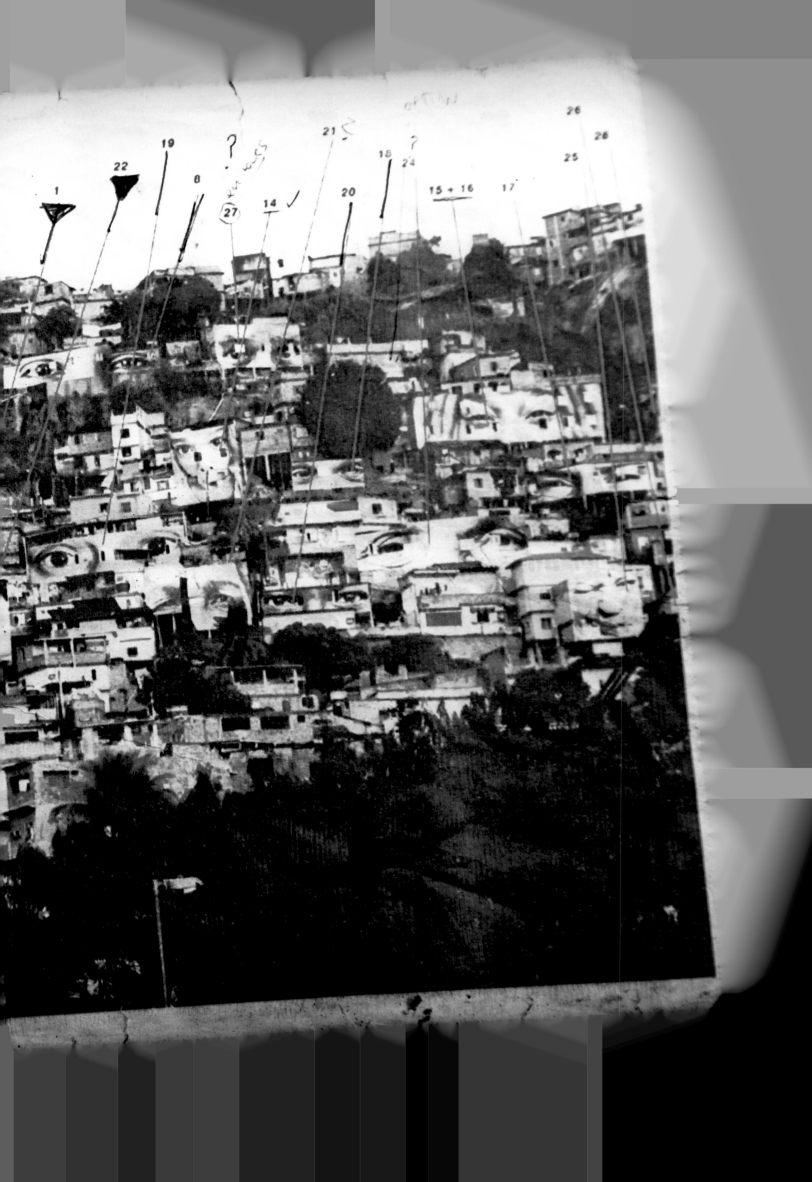

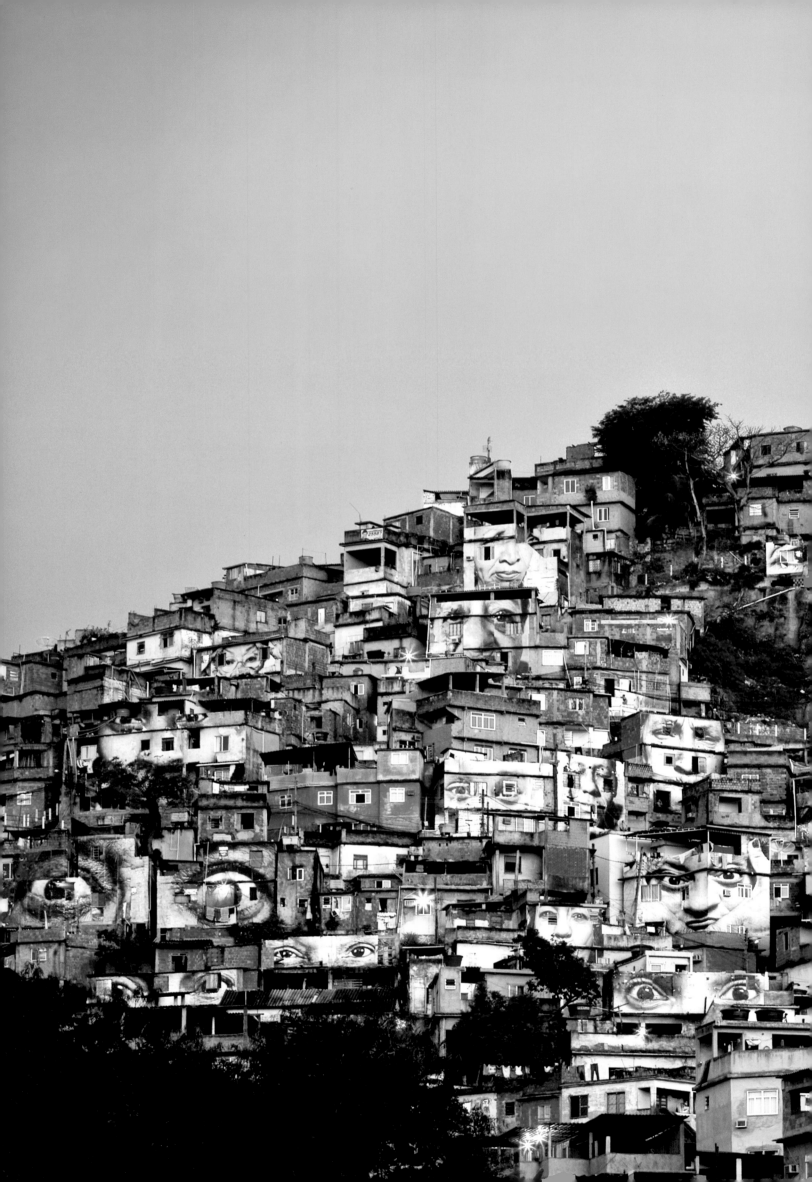

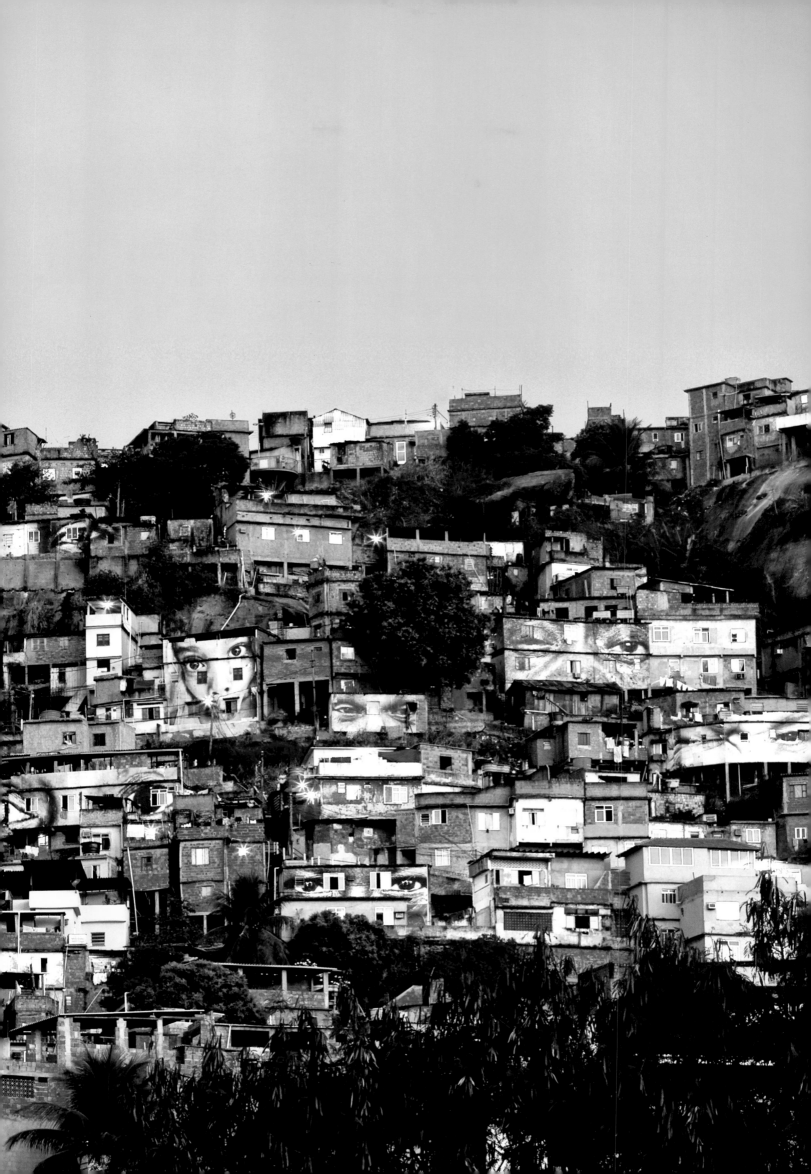

Lacisia Cerqueira

"I'm seventy-four years old. I was born here, and my mother and grandmother were both born here. This is where my roots are. I've been a widow for seven months now. We were going to celebrate our fiftieth wedding anniversary in June. He had a Portuguese name: Benjamin.

My husband came over at the age of eighteen, from Portugal. He arrived in 1951. He was a bus driver – of the first bus that ran in the neighborhood. I sold cakes and pies. I used to go up there holding the trays on my shoulder. I had lots of clients, but then my husband got sick and I had to look after him. I had two kids, Antonio and Maria de Fatima.

I like living here because it's where I was born, where all my brothers and sisters were born, where my mother was born, and where my grandmother was born. I wouldn't leave here for anything.

I had a very hard childhood. There was no water or electricity, and I had to carry lots of water. Goods were unloaded and distributed where Samba City is now. Everything was brought here on wagons, even circus animals. It was the ferry terminal.

I remember the Second World War. I used to come down when the ships were here, in the morning. I'd wake up so I could go and see them. I remember when the soldiers came. Some of them were laughing; others were crying. Everybody would run down there with cigarettes, chocolate . . . and some of the soldiers would laugh when their families came, and others would cry if they didn't come.

The ships docked over there and filled up two warehouses. We had nothing. We had to go collect glass, rubber, and paper. We had a big family; my mother had twelve kids. So we kept whatever we could collect. We had no bread, so I used to go to a bakery in Barroso at three in the morning to buy a piece of something hard and black. I have no idea what it was made of. Living conditions are better nowadays. If you compare now and then, it's gotten a lot better.

There was no violence or anything like that. The violence started about twenty or twenty-five years ago. I don't remember any violence and killings like there are now. It's getting worse by the day.

This last tragedy? It finished us off. I was one of the people who went out to find the guy. I know he wasn't a bad guy. My daughter had just bought a house down there, and he helped her a lot. He was a friend, a good guy. So I went to get him. I didn't even know that the two guys sitting next to him on the bench had been arrested too.

The soldier just said: 'I'm taking him away.' They killed those boys. They were like Jesus going up to Calvary. They took them away to execute them. Then the people rebelled – children, the old, the young, everyone. Even I was there with my son, my grandson, my daughter, everyone. Who could imagine the army would do such a thing?

I'm just asking God to let the inhabitants here live in peace. Because there are people dying who've got nothing to do with all that."

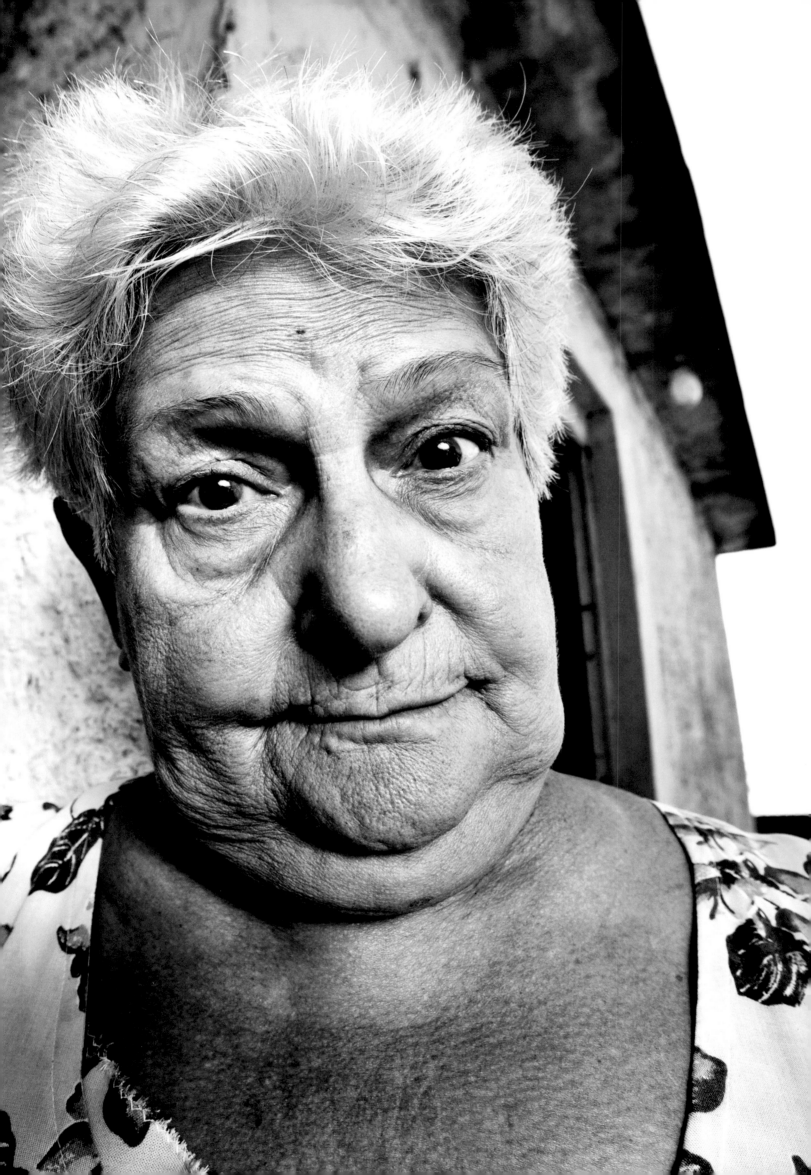

Linda Marinho De Oliveira*

"My parents lived here, and I've lived here ever since. I'm a widow. My husband died about twenty years ago. I have three kids, grandchildren, and great-grandchildren. I love this favela, and I only wish there was no violence. What I love best is when the whole community gets together for a celebration. Even without any money we get by and we manage. We have the quadrille dances, the St. John's Day celebration, Christmas . . . oh, we get together a lot. I'm one of the dancers, and I'm dancing today.

I compose sambas. I like to write them and enter contests. My name is Lindinalva, but everyone in the community calls me Linda. It's Linda's samba. I do it for entertainment and competing with other street carnival composers. There are several here. This neighborhood is called Saúde. There's also Gamboa and Santo Cristo. All three neighborhoods are well-located and right next to each other.

This is the last samba I wrote, two years ago. It's called 'Port Traditions.'

I turned up at the Port Traditions carnival
And I played and sang and sambaed the livelong day!
Then I remembered the carnivals from times gone by,
That I miss, that I miss to this very day
But now I'll let this sweet harmony flow over me
And let myself be swept away
By the beat of the drums.

Our flag is red, blue, and white
And my song is a song of joy oo-oh
It's here,
The Port Traditions carnival is here.
Come and sway in peace, my love
Come and samba on the docks, my girl
Come and sway in peace, my love
Come and samba on the docks, my girl

My deepest wish is that the police would stop shooting all over the place whenever they show up here. It would protect our kids. There are two- and three-year-old kids who play on that square. All the kids play on the square and ride their bikes there. It's so sweet when the kids play on the square. It's fascinating to watch, and besides they don't have anywhere else to play.

It wasn't always like this. It's only been like this for the past thirty years. Unfortunately, the way out of this situation is blocked – by corruption. That's what has closed the door and keeps us from finding a way out. And who suffers from all this? The poor people here and the kids who have nowhere to play anymore. With all the corruption, everyone's trying to get more and more. And look where it leads to. It's hard to stop it, because money is involved. When money is involved, it's really hard to stop something."

* Rest in peace, Dona Linda.

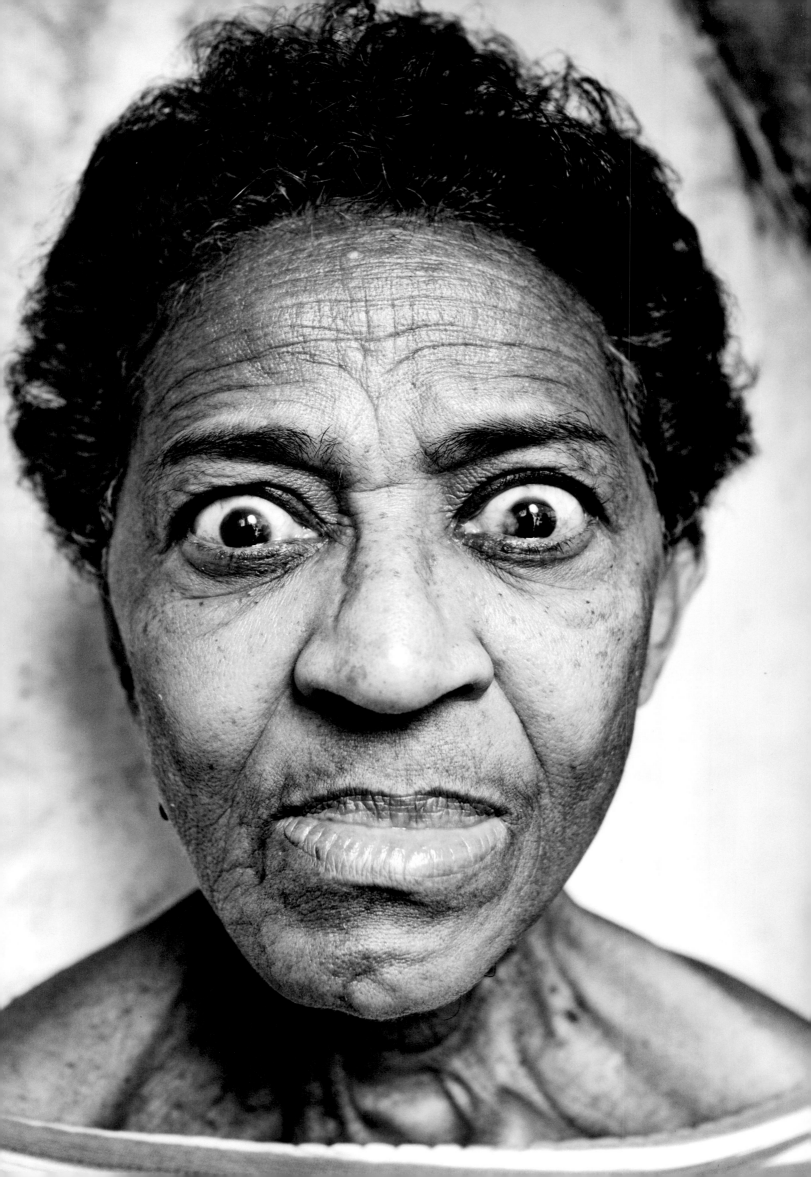

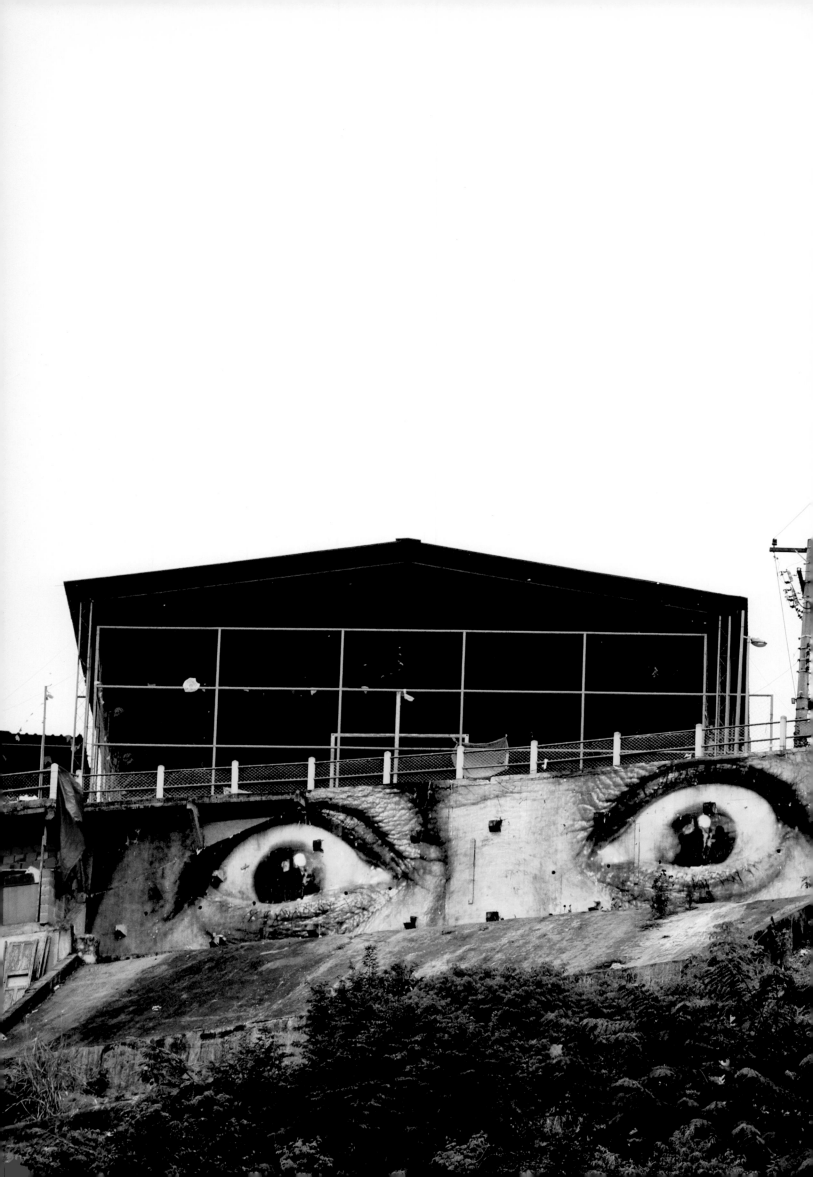

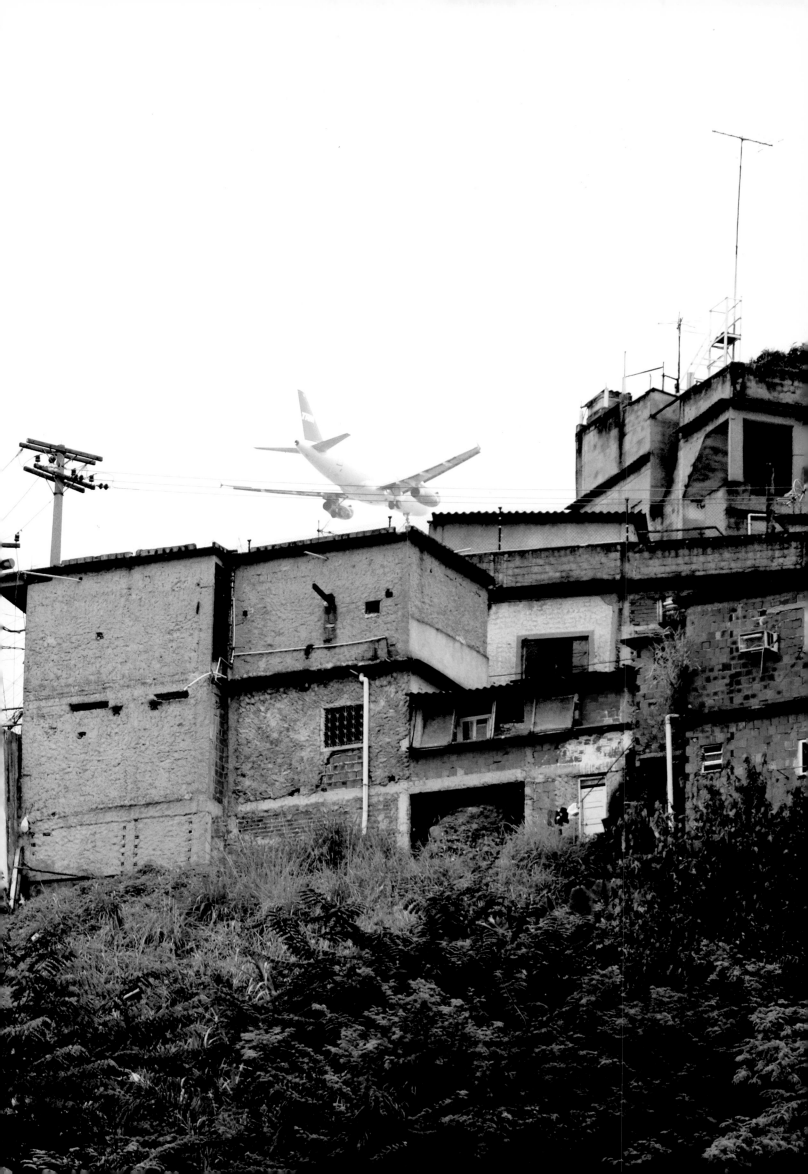

Aurora Louisa Lima

"I was born in Caxias and came here at the age of six. I like it here, because nearly all of my family lives here.

I go to the Darcy Vargas School. I walk there. It takes about two hours. I go with my sister. She's fourteen. I'm in sixth grade. I like it all right. When I grow up, I want to be a doctor so I can take care of my family.

Sometimes I get scared when the police come up here. My mother is afraid of letting us go out to play. I live down there, but my mother doesn't want to let my sister and me play in the square anymore.

On children's day I went down to get some candy – with my cousin, my sister, and a friend of hers. Then the police came up here and the shooting started. People came tearing out and ran all the way up there, where there's a way out on one side. You could see everything. My sister started feeling bad and hopeless. So her friend took us to my mother's. There was a woman there who had passed out in the bathroom, and her face was all red. When it was all over, my mother was angry because we had stayed out in the street.

The things I like best here in Providência are my mother and my family. My dream is to stay with my family forever."

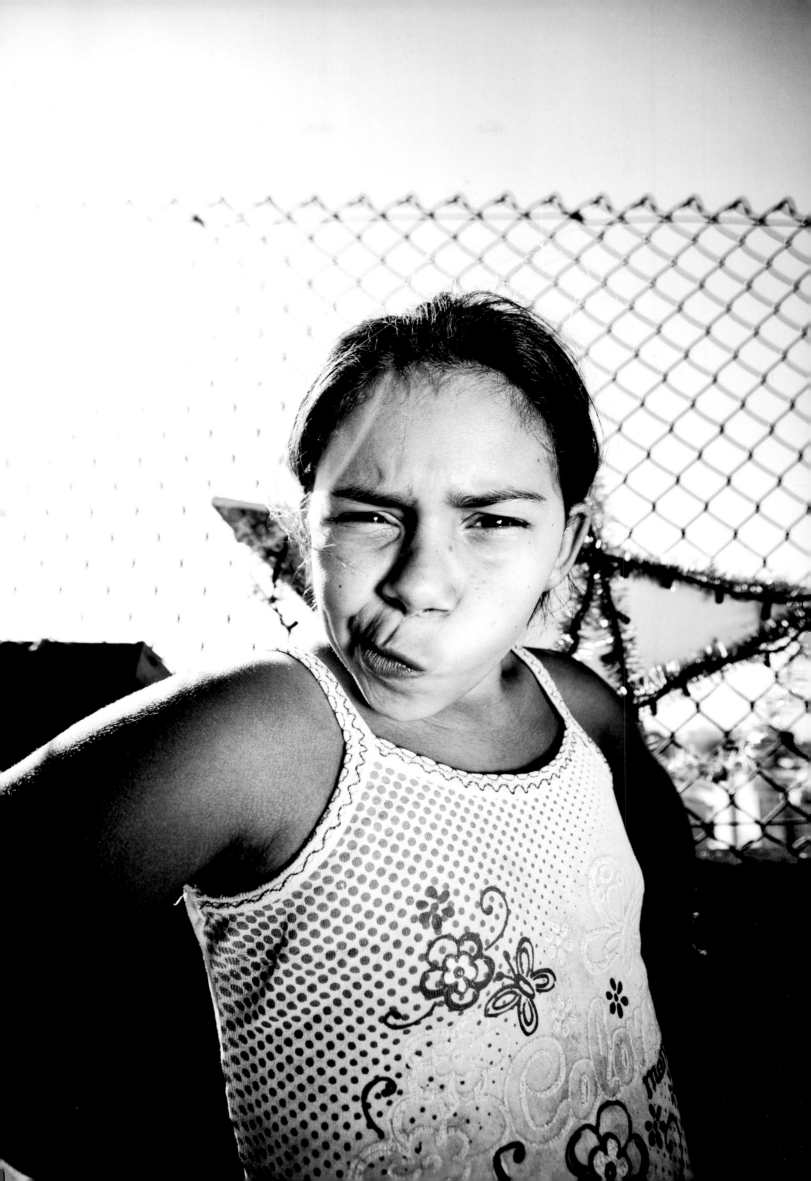

Ilsa Da Silva

"I came from inland when I was fourteen. Now there are lots of people and lots of houses here. Back then it was really backward. It's a really nice favela to live in, especially because it's in the center of town and close to everything. It's a really peaceful favela to live in.

I used to work for a family every day. I'd go down in the morning and come back up at night. I got married at the age of twenty. My husband died about three years ago. He was a good husband, and we never wanted for anything. He didn't drink or smoke. That was the good thing about him. But he was jealous. When he'd say 'You're not going,' I definitely wouldn't go. I'd stay quietly at home. He also chose my clothes and wouldn't let me go out with just anyone. I was under his control.

We didn't have any children. It was just the two of us. I had an operation at the age of eighteen and couldn't have children. I dreamed of having a house full of kids. Now it's too late. I don't want to get married again. People trust me. I've worked as a nanny and as a cleaning lady. I've always been reliable. People trust me, and wherever I go, they like me.

My fear was that I'd marry a man who drank. I'm terrified of drinking. God preserve me from marrying someone who comes home with his breath stinking of cachaça. I wanted to find a man who'd bring me peace and who wasn't a drinker. I found him. You just have to be patient. I met him at work, when he was doing housecleaning for people. He came by one morning and saw me, we were introduced, I agreed to go on a date, and he came by to talk to me that evening. We went out together for three months, then we got married.

He used to go out a lot. He played the *cavaquinho* and was part of Portela. I never went because I'm not a big fan of the carnival. He gave me my first television as a gift for the first time I stayed home during the carnival. After that I got used to it and have always stayed at home ever since. There are celebrations and dances right here on this square where we're sitting now, but he never let me go to any of them. He told me to watch it on television and go to bed if I was tired. His sisters asked me how I could put up with it. I put up with it because I loved him, and when you love, you put up with things. You can get used to anything."

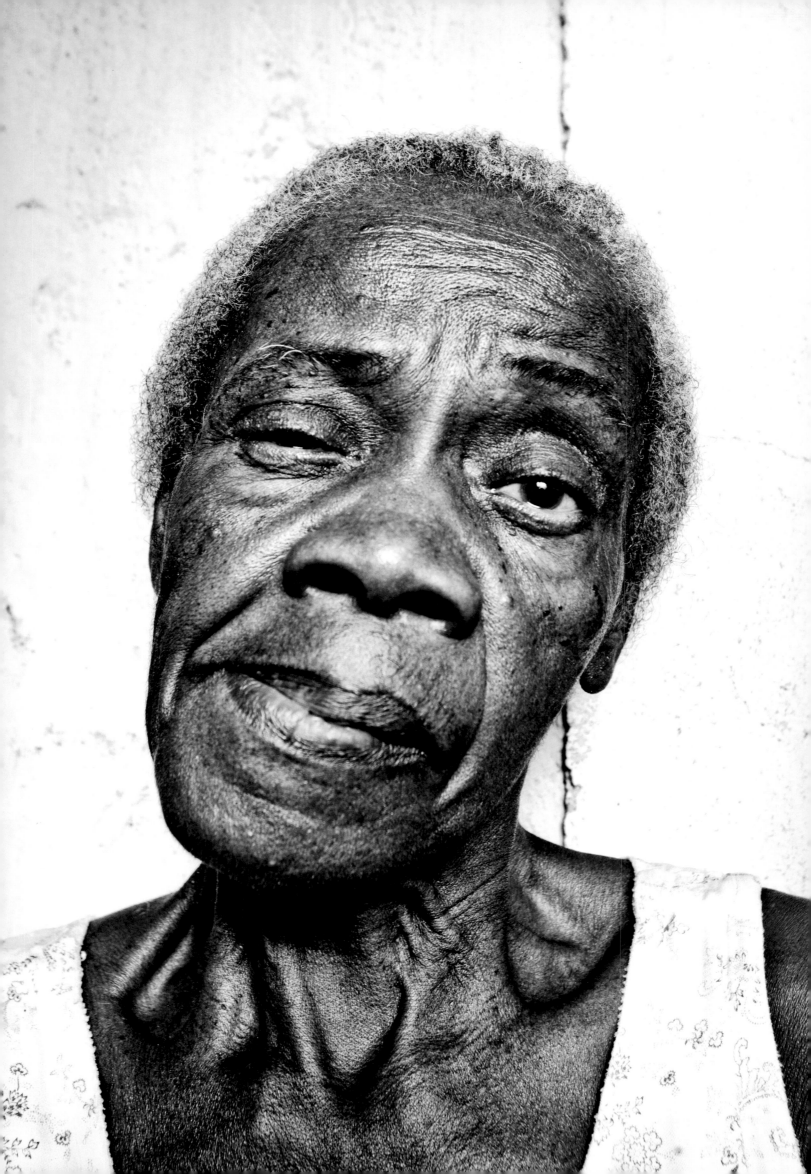

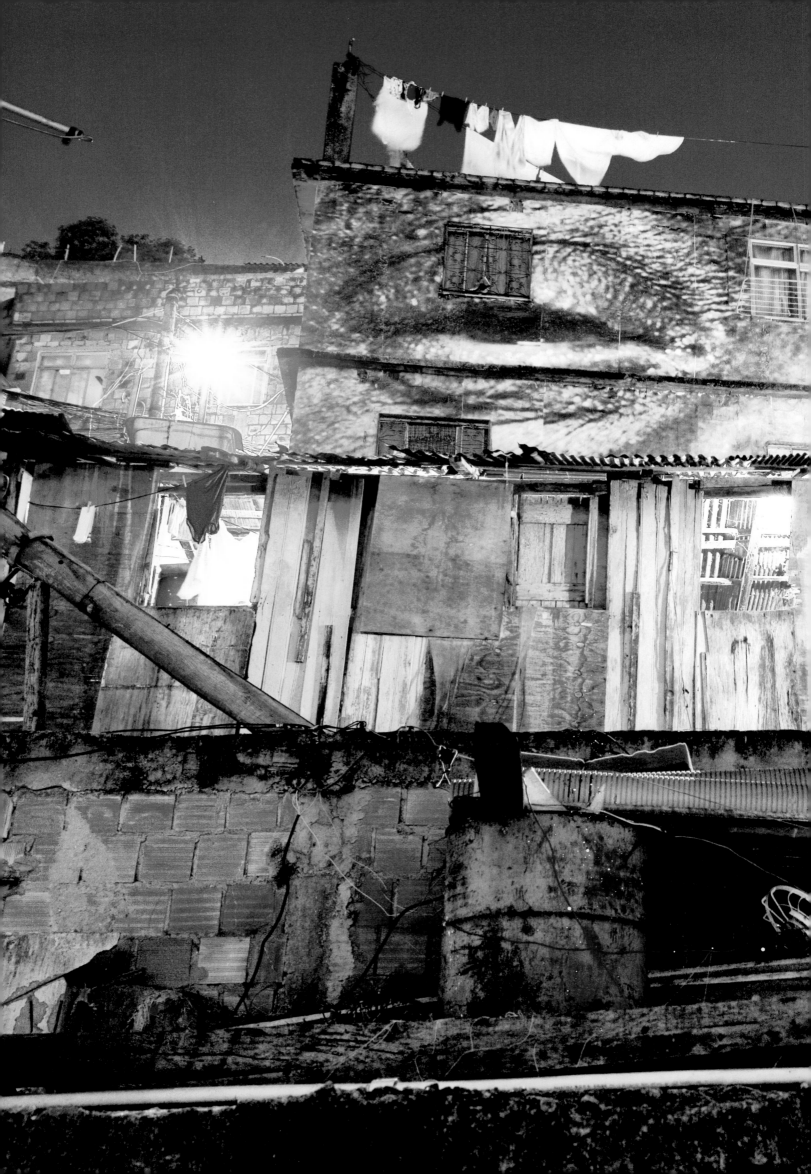

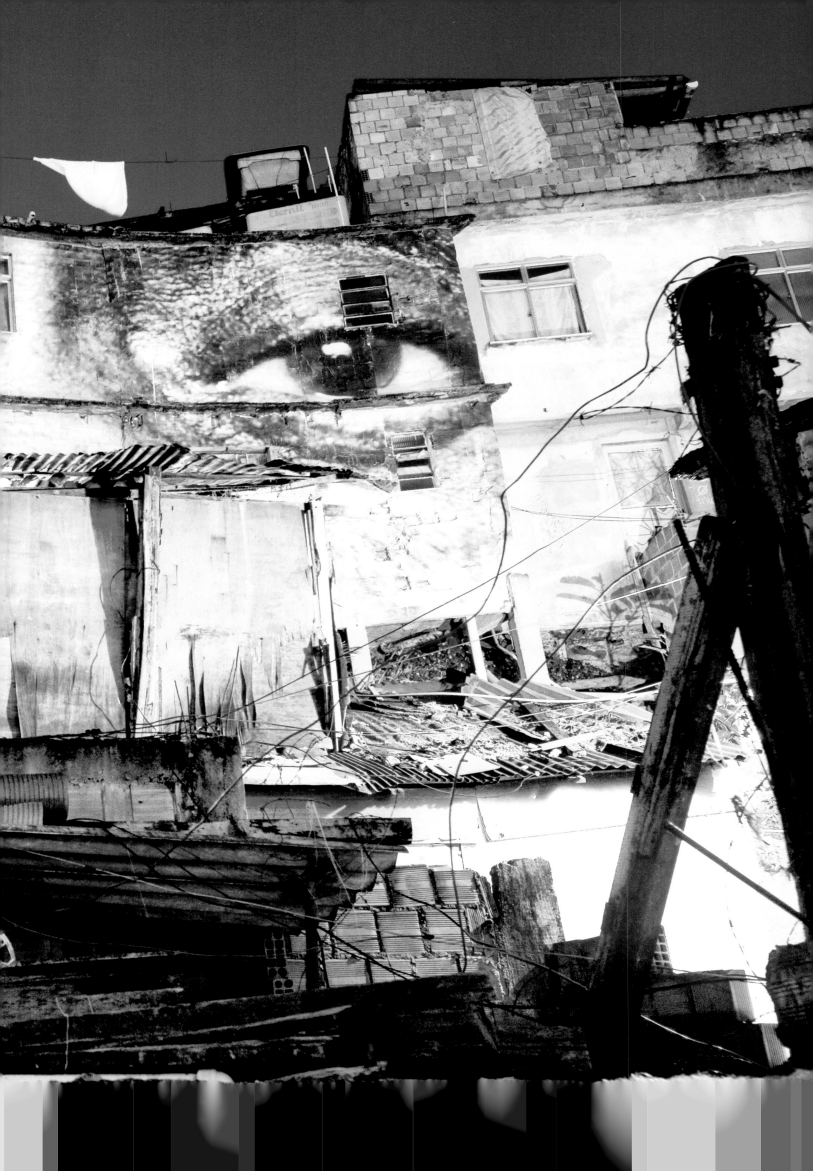

Juraci Vilela Gomez

"I'm from Pernambuco and was born in Recife. I came here to Providência at the age of four. I was always coming and going because my parents fought all the time. In 1968 my father died and we stayed in Rio for good. I came to live here for good in 1970. I raised three kids here, but one of them died at the age of seventeen, assassinated by the police. I have another son who's thirty-five and a daughter who's twenty-four.

I'm a widow. My first husband – the father of my eldest son and the son who died – was born in Place Maua and raised here. My second husband, to whom I've been married for twenty-five years, was also born and raised here in the favela, where they had midwives in those days. My husbands and my daughters were all born here. I'm the only one who wasn't originally from here.

My first husband was also assassinated. It wasn't the police that time, though. It was the result of a mix-up. As for my son, it happened like this: One day after he'd been out, he came back home, took a shower, and went out again. I was at home with a cousin of mine who had stopped by for a visit. It was about seven or eight in the evening. I walked my cousin to the square a bit later and then went back home. Fifteen minutes later I was told that the police had killed him. He's been dead for thirteen years. The reason? He got involved in dealing drugs and then he was gone.

As a mother I always worked and tried to provide him with everything that was within my means. But you know how it goes. Young people always want more and more. And you don't always have the means to give them what they want, so they end up getting involved in the wrong things and die too young. It's horrific. He was doing well in school. Whatever I did for the others, I did for him, too. The proof: my oldest son, who's thirty-five, also went to school, but only to sixth grade because he didn't want to go any further. So I helped him get his driver's license and he became a private chauffeur. My daughter finished secondary school, and she also studied dance and English. I gave them everything I could as a mother.

I've always worked. Now I'm working in someone's house. I'm paid by the day. I took night classes to finish my primary and secondary studies while working. I even went back to finish my secondary studies to motivate my nephew. He was starting to go down the wrong path and didn't want to go back to school. So I signed up for seventh grade to motivate him to go back to school. He didn't go back to school, but I continued. Now he's working.

Unfortunately, we're hostages here. We're in danger all the time. You could be coming home from work and all of a sudden there's a shootout and there you are in the middle of it without a clue. They always tell people who live here that it was due to a random shot, and they never support our claims because we live in a favela. The things people say mean nothing.

I'm no dreamer, but sometimes I think about winning the jackpot and getting out of here. But I still like this place a lot. I got attached to it. It's where I had my children. Unfortunately, there have been lots of sad times, but lots of good times, too."

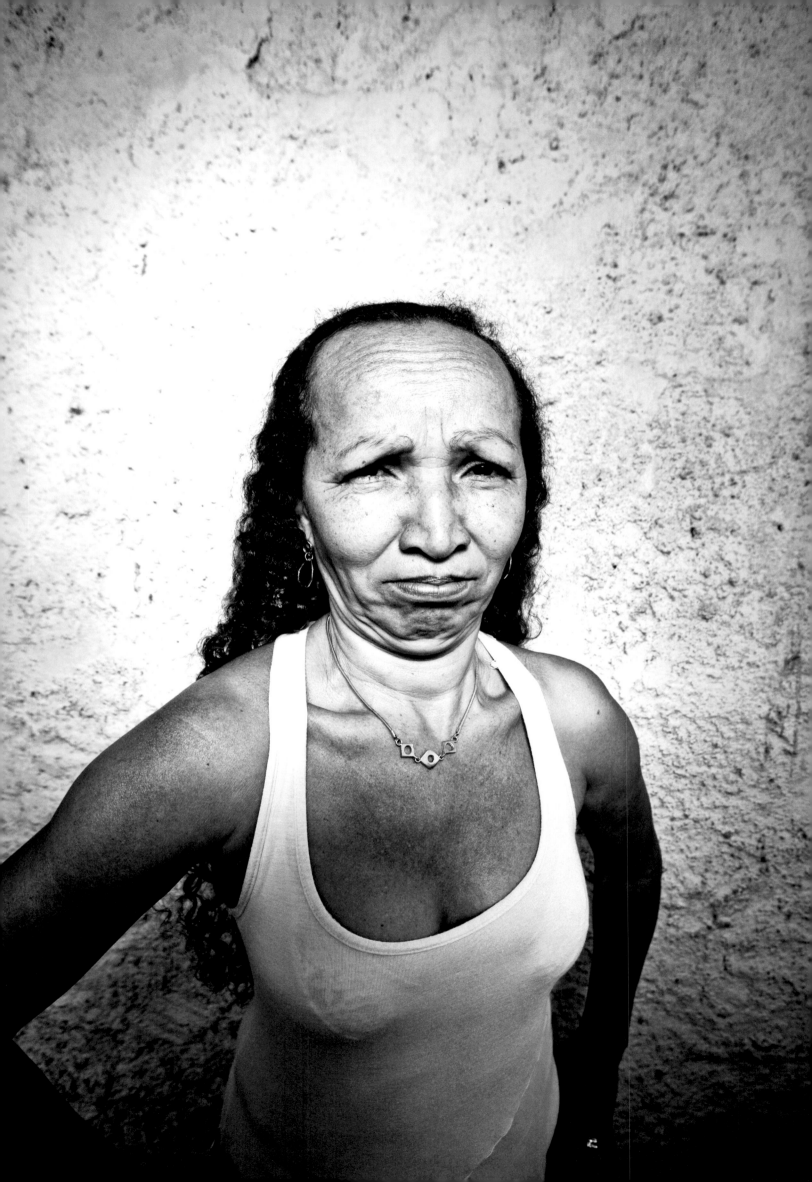

Maria Odontina

"I was born and raised here. I had six kids, and two of them died. The first one died down there in Barão. It was the police who killed him. He was going to his grandmother's. He was going to check up on some work he'd done and was killed in a shootout. He was seventeen. The second one died down there in Santo Cristo, but he was attacked. They grabbed him, but he fought hard, so they picked up a rock and knocked him on the head with it. He was seventeen also.

I have sixteen grandchildren. I have a daughter who's been living with me since her father abandoned us. She's always stayed with me. I raised her while working, and she's never far from me. She had five daughters, and they all live with me. The others got married and went off to live their own lives.

This favela is the best place I know. When strange things happen and there are shootouts I feel like leaving, but when everything calms down I'd rather stay here and not leave the house I bought. I really think I'll stay here.

My dream is to buy a house for my daughter. She comes and goes, and she's already left twice to go live with a guy, but she couldn't stand being away from me so she came back. She's twenty-eight. I always tell her: 'I'd really like to see what you're going to do when I'm dead.' There are seven of us women in this house and not a single man.

For me, this is the best place to be. I was born down there where Samba City is now. Then I got married and moved up here. I didn't get a divorce – he's the one who left us.

I've never stopped working – as the saying goes – cleaning houses. I always left the kids at home. Their father was in the military, and also a fireman, and now he's retired. Even so, he's still helping me out these days. He remarried, but I never wanted to. But he's still helping us out, and he comes to see the kids during vacations. He takes care of any problems with school, parties, presents, and all that. He was here just yesterday.

I felt really sad about what happened to those three boys. We're still in mourning now. It's very calm today. When things are like this, everything's fine, but when the army was here it was horribly sad. I have no idea why they came. We're happy. We have celebrations. I'm a member of the senior citizens' ball. I dance at the St. John's Day celebration. I'm dancing today. We senior citizens have formed our own quadrille. It's an old-style quadrille, and we've even been invited to perform in places other than here.

We're happy. I was really sad only once – when my sons, my mother, and my father all died at the same time. My son died in February and my mother in May. She couldn't take it. She was crazy about him. She got very sick and kept calling out: 'My grandson . . . my little Celso.' She called and called him, and then she died, too. I was overcome with grief. Then it was over.

Now there's only joy – being with my grandchildren, my friends, and my neighbors."

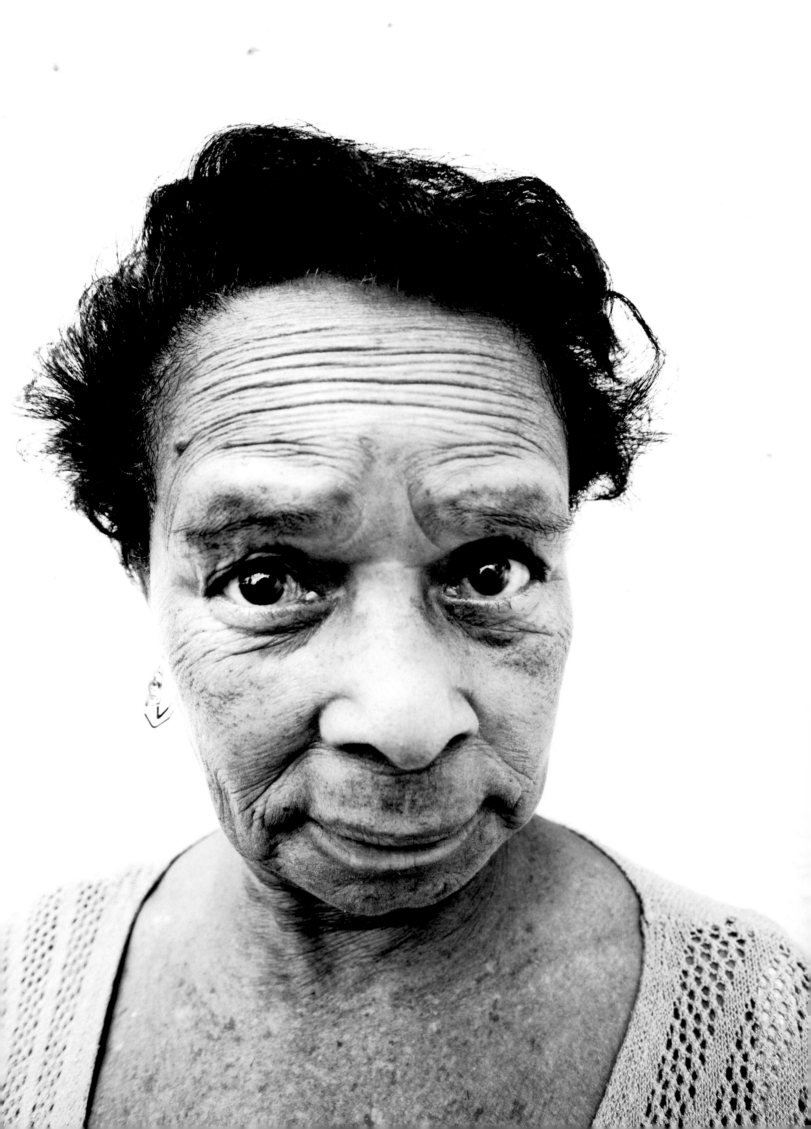

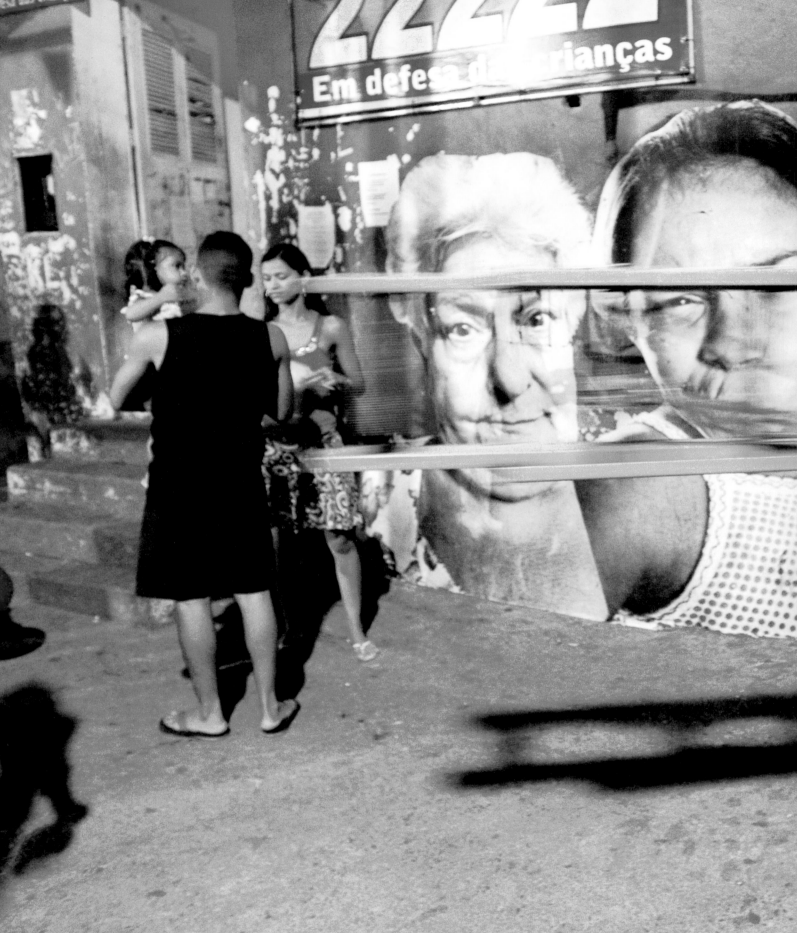

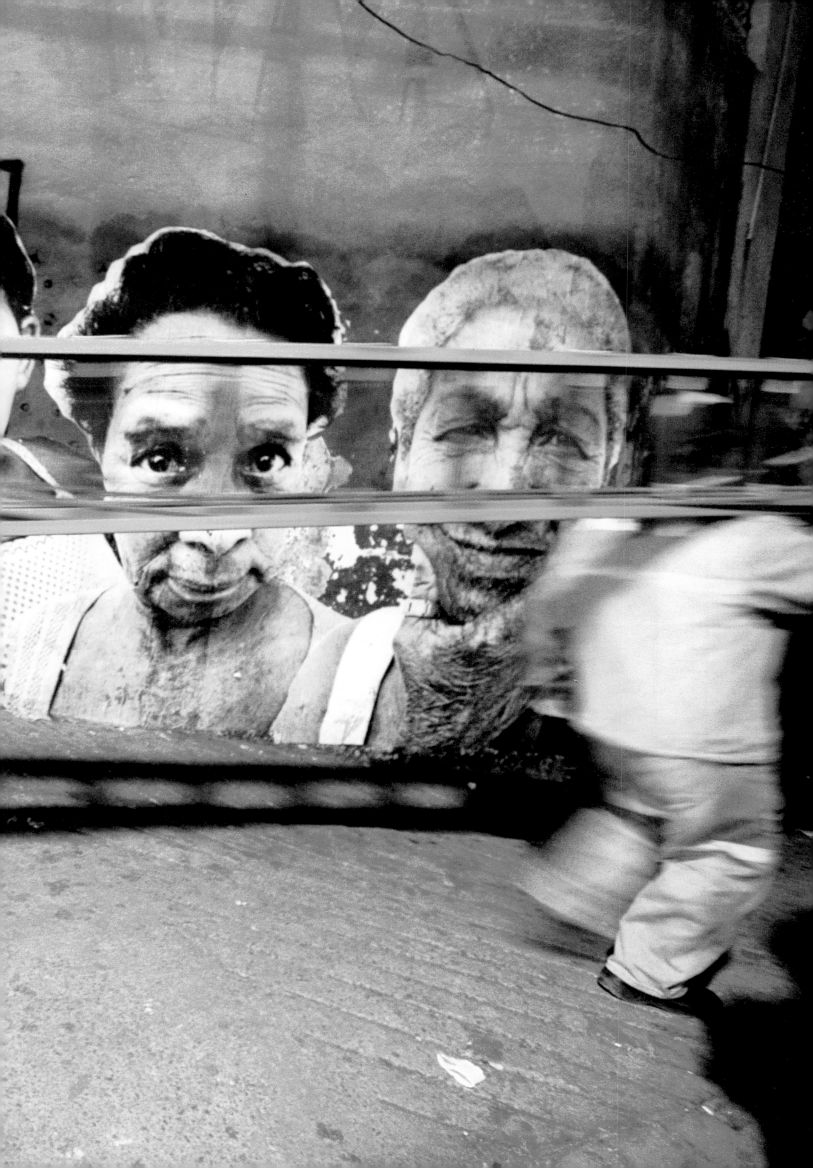

Glorinha Dos Santos Lins

"I was born and raised here. I'm sixty-seven years old. I have three kids who were born and raised here, lots of grandchildren, and two great-grandchildren. Things are going fine for me here. A lot has gone on, but it's calmed down now.

There was that business about the army taking the lives of three innocent boys. That shocked a lot of people here. It really shocked them. But now everything has gone back to normal, thank the Lord. Now everything's fine, but it was really bad. But now we're doing fine.

I really love this place. I was born and raised here, and I don't want to leave. I don't think I'll leave until I die, really. I'm happy. It's good to know how to live. For me, it's good. I've lived in Providência for sixty-seven years. It's a good place to live. Some people know how to live and some don't. I know how to live.

I'm retired and I earn my little minimum wage. I'm happy. I'm a happy woman. I have my children nearby, my grandchildren, and great-grandchildren. My dream is to have my own house. I lived with a longshoreman. I admit that it was both good and not good. I suffered a lot. He left me with nothing when he died.

I was paralytic for two years due to drinking. I drank a lot. Lots of cachaça. I was paralyzed in a wheelchair for two years. But then I got better. Now I can walk and dance and sing. The only thing is I can't open my hand. But I'll open it again one day soon. I started walking again the day they buried my mother. I got up from the wheelchair all by myself at home. It felt like it was God and she was holding my hand.

My greatest dream is to have a house of my own, which I don't have now. I want my own house. Sometimes I even cry about it. I want a house that's my own and more comfortable."

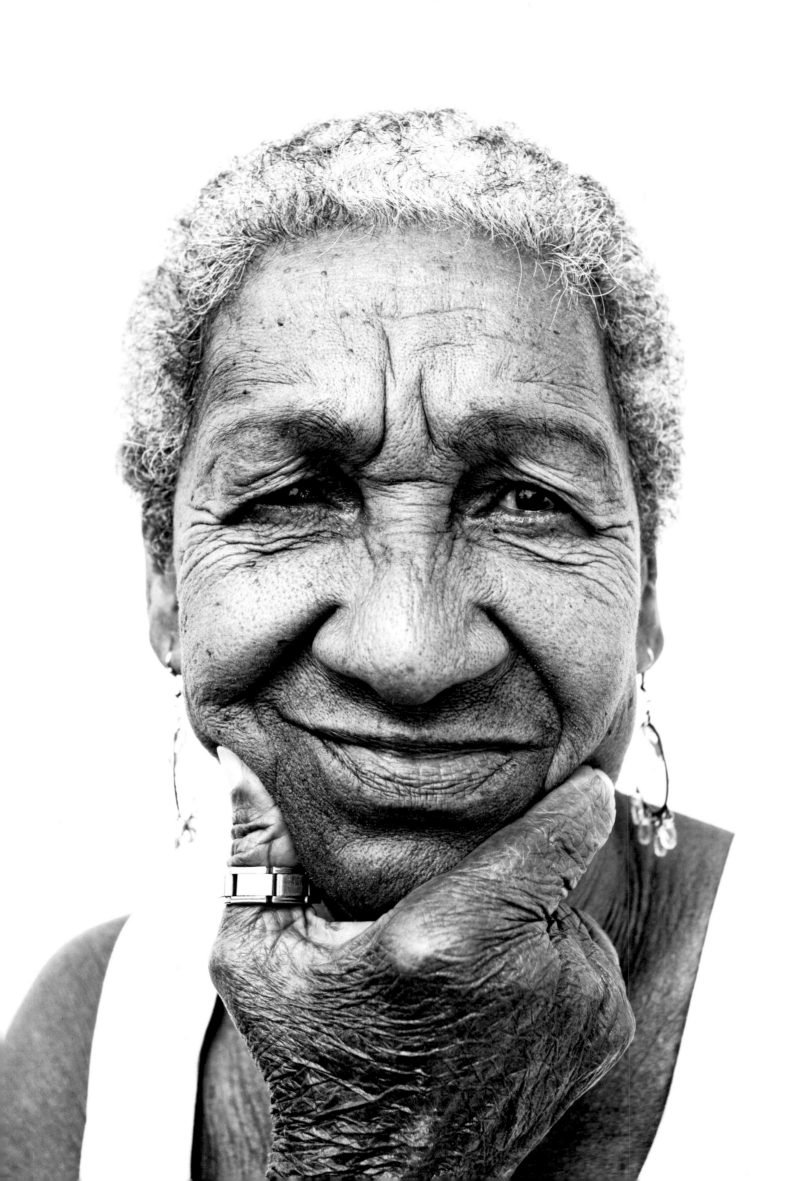

Elaine Vilela Gomez

"My name is Elaine, I'm twenty-four years old, and I've lived here since I was born.

I like living here, but I think it's really violent. We can't come and go the way it says we're supposed to in the constitution. Often after going to work, to school, for a walk, or out doing something, you come back and have to wait in the street because there's shooting and you can't get through.

The police don't know how to act in the favela. They should think of most of the inhabitants as workers rather than dealers, thieves, drug addicts, and thugs. We live in the favela because we have no choice. We live here and we want respect, like people living in other places. There's a lot of prejudice against people living in the favela. Everybody says no, but that's just hypocrisy. When those soldiers betrayed the three boys to a gang from the Mineira favela, for instance. I knew the boys. It happened on a Saturday. The bodies weren't found until Sunday afternoon. I was hoping they'd still be alive, because they weren't thugs. I thought they were going to beat them up down there in Mineira, then let them go. But when they called me and said they were found almost unrecognizable in a trash bin, it made me really sad. The thing that hurts the most is knowing they were tortured. Why? Just because they lived in the favela. There was no specific reason. All that just because of prejudice.

On Monday when I went to work I was still really depressed. I got to work, sat down in my little corner, and stayed there. My colleagues asked me what was wrong, and I told them. The first thing one of them said was: 'It serves them right. I bet they were all thugs and pot smokers. I don't feel anything for them.'

What I'm trying to say is that we're doomed just by the simple fact of living in the favela. How many innocent people die in the shootouts between the police and the thugs? How many workers have already lost their lives? If a woman or child dies, it still has some impact. But if it's a man, they automatically say he was a thug. The family can deny it all they want, but there's nothing to do. No one believes them. 'People in the favelas don't tell the truth. They're all in cahoots with the dealers.' That's what people say.

Our everyday reality is really sad, and only people who live in the favela know what I'm talking about. It's easy to say the police have to catch the thugs. It's another thing getting stuck in the crossfire."

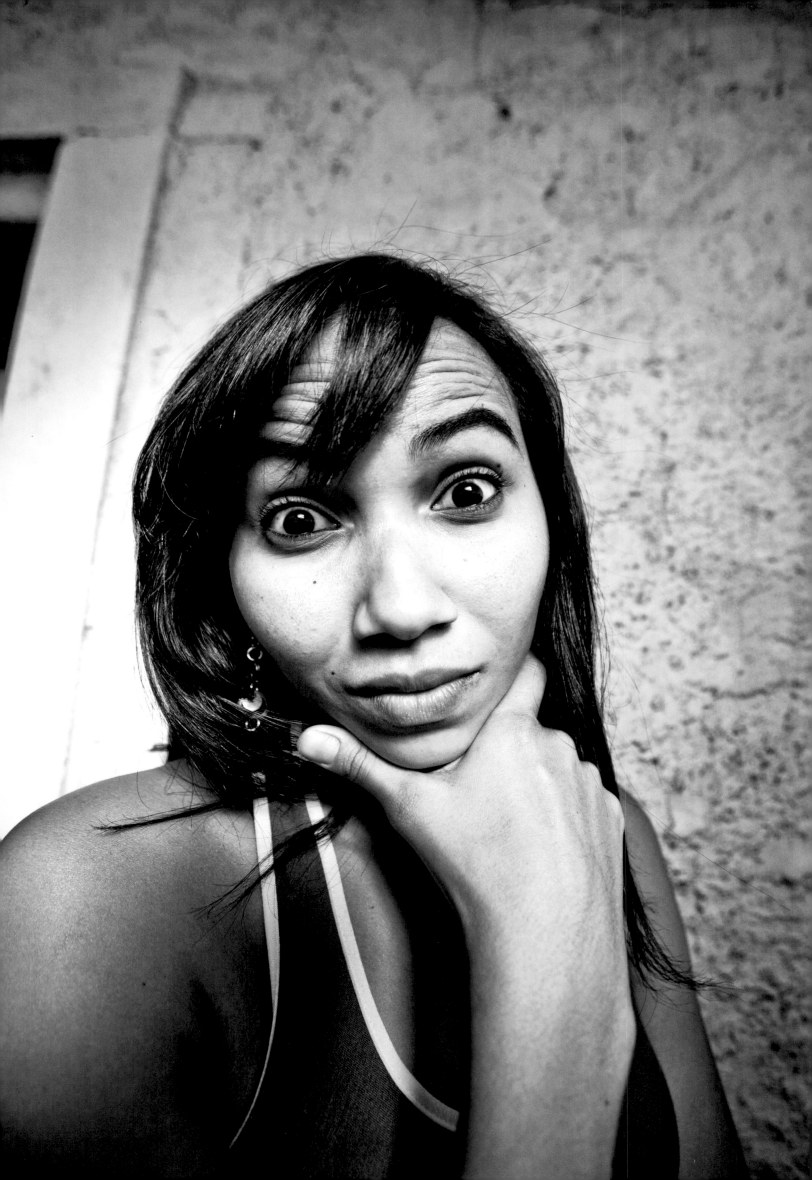

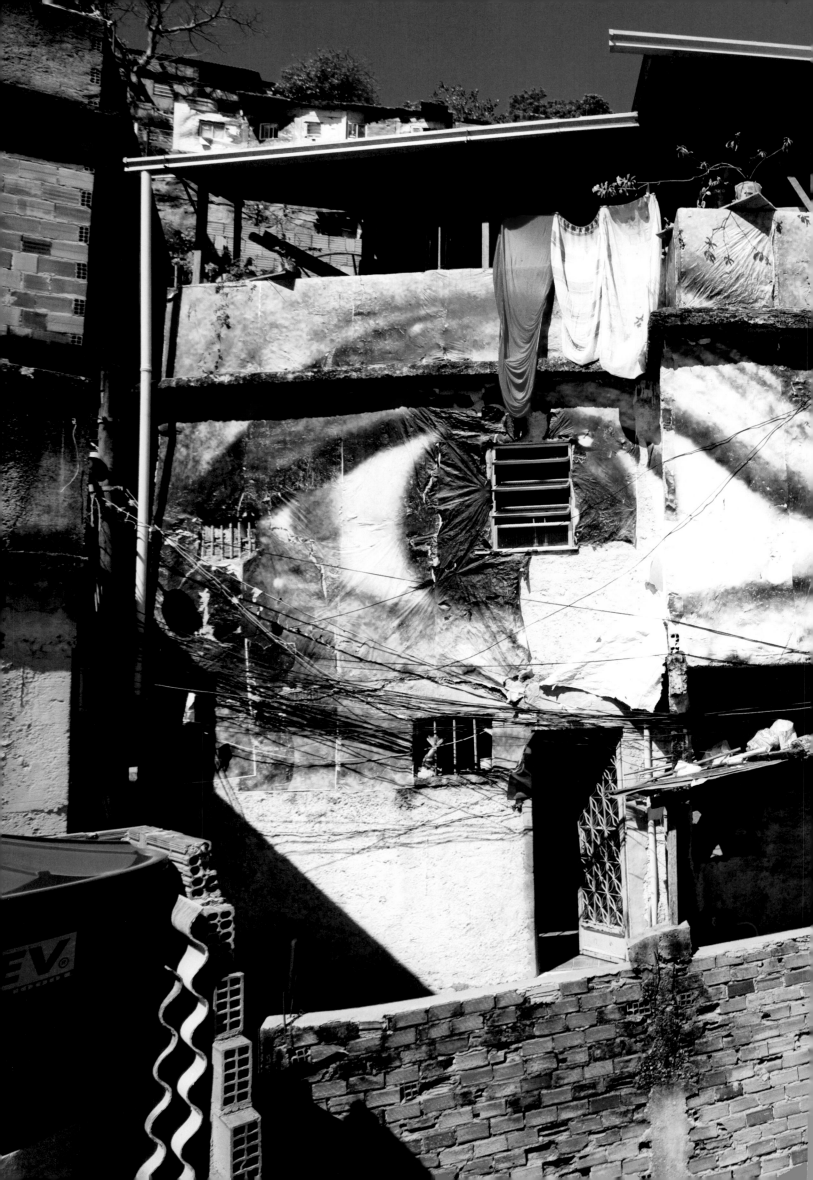

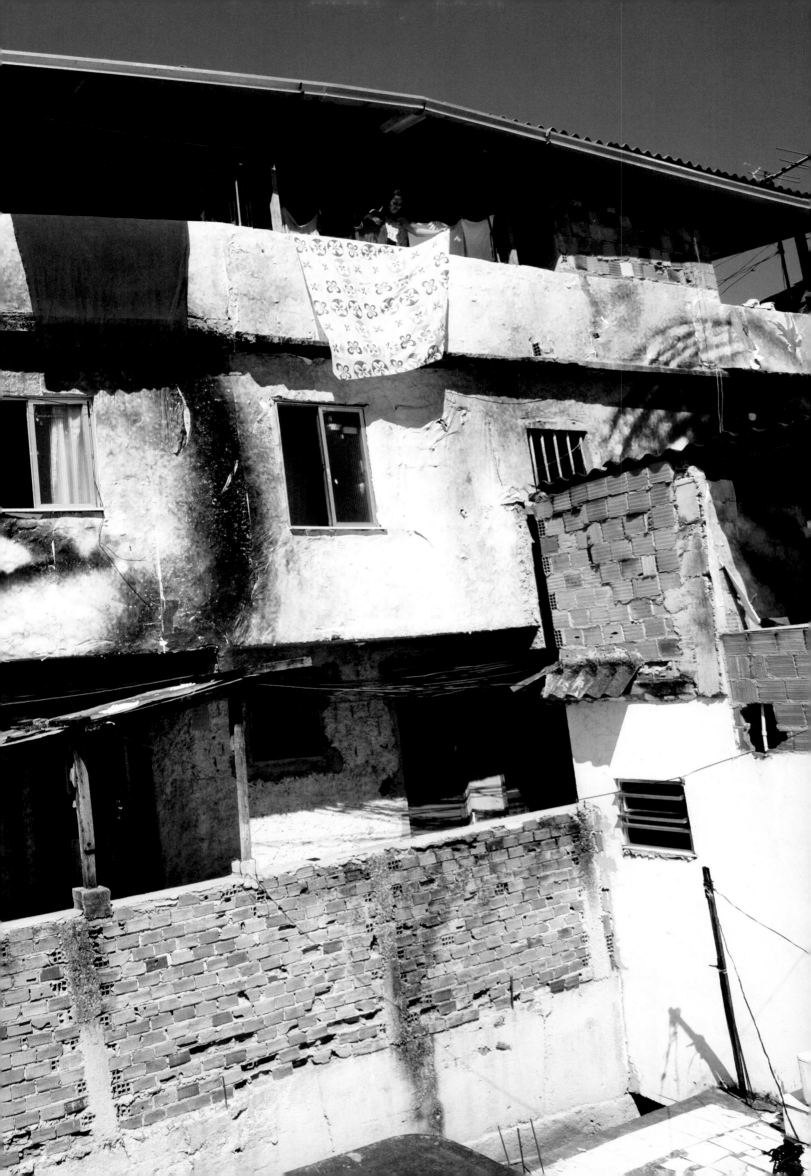

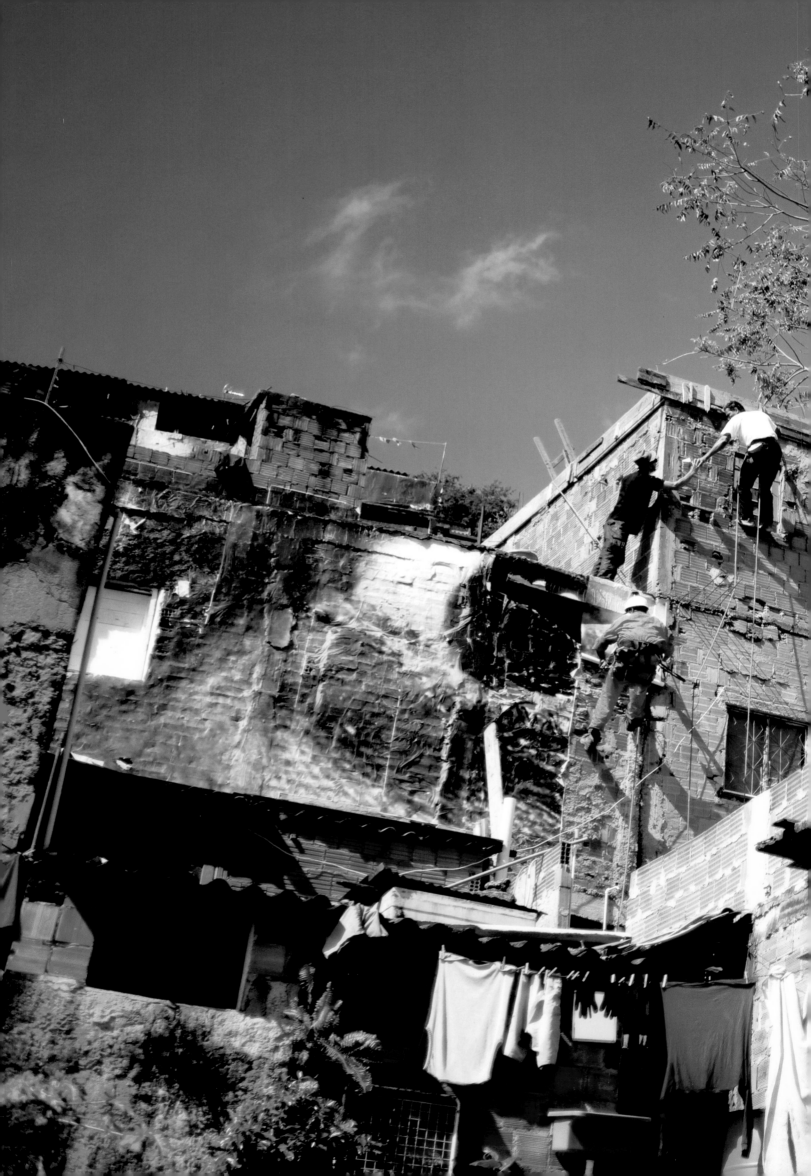

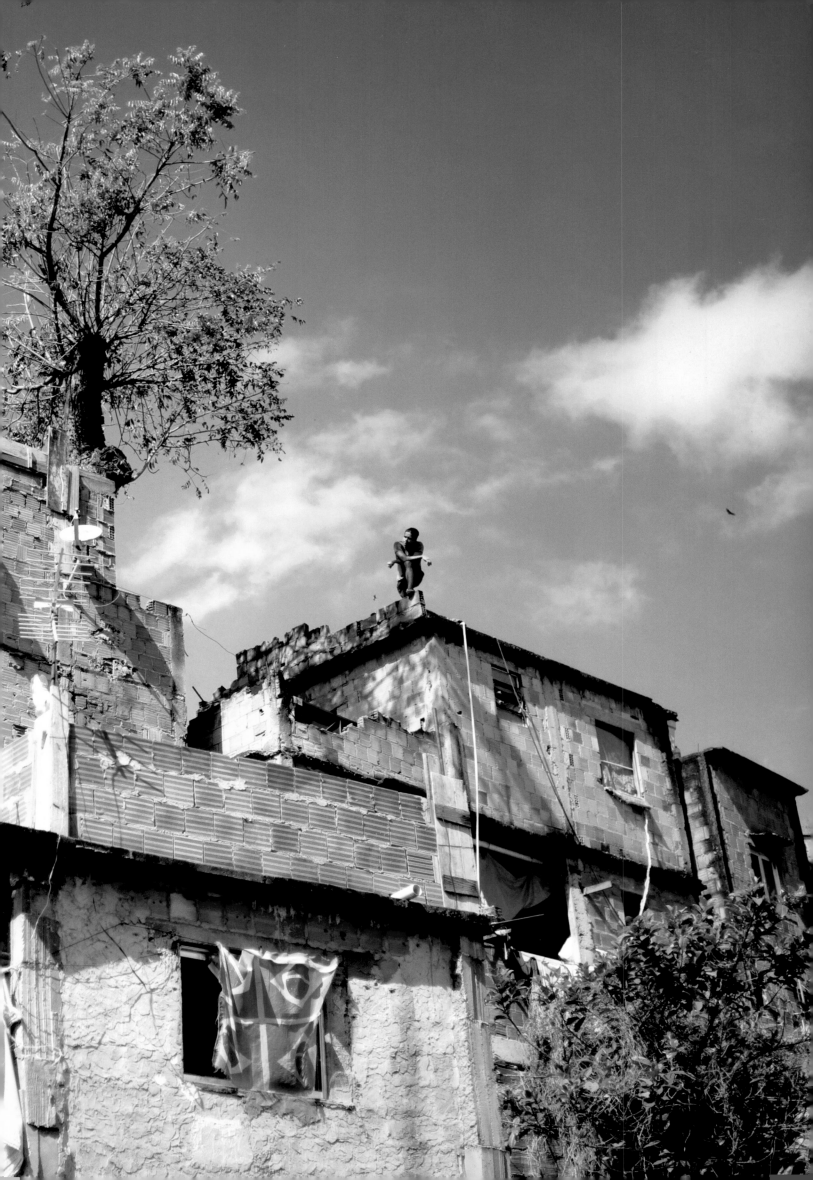

Eliane Martins De Souza

"I was born and brought up in Providência. My parents are from Pernambuco. There are eleven children. My mother arrived here with three small kids, and the rest of us were born here. We are six boys and five girls; I am the third of the girls. All of us are alive, thank God.

I'm married; I have four children and eight grand-children. My husband is a stevedore here on the quay. I had my first child when I was twenty. I had three children with my first husband before I became a widow. Then I got married again and had a baby girl who is fourteen. I've been married now for nearly nineteen years.

I like living here even though there are moments when it's like being on a tightrope. I have been frightened in the past, but not anymore. I used to get frightened by conflicts and shoot-outs.

I lost my oldest son. He worked. One day he was on his way home from his girlfriend's house. He didn't have any papers on him. He said that he wasn't the person that the police were looking for, but he couldn't prove it without his papers. They shot him a few times, took him to the hospital, and he died there. On the fourth of August [2008] it will be nine years since he died.

He was a son, he was a friend, he was a brother. He was really cool. When I separated from his father, he was only eight. So he saw a lot of what went on between me and his father. And he always stayed nearby. He listened, but a lot of the time he didn't do what I said. He was a brilliant son, a good friend.

I think it was through friends that he went astray because he always worked. He worked as an office boy and in a car wash. Because as a mother you want the best for your children, you give them advice at home, but they don't want to listen. And in the street they think they will find something better, and they end up diving in head-first.

Now to be a woman here it's a bit easier. But in my time it was very tough. I began to work early, when I was fourteen. I had to give up school. My father was a worker; my mother had eleven children. So I went to work in a restaurant when I was fourteen. I'm a good cook and understand a lot about food. I started working early so I could buy things for myself and also to help my mother.

Now I live in comfort. I was a real fighter in the past. My life wasn't bad; you can't just roll over and give up. I was a bit depressed when my son died. But I asked God for strength, because I lost one kid, but three stayed behind. And I had to carry on, and I'm still carrying on today, thank God. I don't have many complaints. The only real sadness is that I lost my son.

My big dream is that one day I can have my own house outside the favela. I like it here, but if I could get out I would, because I have a teenage daughter, and these girls are diffi-cult to handle, even with us parents around. And we have to put up with the consequences of what they do. I asked God for strength and lived my life. My children didn't go hungry. I gained people's respect and didn't do anything that could have attracted criticism. The most important thing for a woman is her self-esteem, to be able to hold her head high in public. If I made any mistakes, God forgive me. But there are things that one does for one's children that I wouldn't do again today. Thanks to God I won and I'm still here."

Rosiete Marinho

"I'm proud of how far I've come after all these years here in the favela. This is my home. I love this place with all my heart, and that love is what drives me to do things to make it better here. I come from an era when people here called each other godmother and godfather. And if the godmother or godfather was in need, my grandmother and mother would share with them. Nowadays you don't see that anymore.

I always try to tell stories about who we are and where we come from to the kids who live nearby – to teach them our history. We're part of this country's history, too.

I was a mother for the first time at the age of eighteen. Now I'm the mother of two children and I have two granddaughters. My house is called the 'widows' house' because my mother's a widow, my aunt's a widow, I'm a widow, and my daughter is also a widow. And life goes on. I raised my children all by myself, with my mother's help.

Women are the male role models here. Mothers almost always play the role of father. Since they're widows, they have to take control. Sometimes they can't quite manage it because when kids decide to really get in trouble, there's nothing that can stop them. But they try to do the best they can.

What I'd really like is for these kids to have the same kind of childhood I had, for them to have the same respect I had for the elderly and the wisdom I had not to get into drugs. It's so easy to get into drugs nowadays that kids think it's normal. They have no chance of seeing life from the other side, from the side of society that has rejected them, but where they might find a place for themselves tomorrow. And I'd like them to be able to say: 'I come from the favela, but look where I am now,' and for them to have a real position and establish themselves. They have to have a broader vision. Drugs are so easy that they think it's normal. They have to get a different point of view.

We have doctors, engineers, lawyers, professors in schools and universities, and top nurses here. Most of the inhabitants here are dignified people. And that dignity is what we need for the children today.

We've never had any help from the government, and whenever they get involved it just creates violence. They said the army was going to do the construction work planned by Senator Marcello Crivella, as part of the Social Cement project, to restore the walls in our houses. They said the army was going to do it, but the army didn't do anything other than occupy our community and take away our right to life. They didn't just take it away from us; they also hurt our spirits with the deaths of those kids. The image kids have of soldiers nowadays is deadly. We've suffered a lot. We would never have imagined that soldiers could be in league with dealers from other favelas.

That event brought us a lot of suffering, and lots of weeping. In all my life I'd never seen an entire favela crying on the public square."

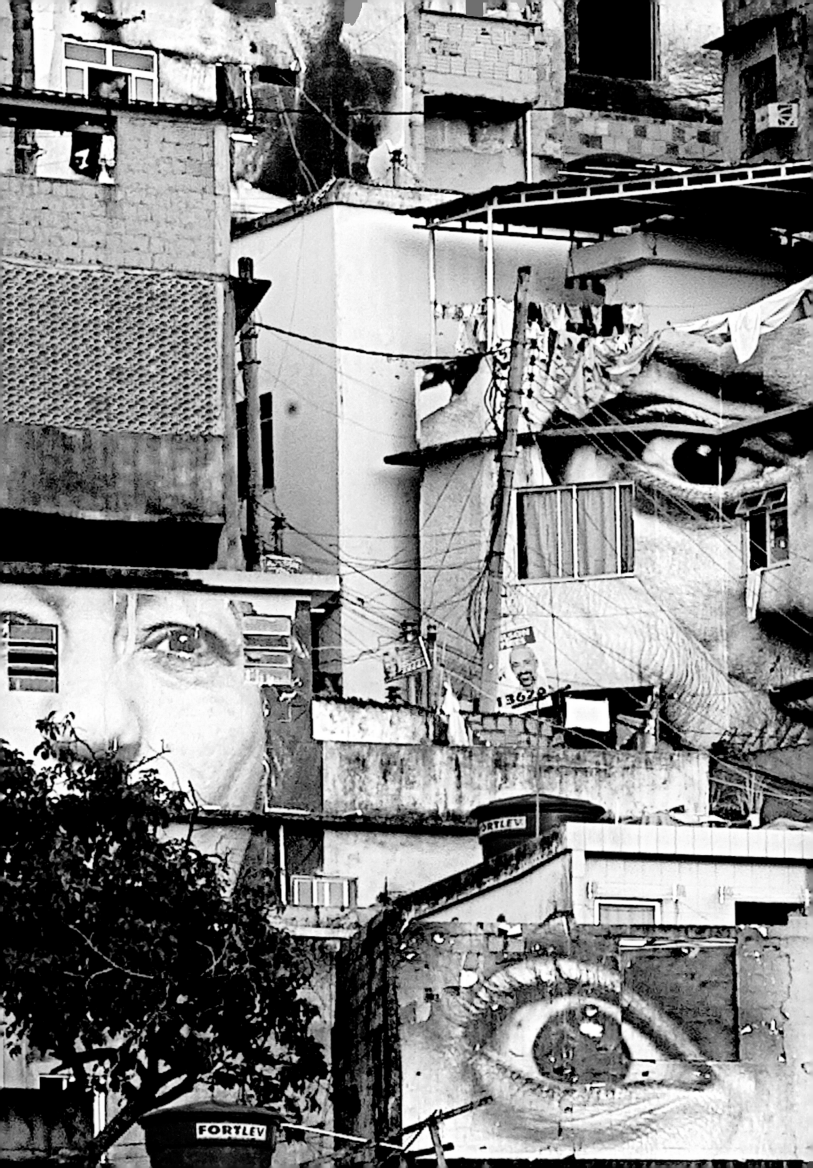

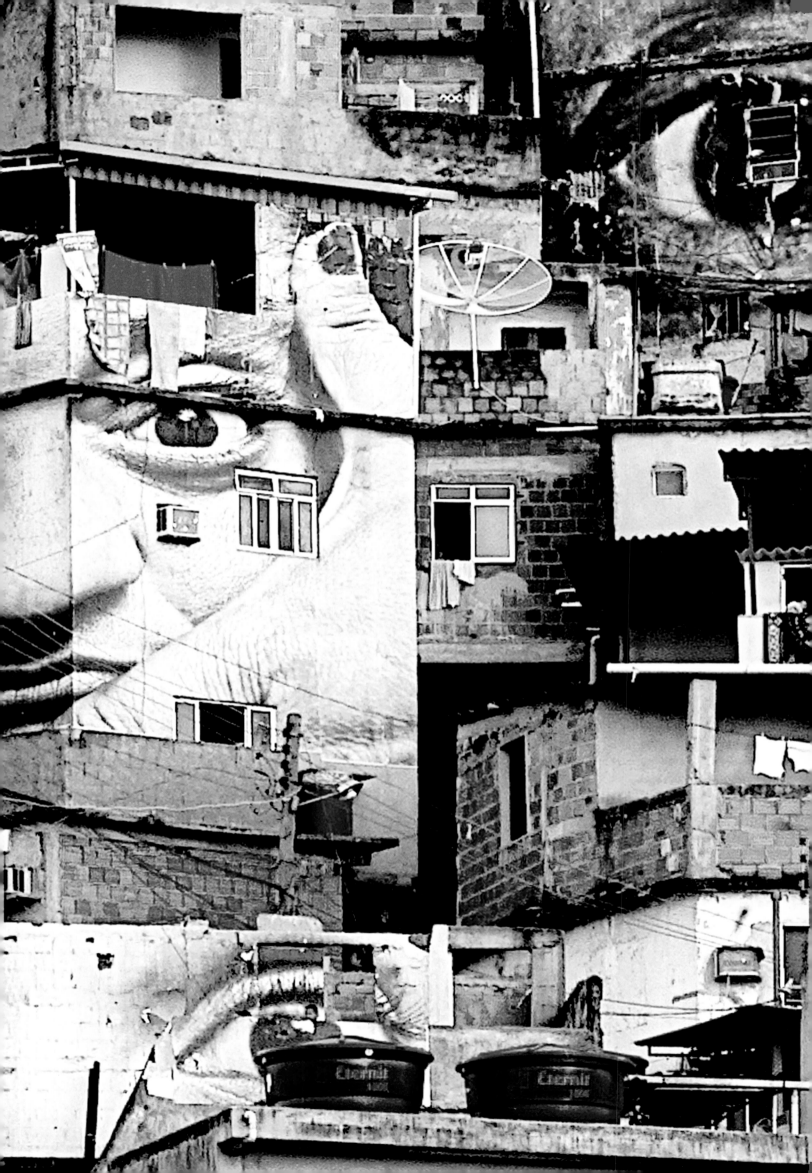

Maria Jose Silva Do Larmo

"I was born in Alagoas and came here at the age of nine. Now I'm . . . about eighty, I think. You see, I only remember the past. Not the present. I forget everything.

When I came here as a little girl, the favela was really poor. There weren't so many people. There were only dirt roads here. It wasn't full of cement like it is now. The other day I went for a stroll and didn't even recognize the place. I went to live down there. My husband died, and so did my brothers. I was all alone, with my dog as my only friend.

So I went to live down there, but it was still in Providência. Because the only way I'll ever leave here is when they carry me out feet first.

People here complain about the shootings, about this and that, but it doesn't bother me. In fact, I don't hear very well anymore, so what's there for me to complain about? Don't people in Copacabana have problems? Don't people in Barra have problems? Is there anyone here who doesn't have problems? I stay at home because I can't see very well anymore, and I can't hear either. So why go outside? I like it here.

I was married for fifty-five years. I never divorced. My husband died of meningitis at the age of sixty-eight. My daughter studied journalism and business management. She works for Globo. My other daughter also has three degrees. I have a really big house with three living rooms, three bedrooms, an office, a kitchen, a balcony full of plants, and there you have it. I have two wonderful grandchildren. I was never dependent on my husband or any other man. There are these rascals who marry you and after that it's 'keep talking' and they're off skirt-chasing again. But even so, I stayed with him until he died.

When I was younger I had lots of dreams. I was three years old when my mother died, and my father had already left her. I grew up in the street. My brothers and I used to panhandle in Maceió.

My message is to have deep faith in God, lots of strength, and not to be scared of anything. Whatever your religion is, the important thing is for your faith to be strong. When God calls me, I'll be ready to go. I've already prepared my things and put money aside for my funeral."

Benedita Florencio Monteiro

"I'm sixty-eight years old. I was born in Fortaleza, and I wasn't even twenty when I arrived here. I got married, then became a widow after my husband died when I was thirty-five. I've been all alone ever since. I had five children, all of them married.

There was that tragedy when my grandson died. They killed him. He was living with me. He was twenty-four years old. The army was on the square when he came back from the funk dance, and they asked him to lift up his shirt. When he refused, they grabbed him and took him away with two others to the Mineira favela, which is controlled by rival dealers.

They did it out of sheer meanness. He used to go by there every day on his way to school, and everyone here knew him. Everyone who was on the square saw it. They betrayed them for sixty reais. Then they killed them down there. They cut them up in pieces and threw them into the trash bin. They vandalized them. They not only cut them up, but they also shot my grandson in the face five times. He was studying. He was about to get his degree.

We want peace and justice here. My dream is to buy a house somewhere else and leave this place."

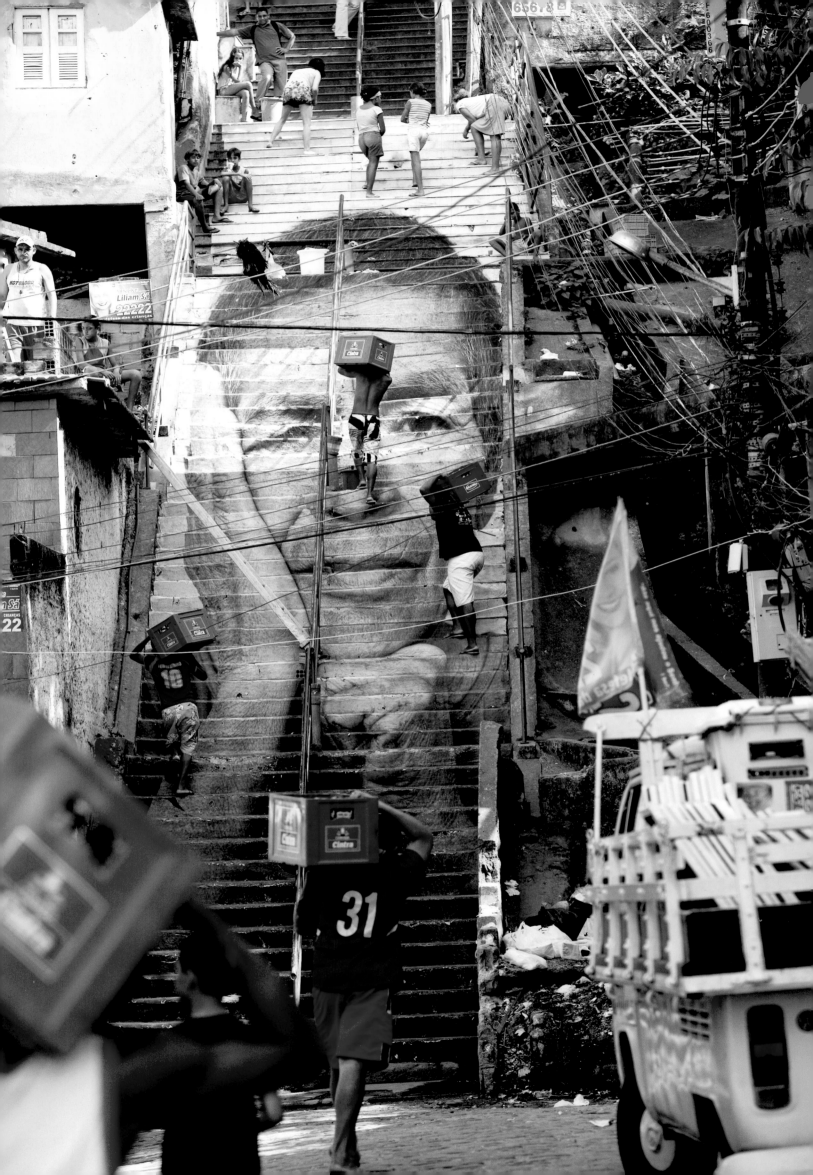

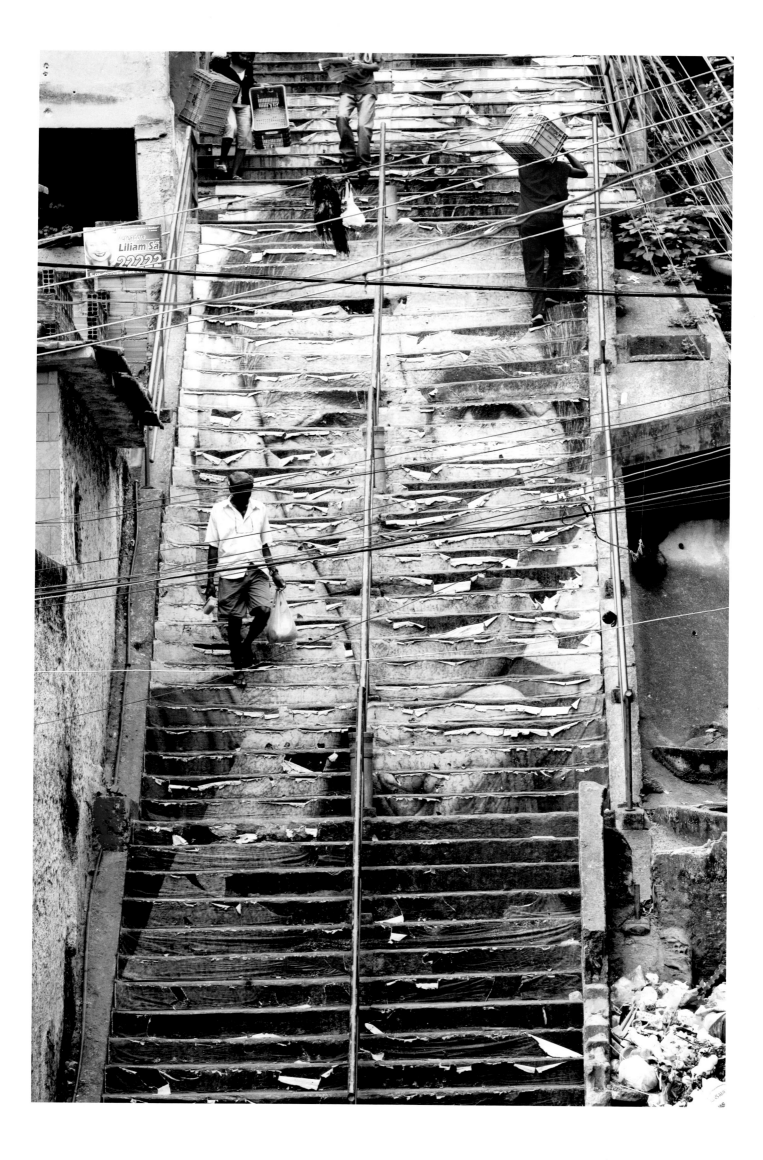

Thaisa Martins Marinho

"I'm fifteen, and I've lived here since I was a little girl. I was born and raised here. A few family members live in Ceara. I never knew my mother. I've always lived with my grandparents. Now they're divorced and I live here with my grandfather.

I love living here. Everybody communicates here. It's a really nice place. It's very cheerful, and I'm always on the go. Things are pretty hectic here, too. I've tried living in places that were calm and peaceful, but I can't do it. I miss all the hustle and bustle. So this is the right place for me.

I have lots of friends, and I'll never forget them. The problem is that sometimes someone dies, then another one dies. A lot of my friends have died already. I miss them and it makes me sad, but then I get over it.

Four friends have already died this year. One in a motorcycle accident on Tiradentes Square, and the others were those three boys. I was friends with all of them, but especially with Wellington, Erica's brother. We used to talk a lot together.

He was an amazingly upbeat guy. He gave me advice whenever I felt sad, and I miss him a lot now. When I'd go somewhere and he'd see that I wasn't talking to anyone, he'd take me aside and say, 'You're not going about this the right way, Thaisa.' Whenever people felt sad, he'd do anything to entertain them and cheer them up.

I pray for him every night. I ask him to protect me and for nothing to harm me, his friends, and especially his family. His mother is still suffering. It was really sad to see her lose a son. Lots of people suffered from the deaths of those three boys, but all three of them know they'll always be in our hearts and in the hearts of everyone here in Providência.

My dream is to be in the Navy. I think it's pretty. I go every September 7 to watch the parade, just to see the Navy marching by. Sometimes when I go to the Navy with my girlfriends, we stop off at the Bank of Brazil Cultural Center to see the submarine and all that stuff. Before, I wanted to be an actress or a singer. But now I'm sure I want to serve in the Navy."

Eugenia Mendes Da Silva

"I'm from Pernambuco. I came here at the age of fourteen, and I've been here for fifty years now. I came as a teenager. My mother died when I was young, so I came with my father.

I started working as a domestic servant until the age of nineteen. Then I met a boy and moved in with him. I didn't even get married, and I left him because he was very violent and liked to beat me up. I had two children from that union, Milton and Marilda. They're both married now.

About five years later I got involved with someone else. I got married and had five children. I've already got grandchildren and was about to have a great-grandson, but my granddaughter got dengue fever and the baby died ten minutes after he was born. A month later I lost an eight-month-old grandson, also to dengue fever.

I've spent nearly all my life here. I only lived away for four years, when I was with that first boy and went to live with him in the suburbs. My marriage lasted thirty-two years. Then my husband died of cancer six years ago.

That's my life. I'm quite well-known here. My husband was born and died here. I'm an Evangelist. Ever since I was a young girl, I've never liked the carnival and all that business. Down in Recife it was frevo country, but I don't even know how to dance it.

To tell the truth, I'm happy. Being a woman here has been a struggle, because I've had to work to raise my five kids. Being a woman means being a woman and a mother, too, because being a mother just to bring a son into the world is senseless. Being a mother means bringing them up for as long as it takes. Up to this point, all of my children have respected me and treated me well. That's really good. I worked hard to raise them and get them to go to school. For fifteen years I worked in another woman's house. I learned how to do nails, too. On Saturdays and Sundays I did manicures at home.

My first relationship only lasted four years because I couldn't stand being humiliated like that anymore. My father didn't even beat me, so how could I take being beaten by my partner? He used to lock the door with a padlock so I couldn't get out or talk to anyone, and I felt like a prisoner because I was so young. There came a time when I thought, 'This can't go on,' and I left him. The worst part is that he wanted me back!

My dream is to see my children well-equipped to face life and have a house, but down there. I've been going up and down here for fifty years. Who doesn't have dreams? If God thinks I deserve it, he'll give me what I want."

Roberta Christina Da Silva Gomez

"I'm not working at the moment, but I used to work as a saleswoman in shopping centers, or in Saara [translator's note: a complex of shopping streets in the center of Rio]. I was married for four years and have been divorced for two years. I was happy sometimes. Now I'm enjoying being single, because I got married too young and missed out on part of my youth. I started going out with my husband at the age of fourteen, moved in with him at seventeen, and got pregnant with my daughter.

Now I'm ready to start dating men again and traveling. That's all fine. But nothing serious. You can't go back after you've had a taste of freedom. Nobody can capture you or make you their prisoner anymore. It's way too early to get remarried. That can wait.

It wasn't that hard raising my daughter, because where we live you can see how everybody lives their life on a daily basis. That's how you learn to look after kids and soon start to get a hold on the situation.

My pregnancy came without my wanting it. There were those who wanted me to have an abortion but I said: 'No. He's here now, so let him stay.' Most people, my family, and girlfriends said I was too young and it was too soon. But I didn't pay any attention to them and went my own way.

I was born and raised here. I like this place because it's close to everything and it's really convenient for everything – the housing, the place, the location. If I could afford it, I'd live somewhere else – in Gloria. I really love it there. It's near the beach, and it has a different atmosphere and different kinds of friendships. I have friends who live there. I have friends here, too – but not that many. Some people think I'm meddling where I have no business. But that's not true; I'm meddling where I do have business. I have nothing against this place. I'm quite fond of it.

The dream I had as a little girl was to be a model, but I'm over that. Other dreams? I have so many. Dreams are the only thing we have that no one can take away. You can dream as much as you like. My dream is to start a new life, to live a life of luxury and go on vacation wherever I choose. I'd love to have that kind of freedom.

I'd like to have another child but only when I have a more stable life, a nice job, a nice house – in other words, better living conditions for my daughter and the new baby to come. Something a lot better.

I like going out in the evening. I love to dance. I like pagoda and funk. I've got lots of energy, and my girlfriends say I'm wired 24/7. I'm very lively, and it's easy for me to meet people. I still go out even if I'm alone. I can't stay at home for a whole weekend without going out.

I like to enjoy life. I say to women who want to get married young: 'Don't get married and have kids too early on.' Enjoy life as much as possible, because you're here today but who knows if you'll still be alive tomorrow. Who knows what tomorrow may bring, so you might as well enjoy life and live every day like it was your last.

That's the way I am, and my mother always says: 'You're crazy.' So I say: 'OK, then let me be crazy.'"

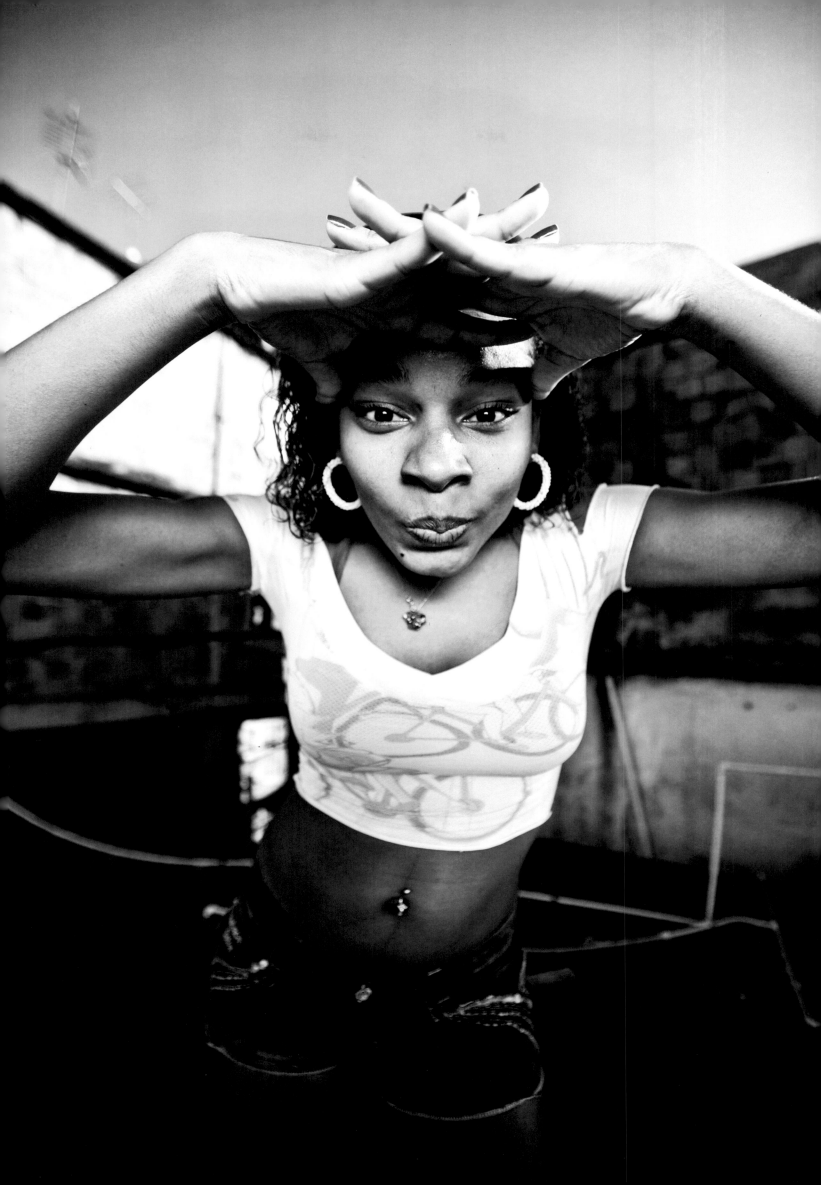

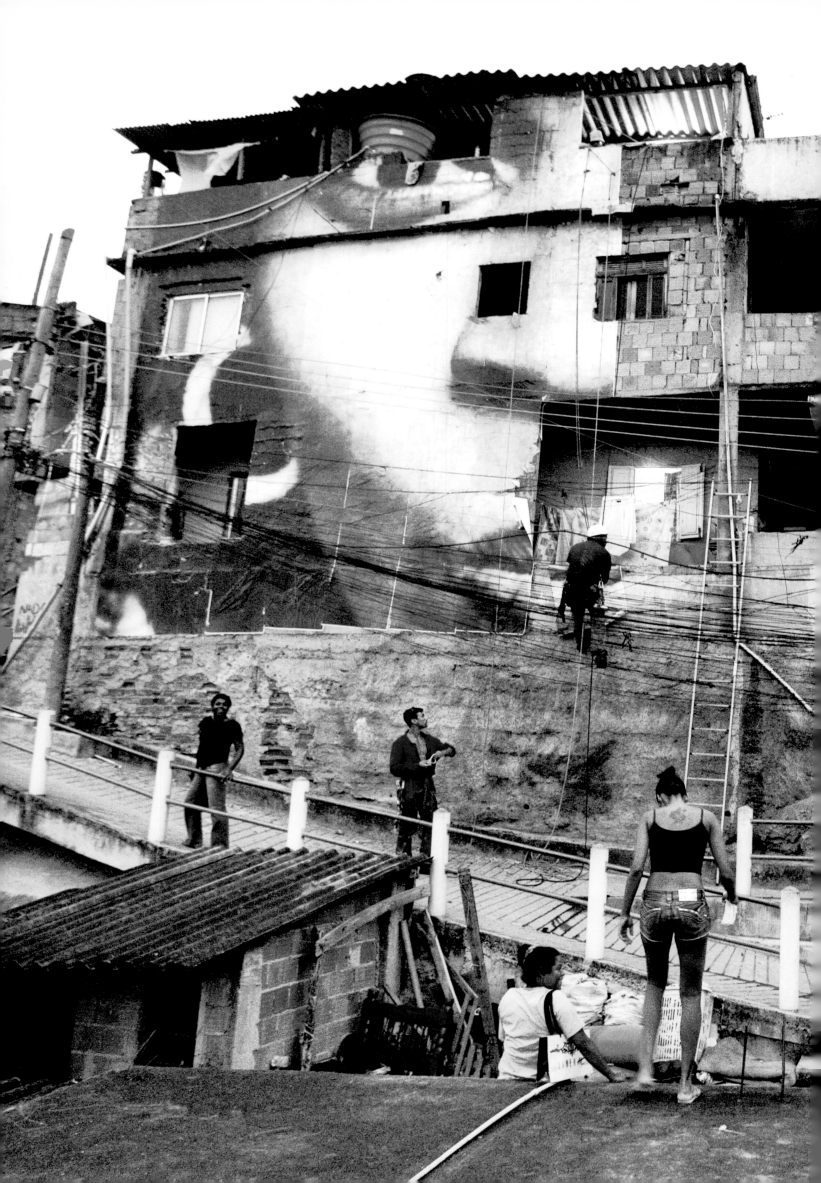

Julia Monteira

"I'm sixty-nine years old. I was born and raised here. I've always lived here, but now I'd like to leave. I have a house in Niterói, which is closed, and I can't abandon it. Otherwise people without any land will occupy it! But for now I'm living up there and nobody's giving me a hard time.

I've been here for many years. My family doesn't live here; I'm the only one here. They started a new life. My niece got married and had kids, and they're all working. My husband died in Niterói seven years ago. He was a steelworker. I worked for a cleaning company, in a restaurant. My husband was from here, too. He was very good to me. He left me a house and a pension.

I had only one daughter, but she died. If she were alive, she'd be forty-three today, but she died when she was little.

She was born sick and only lived for a little over a month. I was one of twelve brothers and sisters, and I looked after the others. My mother was a maid. I was the one who took care of the children because she worked outside the home. My dream is simple. I really want to travel and have fun. The only place I've been to so far is São Paulo, because I worship Our Lady of Aparecida.

I fell and broke my leg in three places. I stayed in the hospital for two months, and the doctor told me I'd never walk again. But I do walk. I do my errands; I go to the market and everything. The doctor said I'd never walk again, but I do. I made a promise about it to the Saint."

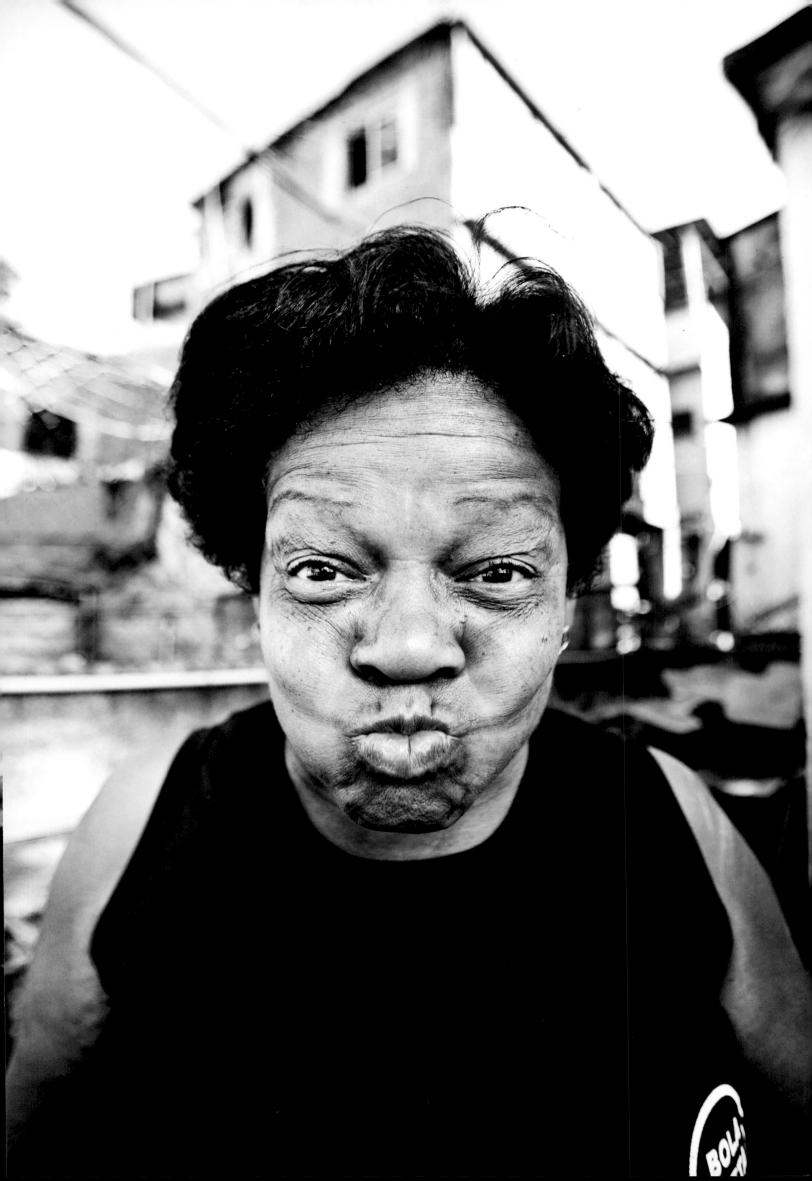

Lucia Elena Dos Santos

"My story? I'm originally from the area of Espiritu Santo and came to Rio at the age of nine with my father. First I went to São João de Meriti, then I came here at the age of fifteen. When I got here I thought it was a normal place. Then I got married and had children, and I'm still married. I'm a cook and I also clean houses.

I learned to cook by watching other people when I started working for a family at a very young age. I was always watching, and that's how I learned. I know how to make several different dishes, pies, tarts, and savory things . . . that will make your mouth water.

My dream? For my son to be happy, and study, and become someone. He's thirteen. That's my dream – for him to become a doctor. I had to give up my studies at a very young age to work. I starting worked as a servant for a family at the age of twelve. It was a family that lived on Governador Island. I worked there during the day and studied at night. I studied up to sixth grade, then I stopped.

I haven't traveled back to the Espiritu Santo region. It's nice here, because it's calm. I'm used to it here."

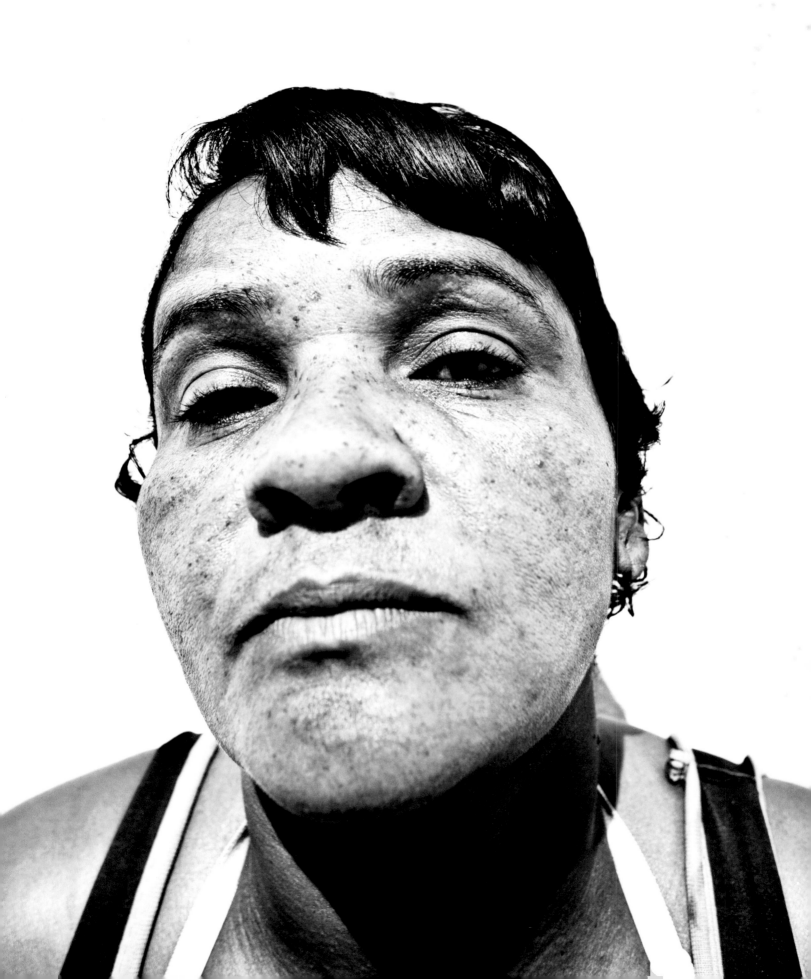

Darci Tavares Lins

"I was born in Pernambuco. I came here with my mother and my family at the age of seven. I've always lived here, and I like it. I had nine kids; seven of them died, and there are only two left, a boy and a girl. I worked away from home and paid someone to look after them, but since no one really looked after them properly, they died.

I started working at the age of fifteen, in a cookie factory near here. I got married and divorced. My husband is already dead. He didn't leave us anything. He left me, and I had to work to raise my kids.

I had the first one at home, with a midwife my mother paid for. I almost died because the baby was very big and wouldn't come out. That son is no longer living. He was killed in Belford Roxo because of a woman. He'd found a woman who was married, and the husband killed my son. He was young, only twenty. The others died of illnesses. Now I have nine grandchildren.

The things I like best here in Providência are the sea and the boats.

I don't have any other dreams to fulfill."

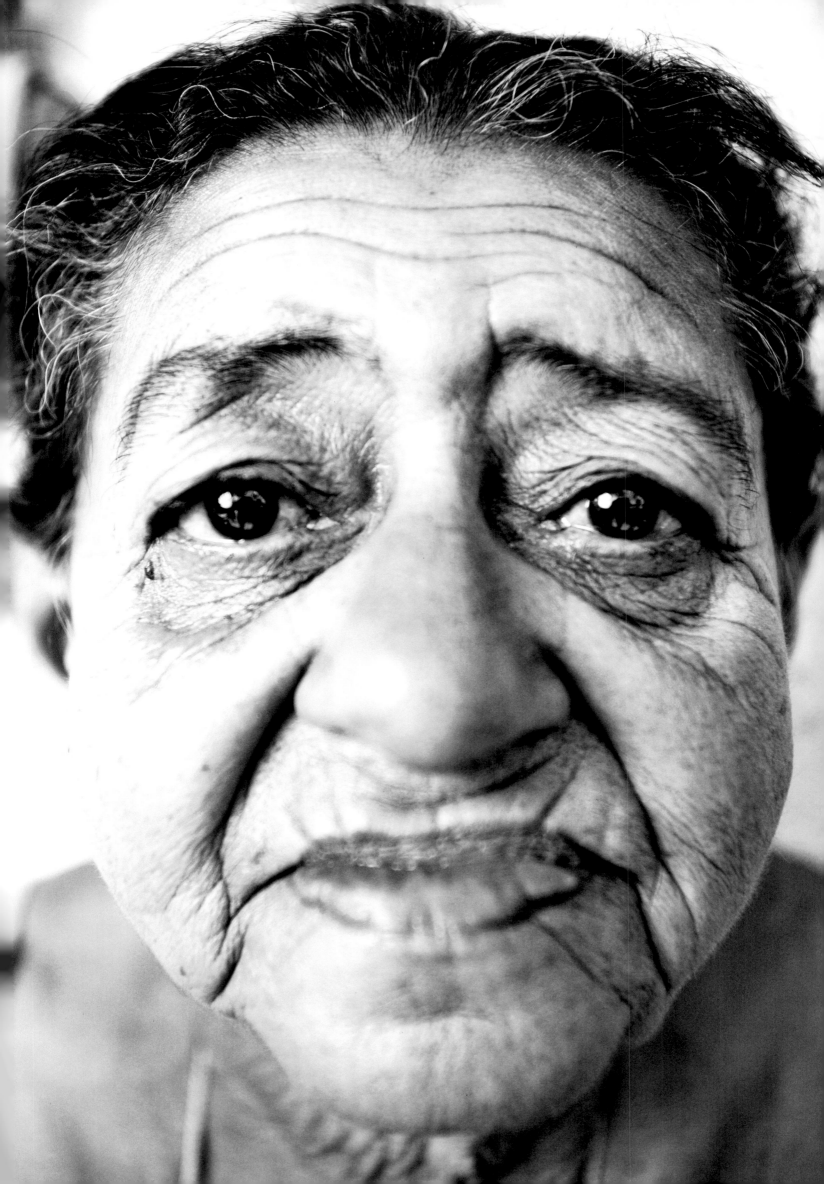

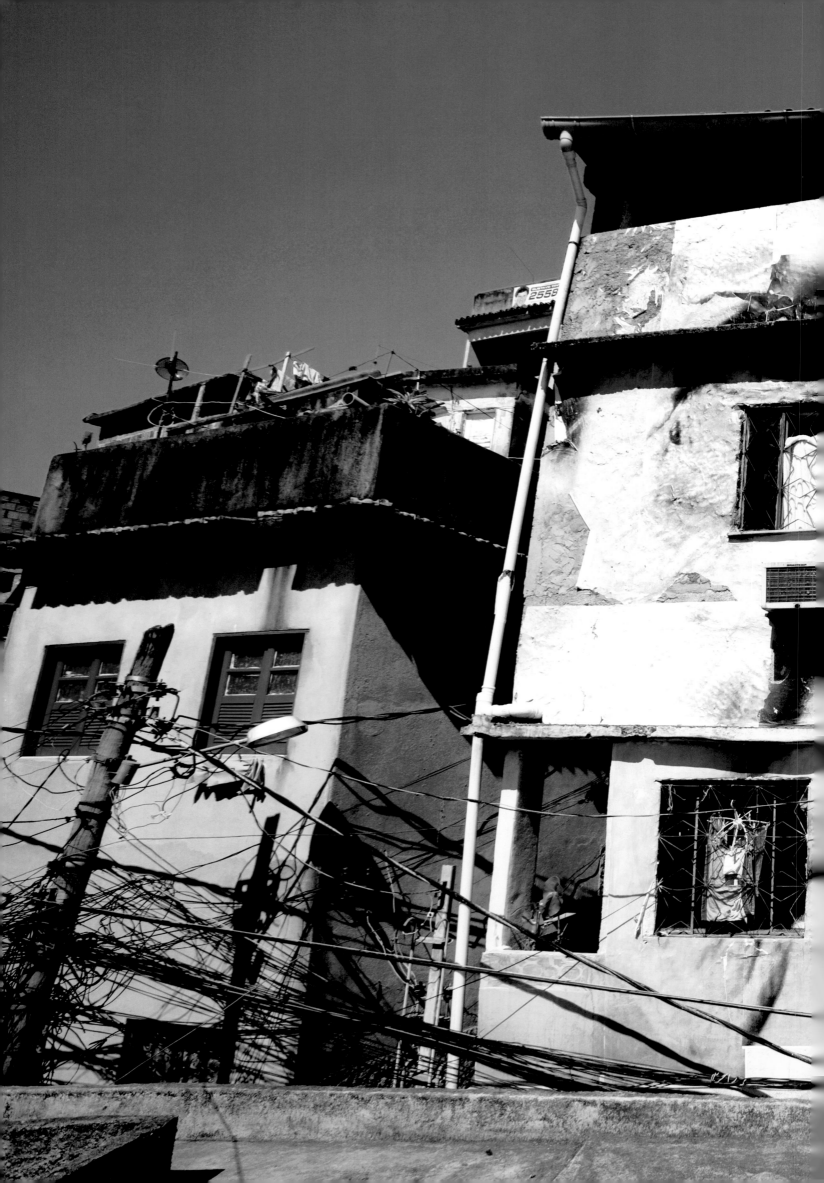

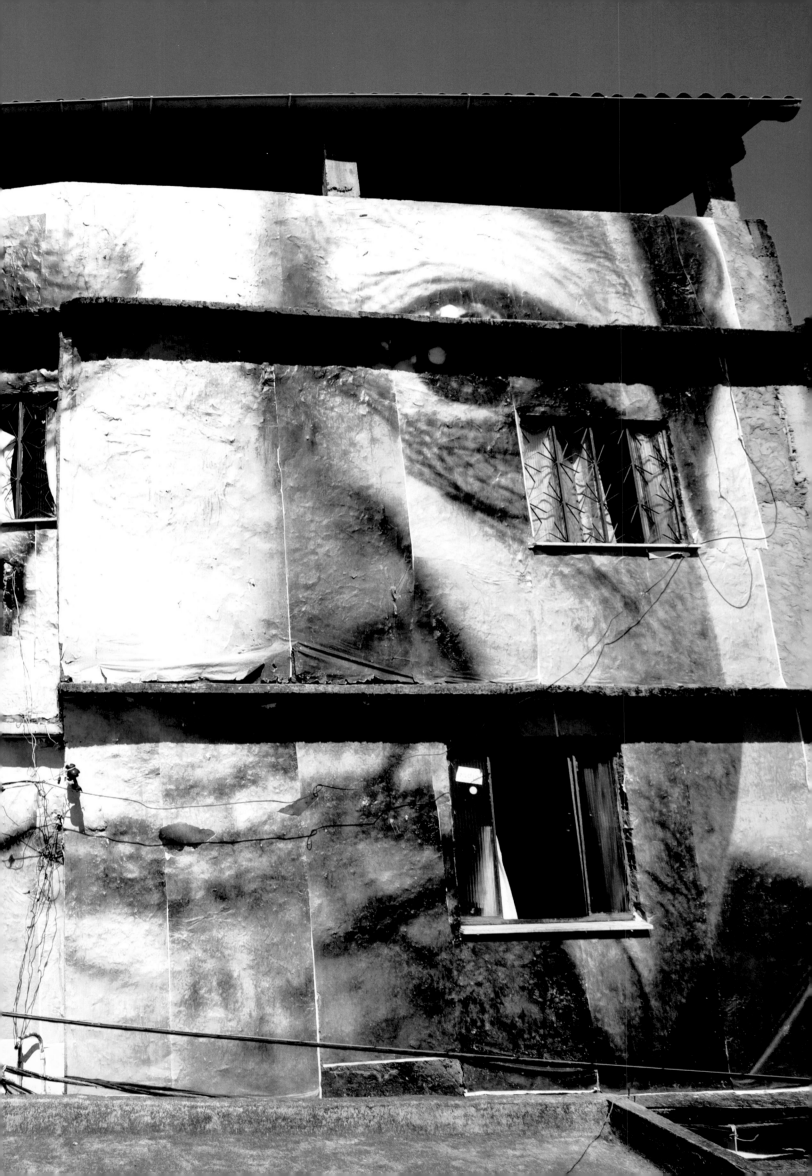

Helena Ribeiro Ferreira

"I was born here. My mother is from Minas Gerais and my father from Bahia. They met here.

I have a twenty-two-year-old son, Wellington. I'm a seamstress, but for the moment I'm doing other things. Sewing clothes is my favorite thing to do – men's clothes, that is. I taught myself to sew by working for companies. I have a sewing machine at home. My dream is to have another profession. I'd like to be a cardiologist. Unfortunately, it wasn't possible. I think it's a fine, really nice profession.

I love living in Providência. I've been here for many years, and everybody knows me. And I know everyone, too. I'm attached to this place and I like living here. I'll never leave. That's the way it is. For people who live on the hillside or in the community, it's strange. People who aren't from here would probably never come to live here because they think it's weird. But for anyone who was born here, there's no way around it. You have to love it. I think everybody here loves it. It's the same for me as for people from other communities. I was born here, and it's the best place around. End of discussion.

I'm one of the old ones in the favela. I carried lots of water on my head. We didn't have easy access to water and electricity like now. I used to walk up from way down there and go by this square carrying a full tub of water on my head. Living conditions were really bad, by which I mean there were no living conditions. Everything was different.

Now it's easier, so my son is going to university. That's quite a difference from me. I'm trying to give my son what I could never have. He wants to do so many different things that I don't think he'll have time to do it all. I raised him all on my own. His father left when he was about seven years old. So I had to work all the time to bring him up.

We were lucky, really lucky here. I hope my son will always respect me the way he has up to now. That's been very important for me. You just need to trust and everything will work out in the end. You can't give up."

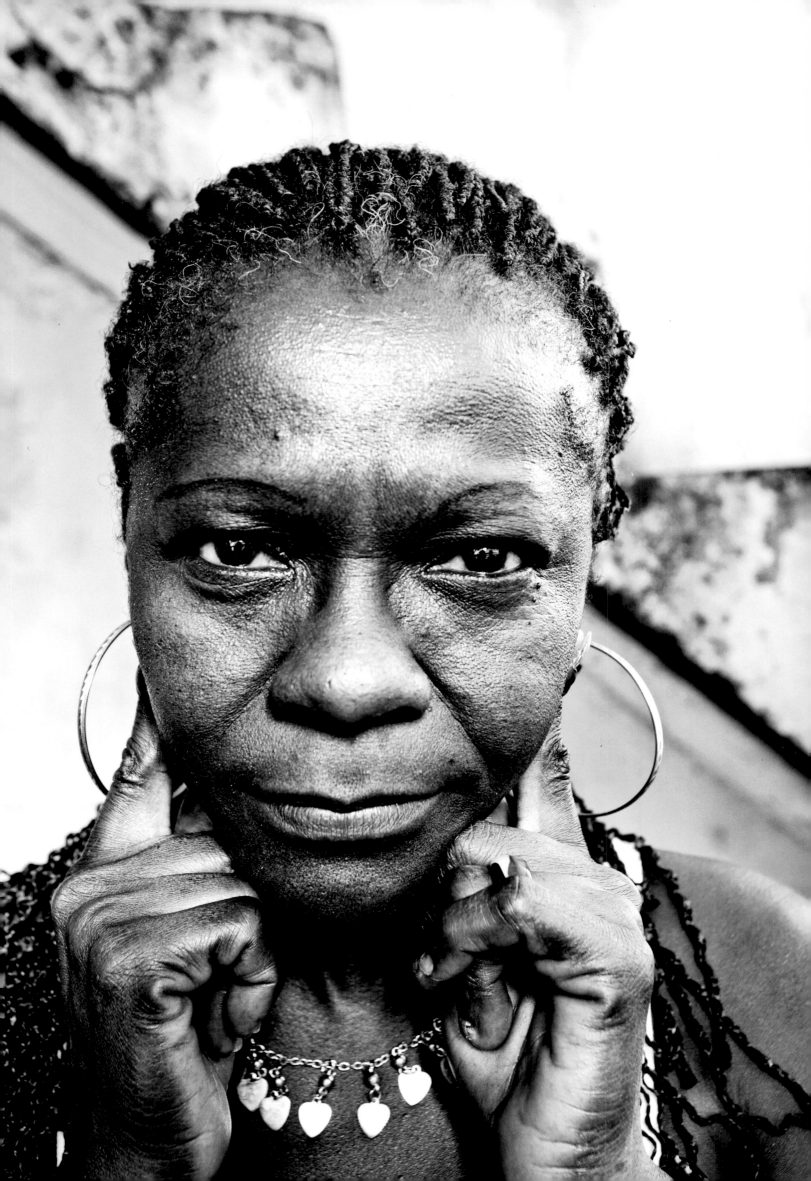

Salete De Franca De Lima

"I'm sixty-nine years old. I was born in Manaus and came here when I was a year old. I've lived here my whole life. I have eight children, seven grandchildren, and five great-grandchildren. I've got a big family. I wouldn't change this place for anywhere, because I like it here. I grew up here and raised my children, grandchildren, and great-grandchildren here.

The nice thing here is that it's peaceful. You don't get mugged, there's no fighting, and no one comes to bother us. Living here is pleasant. You can go out in the evening and come back without anything happening. The place that scares me is the town center.

When I was a little girl, it was horrible here, because there was no electricity or water. I used to get up at four in the morning to fetch the water. It was from four to six. There was only water between four and six. So I had to be there at the tap at four o'clock, either in Central, or down on America Street. I'd fill five barrels of water and four buckets. You don't know what a bucket is? It's a big wooden tub they washed the laundry in. So to do the laundry I had to get all the water for the whole day, and the next day I had to go back at four o'clock and start all over again.

It was hard, but it was nice, too. It's not like that nowadays. Now there's water, electricity, sewers. Before, there was nothing like that. Houses weren't made of brick; they were made of wood and had tin roofs. When it rained or was windy, it made a lot of noise and everything would start swaying, so we'd cover our ears because we were scared. It was fun. I like that childhood memory. There were wood stoves instead of gas ones. I miss the parties we had back then. There were street carnivals, samba schools. Now that's all gone. People changed; the old people died or went away, things went downhill, and then it was over. I used to take part in the celebrations and my mother would wallop me, so I'd sneak out, and she'd hit me again, but I always came back the next day. I got walloped over the three days of the carnival. But the more she smacked me, the more I wanted to go.

I wish that I, my family, and the entire community could live in peace and be united – that we could be a free community. That no one would be afraid, like when I was a child, when it was peaceful. I wish that we could go back to that time and that we could come and go as we please, like we used to. Now people go out to work and you never know if they'll come back. You have to think about everything.

I'm about to celebrate my fiftieth wedding anniversary. My youngest daughter is forty-one years old. I like to say that I'm the only baby now. My husband was a civil servant. Now he's retired, but he stills works here and there. He's eighty-three years old, but he doesn't like to sit around doing nothing.

When I got married, a married woman couldn't work. You had to stay at home. So I made a deal with him that I would never work during my life, but he had to pay me a salary every month. He agreed and still pays me every month. A deal's a deal."

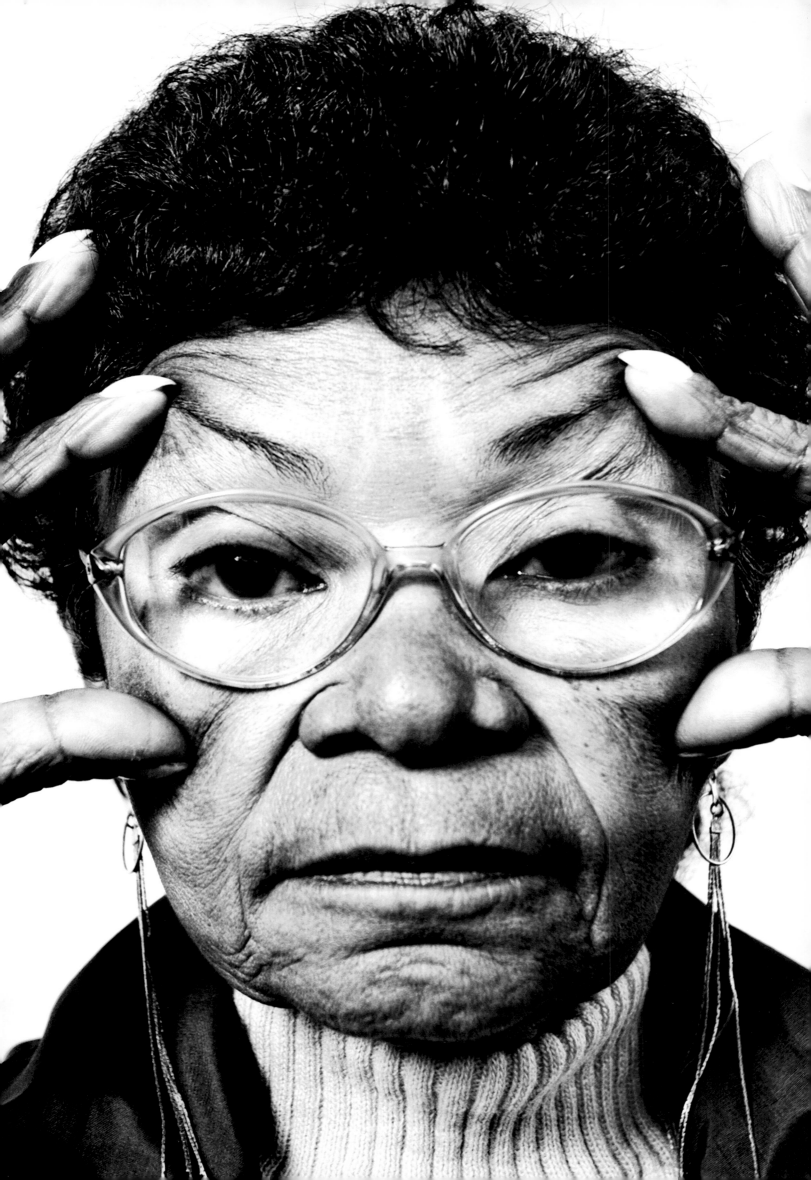

Erica Gonzaga De Souza

"I'm twenty-six. I was born and raised here. I like living here because it's a nice community. It's a good place to live. I had two brothers, but one of them just died with those two other boys.

How did it happen? The army was here to supervise the construction work, and they grabbed him and took him away. The three of them were coming back from a funk dance at dawn, in full view of all the local inhabitants. They searched them and started beating them up. Lots of people saw it. There were several witnesses. They said it was a refusal to cooperate.

My brother was nineteen. Wellington Gonzaga da Silva. He was working. He had quit his job at the pizzeria and was going to work on the construction site. People with kids should watch out, because what happened in our community could happen in other communities and other places, if it hasn't already. I'm talking about making innocent people pay for something they didn't do. Because that's what they're doing nowadays – taking away the lives of innocent people.

Even the government came to apologize. It was pointless, though, because it wasn't going to bring those boys back to life. We just want justice now. Because the same thing that happened to the innocent people here could happen to the sons of one of those people in the government – the governor, the vice governor, or the mayor – because all the young people go to the funk dances, not just the poor ones. The ones who took the boys away all have kids, too. When they look their own kids in the eye, they'll remember those boys, because they were all innocent."

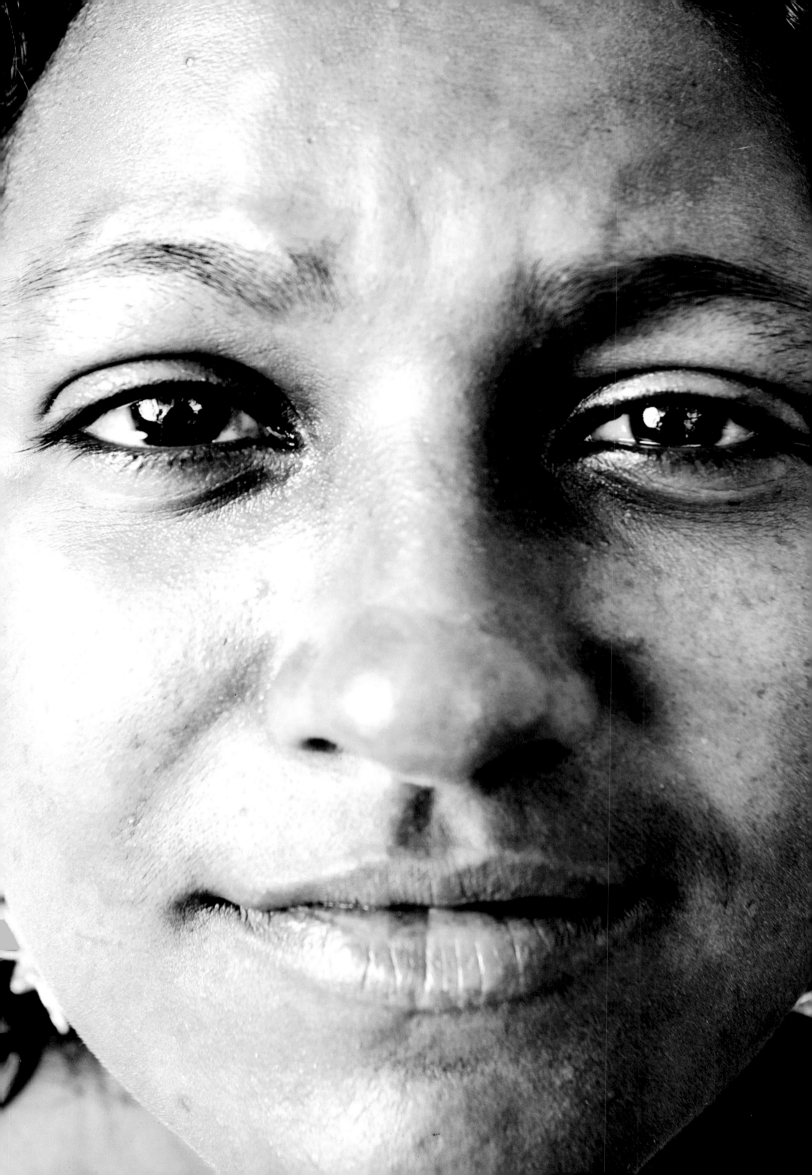

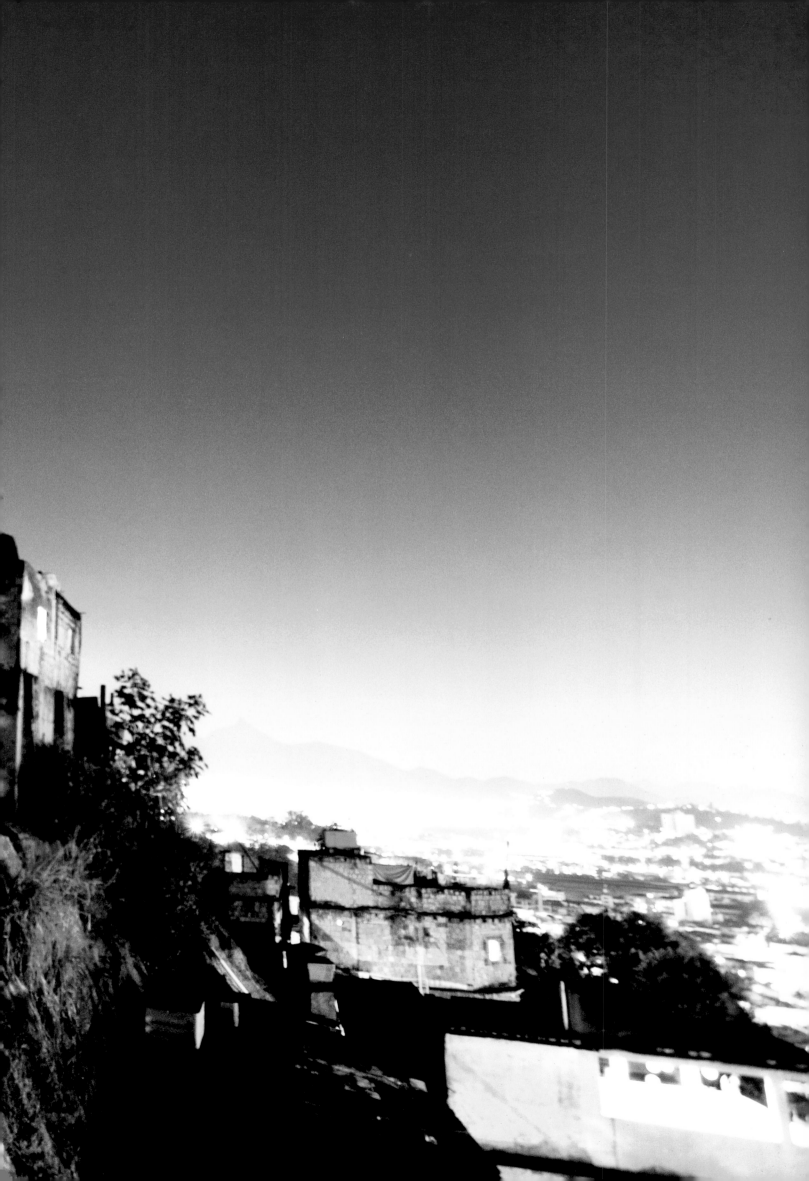

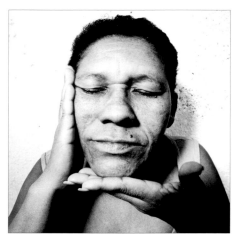
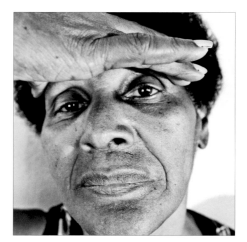
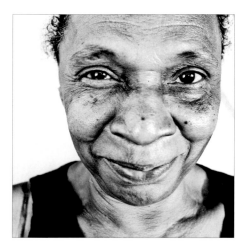
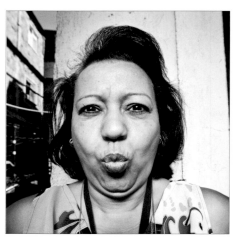
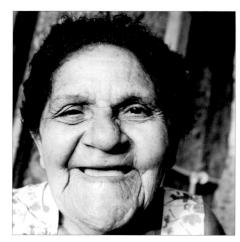
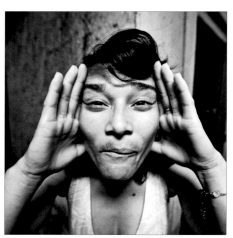
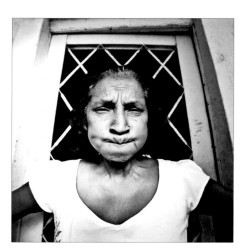
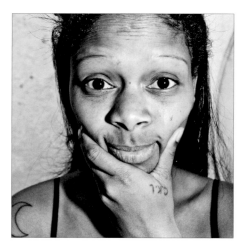
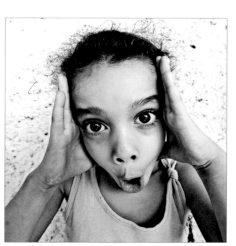

Maria De Fatima	Leda Da Silva	Eunice Santos De Oliveira
Mara Lucia Da Silva	Rita	Rogeria Vilela De Melo
Neuza da Cruz Oliveira	Ivana Soares	Georgia Clara Marinho

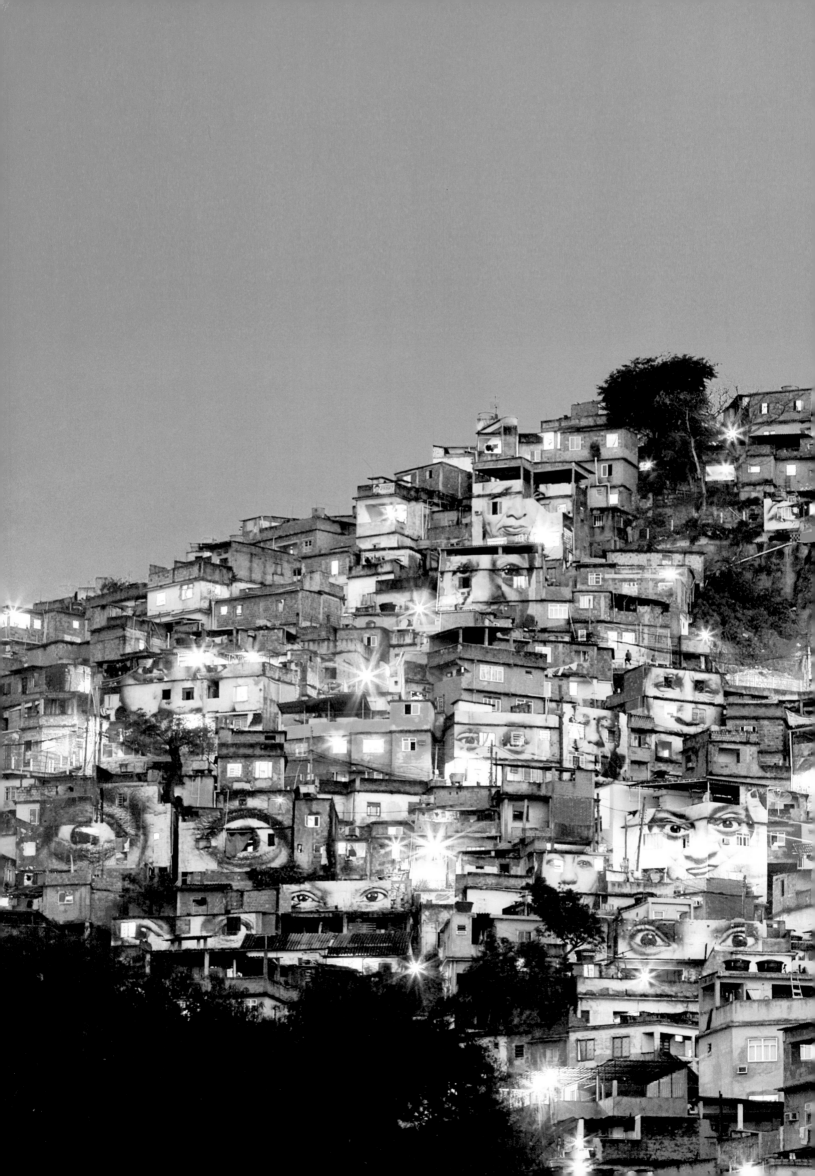

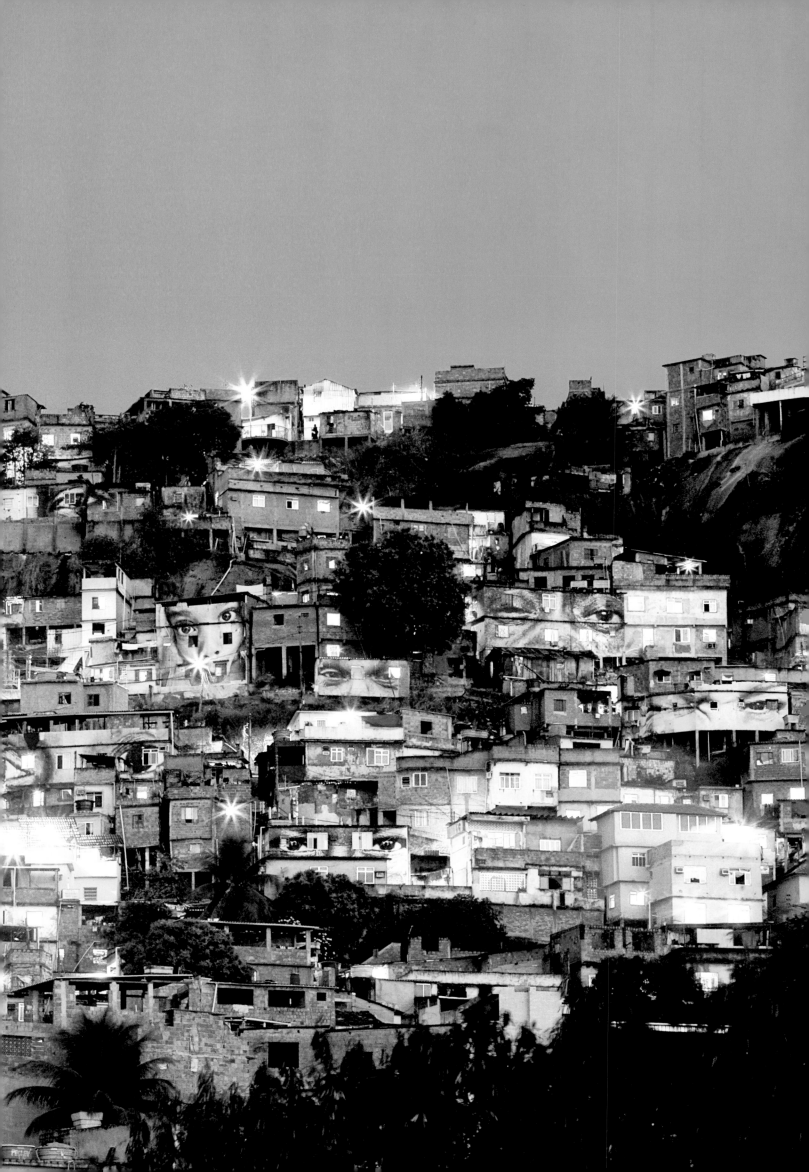

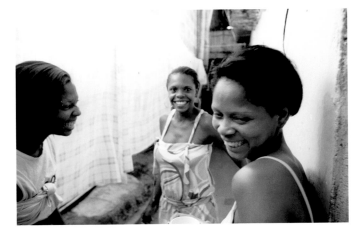

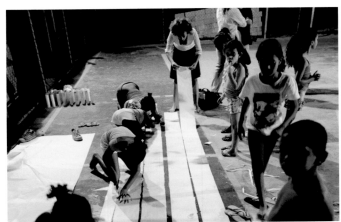

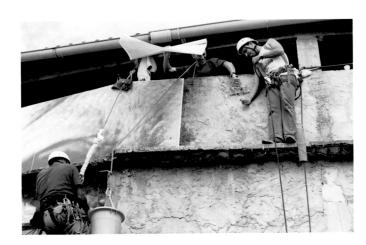

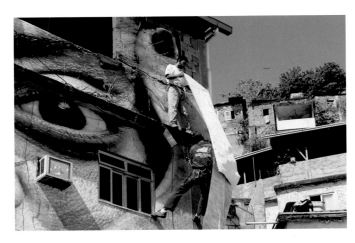

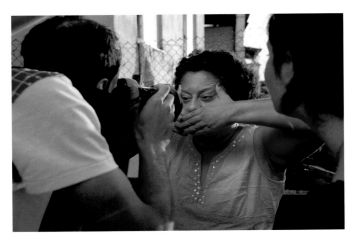

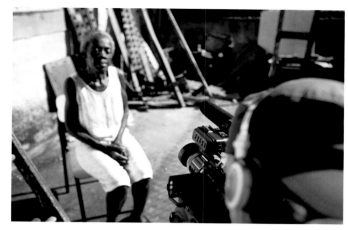

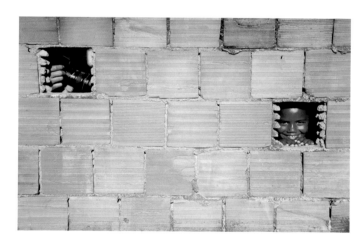

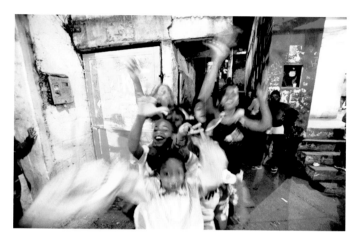

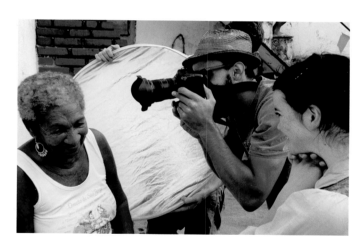

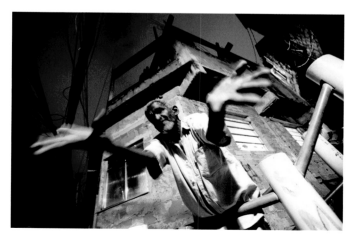

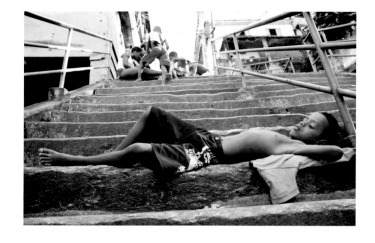

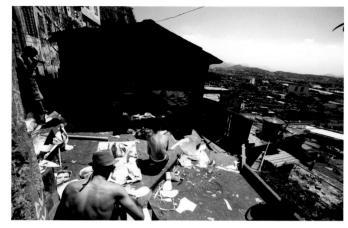

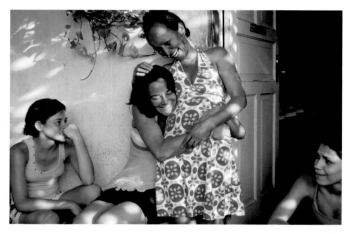

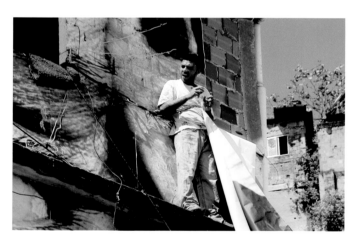

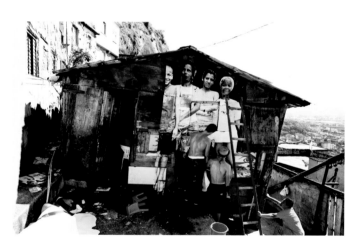

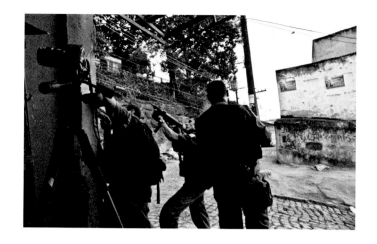
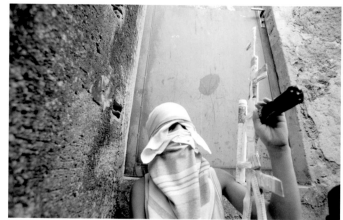

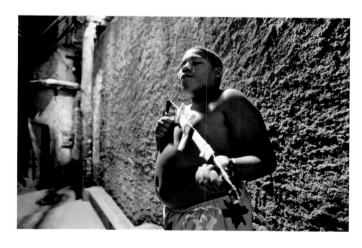

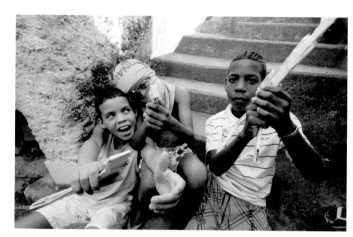
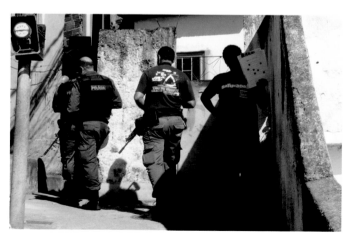

INDIA

India is an immense country, and the links between its many traditions, castes, and states are complex.

JR chose to begin his project in the capital, New Delhi. There, he started looking for women who are, quite simply, the heroines of daily life: women from all social classes and religions who managed to overcome their problems and difficulties.

JR photographed women who followed very different paths, who had the desire and strength to bounce back and banish their traumas. All of them told their stories with great sincerity and dignity, sometimes even as if sharing a secret.

When the time came to exhibit the photographs, JR and his team, who were working without authorization from the government, pasted what appeared to be plain white paper on public spaces. They hoped that pasting such an innocuous-seeming substance would not attract negative attention from the authorities. But the paper was not completely blank; an adhesive had been stenciled onto the paper, tracing JR's photographs. Over time, dust from the street settled on the paper, darkening the adhesive so that the hidden image became visible.

However, New Delhi is big and crowded, and there are few buildings suitable for a large open-air exhibition project. So JR went to Jaipur, the Pink City, capital of the state of Rajasthan, for Holi, the colorful festival that celebrates the spring solstice. Three days before the festival, gigantic white self-adhesive stencils were installed at several crossroads in the city. Simple white rectangles against a background of traditional architecture. Nothing is more abstract than plain white.

Like New Delhi, Jaipur is a dusty city. For three days, dust settled, covering the sticky parts of the stencil, revealing the faces of the models who took part in the project.

On the day of the festival, everyone got ready. Men were in the streets, armed with bags full of powdered paint. Things are allowed to get a bit out of control on that day. Women generally stay home, to avoid being targeted.

The fun began with the throwing of handfuls of pink, orange, purple, blue, and green powder. Street music blared, against a background of pictures slowly revealed by powdered paint adhering to the stencil. Everyone took part in creating an artwork that finally revealed the women who were to become the festival queens.

Once the portraits had been revealed, by color in Jaipur or dust in New Delhi, the women were able to see their portraits and challenge the glances of passersby, symbolizing their desire to change their status and the way people see them.

Shanti Mehrar

"I come from the village of Nasirabad, in Rajasthan. I spent my childhood in the hills of Rajasthan, crushing wheat, breaking stones in the mines, and gathering wood. My childhood was just that. Every day, I would break a crate of stones for the railways. I was paid ten paise. My family traveled to and fro between Rajasthan and Delhi to earn a living, and I would follow them. I never went to school. My hammer was my pen, the great crate for the stones was my inkwell, and the contours of the hills were the pages of my book. That was all my schooling.

It was the same in Delhi. There were no tar-spreaders. We mixed tar by hand, then carried it on our heads. It dripped onto our faces and bodies.

I was married off very young. I don't know when . . . I was only a child. But I left him. Then I chose a partner from a different caste, someone I loved a lot – I wasn't even eighteen! For some years, life was good. He worked on building sites, too. Near the Kashmiri Gate, there is a university, whose foundations I laid. At that time, I wore the traditional woman's dress, a skirt nine to twelve meters long, a blouse, and veil. Today I have come back to that same university to lecture on women's rights! So when I think of all that, I am proud, very proud. Once I carried and laid bricks. Now I am laying the bricks of thought, of experience, to build a different society.

Throughout my life, every change has been like a rebirth. My first birth was my biological birth. Then I came into the world within society, through thought. Teaching has made me discover a new light, a new way. Thorns or flowers: you choose.

My grandmother believed in the five powers: heaven, fire, water, wind, and earth. She paid them homage every morning. She taught us that as well. I have learned a lot from nature. In the bus, I speak to the sun, and no one else knows! When I was just a small child, I began to love the goddess Kali, as a friend. Mother Kali, who represents strength, is part of my life.

My dream is that my family should grow up through my thinking and my strengths. That's my personal dream. You may find that egoistical, but I am nearly sixty-five now (I only learned how old I was when my mother died, not so long ago), and I hope that my last nights will be peaceful."

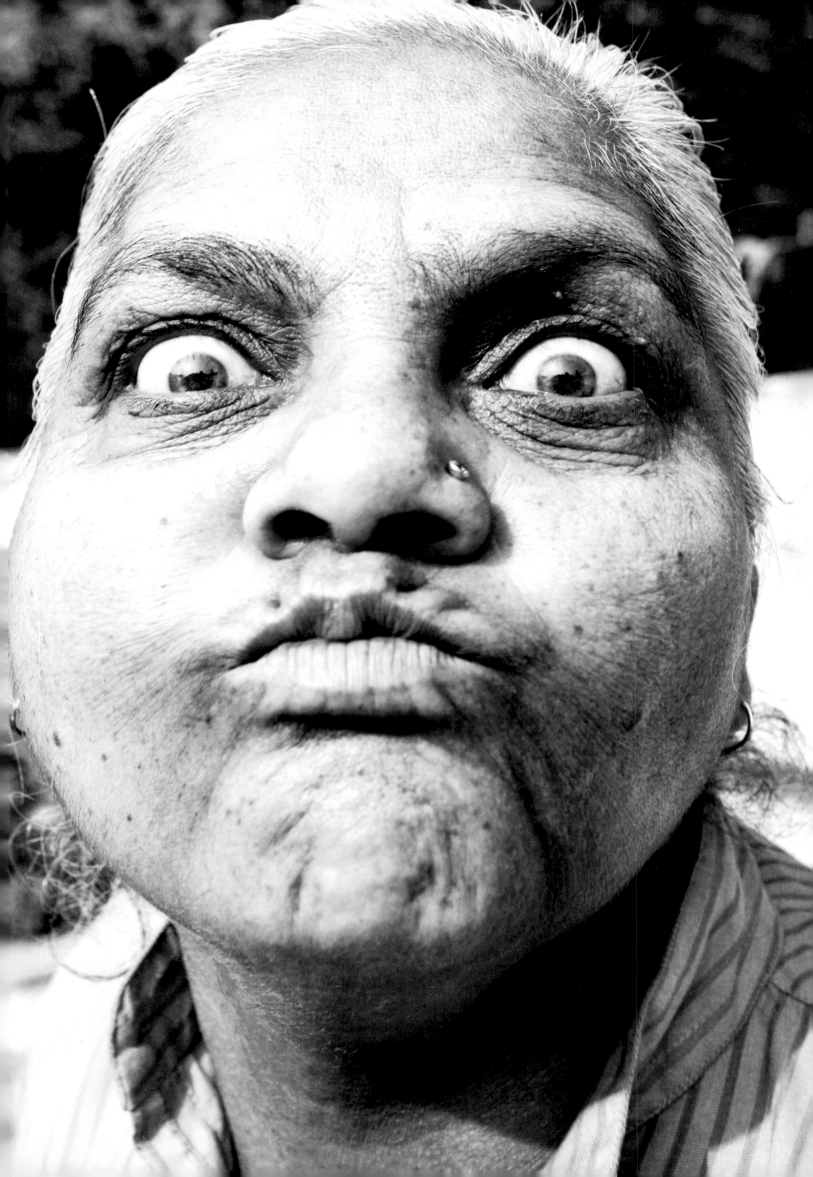

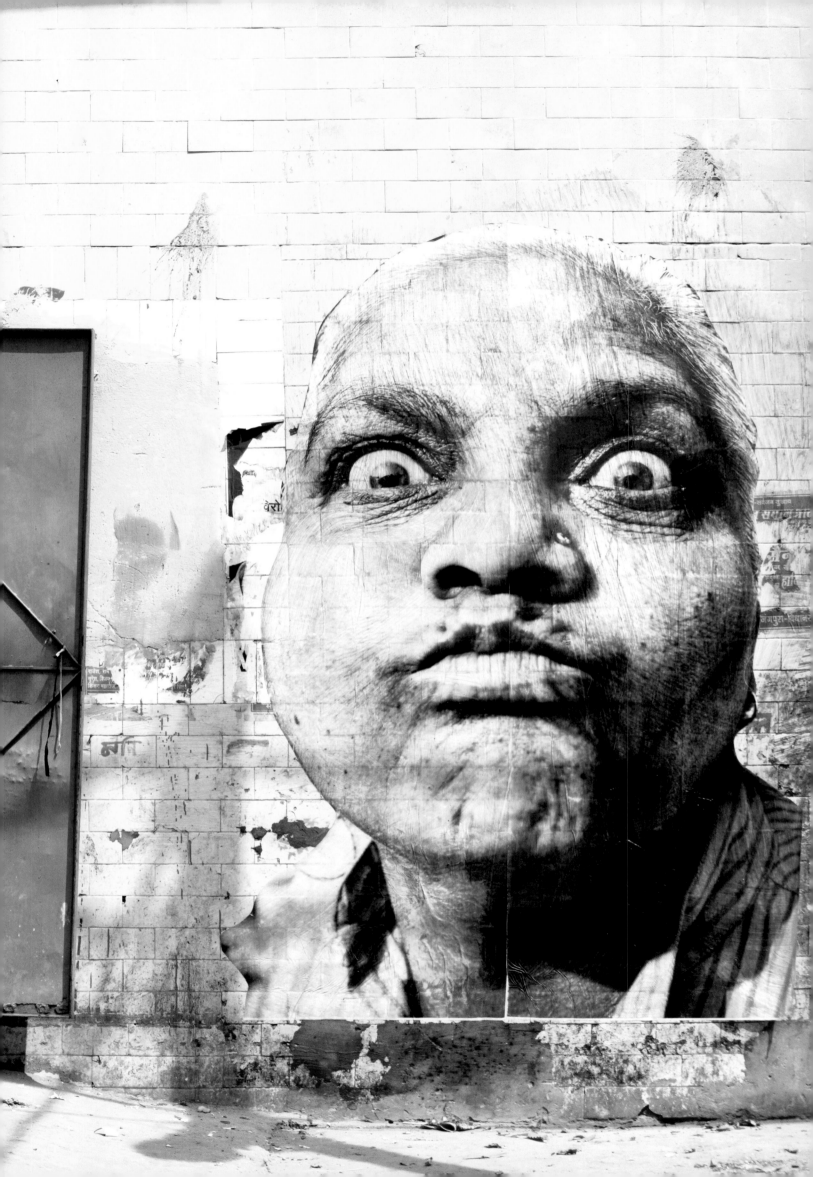

Sunita

"I was married for nine years and have a daughter aged five. I am now divorced and have been living on my own for four or five years. I have experienced the usual problems single mothers have with in-laws: physical, psychological, and emotional abuse. Even though it is not all over (my in-laws would like to take my daughter away from me), I have pulled through with the help of my parents, without having to go to court.

At the beginning, it was very difficult. Family, society, everyone put pressure on me: 'How can a woman live on her own? After all, he is your husband!' and so on. Then convincing my husband was no easy task. I had to prove to everybody that I could live alone and bring my daughter up alone. Today I am independent. Before, I was vulnerable because I didn't know anything. I had no experience. I had heard nothing about women's rights. Today's Sunita is very different! I am aware of things. I travel everywhere alone, and that gives me confidence.

I no longer pay any attention to what people say. In any case, people gossip, whatever I do. I don't really understand why people interfere in others' affairs. Even today people are against me because of how I live my life, the way I talk about women's rights. In our society, a woman who expresses her opinions is disreputable. As I know how to defend myself, I am accused of all sorts of bad things.

I have only one regret: that I was married so young, that I had to face all these family responsibilities so young. I might perhaps have met an understanding partner, with whom I could talk, communicate, and share my feelings. That doesn't matter now. If I find one, that would be nice; if not, too bad, I know I can live as I am. I only hope that my daughter can be independent, so that both mother and daughter can show the world that we have succeeded."

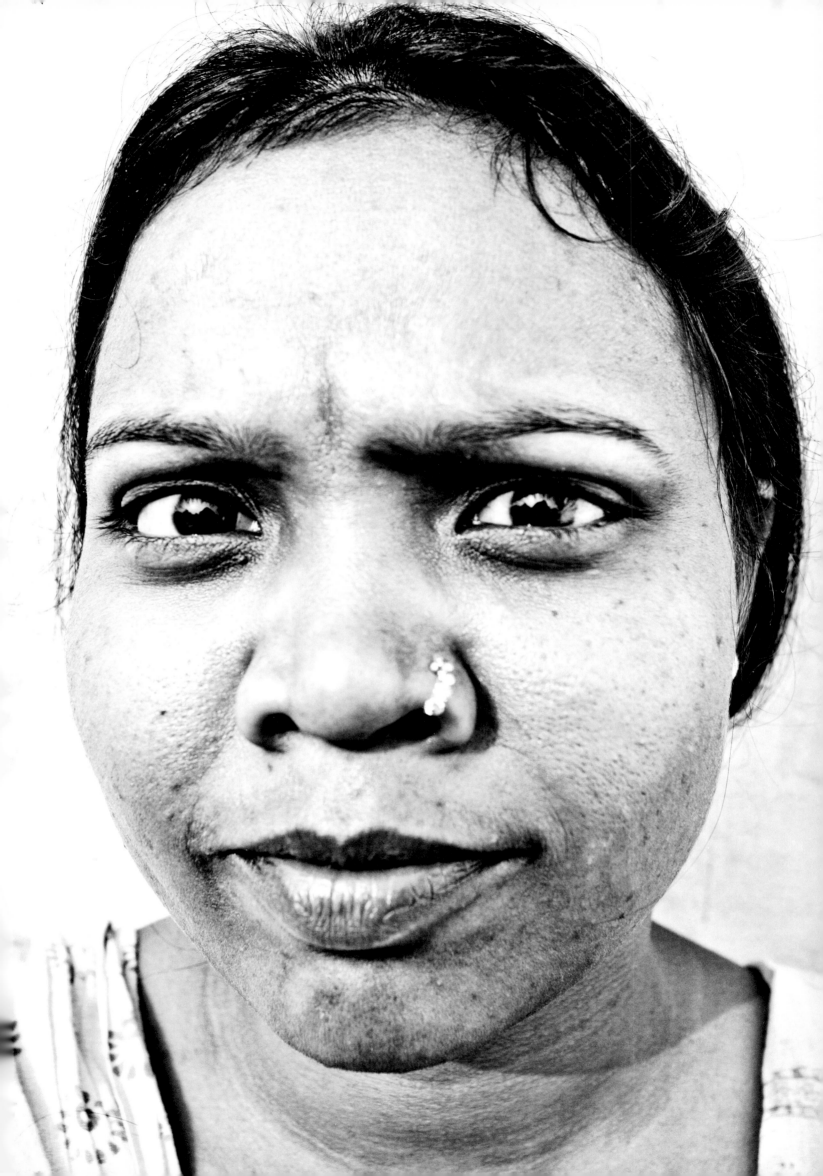

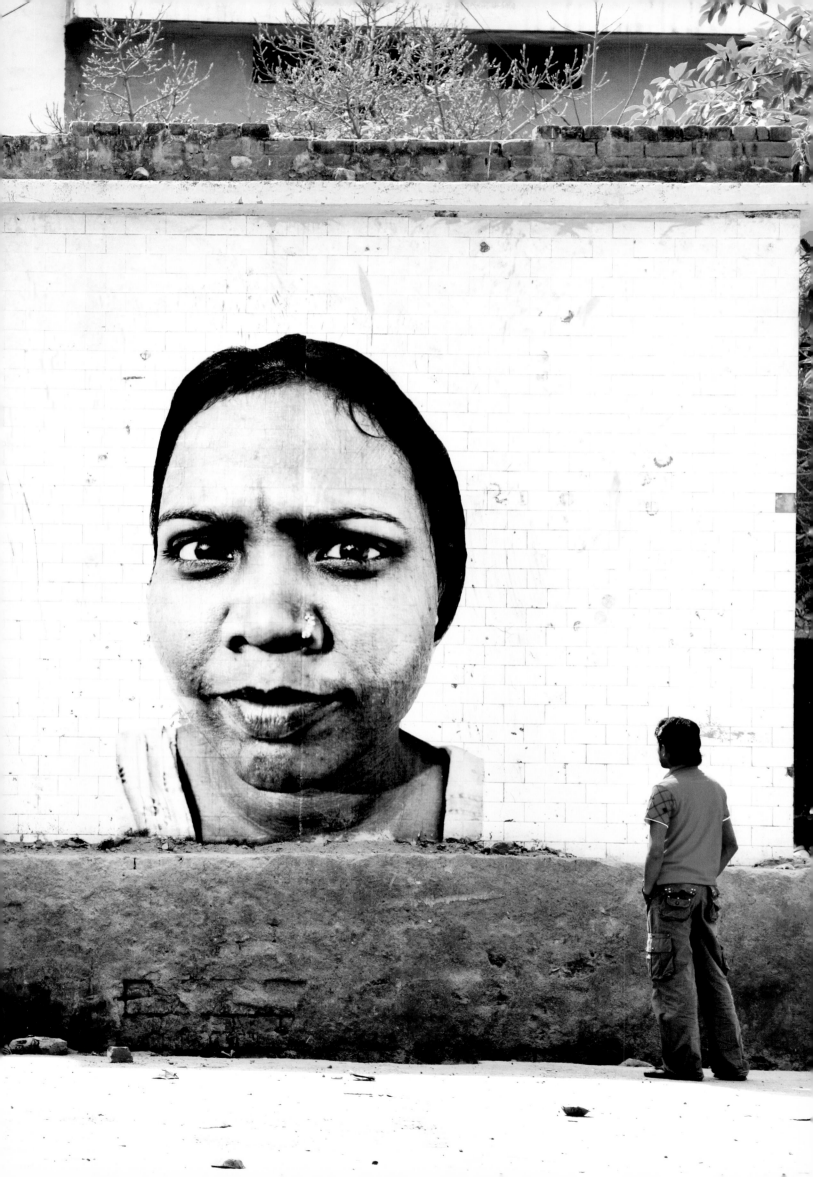

Sheela Karki

"I was born in a highly educated family. My father was an artist and my mother a teacher. So there were many different influences from all over, and my father was involved in the birth of India, during the struggle for independence.

I learned English and French at school. I got married at eighteen. I was glad to be married because I thought it was the only future a woman had at the time. We had two children. I traveled all over India with him. But then there were problems with his family, so we got divorced. It was OK in the beginning. But as I began to evolve and he was still in the same situation, I think the problems started then. He was very self-centered and wasn't pleased when I started working. But the children were already grown up, and I wanted to do other things besides look after the house.

At the time, it was quite revolutionary and really scandalous. My family didn't like it, and they completely abandoned me. At first I couldn't even find any work because there was so much prejudice against me. But little by little I found work. I got a job teaching French at a fashion school.

I had studied literature, at the Sorbonne, and that's what I wanted to teach and continue to study. Even finding someone to advise me and be my thesis supervisor on French Canadian literature was very hard, but I traveled to Quebec at my own expense. They liked me there, but unfortunately I couldn't stay, so I came back to Delhi.

I didn't want to come back to India because I didn't want to face my problems here. But I was forced to come back because they said I didn't have any money or a work permit. I found work, finished my thesis, and now I teach in a girl's middle school and am quite happy.

I write a lot. Poetry is a very personal thing. I'm sure that all my struggles, my problems, my sadness, and my solitude are all in the poetry I write – and in the paintings I make, too.

The condition of women in Indian society still isn't very good. I think it's all right for educated women who come from well-to-do families, but women from lower-class families have problems. In India it's the society that remains the problem, whereas in France the feminists are very intellectual. Feminism there is a true philosophy. Here it's more a matter of social problems, poverty, crimes against women.

I think putting up those photographs of women in cities is very symbolic, because women are very important in every society, as mothers, women, and lots of other things. There are lots of women who are professionals today, like me. I don't just say and teach anything to my students at the university. I have to know what I'm saying to my students, because their knowledge of this foreign language comes from me. And I think maybe it gives women an idea of power. When you put up photographs of women in the city, in certain neighborhoods, it definitely gives women a sense of power."

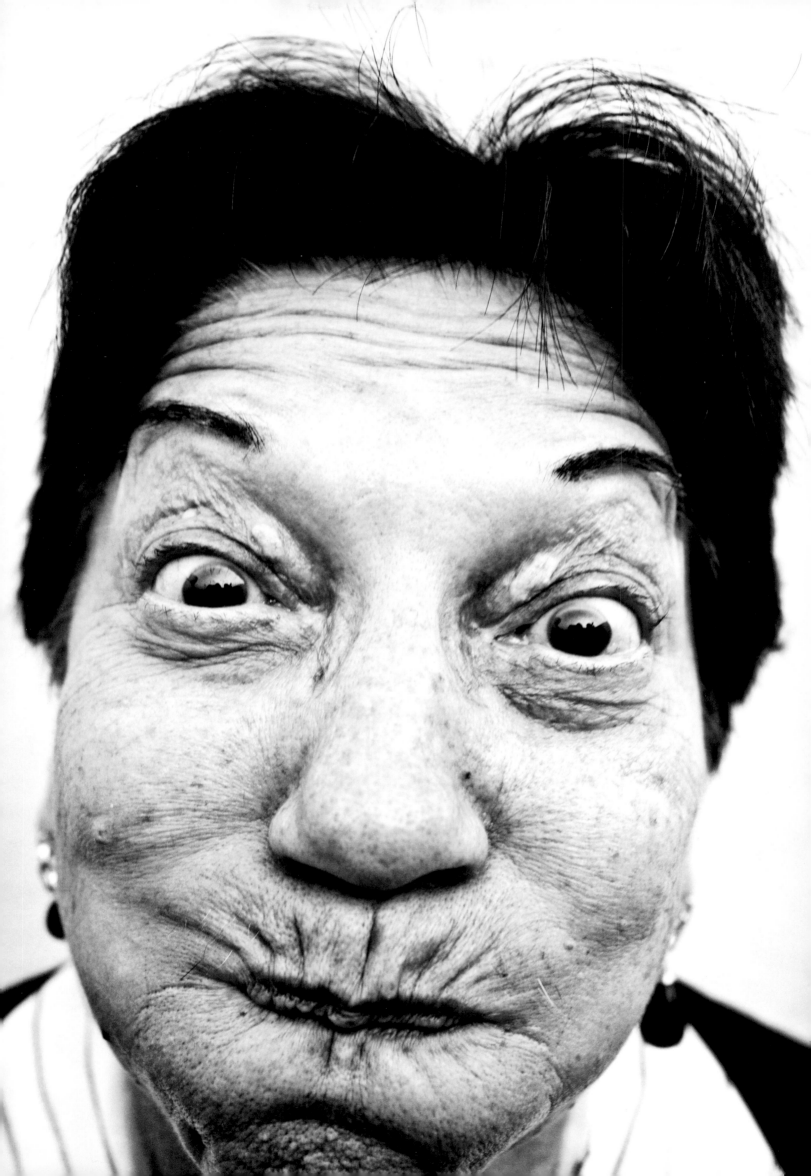

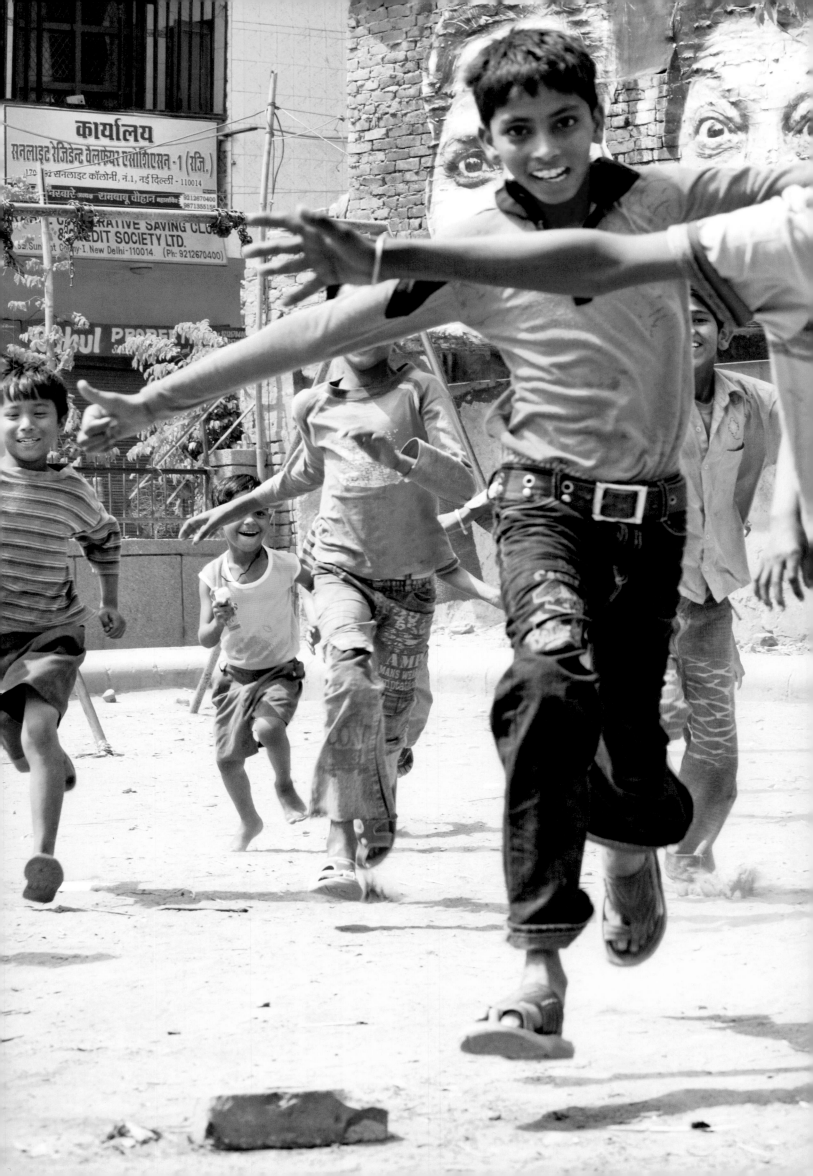

Urmila Devi

"I live in the Harijan Basti quarter of Nangloi Sultanpuri, in the eastern part of Delhi. My parents married me off when I was fourteen. My husband was simpleminded. He had an elder brother whose wife had died, and who had his eye on me. I had to be on my guard.

I refused to give in to him, left my husband, and returned home to my father. One afternoon, my brother-in-law came looking for me and beat me with bamboo, until I bled. Four or five years went past without my husband coming to look for me. My family could not understand. A village council was called, which decided I should either be remarried or banished from the village.

I was remarried. Then one day, my former husband came back with his brother to apologize; he wanted me to go back with him. But I was already married and had a child. I cried a lot, but what could I do? I told him it wasn't possible.

Back in Delhi, my husband's earnings were no longer enough and I began working, too. Life was very expensive, and I got in with a bad crowd: a group of women who were prostitutes. They persuaded me to leave my job. I met rich people who had houses, families, cars, everything they wanted, yet needed our services! I began to earn a lot. My husband knew nothing about it. All I know is, my body became the victim. I was ashamed; I am ashamed to talk about it. I slept with senior officials, judges, and police officers. They promised us help in return, as well.

Then one day the police got wind of a traffic in women and drugs, and I was put in prison with others. When I appeared in court, on the day of my trial, my husband said to me: 'Did you think the police would help you, then? Now you tell me that God has forgiven you, so who am I not to forgive you?' I was conditionally discharged.

After my release, they tried to lure me back into the same work, but I refused. Our financial situation was terrible. Our children started selling water outside drink shops, but I asked them to stay at home, to avoid making the same mistakes I had made. I found work in a factory. After a bit, my superiors tried to take advantage of me. Because I defended myself, my boss had me thrown out. It was very difficult, but I did the right thing. Today my husband transports building materials on a wheelbarrow, while I work in a large household. It's a better way of life, and I have regained my self-respect."

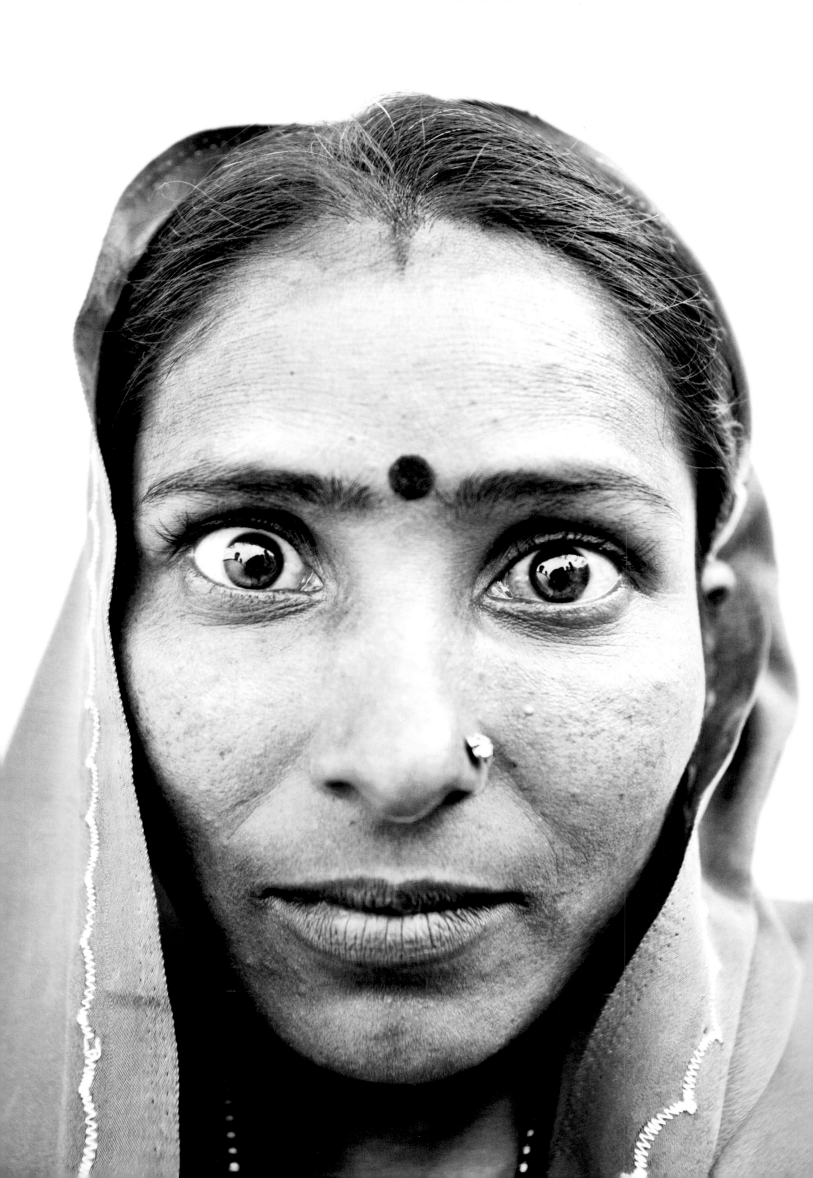

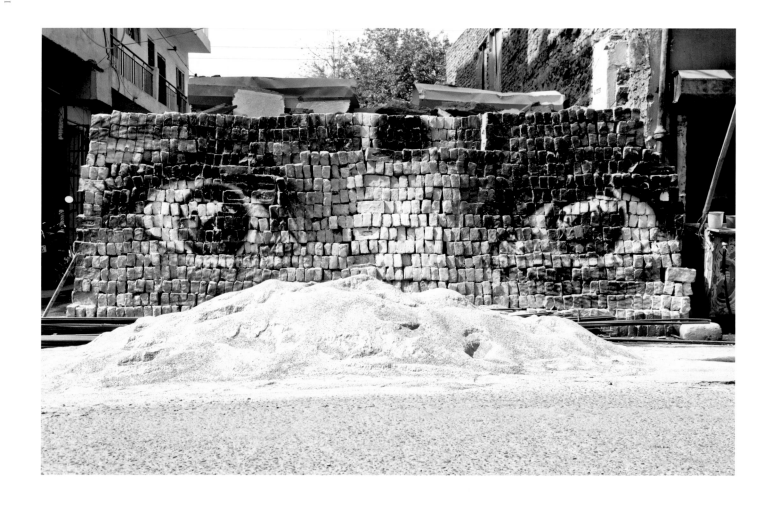

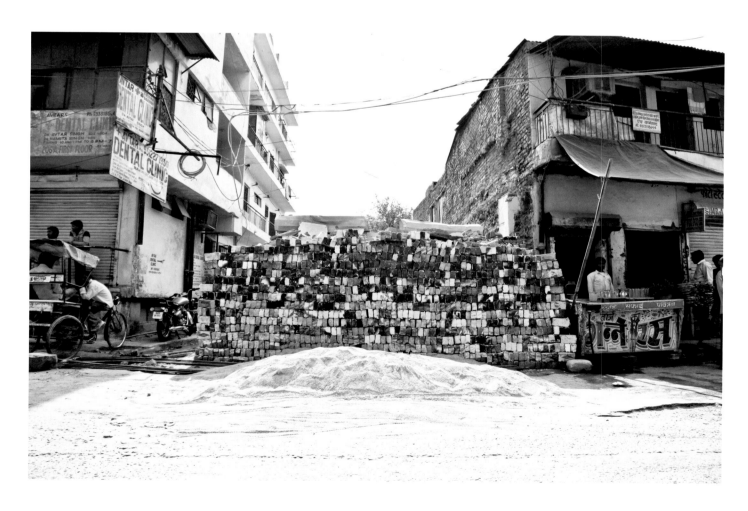

Kamlesh Chauhan

"I live in Timarpur, New Delhi. I am thirty years old. I work at the Ganga Ram hospital, where I am a nursing assistant. I have three children, whom I am bringing up alone. My parents support me, and I am living with them.

I married thirteen years ago. For the first year or two after the wedding, everything went well, but then the problems began. My husband started drinking, beating me, and insulting me. Then he died and my parents-in-law threw me out. They accused me of having lovers. They lodged a complaint about me with the Tis Hazari court in Delhi, because I was asking for my share of my husband's inheritance. I have two daughters and a son; I have got to think about their future. I will need a lot of money for their weddings.

I also have heart problems and am already fitted with a pacemaker. I don't know how much longer I have to live. My husband is dead, and I myself may die soon. Who will take care of my children afterward? All I want, then, is to recover what is due to me, to leave something to my children. I am only asking for what is right.

If women show they are weak, men and society will continue to take advantage of this to dominate them. I am sure that if they have confidence in themselves, they can bring up their children, be successful in their jobs, and live decently.

All I want is for my children to complete their studies successfully and become independent. Should they meet someone like my husband, at least they could manage on their own. They could go on through their own strengths, knowledge, and education."

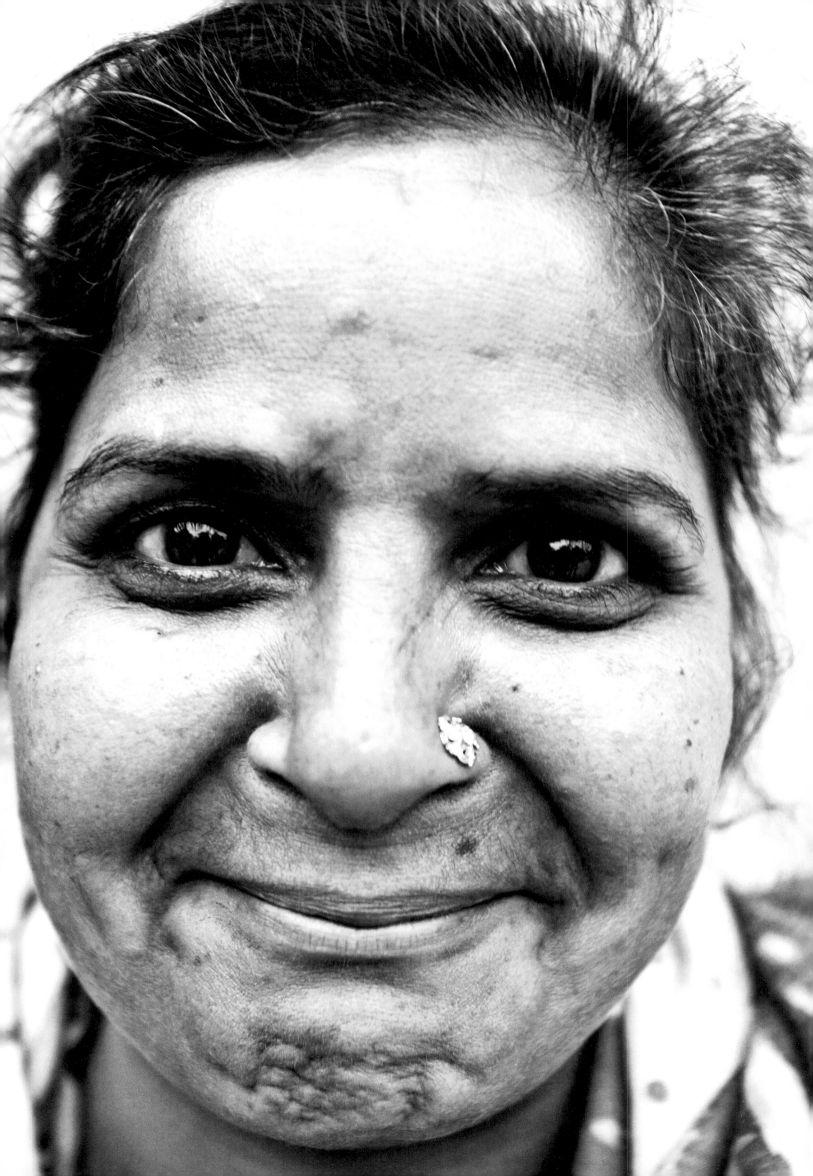

Praveen Mazahar

"My problems began after my marriage. My husband beat me because of difficulties over money. He spent his days playing cards and drinking. Then I had children and life became even more difficult. I ran up debts here and there.

When my father-in-law died, my in-laws threw me out and I had to find somewhere to live. My brother helped me with the rent, and my mother helped with our meals. There are five of us, brothers and sisters; I didn't want to be a burden. I began dreaming of going away . . .

My husband then began hassling me, threatening to burn me, to kill himself. Even my landlords ended up frightened of him. In any case, at worst I would die, but it would be better if my children died with me. I had made my decision. I could not leave my children; their lives were in danger. I lied to my husband; I took two hundred rupees to go to the Nizamuddin Dargah [translator's note: a Sufi shrine in Delhi].

We arrived in Bombay. I had never left Hyderabad. A driver agreed to take us to the Haji Ali Dargah without payment. We settled in and I bought food for my daughters. I had nothing left. In the evening, we were asked to leave; I spent the night in the street with the girls.

In the morning, I had just one idea in my head: to get to the dargah in Delhi; there, at least, we would be fed. As I didn't even have a paisa left, we had to go to the station on foot. The children were crying with hunger. We got off at Delhi. A young boy led us to the dargah. He came back with his mother, who saw the state we were in and took us home. She fed us. She told me it would be too difficult here, alone with the children. But I had made my decision; I couldn't go back.

I am now working near the dargah, for an association that educates and cares for children. I lost everything, but my trials, every argument with my husband and his brutality, convinced me I was right. Even though he himself was incapable of feeding us, my husband used to tell me every night that I was good for nothing, that as a woman I couldn't do anything. Now I am looking after my children and educating them!

My daughters now know that women, too, can be independent, that they have the same rights as men. Even if I marry them off, I will not give them a dowry. If they wish to choose their own husbands, I will let them. If they don't want to get married, I will accept that, too.

They can read and write; they are very knowledgeable. At least, we try to be well informed. I say to my girls, 'Learn, learn everything you can, to cope with any situation. You never know what life has in store.'"

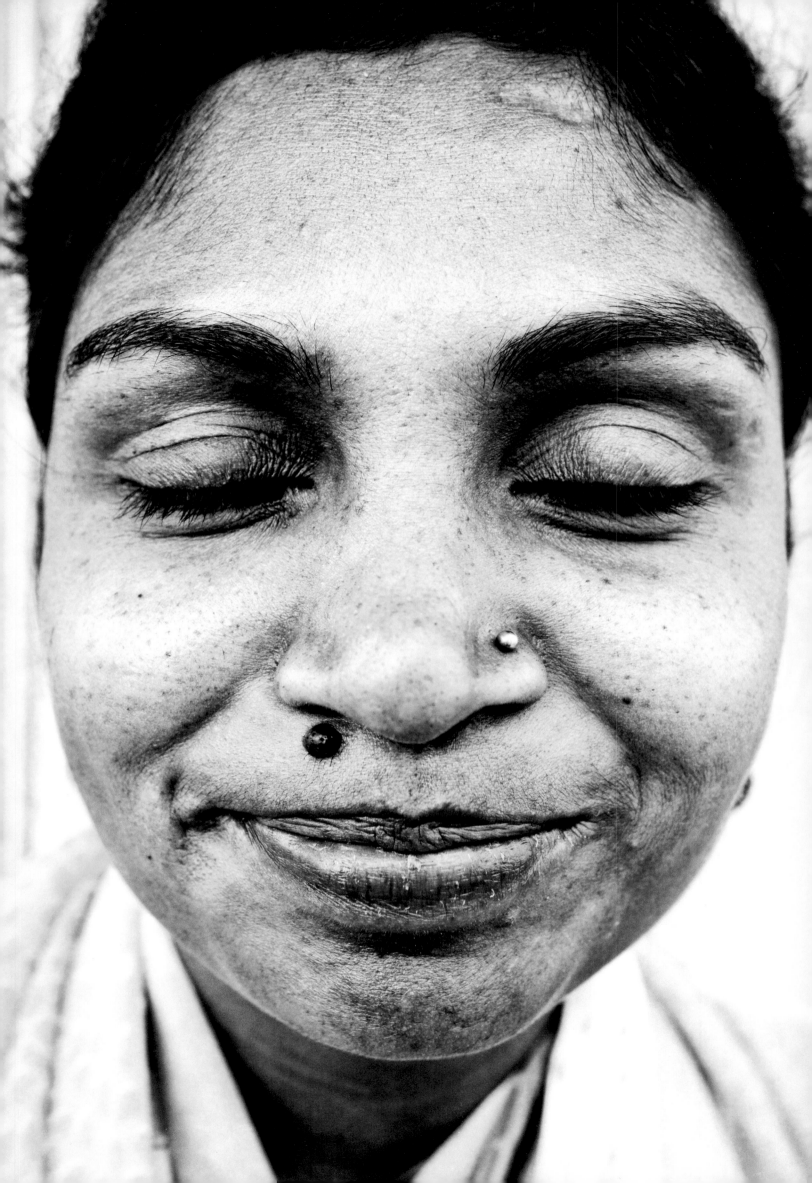

Nirmala Sehrawat

"My name is Nirmala Sehrawat. I live in sector 17 of Rohini, in Delhi. I have four children, the oldest being sixteen and the youngest seven. My factory is in Sultanpur Majra, in north-west Delhi.

Two years ago, my husband was sentenced to seven years in prison for fraud and counterfeiting. He was jailed. For a week, I was completely shattered; I kept crying. I went on going to the factory, of course, but stopped eating. It was he who had run the factory, while I looked after the home. He had been drinking, had become brutal and aggressive both at home and in the factory . . . I prayed to God to take his life or mine. In the end, his sentence was a blessing, because everything is better now. He was released on parole on May 16, 2009, and has completely changed.

Meanwhile, I had taken over running the factory. Since then, I have supervised everything, from the lowest employee to the manager, from cutting to payments. The workload has increased considerably. We have fifty specialist workers and a number of supervisors. All of them speak to me with respect, because they know I am honest. I arrive from home alone each morning, sometimes with large quantities of cash on me, but nothing has ever happened to me.

I feel strong. I no longer need my husband's help. I can also help others: I give work to women like myself. I neither lie nor cheat. I keep my husband informed about everything, including financial transactions and meetings, because I believe in openness. I would like to do even better, and shall gradually do so.

I invite people to visit the factory, to see how successful I have been. One cannot be content to stay at home, behind the curtains. I myself have fought, and I tell others to fight. I am only the daughter of peasants. I come from Sonipat in Haryana State. I studied to fifth-form level. I married; we lived in the village for ten years, working in the fields. We had two children when we came to Delhi and wanted to send them to school. My husband was working, but life was hard.

Now my husband has so much faith in me that he seeks my advice on everything. He thinks he is good for nothing. I try to tell him that he has done nothing wrong, that he has nothing to reproach himself for, that he was framed. He has a lot of respect for me. He is attentive to me, wants me to wear nice clothes, and eat well . . .

There are people with grudges against me, who are jealous. They invent lovers for me. My in-laws also speak ill of me. But I am honest, I am married, and I shall never leave my husband. I have a head on my shoulders; I don't get angry. And I told my husband all this while he was in prison. I took care of everything."

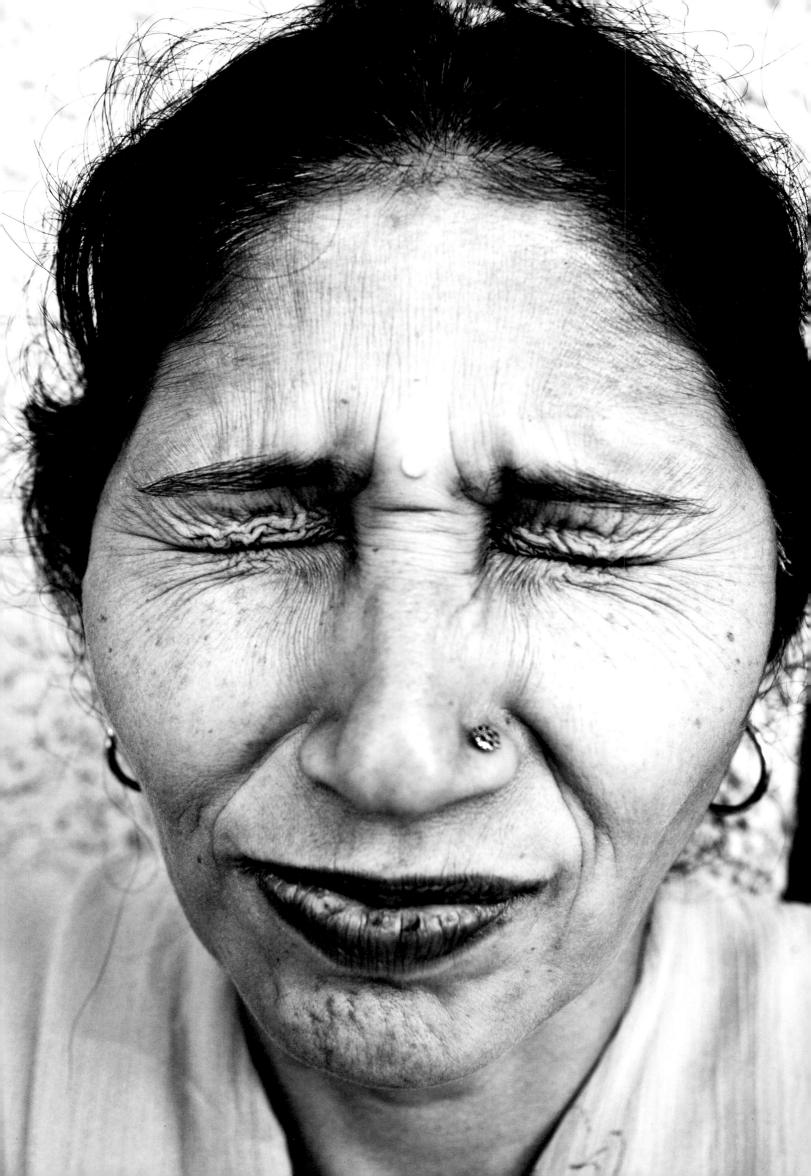

Shantosh Takur

"I come from the state of Himachal Pradesh, from a very poor though high-caste family. When I was married, we didn't know my husband already had two children from a previous wife. I was fifteen; he was forty. He allowed me no money. I was hungry. If he saw me approach the window bars, he would accuse me of trying to talk to a lover.

Then we left our village for Delhi. We lived in a small shop, closed off with a blind. When my husband left in the morning, he took the key in his pocket. I stayed imprisoned like that for three years. In the evenings, he would come home completely drunk, demanding his dinner. He beat me so hard he had to put on the radio so that no one heard.

I was expecting my second daughter and was ill. The doctor said I needed air. I couldn't meet anyone. I hadn't seen my parents for twelve years! The landlady had found out about my situation; she made up a story about checking the electricity meter and borrowed my husband's keys. She began to take me out a bit. Then I gave birth to my little girl. I couldn't leave the house for some time. I wondered what I should do. Where could I go? Sometimes, I felt like swallowing poison and making my little girls do so, too. The secret outings went on for about two years.

My landlady introduced me to an association that offered me work. It wasn't easy, but little by little, my husband began to understand. The children were growing up, I was going out of the house, and he realized I was honest. Today I am part of a committee of twenty women. My husband listens more to me when I speak; he takes my advice in the home and outside.

There is a law against domestic violence. Now we go to the police as a group, to exert pressure. It is not a family affair, it is the law, and a woman is entitled to police protection. We try to convince with words.

Without this daily struggle, I would disappear. My name would disappear. The struggle helps me move on. Sometimes, one cannot get things by asking for them; it has to be done by force. Previously, I listened and waited. Now I get what I want. I am not preaching excessive liberties, but everyone is entitled to find happiness. There are limits to husbands' rights. Going out, seeing life, enjoying it . . . every women should be able to do these things.

Your posters are like reading stories, or seeing a film: one realizes what is good or bad in the light of one's own experience. Our stories and problems will go into these posters. That's good, but it will only influence people who are receptive."

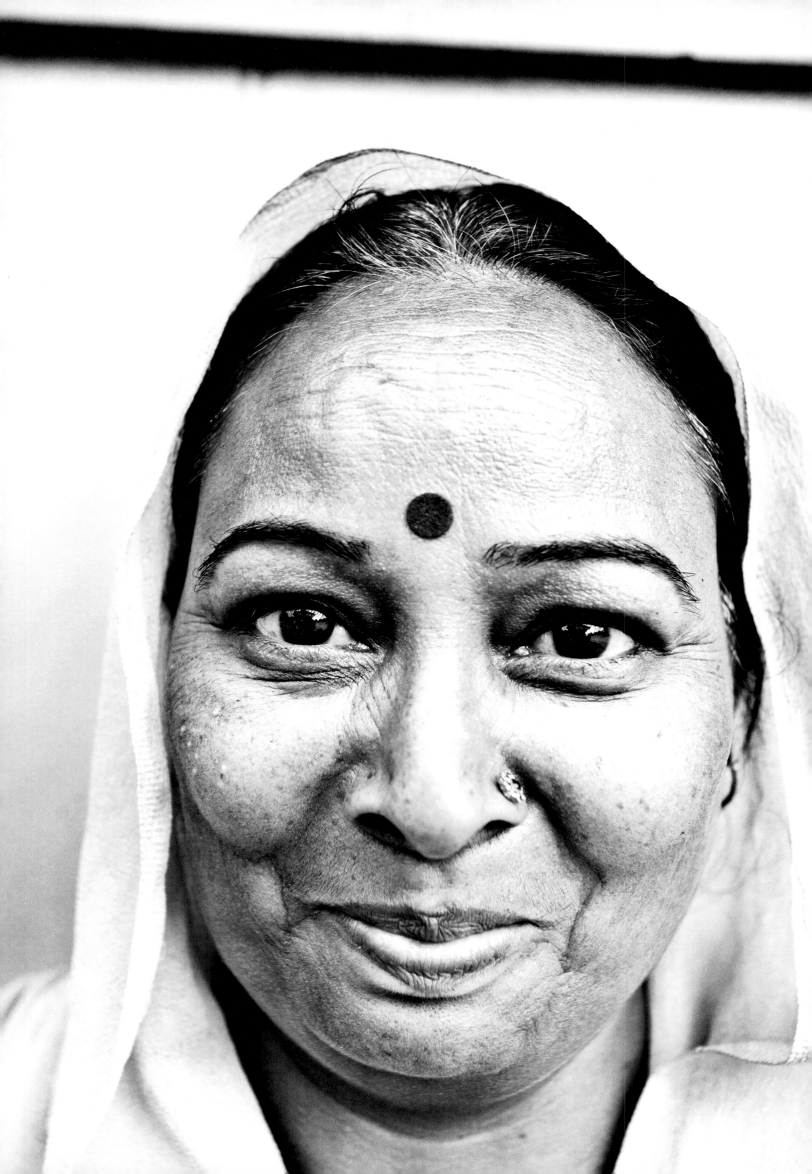

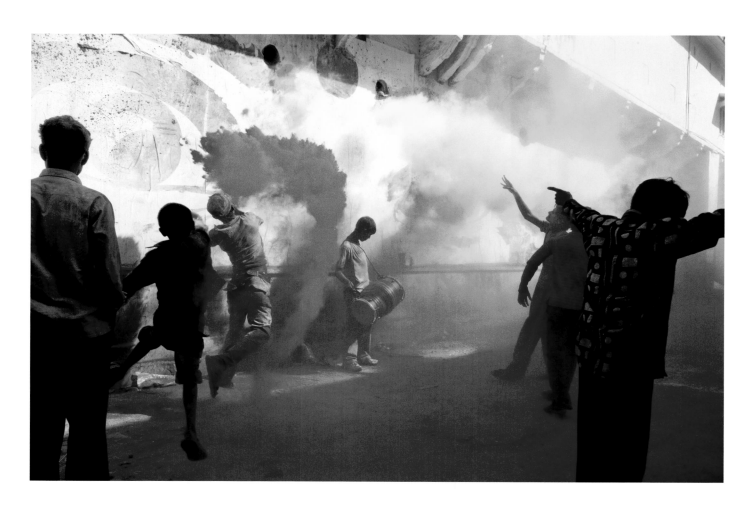

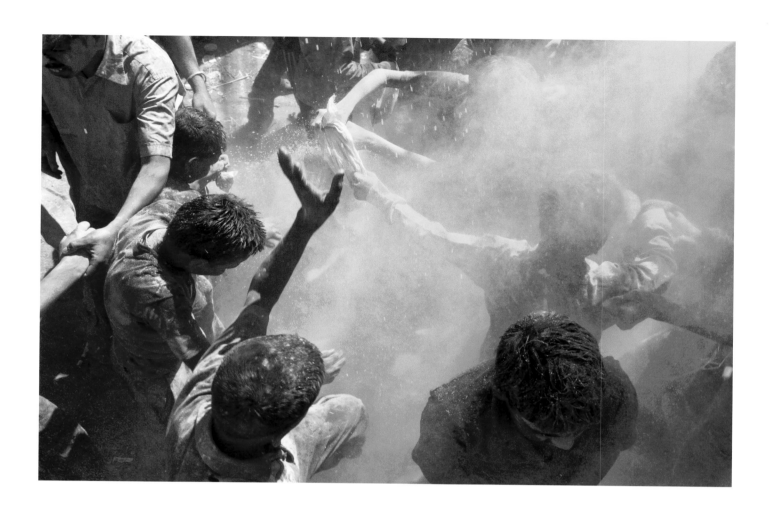

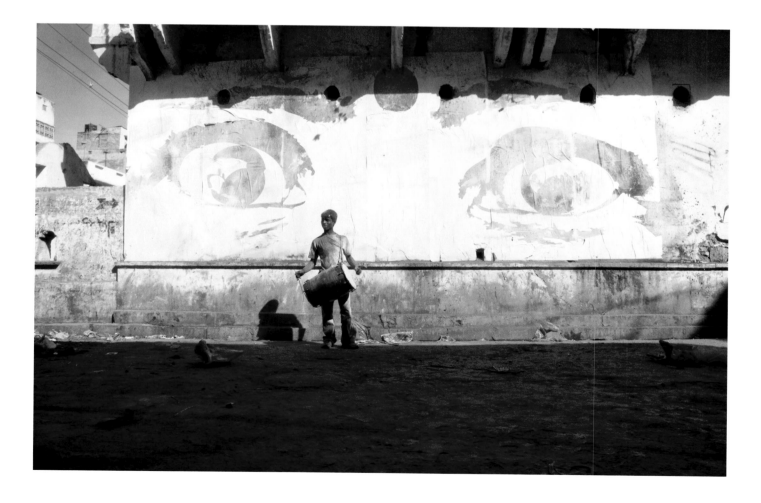

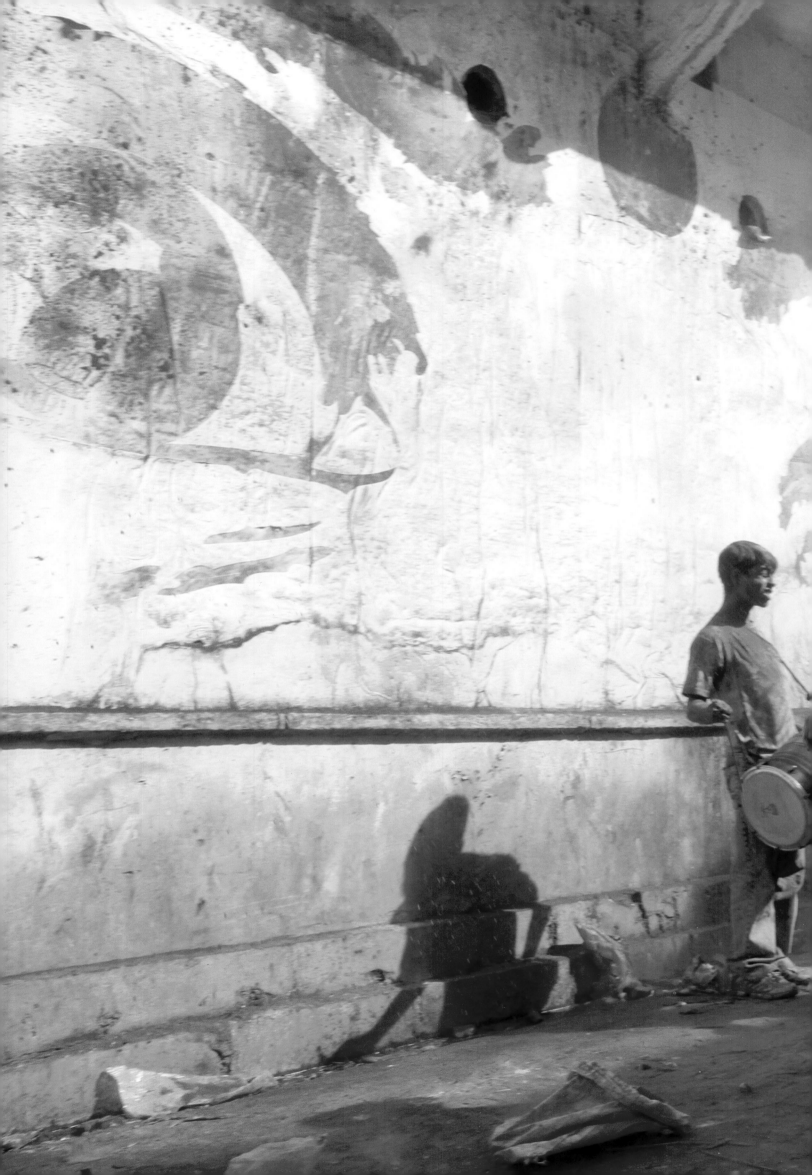

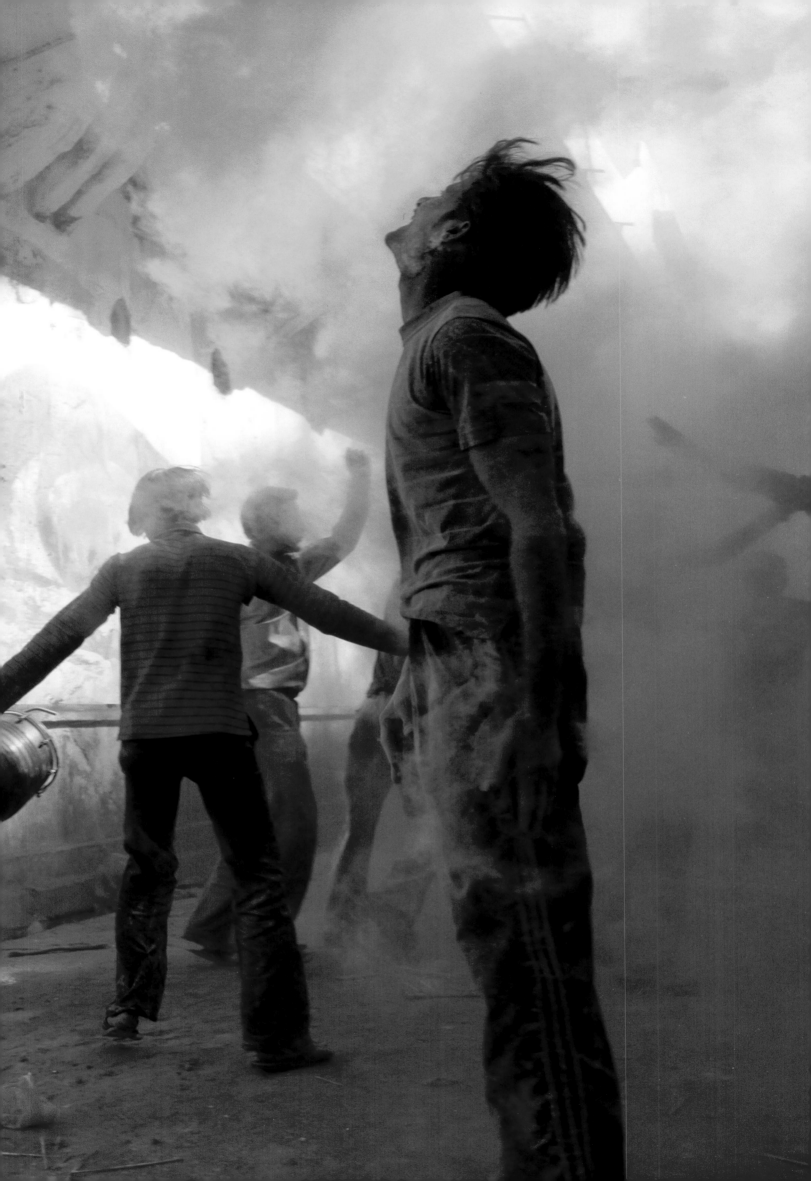

Antara Nag

"I was born in Calcutta and came to Delhi four years ago. I had two young children and was four months pregnant. I trained as a speech therapist and am also a beautician. I consider myself a successful woman.

In Calcutta, I never got on with my husband and was not happy with my marriage. He did not let us eat enough; he beat me and swore at me. I decided to leave him and come to Delhi because I was confident of my future and had an absolute desire to be independent. I couldn't bear to see my children go to bed on an empty stomach. I wanted them to live decently. That's why I found the courage to leave, even though I had to put my own wishes second in order to educate them.

Here, in the Friends' Colony quarter, I am now respected and known by my name, Antara. I would like to be known by this name not only by people in my country, but by foreigners as well. For example, as a speech therapist, it is important to appear on television, to be known through programs. But it is not simply a question of making money; it is above all because I believe I can cure people through speech therapy. To get rich through television, you need to be beautiful, which I am not!

When people see our portraits on the walls, they will realize we are people like themselves, who have succeeded, and perhaps they, too, will find courage for their struggle in this way. By seeing these ordinary women, other women may regain confidence in themselves.

I am very happy; I am not made of money, but I can meet our needs using my abilities, which is enough. I work hard, but manage to spend time with my children and mother, and they are happy with me.

Because of our traditions and customs, Indian women enjoy little freedom. They would like to do a lot of things and are perfectly capable of doing so. Many women work, but family and society do not encourage them. Women are not treated as equals of men, who fear they will become too independent, will do better than them. In particular, they can't bear single women. That will have to change.

If a woman raises her voice, expresses herself, works outside the home, and especially if she is single, others criticize her enormously. She is suspected of being immoral. The problem in India is that everyone interferes with everyone else's lives. Elsewhere, in Western countries, people have their private space to get on with their own lives. In India, communities are more united; one takes care of one's neighbors, even though sometimes one is too concerned about their private lives. In the West, the opposite is true."

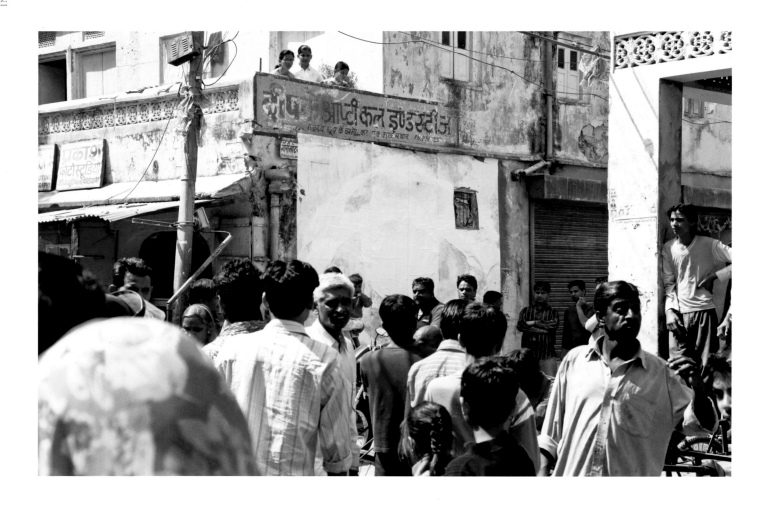

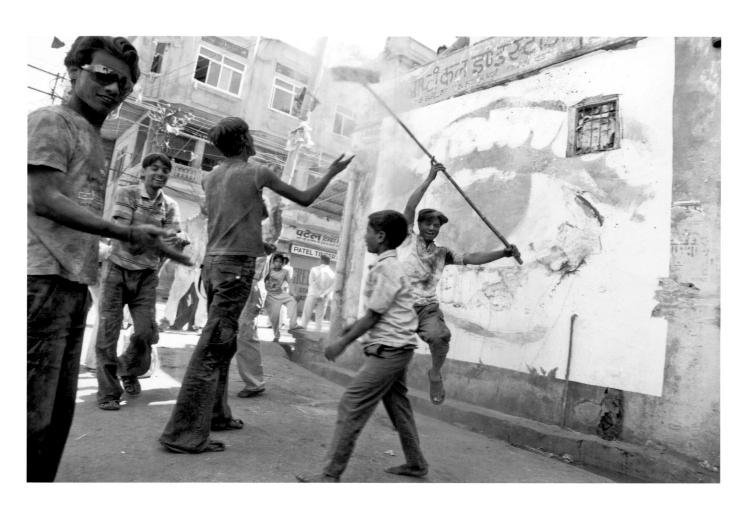

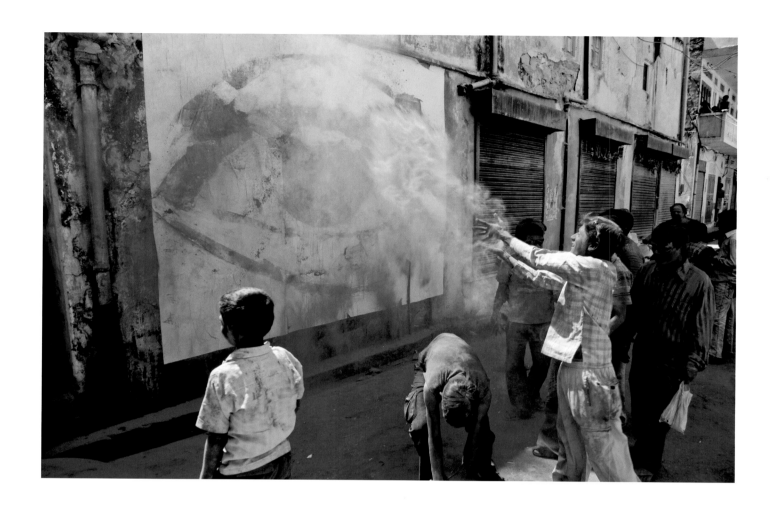
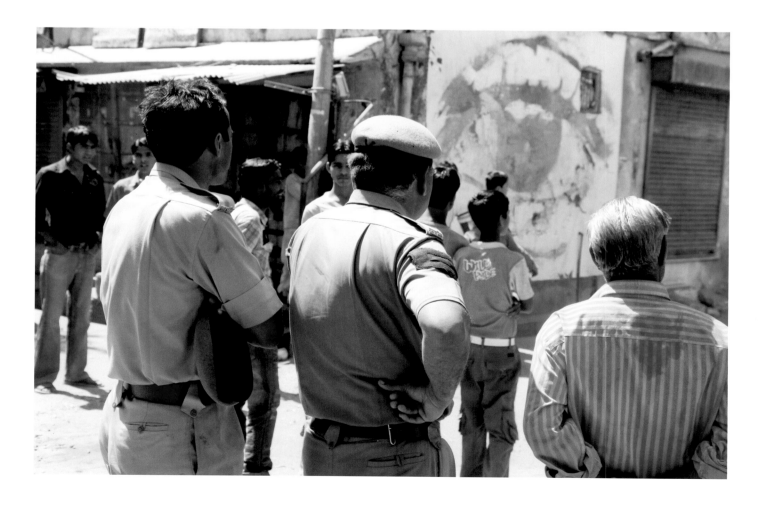

Shaha Jaham

"I come from a Muslim family. My very existence has not been easy, and on top of that, my daughter was killed. I was overcome with anger. Why my daughter? I found out that it was not an isolated case. So I decided to leave home.

I founded an association that I called the Women's Association Against Dowries. My work enabled me to create a network of acquaintances among associations. Some while later, a new association was set up, Shakti Shalini, which means Power to Women. I have given a lot of my time to this association, which I no longer work for. My dream was to set up a refuge for women and children, and this dream has come true. We had to teach women who had fled their homes, or had been thrown out, how to live alone, work, and bring up their children.

My work was difficult; I had to fight constantly, among other things against society, the administration, and the police. A woman's life is like a rose: her body is surrounded by thorns. You see the rose, but no one sees the thorns. Even today my struggle continues.

In India, a woman's life is one long struggle. So struggle has become a woman's second nature. All I have endured is in the past – my sons and daughters now have their own families – but there is one thing I can never forget: my daughter was burned alive. I sometimes think they will kill me, too, because of my militancy, but I am not afraid, because my work with associations has enabled me to regain my self-confidence.

I have brought up my children in a spirit of tolerance. When my son was married, I warned him he must treat his wife with respect, never mention the rape of which she had been the victim, and he accepted this. Since then my daughter-in-law has been living at home, and too bad for those who don't like it. Our family is very close; we live within our society, but differently. For example, my granddaughter wanted to choose her own husband, but no one wanted her to. 'Why?' I asked, 'If she wants to marry a boy she loves, let her marry him.' And in a fortnight, I had organized her wedding.

My work brings its rewards every day. In this age of computers and telecommunications, change comes faster. I see this above all among children in towns (in villages, there are still enormous difficulties). Modern ways of life make education easier. Life for future generations will be even more different. But I hope others will be able to follow in my footsteps. Even when I am dead, I hope my strength and words will endure."

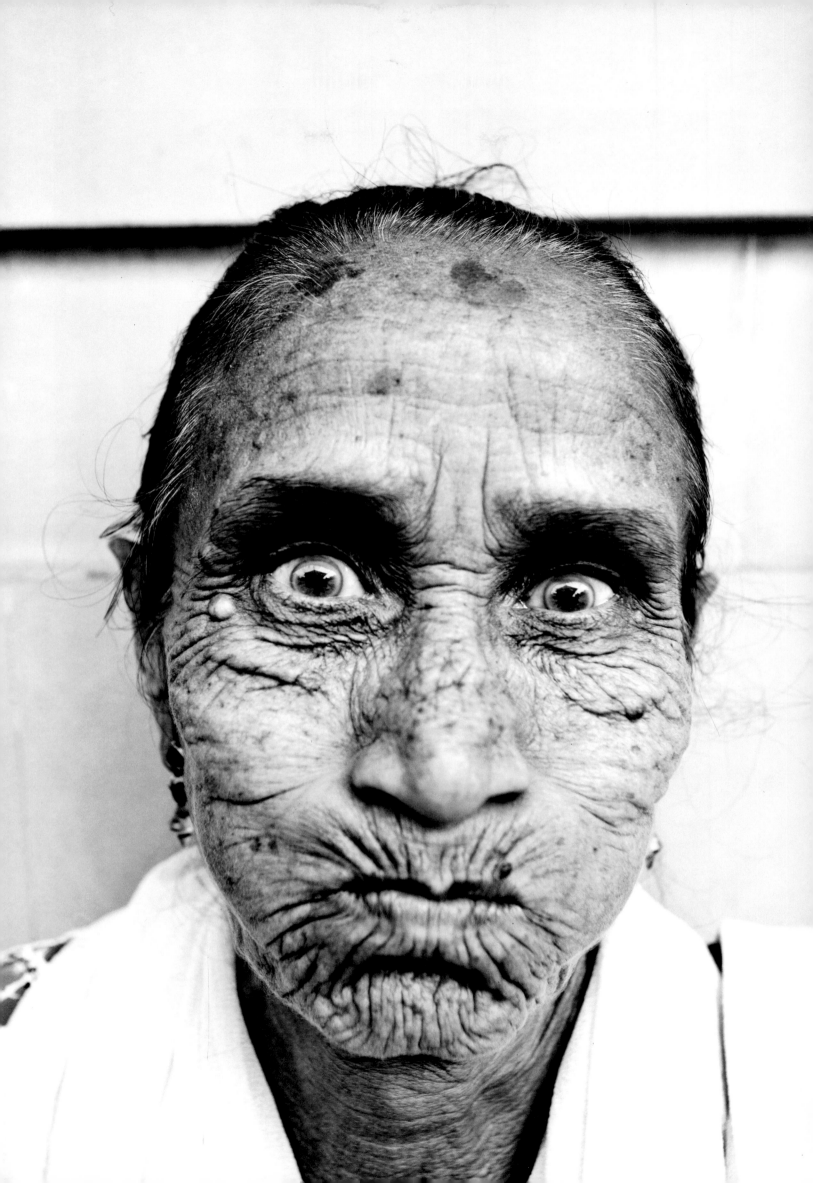

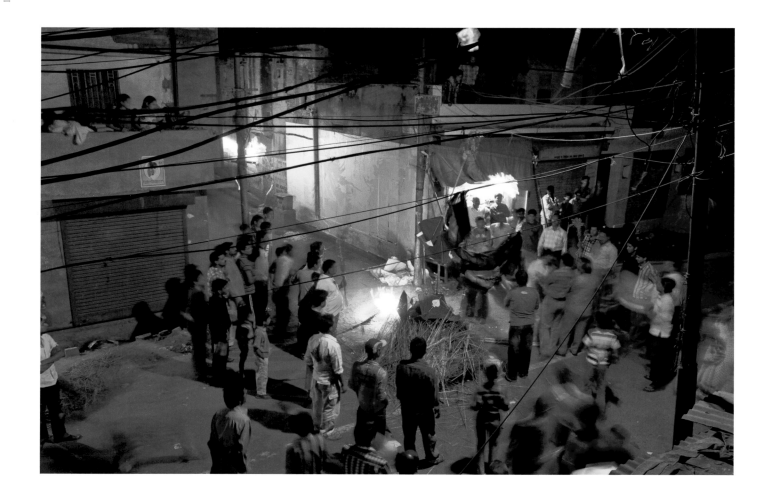

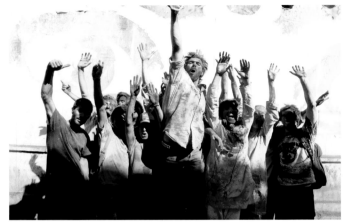

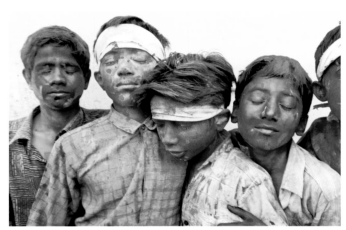

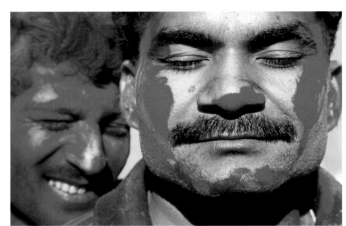

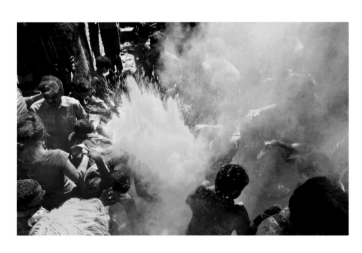

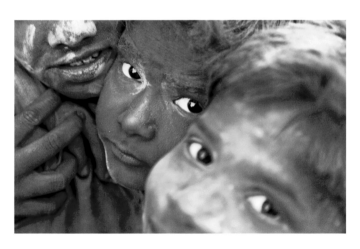

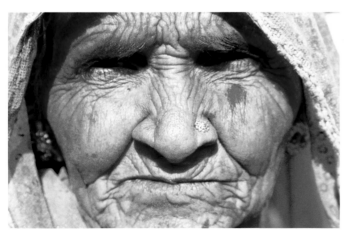

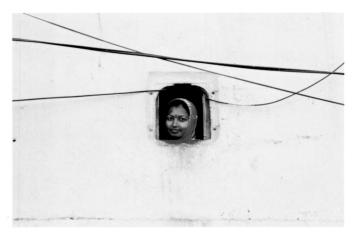

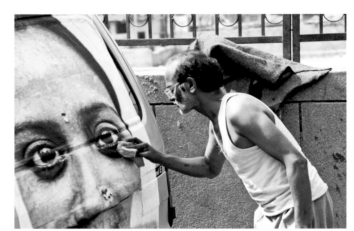

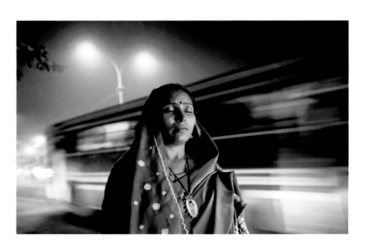

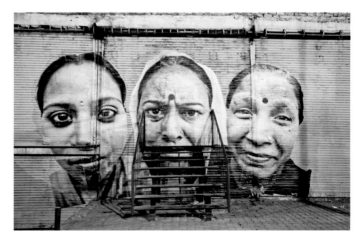

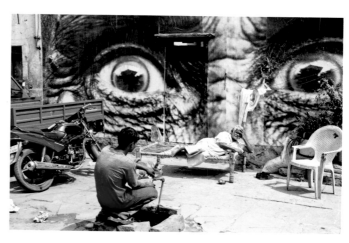

CAMBODIA

Today Cambodia is living on the ashes of the Khmer Rouge regime, which was responsible for the death of a fifth of the Cambodian population between 1975 and 1979 and for the violence that continued until very recently. Since 1985, a former Khmer colonel has been the prime minister in control of the country.

The painful memory of the Khmer's arrival in the city on April 17, 1975, is still vivid at the French Embassy in Phnom Penh, a huge building that stands as a reminder that Cambodia was a French protectorate before gaining its independence in 1953. Hundreds of terrified Cambodians had taken refuge within its walls, but on April 20 the consul was forced to give in to the Khmer's blackmail and hand over the refugees. "We are no longer men," he said. JR knew he couldn't turn down the opportunity when Photo Phnom Penh invited him to create an exhibition on this wall steeped in history.

So JR's exhibit began on this two-hundred-meter-long by three-meter-high wall (see page 313). He decided to put on view the gazes of women who had already been photographed in his Women project. The French Embassy is on Boulevard Monivong, which runs across the city for six kilometers, and most people in Phnom Penh walk by it several times a day. The few billboards that can be seen are in color.

The first strips that were put up immediately attracted the attention of passersby, and dozens of taxi-scooters and pedestrians stopped on the side of the road.

You could see the incomprehension on people's faces as they stood there staring but not daring to ask any questions.

Was it because many of them had never seen an African woman before, because people here aren't used to flaunting their ideas, or because fear of spirits and ghosts is still part of their folk tradition?

When the city authorities made it known that they wanted the exhibition to be taken down, the French ambassador refused but said that with this kind of art people were allowed to tear down the posters, put up other ones, draw on them or simply wait for the wind to blow them away.

Then JR went looking for women with a particular destiny and met Ratana in the restaurant that she runs.

At twenty-eight, she is the manager of a pizzeria in Phnom Penh. As a child she worked in a dump located a few minutes from the city. She made it out of there thanks to an organization that provided her with an education that subsequently enabled her to find a good job.

Ratana then went with JR to the dump, driving down a dirt road used by dustbin trucks, heading straight into the chaos and the underbelly of society.

It was an incredible sight. People began working at about 4 AM, with torches strapped to their foreheads because it was still pitch black, hunting for plastic, metals, and other materials to be sold for food. The dump covered several hectares. The trucks unloaded "fresh" rubbish at the entrance every quarter of an hour, and at 6 AM it was rush hour. Hundreds of people were climbing up and down the mountains of rubbish.

Ratana explained how she used to cover her face to protect herself and keep her skin soft. She was eager not to catch any of the diseases that most people got there, or to cut herself. She also talked about the pestilential odor, which one never gets used to and cannot be described in words.

Ratana prevailed in her struggle. She now lives and works in a healthy environment, she can help her family, and she has the courage to face her past by offering her gaze to be wrapped around a dustbin truck that is driven through the dump.

Other women are at crucial points in their struggle. Two women activists, Chanta Dol and Narin Nou, are fighting to hold on to their houses in the Day Krahorn slum on the outskirts of Phnom Penh. The city is currently experiencing a real estate boom in which rents are soaring and many new buildings are being constructed.

The slums near the city center are benefiting from a "city planning" project.

The women we went to see are fighting the city, government authorities, and the developers, trying to keep themselves and their families from being expelled and "relocated" to someplace they don't know, often very far from the city center.

They are fighting against the expropriation of their land, which is where they live, and also the place where they, their children, and grandchildren were all born.

They showed us pictures of their struggle against the men from government brigades who were given the task of intimidating them, and against the excavators that dug right under their feet when they formed a human shield.

In order to create a powerful visual and symbolic link with their stories, the portraits of Chanta Dol and Narin Nou were displayed on the dilapidated walls of a construction site, a stone's throw from the central market. As the construction site progressed, their faces disappeared under the blows of the pickaxes . . .

Peng Phan

"I'm fifty-five years old. I was born in the village of Kbal Kâh, in the Kien Svay district in the province of Kandal.

The events in 1970 separated me from my parents. They were civil servants in Phnom Den, on the Vietnamese border. My father was a policeman. He was killed, and we found our mother in Kien Svay. My older sister, who worked for the police, persuaded me to join the Special Commando forces. It was all women, and the leader was a woman, too. When I joined, I wanted to avenge my father's death. In the end, after a year of training, I chose to study art. We were taught oral theater, modern dance, and ballet. I continued doing theater studies.

In 1972, I began working as a television announcer. I read the news on the radio and also dubbed a film. In 1973, I was the newsreader for the Army television channel, which I continued doing until the Khmer Rouge took Phnom Penh. My brother, my mother, and I were asked to leave the city just for a few days, so the Khmer Rouge could reorganize things. We eventually reached my mother's village, Kien Svay. Money was no longer worth anything, and you had to pay with rice instead of bank notes.

At the time, single people were nicknamed 'the primary forces,' and they had to dig irrigation canals. I dug one at Chong Ksach. We would get up at 4 AM, and it was very hard work. I didn't have enough to eat. Our meals consisted of one bowl of rice. Eventually I was sent to Banteay Angkor Chey, a place where those involved in politics were taken – either civil servants or people whose parents had been civil servants. I was so scared that I decided to run away. In the end I was sent to a prison at Champouh Ka'ék after being accused of being against the regime, when in fact I had only worked as an artist and television announcer. I became so skinny that my bones were sticking out. I was lucky to remain alive when the Vietnamese came, because lots of the other detainees were killed. I just stayed honest and didn't steal any food.

In 1979, I entered the Royal University of Fine Arts. In 1987, the government confiscated my house, took all my belongings, and I became homeless. Later on my husband and I settled in Beung Kâk. We were both artists. With a few other professors we created an organization to help poor children whose parents had died of AIDS, so they could attend school. I did it because I wanted those children to have a good future. I'm raising funds to feed them up to the age of eighteen, until they find jobs. The money I've invested comes from my work, here and there. I've done some films and some educational programs, too.

I'm a very sentimental woman; I feel compassion for others easily and want to help my country. My desire to help these children gives me strength, and I hope that what I'm doing will bear fruit, but for the time being there are lots of things I still need because it isn't easy to raise twenty children. Later on I'd like to make a film about myself, because I've had quite a full life."

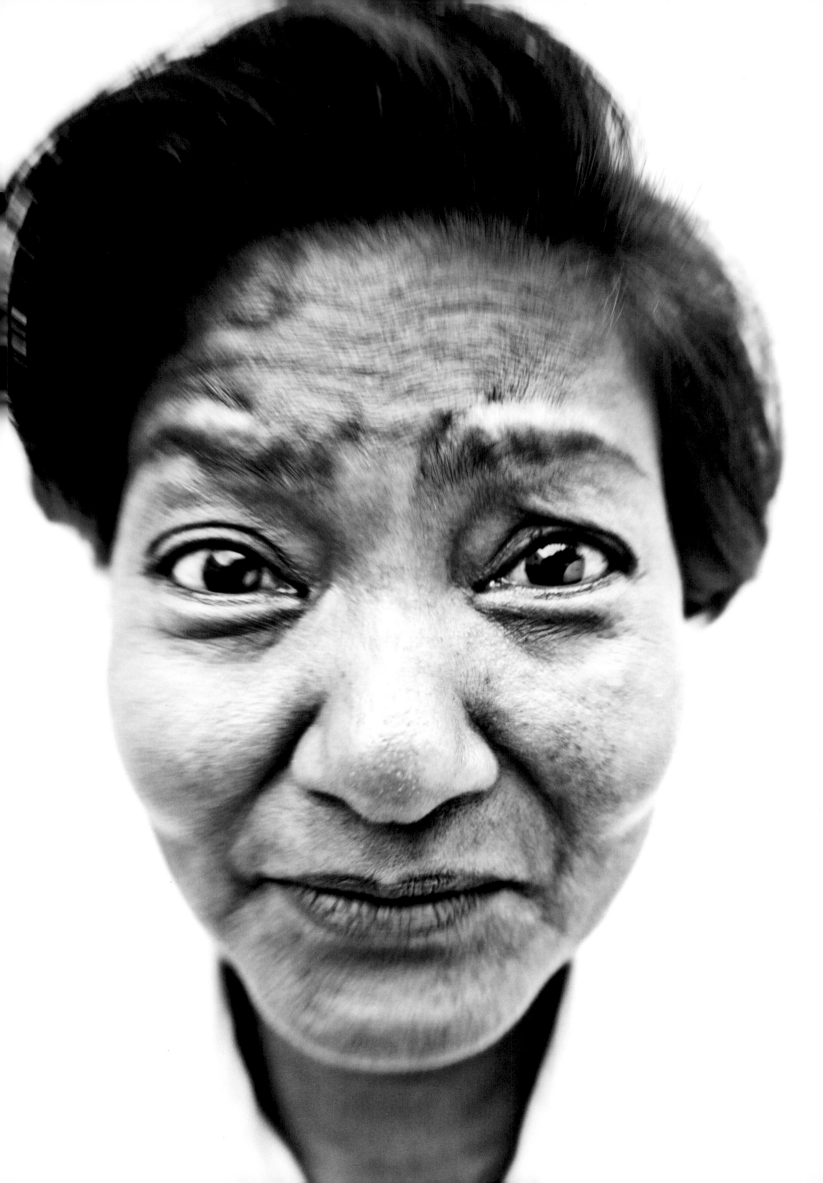

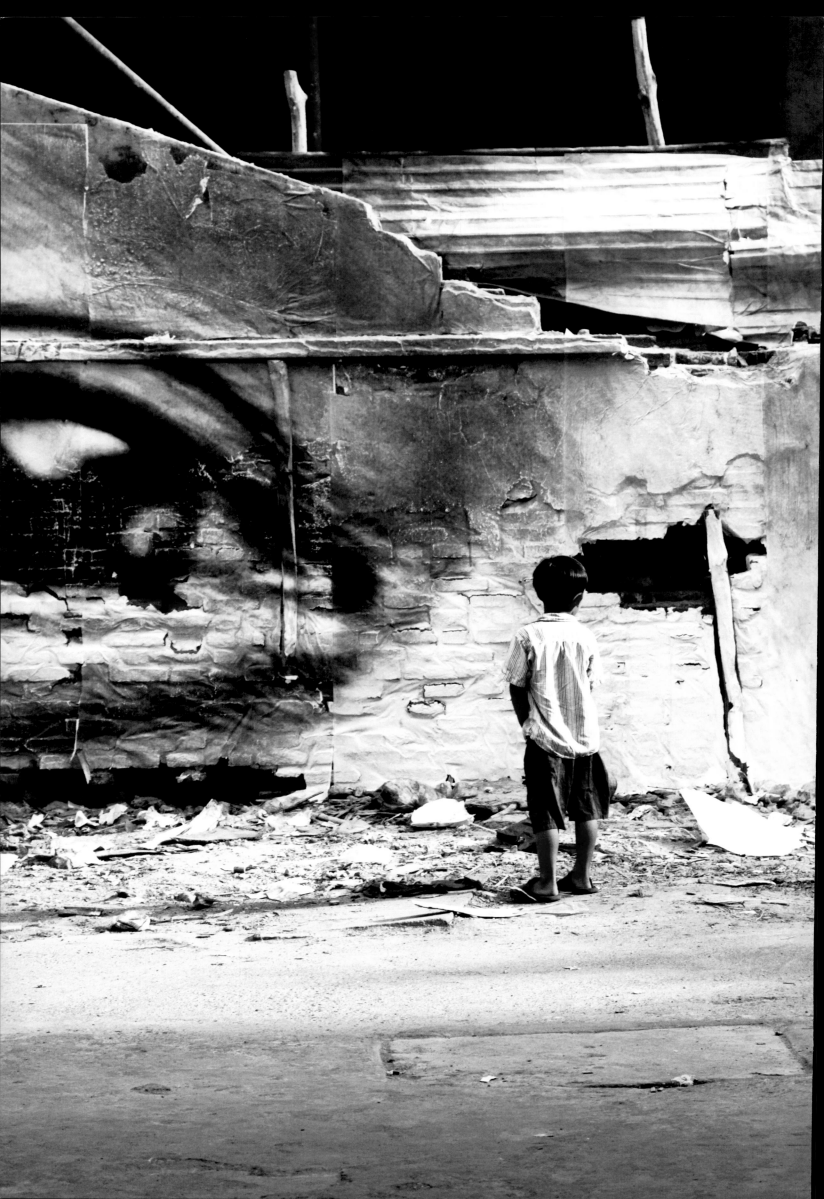

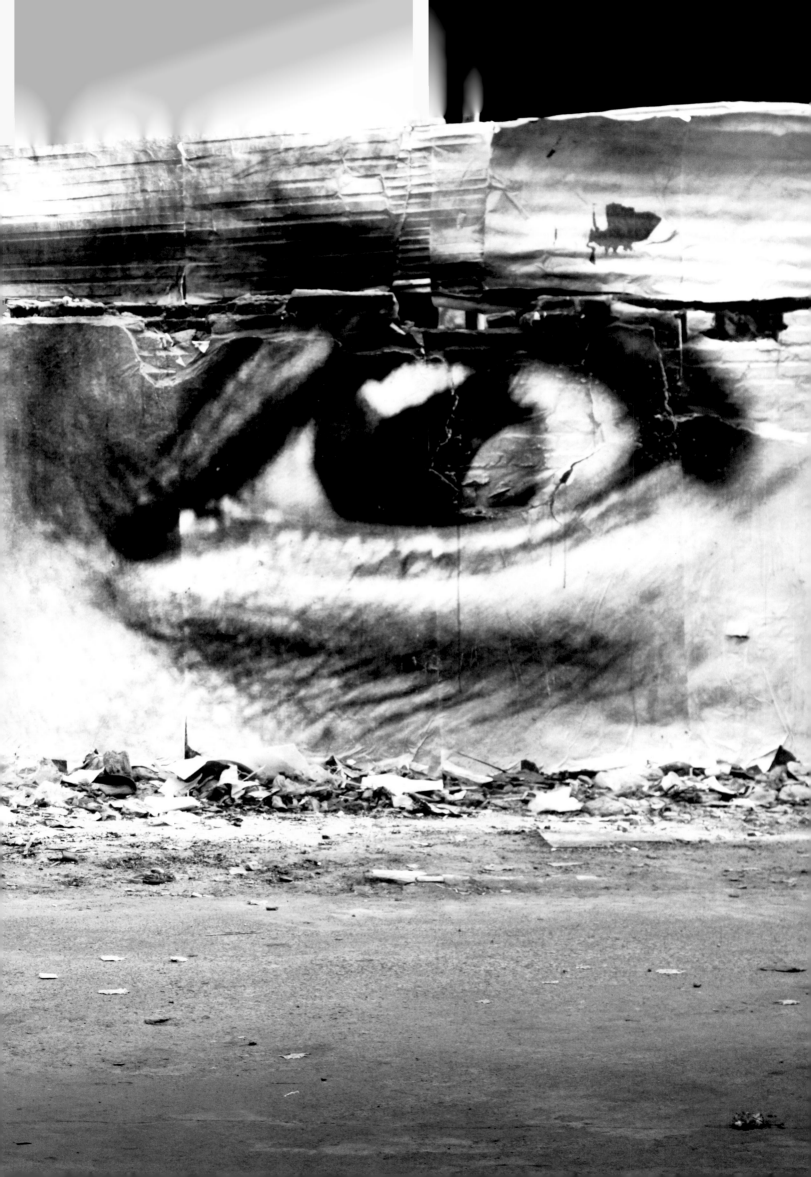

Chantha Dol

"I come from the province of Prey Veng. I'm fifty-one years old. I've known only hardship since the age of eighteen. I came to Phnom Penh in 1989, and my husband died in 1990, leaving me with three children to feed. I lived behind the Russian Embassy, and in 2001 my house was destroyed by a fire. We were relocated to the village of Khmuonh, in Sen Sok township. I had no work and some family members were ill, so I had to sell my land and came to live in Dey Krohâm, where we bought a house. Unfortunately, I was the victim of an agreement between 7NG [editor's note: a real estate developer] and the local authorities, who drove us out in order to rebuild because of that agreement. No one asked us what we thought of the idea.

At first we refused to leave the place. We asked for a decent price, just fifty thousand dollars, because the new houses were going to be sold for between three hundred thousand and five hundred thousand dollars after we left!

Most of those who agreed to sell their land at a low price didn't do so voluntarily. They were provoked into reacting violently, taking photographs of us and accusing us of assault and battery or of destroying other people's property. Those who were afraid of being sent to prison agreed in the end. Others, who worked for the government, were threatened by their bosses with losing their jobs.

Only the women continued fighting to keep their land, because it's easier to find something to accuse a man of, but they couldn't do as much against women. There were little girls, pregnant women, and older women, too. From one day to the next we saw the police coming in with tear gas, bulldozers, and fire hoses to drive us out. We had no other choice but to save our lives. I was wounded and passed out. They sent me to prison, then to a hospital. When I went back to see my house, everything was gone. All I saw was a fence with a sign saying 'Property of the 7NG Company.'

I thought I was going to be able to live in peace in Phnom Penh and build my own house, but I've lost all hope and don't feel free anymore. The government relocated us to Damnak Trayeng. Some people live in the pagoda, at the market, in the streets, or with friends. In the media they made it sound like each family was going to be reimbursed with twenty thousand dollars, but we still haven't received anything. They just gave us a house with no electricity, water, or toilets, and the worst part is that we had to pay a six-hundred-dollar bribe to get it.

I agreed to have my photograph put up so that the men in power in Cambodia would open their eyes and take a look at our condition. The reason my eyes are so wide open is to show my anger. Words are no longer enough. I want people to ask themselves why these photographs of women were put up on the walls of their houses."

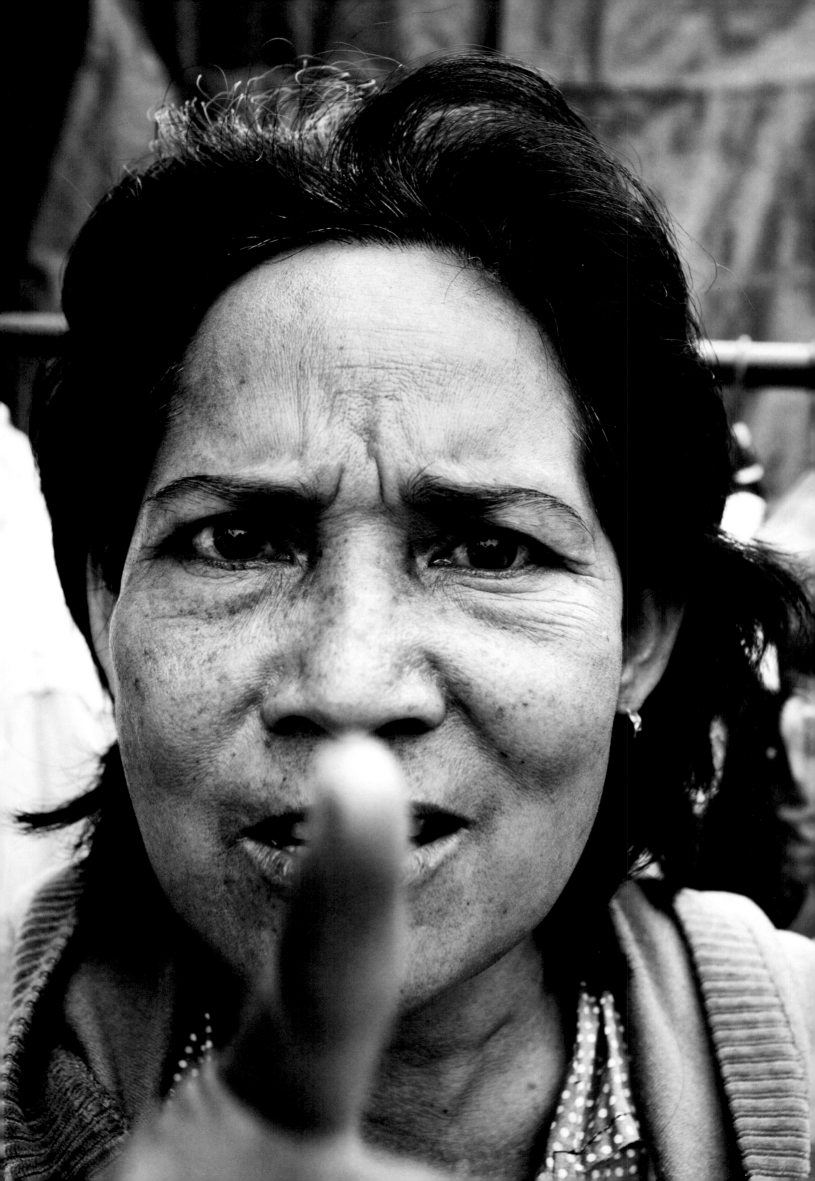

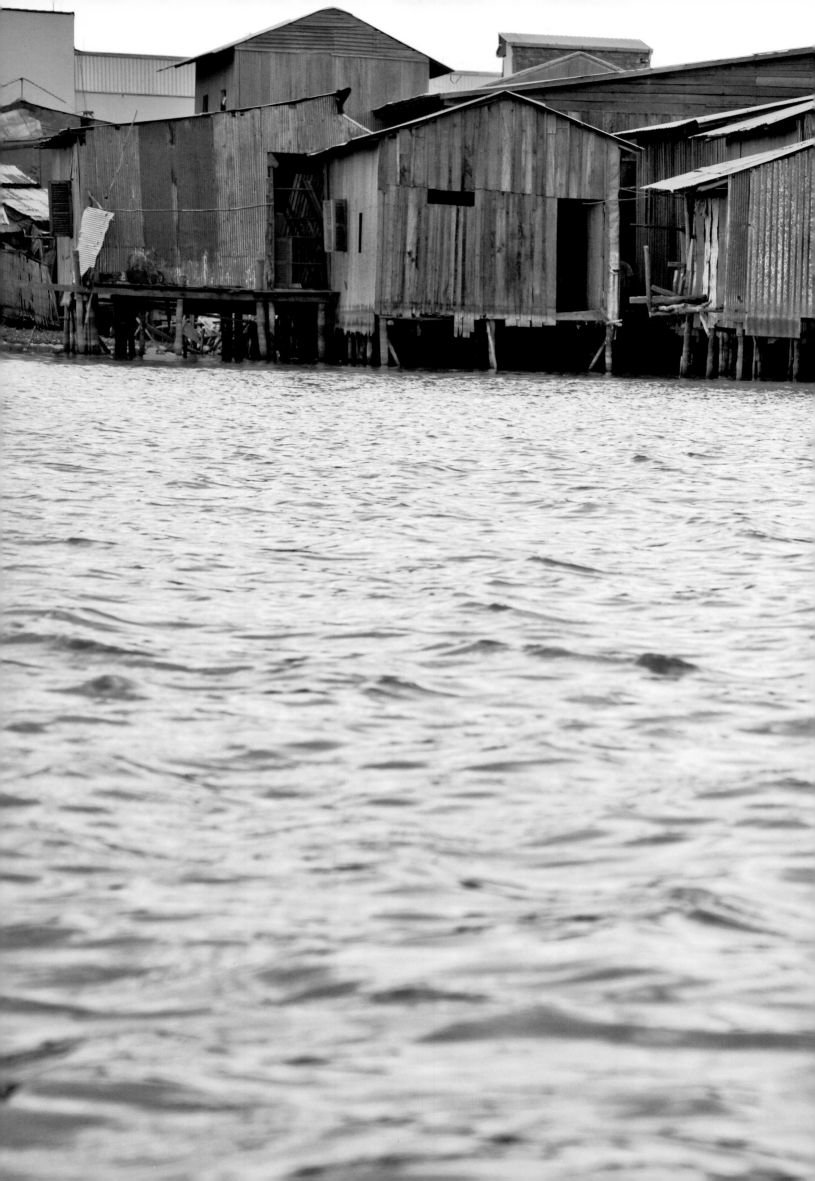

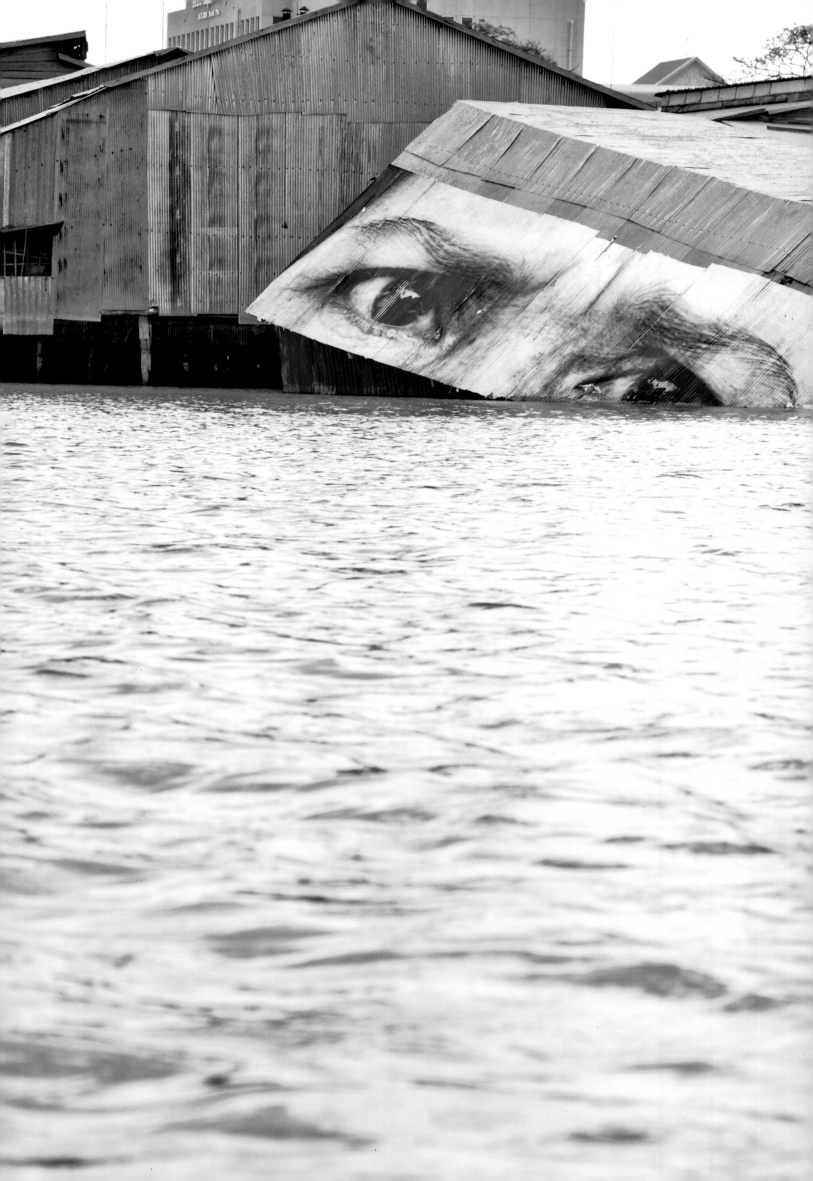

Sinou Vissaka

"I was born in Phnom Penh in 1952. I learned French at Malika primary school, which the royal family attended. My father was a civil servant. I was lucky to study there, and I'm very proud to be able to speak French today.

Three days before the arrival of the Khmer Rouge, my first husband and I went to Battambang. That's where my husband died. They killed him when we got there. It's a sad story that I'll never forget. My husband was a good person.

After that I lived in the mountains for nearly four years. At the end of the war I was alone with a group of handicapped friends. We walked to Phnom Penh. Living in the street, with no family, I felt sad and alone and had no desire to live. I hoped my husband might still be alive because I never saw his dead body. In the end, my desire to find my family gave me the strength to live. When I went to see our old house, I took a piece of coal and wrote on the wall 'I, Vissaka, am still alive,' with the date. The message was for my family members.

Before 1970 I was chosen to be on the national volleyball team. They were taking all those who had been picked nationally to the Olympic Stadium. I went, they gave me something to eat, and a place to live. I worked as an accountant and administration assistant.

Then I remarried in 1980 and had two sons. Since then I've been both "father" and "mother" and have taken care of my entire family. Sometimes as I was leaving the office, I'd see husbands coming to pick up their wives, when I had to walk home, sometimes even in the rain. I've been divorced for almost four years now.

My sons were the most important thing in my life. I didn't want them to know about my problems. I was struggling for the benefit of these innocent boys, because I was the one who brought them into the world. All mothers should devote themselves to their children.

In 1990 there were still no universities. I went to see the director of the Alliance Française to find out if I could take classes to improve my French. He asked me if I wanted to work for him. I thought about it for a minute, and in the end I agreed to take care of the accounting, which I'm still doing.

I'm very proud of myself as a Cambodian woman. I'm especially proud of what my children have become. I led them down the right path. Now they have jobs, they drive their own cars, they're friendly and polite. I'm very proud of them.

This is the first time that I've ever seen such large photographs of myself. People will laugh when they see those portraits of a wrinkled old woman like me! I don't think the people's gazes on the walls of the French Embassy scared anyone. They just didn't understand. That's why they laugh. People here smile when they're happy, but also when they don't understand something."

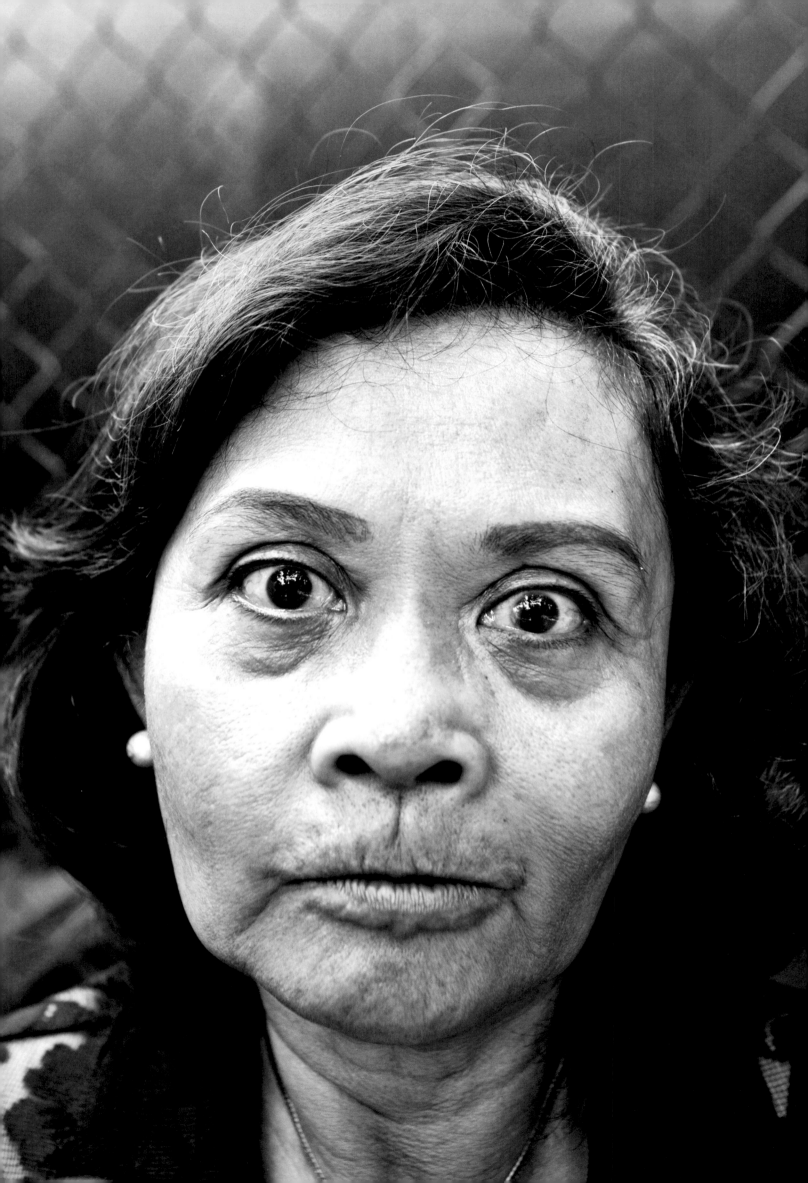

Nou Narin

"I come from the province of Kampong Speu. I'm forty-six years old. I've lived in Phnom Penh since the age of ten.

Under Pol Pot, I joined the young girls unit, where I learned to sing. I wanted to become a professional singer, but the regime wouldn't allow it. I trained several hours a day, but they made me do the same work as the men – building dikes and digging irrigation canals. Ploughing was the only thing I didn't do.

It was really hard. My father was killed. There was nothing to eat. I can't read properly because I never went to school. After Pol Pot, I learned to sing traditional songs. Now that I can sing and am able to earn my own living, the 7NG company [editor's note: a real estate developer] wants me to sell my house for a small sum of money and a piece of land that's far from the town center and my workplace, which is unacceptable. If the company wants my house, they have to offer a decent sum of money, and then I'll agree to go.

This is a land grant that was given by Samdech Hun Sen, and it belongs to me. I don't think I'm wrong to oppose the company's practices, because I haven't done anything wrong. The problem nowadays is that the law is only for the rich. Those who have money have everything, and they know they will prevail. I'm staying here. I'm sure they won't go as far as tearing down my house, because I'm not a violent or dishonest person.

As a woman, I also have to watch over my children. Most of the children here [editor's note: the Day Kroham district] are not well-behaved, but mine are all well brought up. I want to educate them well so that they find the right path. I think I'm a strong woman. I'm not saying my husband is a good-for-nothing! He works, and as the mother of the family, I take good care of the house, the household expenses, and my children. My husband doesn't know how to do those things. But I think I could do what he does to earn money. I think that even without a man I could work and feed my family.

Women here are standing up to the 7NG company because they've been through a lot of hard times, which is not the case with men. Men only have enough strength to follow us and protect us, but they have no idea.

Since childhood I've always been afraid of poverty, hardship, problems within the family, violence, and war. I'm afraid of the Khmer regime coming back. Other than that, I'm not afraid of anything. What would make me happy would be the opposite of all that: for my family to be happy, for my children to behave well, to have good relations among family members, to have a financially secure life, not to be oppressed, and for no one to make fun of me."

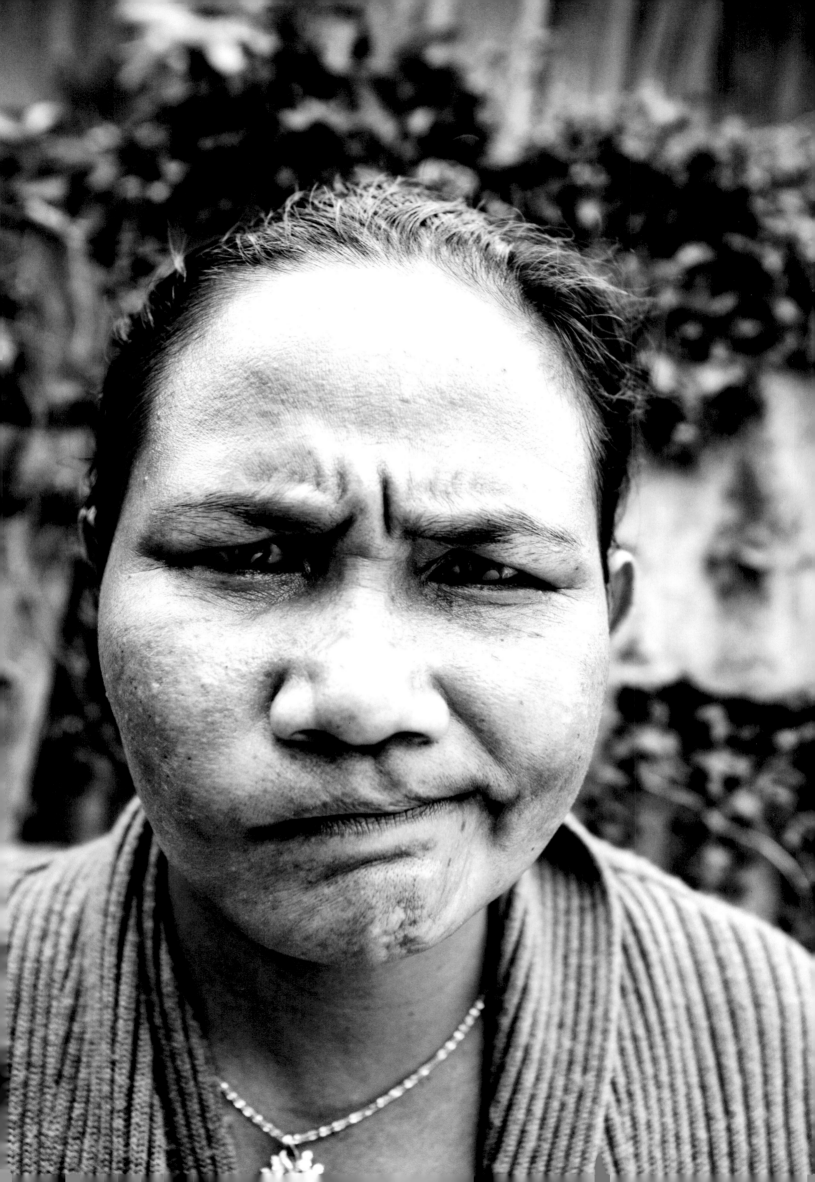

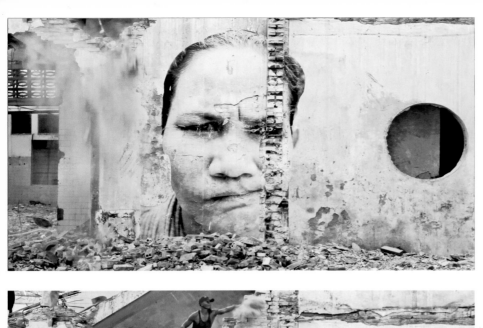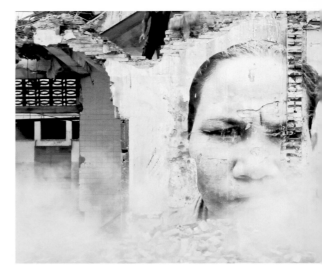
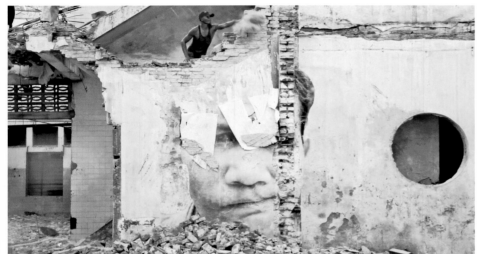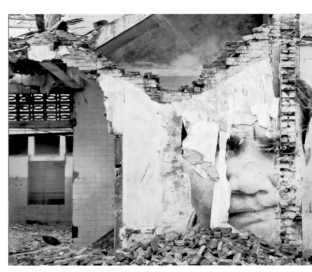
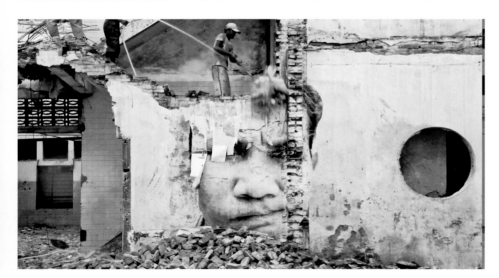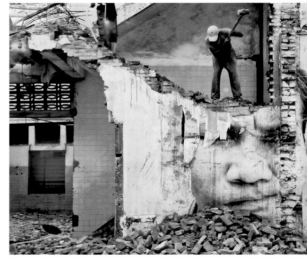
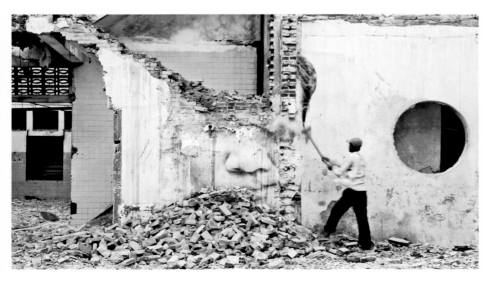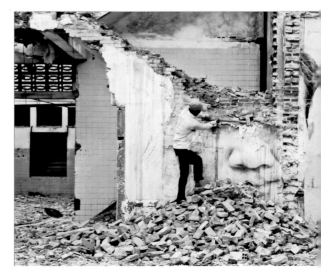

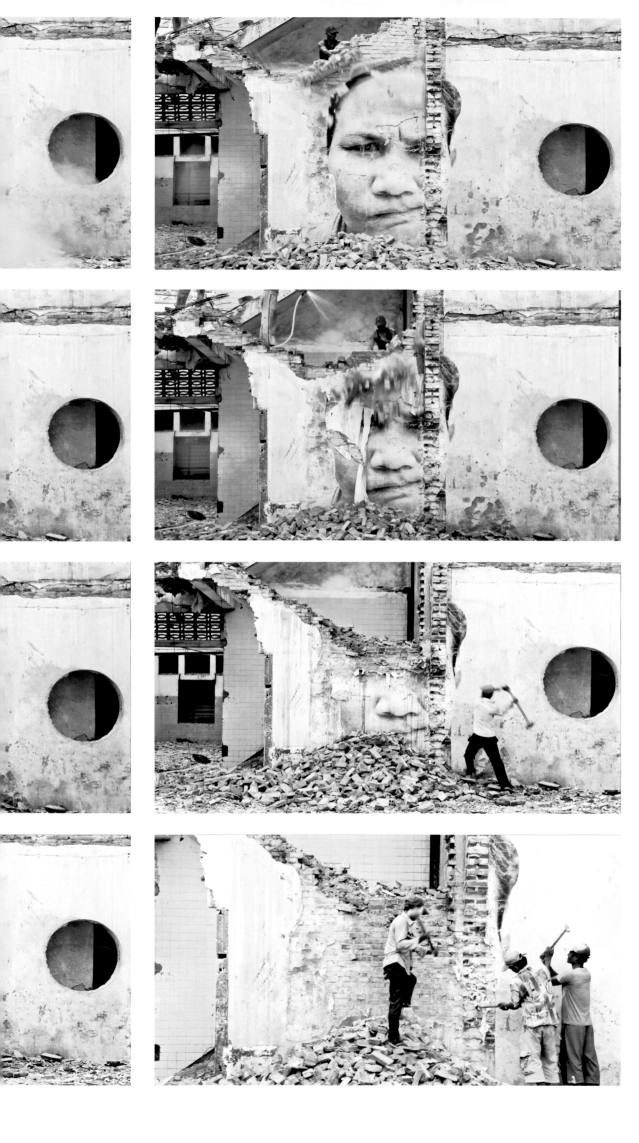

Ratana Loeung

"I'm twenty-eight years old. I was born in Siem Reap. Now I live in Phnom Penh. When I came to the capital, I lived with my aunt in the village of Russey.

After school I would often go to the dump and search through all the rubbish. Once a week I sold what I collected. My life was hard here. My parents also came to live in Phnom Penh. We had no house, so everyone lived at my aunt's. My father's salary wasn't enough, so I left the house and went to Beung Tompon to work.

I didn't have any money to pay the rent, and as the eldest, I had to keep on working. I worked for three years in the Ocean Gouvernent factory. It was very hard. Then I met the director of an NGO who offered me a three-year training position. During the last year I did internships in hotels and management. Once I had finished the internships, I had an interview for a job in a restaurant. In the end, four people were hired. The employer sent us to South Korea for a three-month training course. Since that course, I've been working in his restaurant.

I like cleanliness, beauty, and my skin. When I was working at the dump, I had figured out everything I needed to protect my entire body. I would pick up everything that could be sold, including plastic, glass, iron, cans, et cetera.

I think I'm strong because I've always helped my family. Wherever I've been, I've always saved a bit of money to send to my mother. I worked overtime, day and night. I've always cried deep down in my heart, my whole life long. But no one has ever known it. My heart has never known happiness.

At the moment I'm renting a house, because everything is expensive in Cambodia these days. But I'm keeping the faith and hope to have my own business one day. I've worked hard. I've even cut banana leaves and lotus leaves. I've climbed up trees to cut fruit and tamarind leaves, carrying them on my head to be sold far away from the village. I don't know how to sit around doing nothing.

I'm really pleased to have my photograph taken. You're interviewing me, writing my biography, then you're going to put my portrait up on the dump truck to show other people what kind of person I am. For me these pasted-up photographs are a form of living art that tells the real story of people's lives. I'm not at all embarrassed about showing what I've known and lived through. I hope to represent all the children who have worked in this dump. On the one hand, you're showing these photographs of me, and on the other, the way people live here. Everyone's going to know about it.

Like everyone, I would like to have a family, but if I get married I'd like to have a good husband who loves me, is responsible and honest, isn't violent, and talks things over so we can find solutions together. Honesty and love are the most important things. If I had children, I'd want them to love their parents like I do, because I've always loved mine. Real love isn't a thing, because things can get lost; and real love should never be lost."

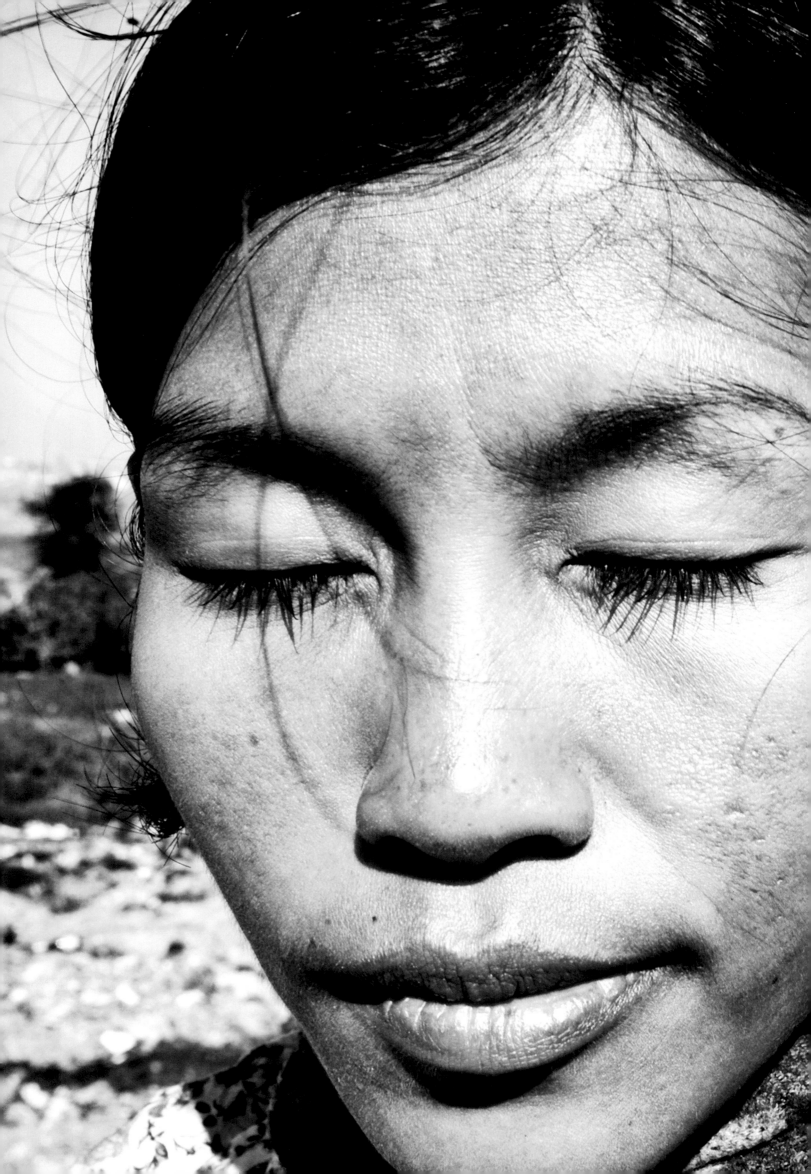

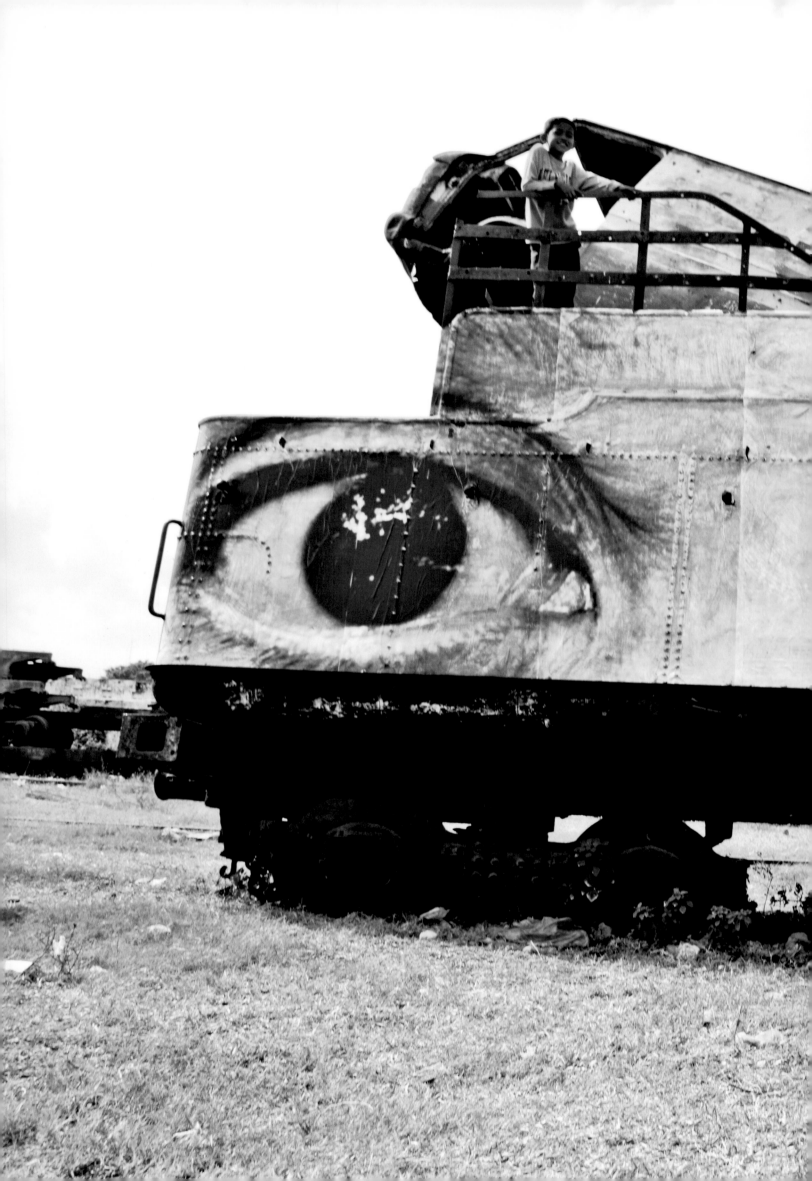

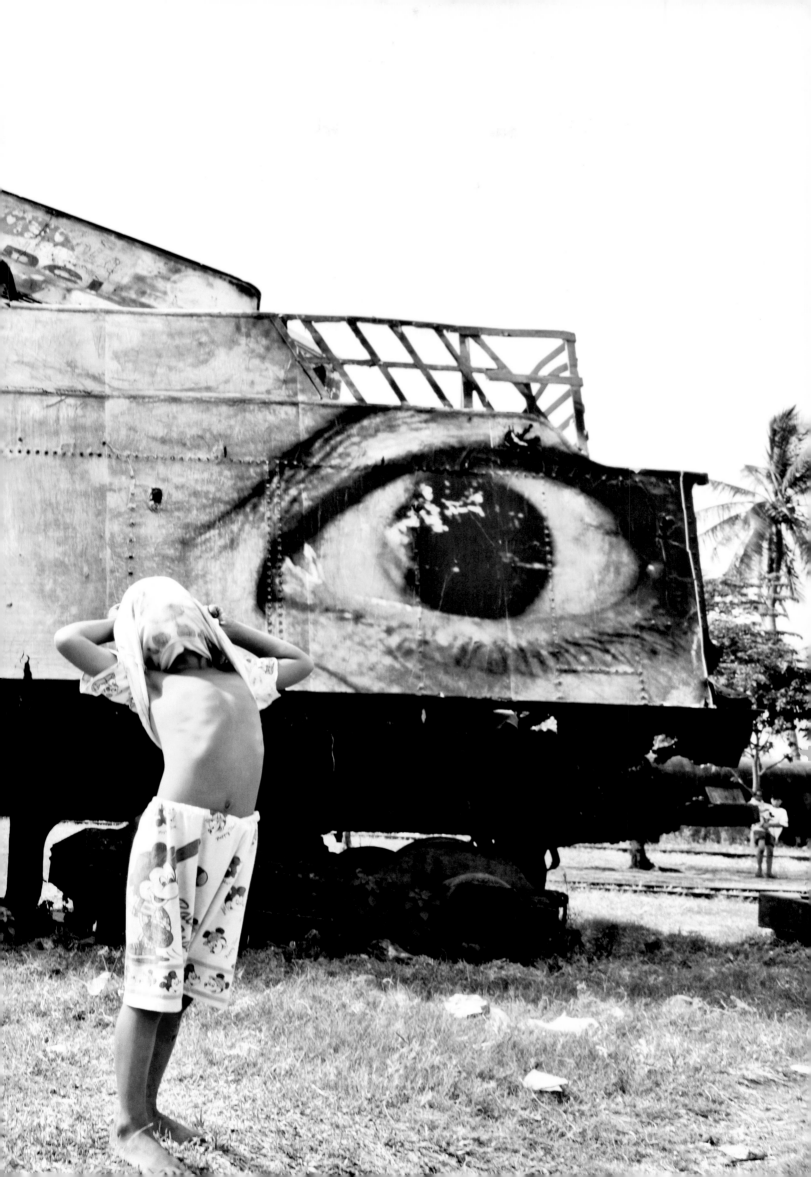

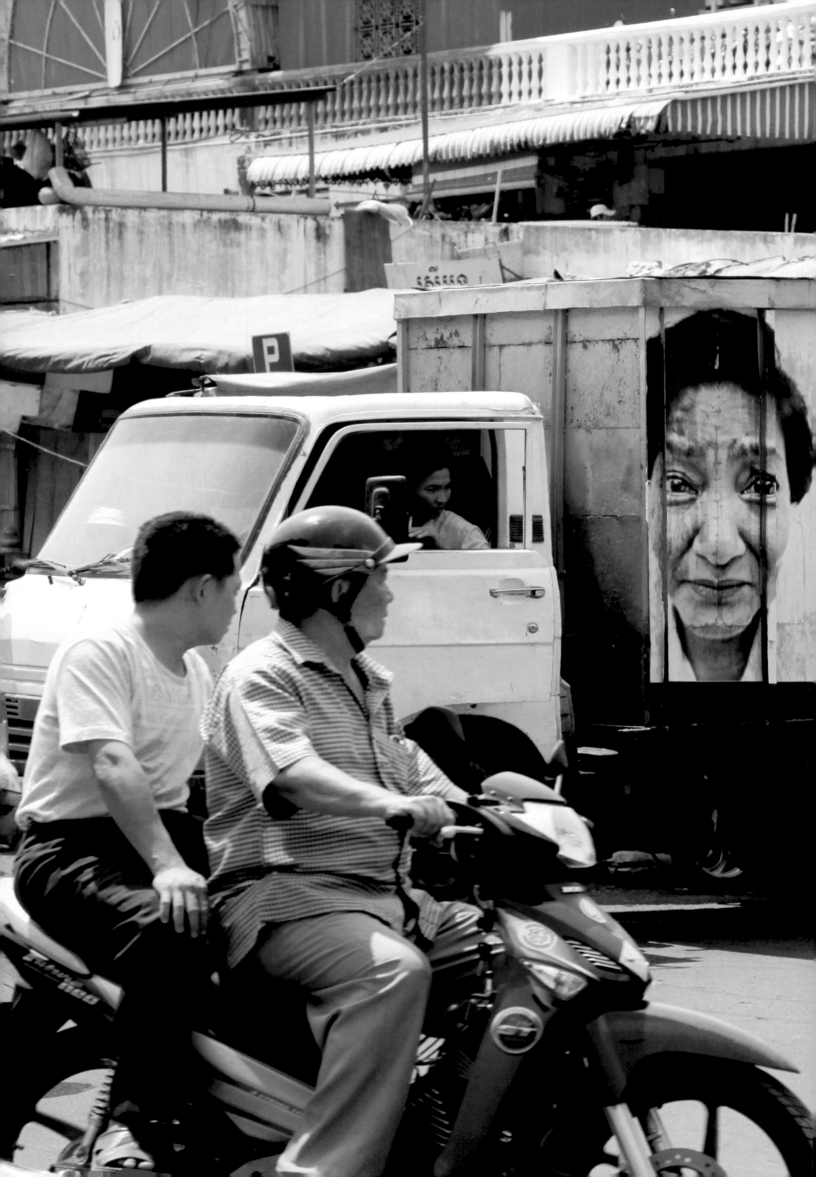

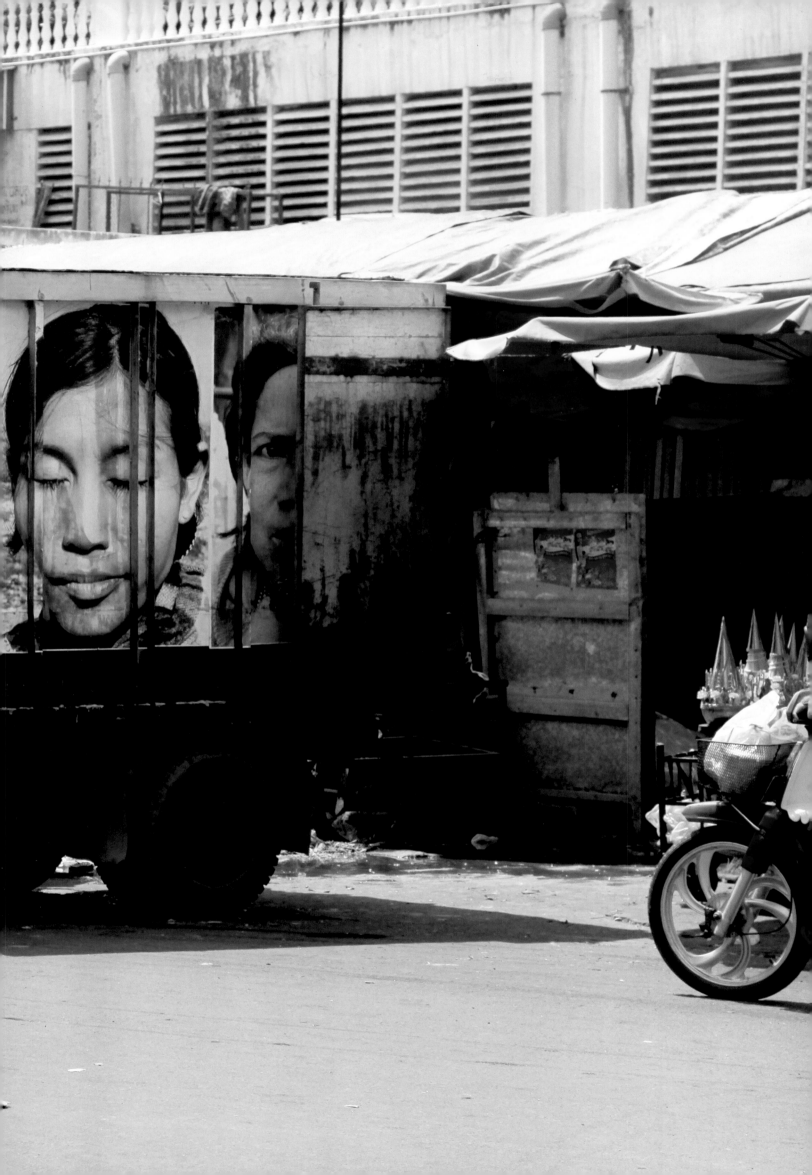

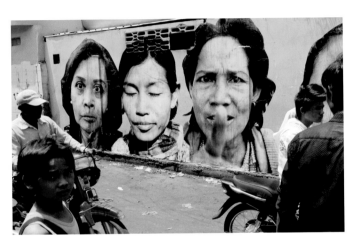

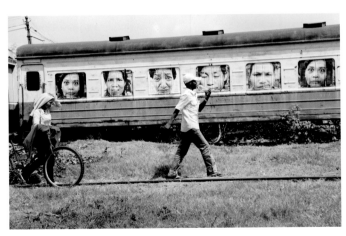

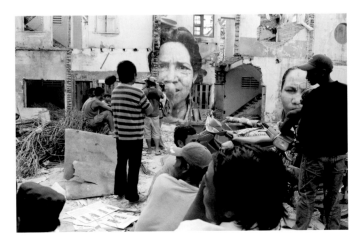

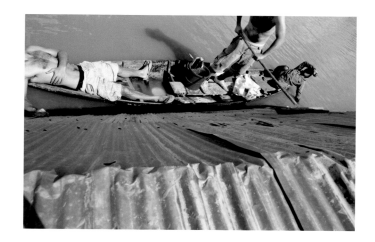

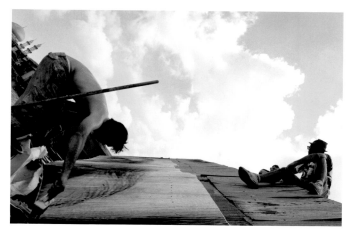

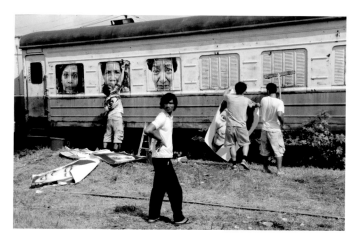

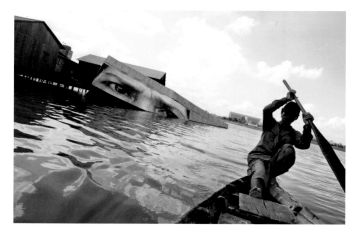

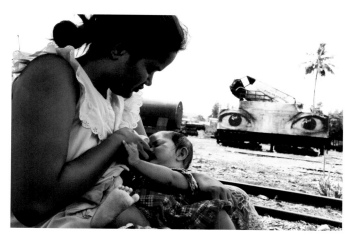

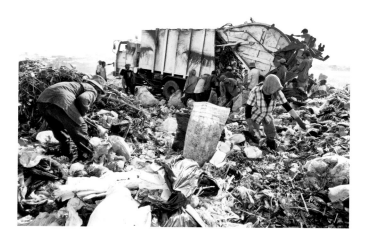

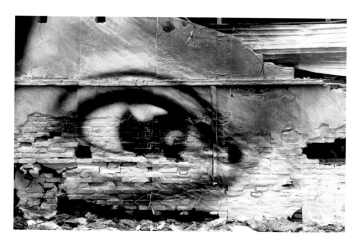

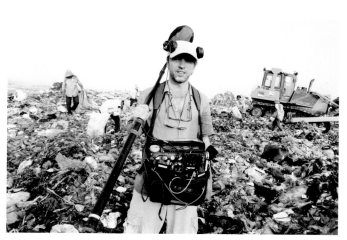

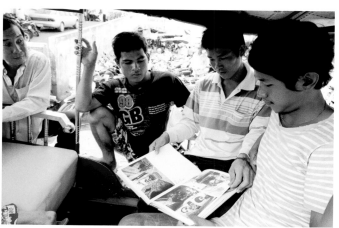

EXHIBITIONS

RIO DE JANEIRO

Several exhibitions held in different countries have enabled the portraits and the women's stories to travel all over the world. This crucial phase has provided a unique way of promoting the project and experimenting with new kinds of exhibits and exchanges with the public and passersby, including large-format posters, video installations, partnerships with the media, and urban audio guides with free access to interviews with these women from around the world.

From April to June of 2009, JR went back to Brazil to take the portraits of women from the favela into the streets of Rio. A gigantic 17-meter-high by 150-meter-long image was displayed on the Arcos da Lapa, one of the city's historic monuments. The street audio guide was used once again, after a successful trial at the exhibition staged in London. The Casa França Brasil hosted several video installations, as well as the community of families from the Morro da Providência favela who came for the opening. Several days later the Casa Amarela cultural center was inaugurated in the favela's heights, offering photography classes for children and legal counseling for adults.

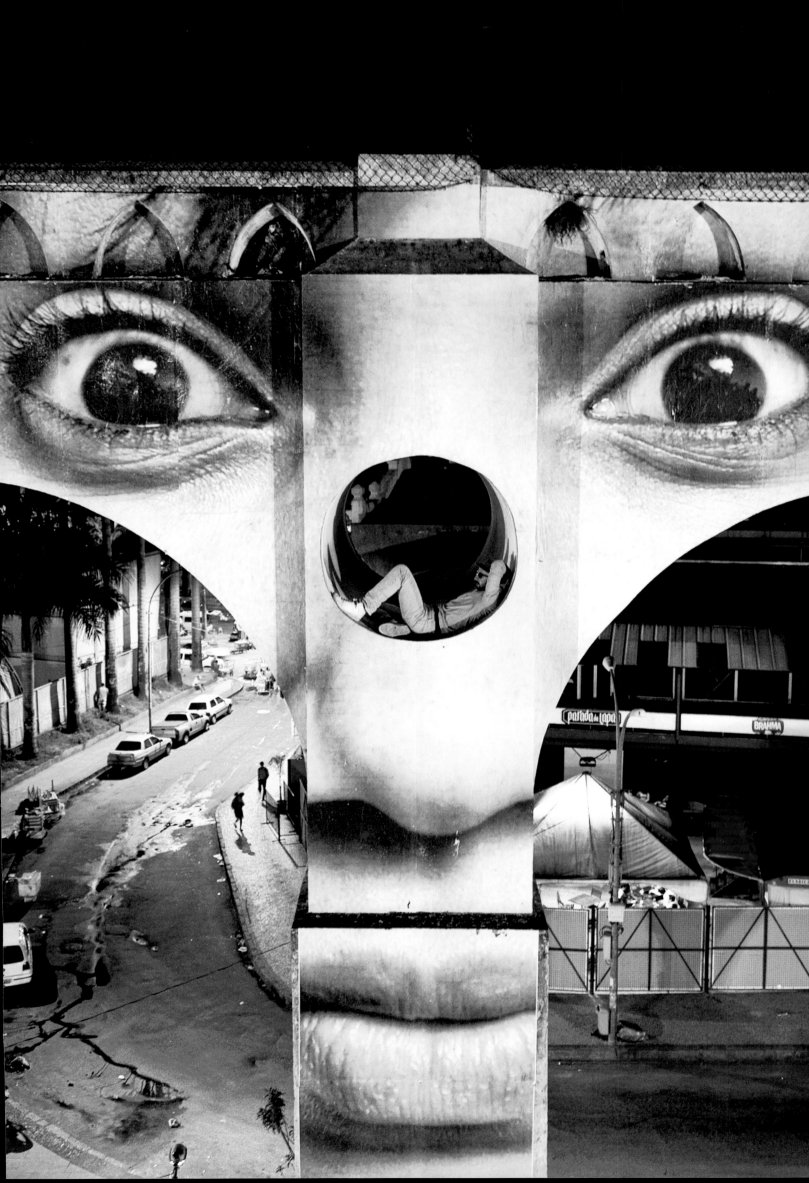

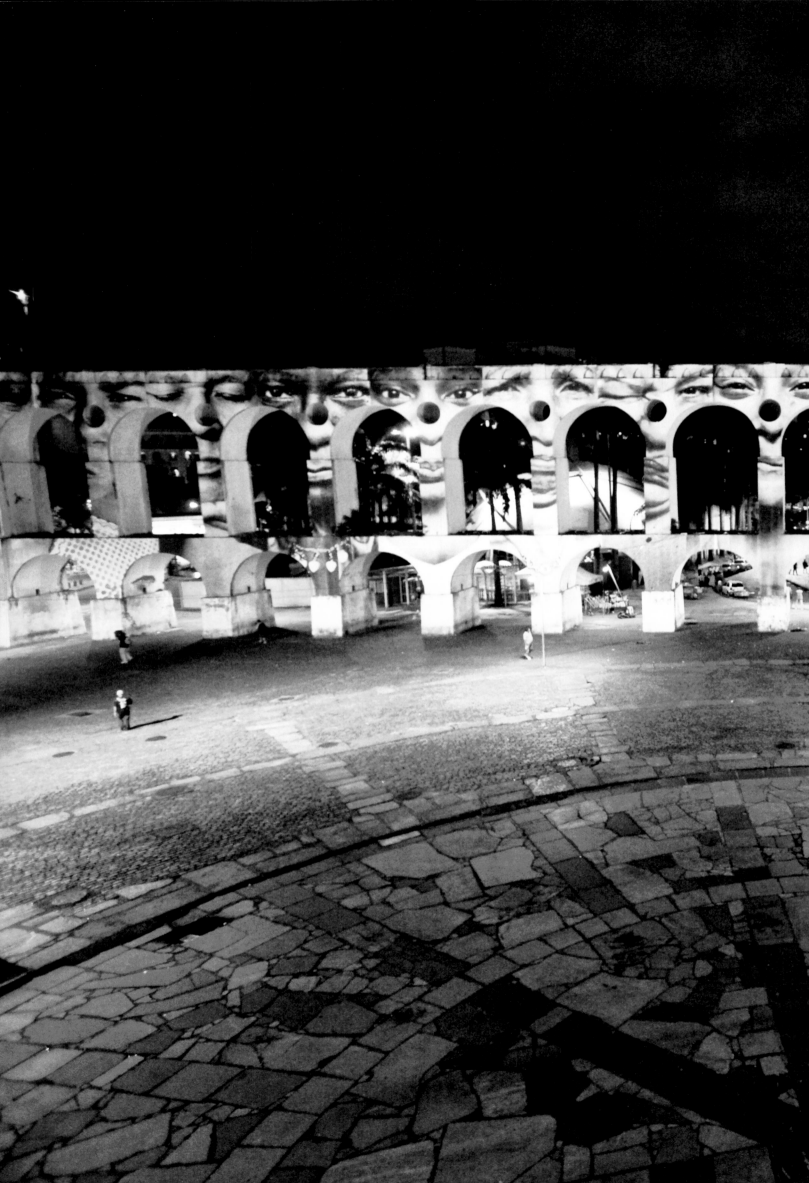

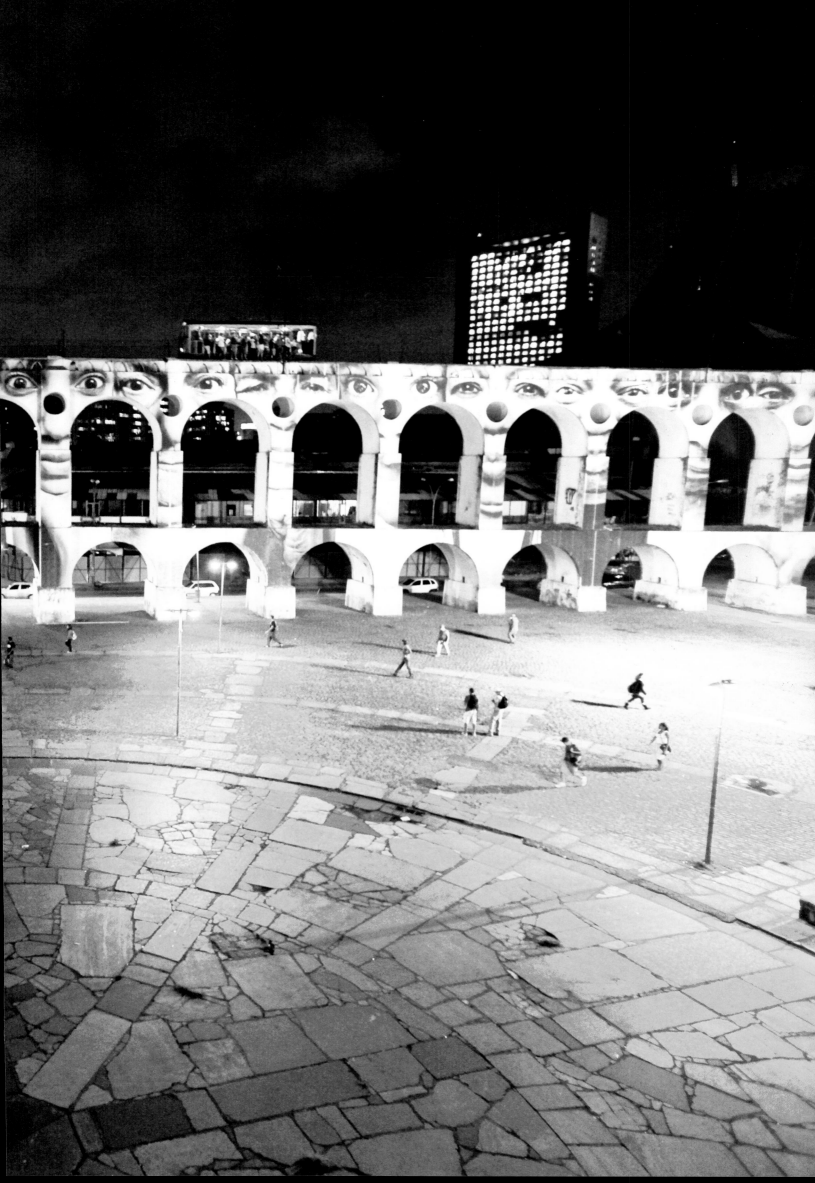

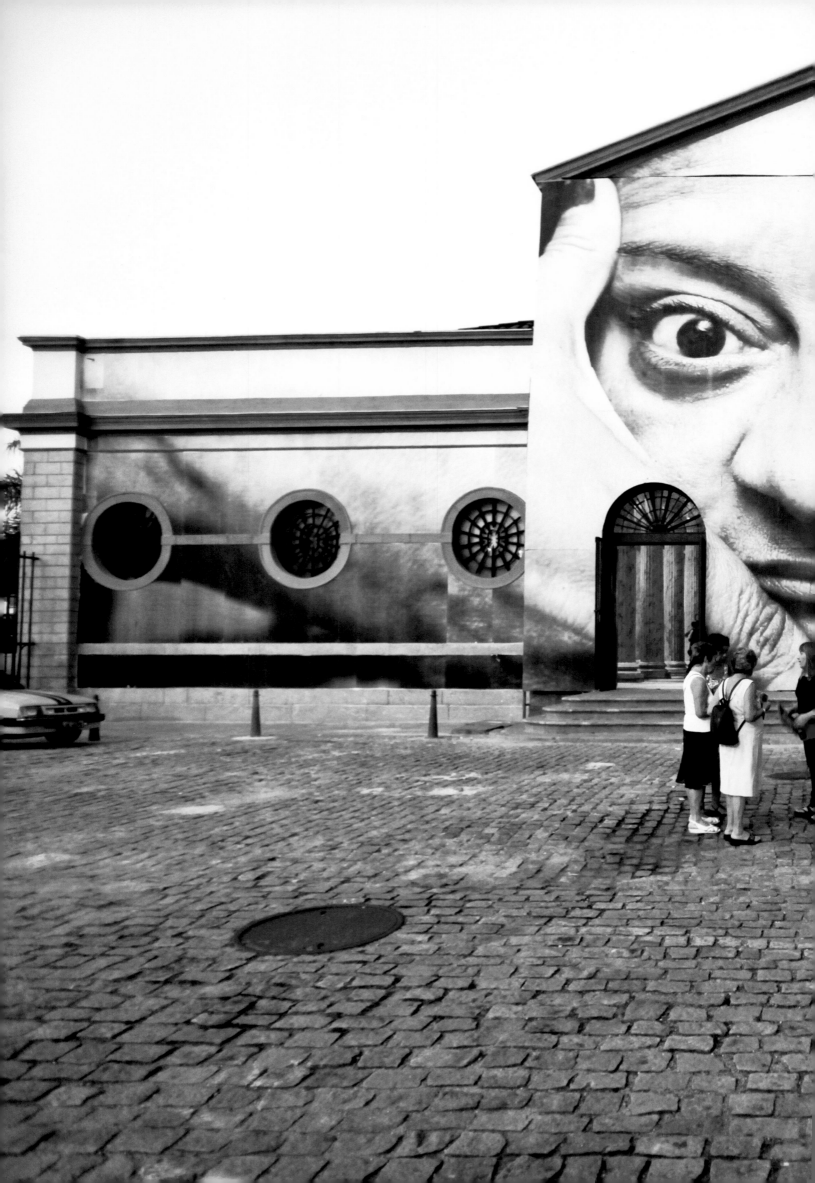

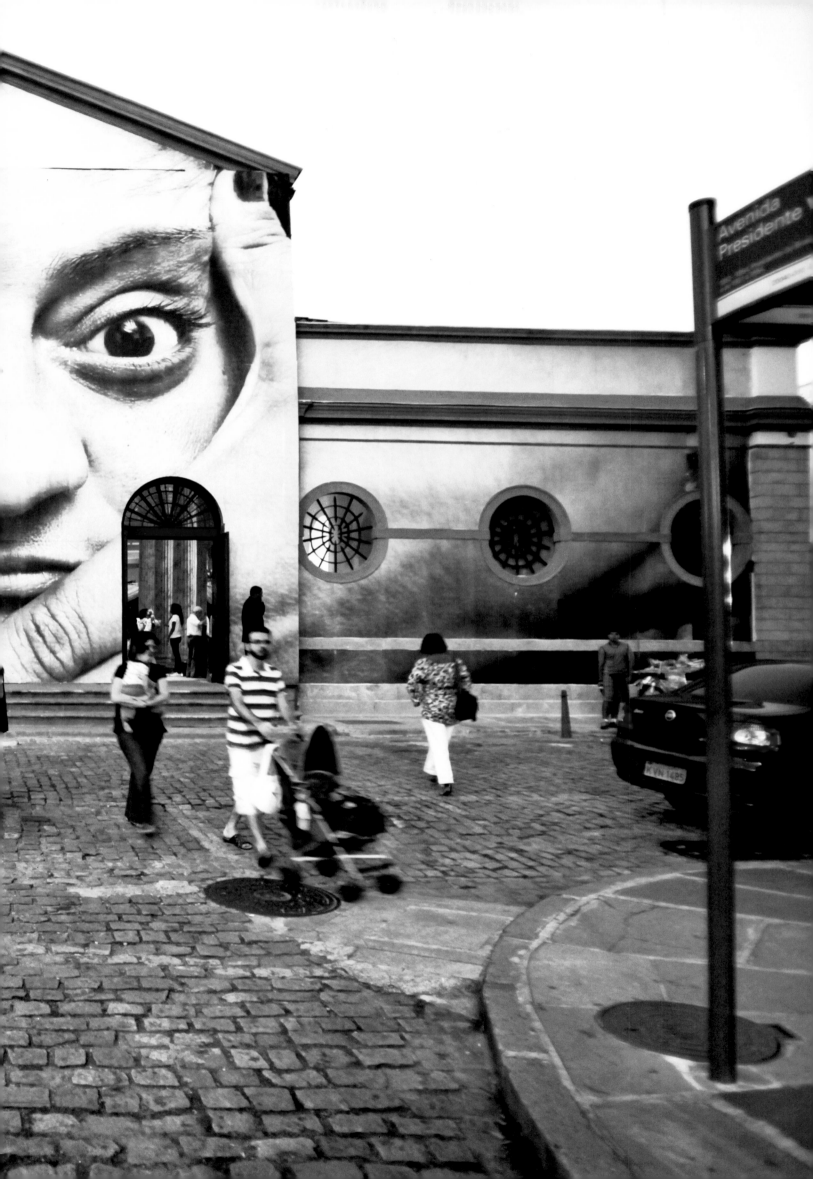

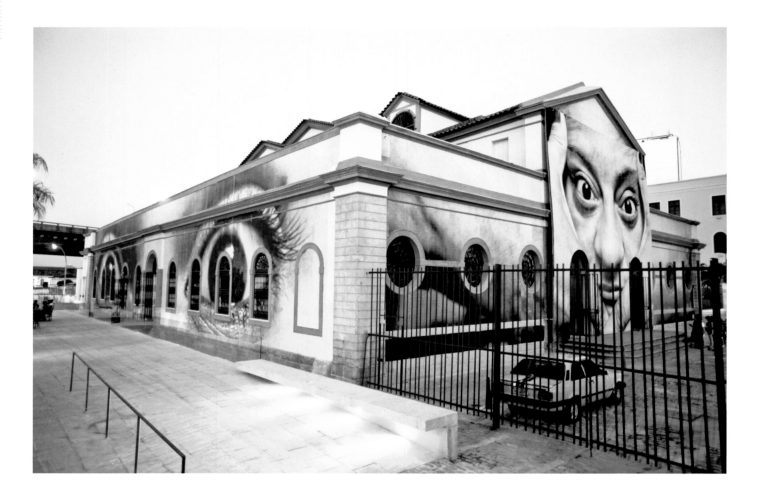

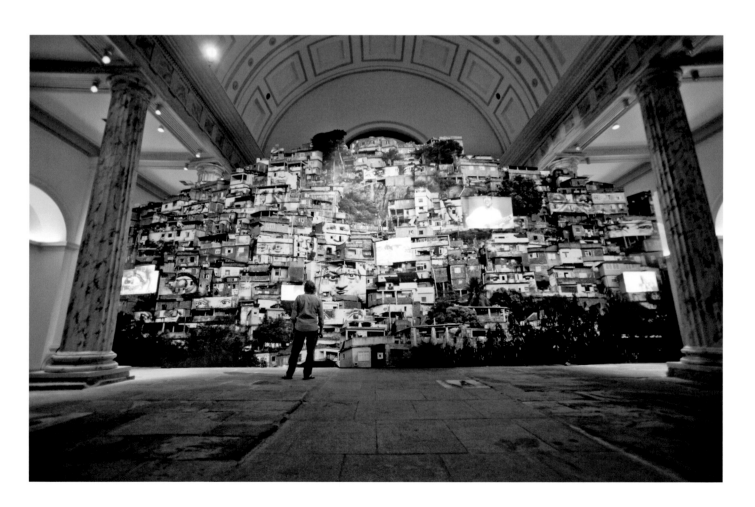

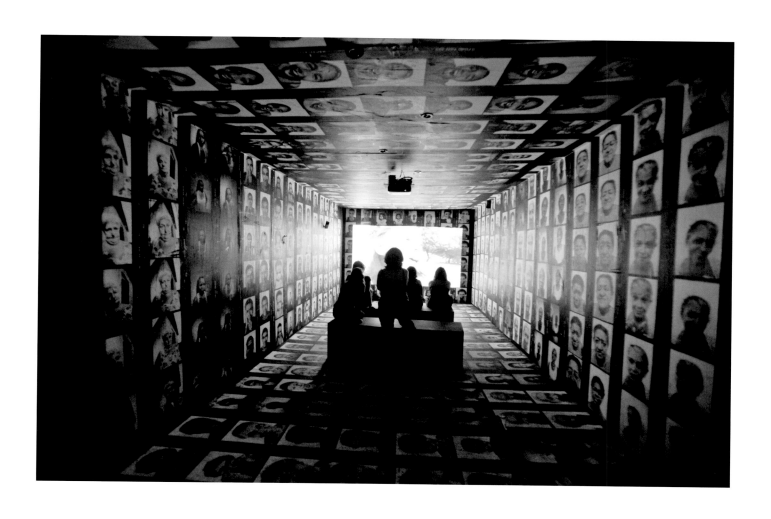

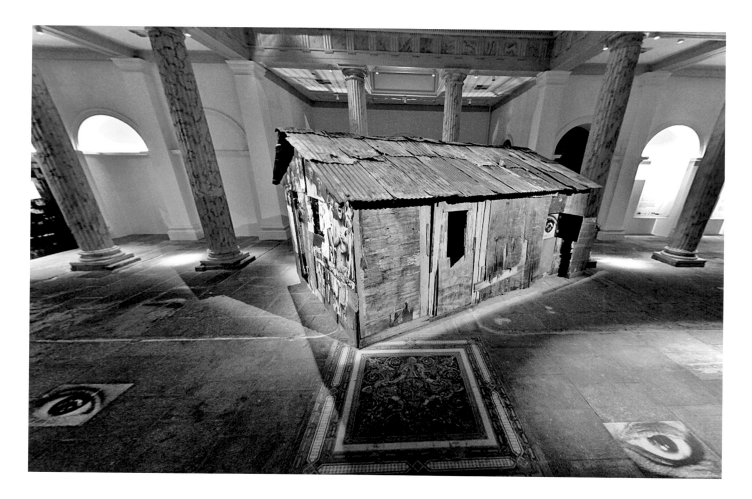

PHNOM PENH

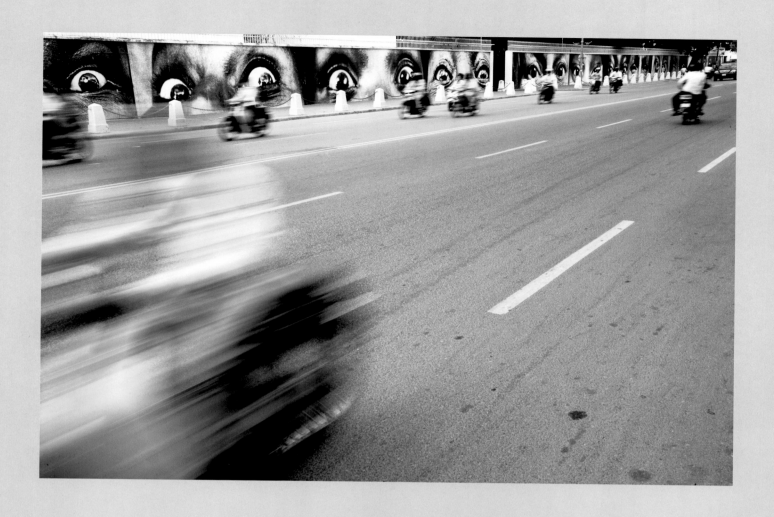

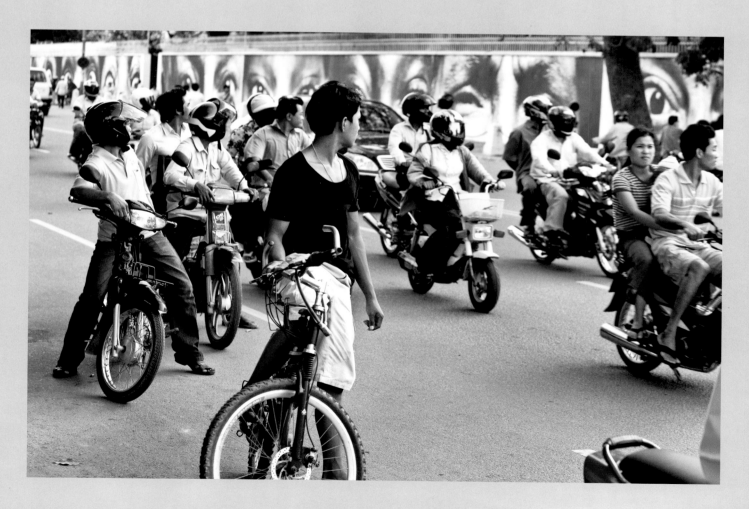

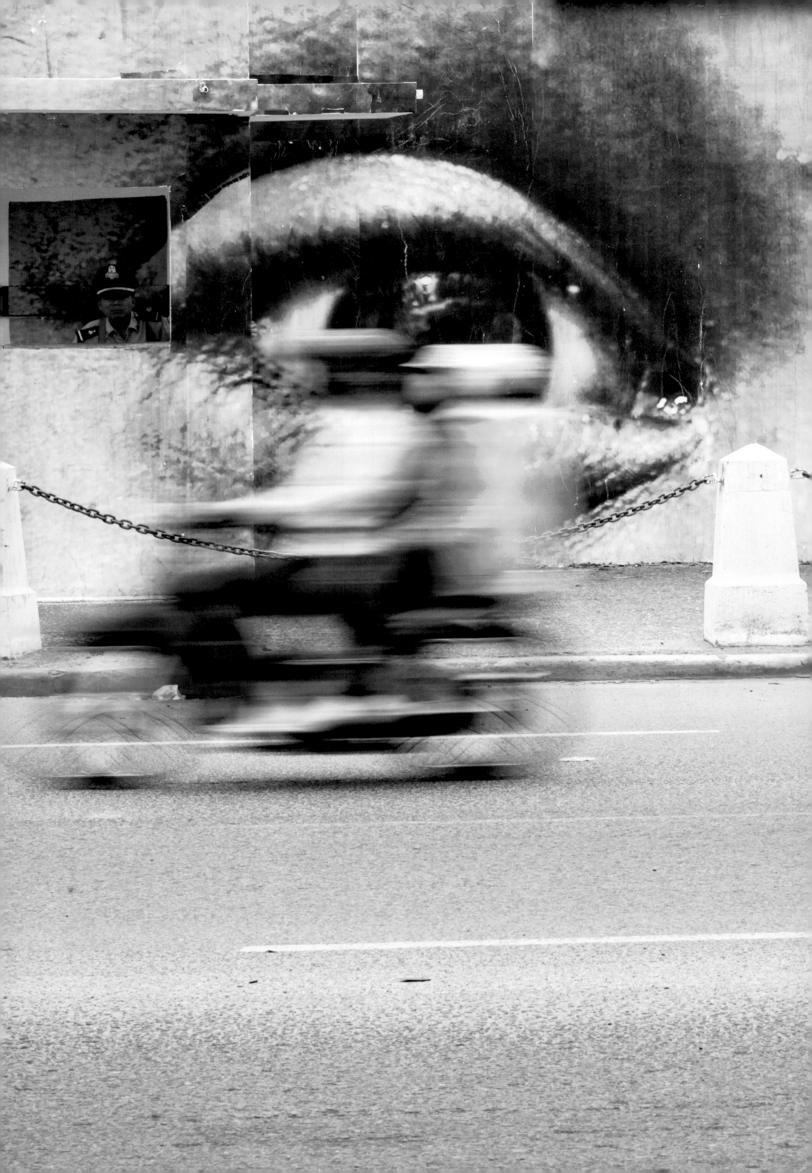

NEW YORK

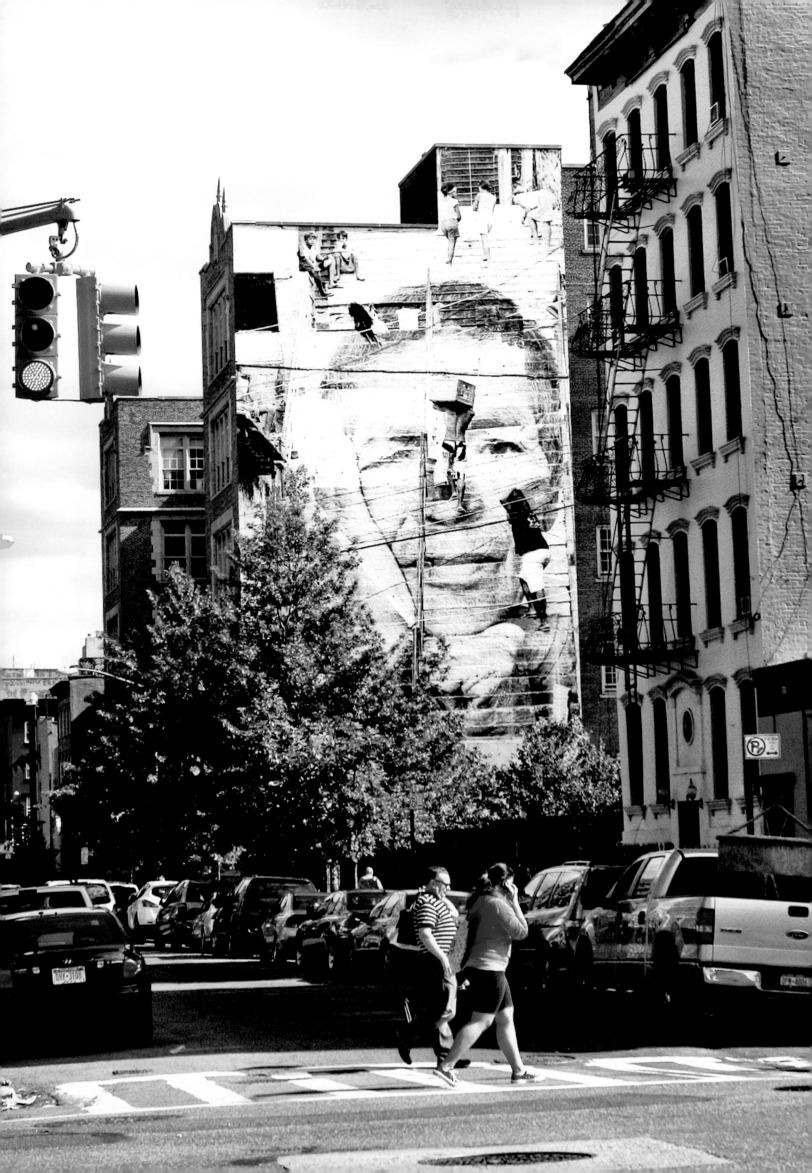

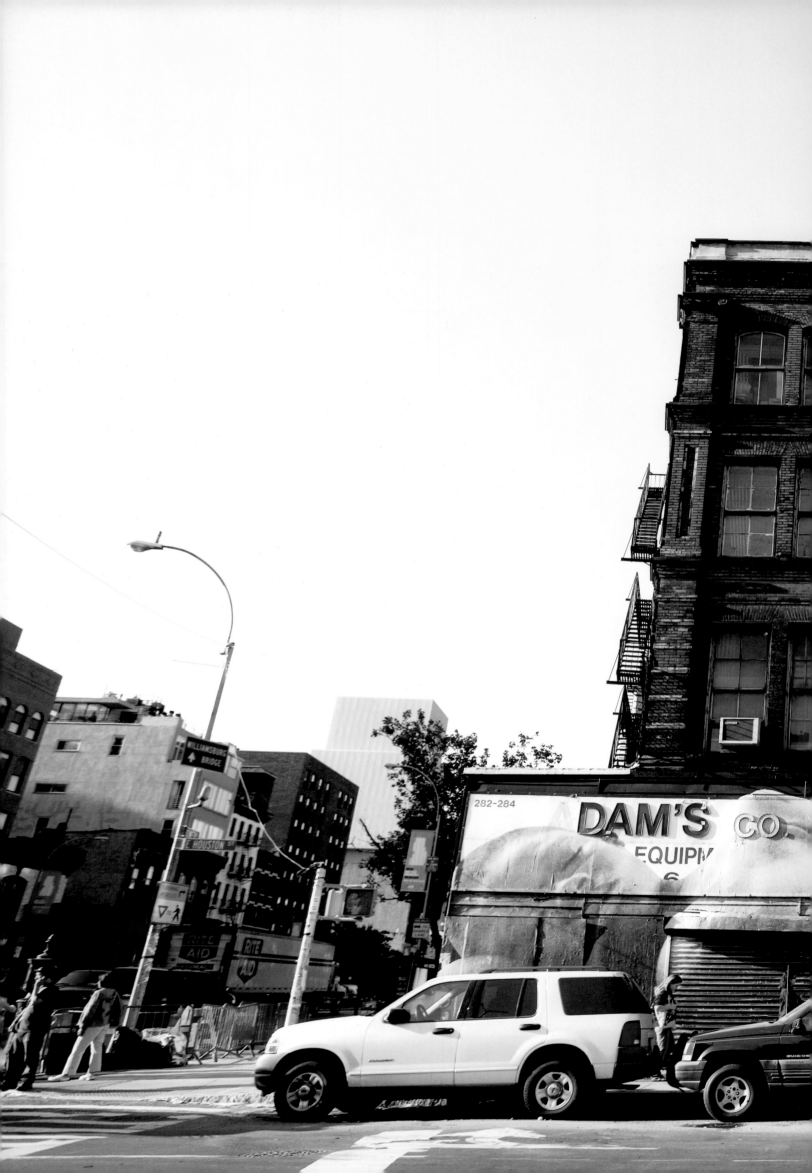

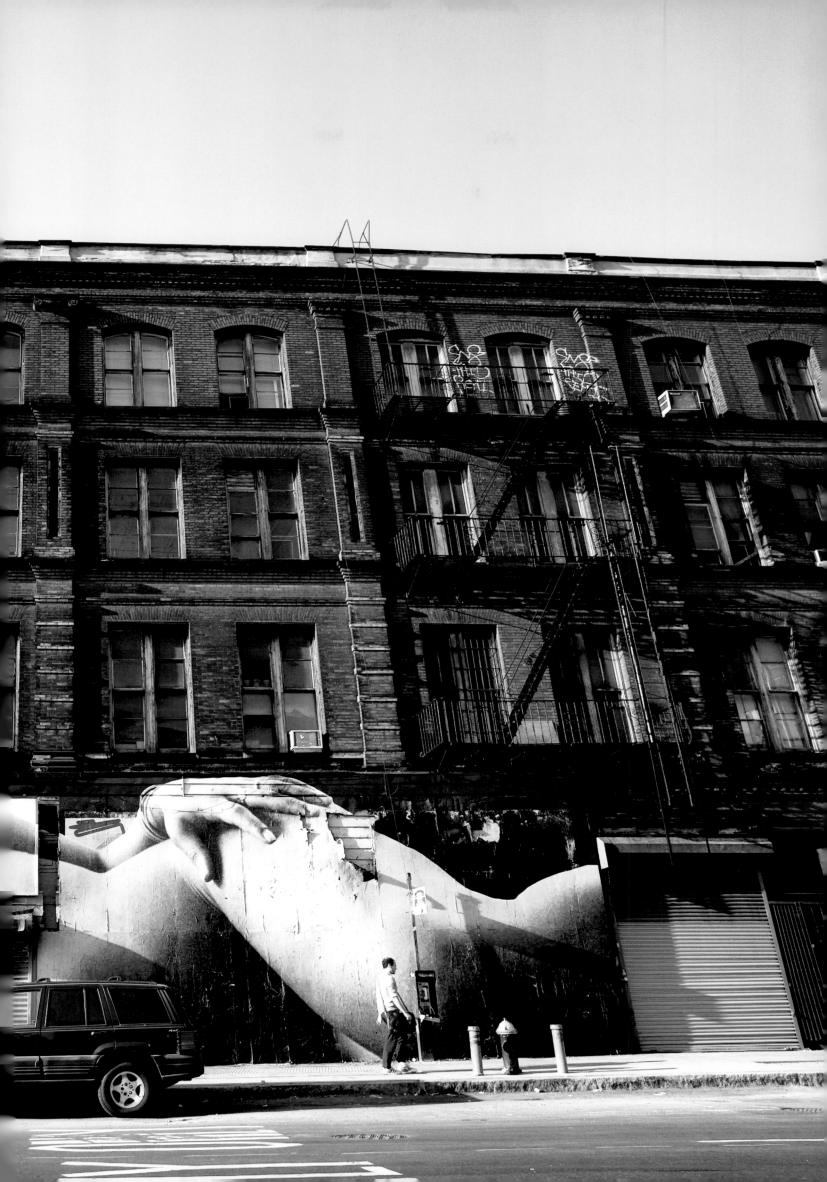

LONDON

October 2008: A month after the initiative undertaken in the Morro da Providência favela, JR was invited to present the Brazilian section of the project at the Lazinc Gallery. He covered Manette Street (Soho) with several huge posters, portraits of women in particular, and presented a video installation.

The viewing public – passersby – could access the women's interviews and stories by dialing a free number on their mobile phones. JR was experimenting with this street audio guide format for the first time, and he used it again in the Rio exhibition the following year.

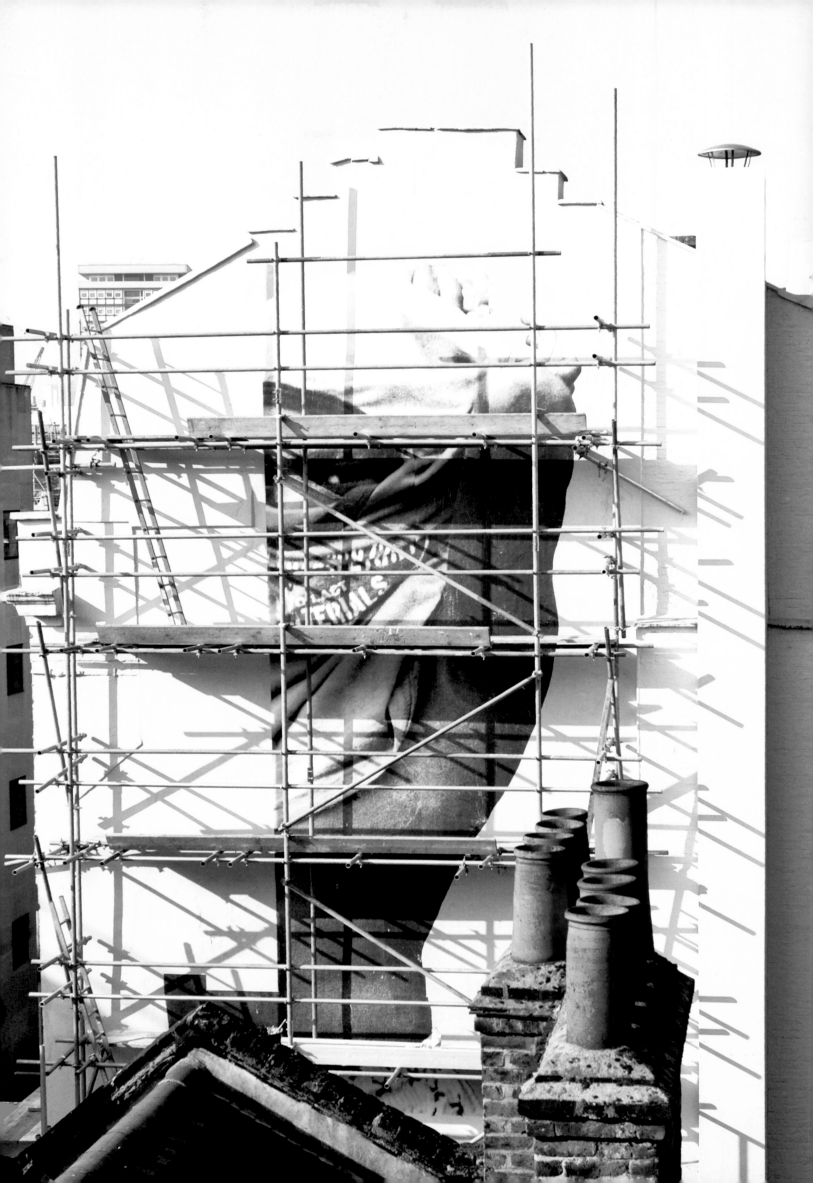

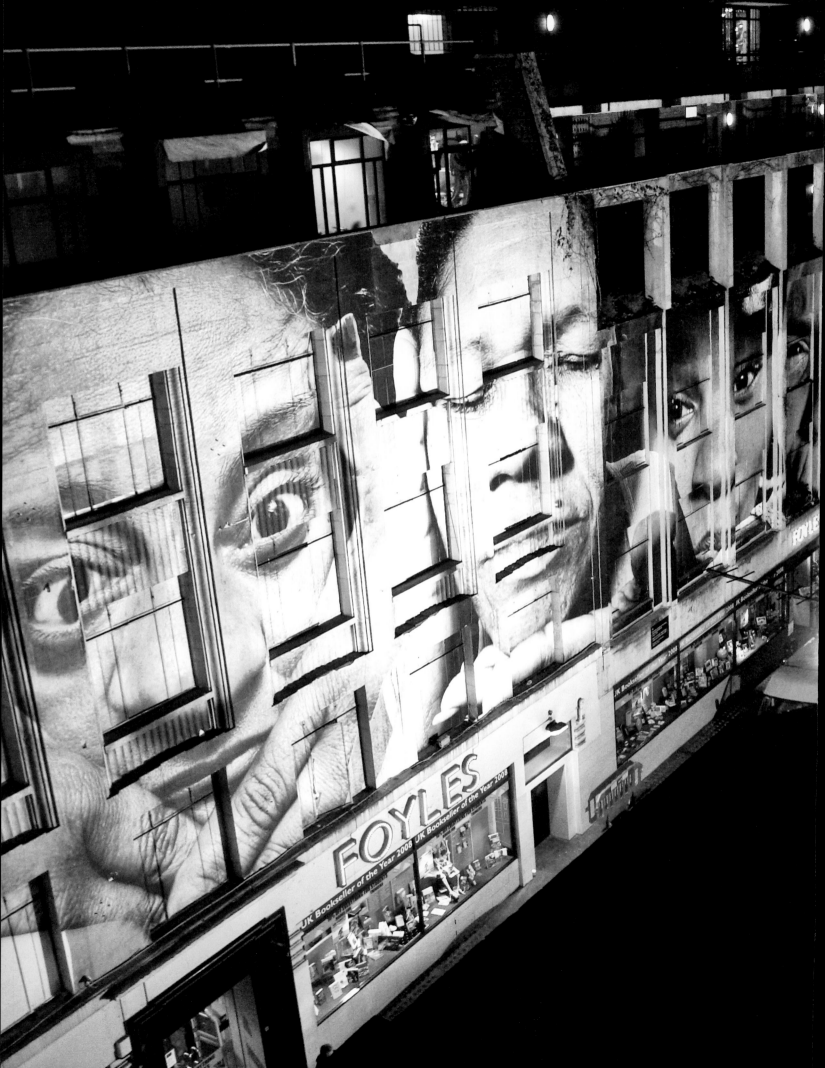

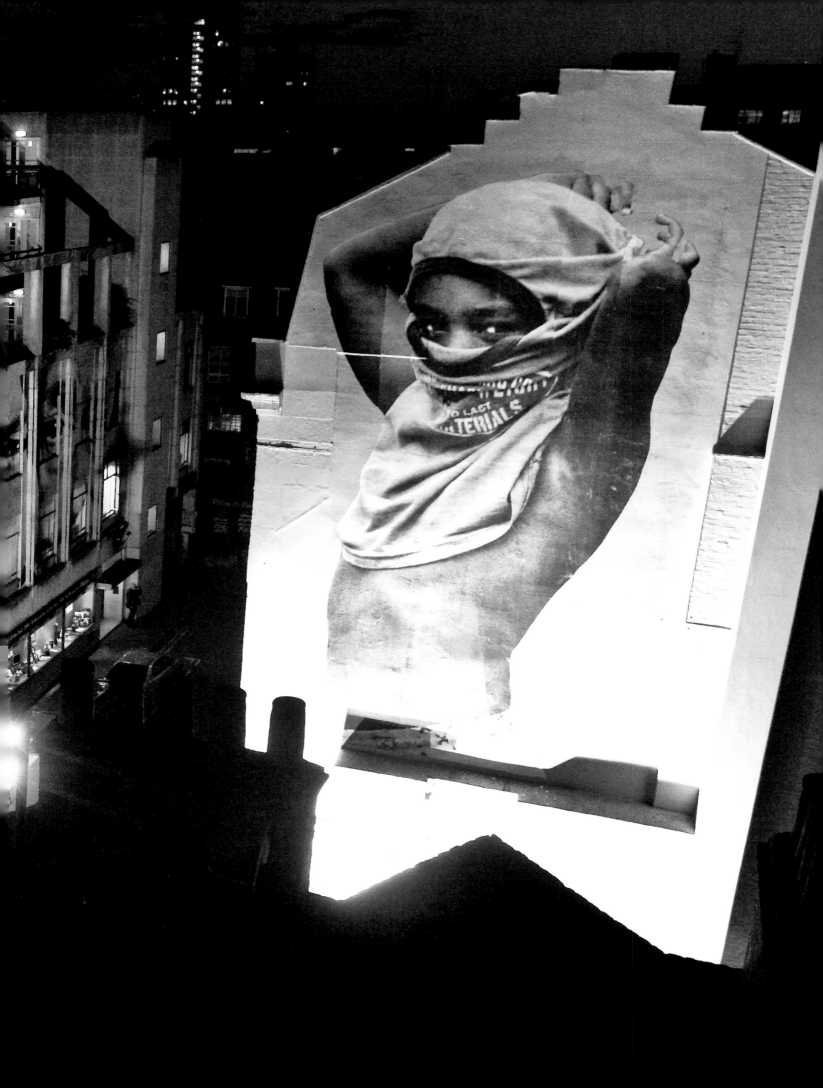

BRUSSELS

March 2008: This was the first exhibition devoted to the project, specifically to the African section. The huge posters were plastered on façades made of various materials ranging from wood and glass to tiles and roughcast. JR used video projectors in an urban environment for the first time, with a huge eye blinking at regular intervals on the Place de Brouckère.

Partnerships were also established with two national newspapers, *Le Soir* and *De Morgen*. JR released two special editions promoting the exhibition and presenting the project. Both newspapers sent reporters to Sierra Leone and Liberia to meet the women who had been photographed and to record their stories. Readers could then easily access the information and make the connection to the giant portraits on display in the streets. It was the best way to provide the women with a forum in western Europe.

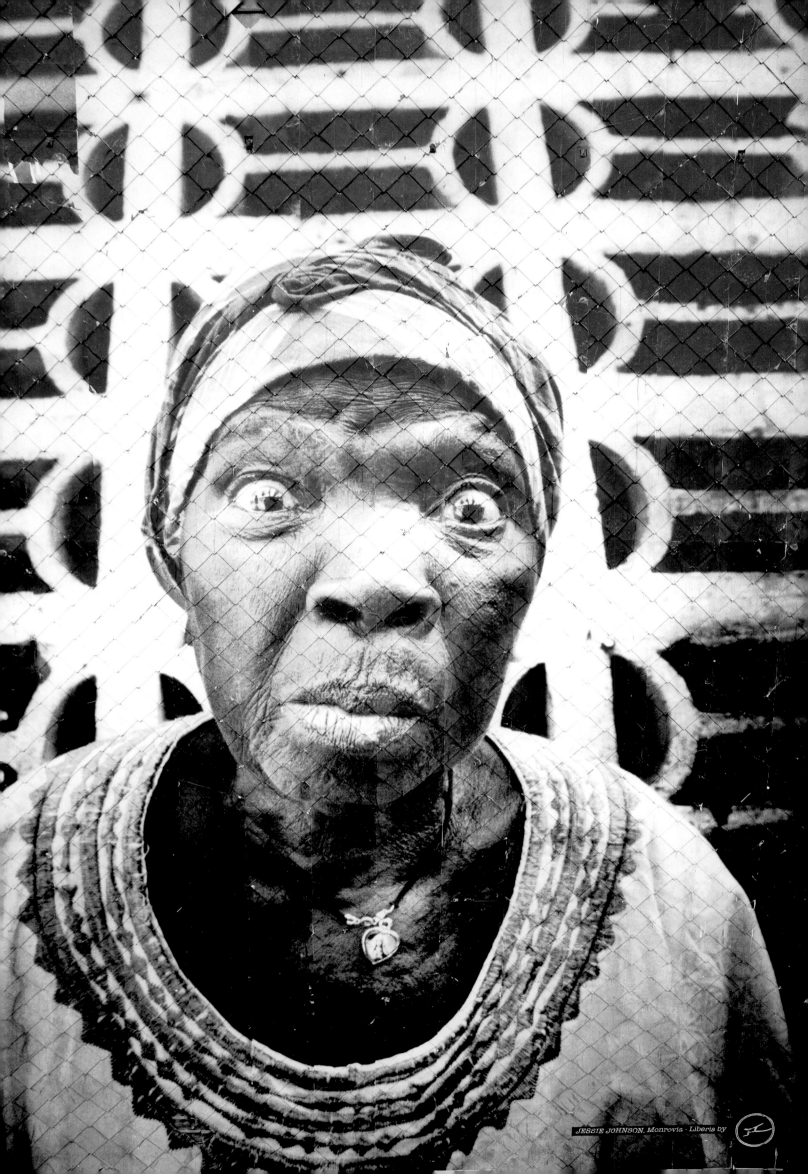

JESSIE JOHNSON, Monrovia - Liberia by

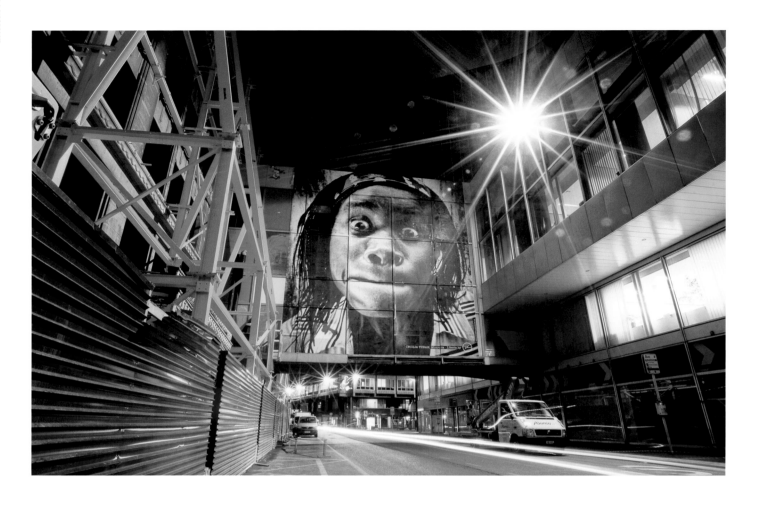

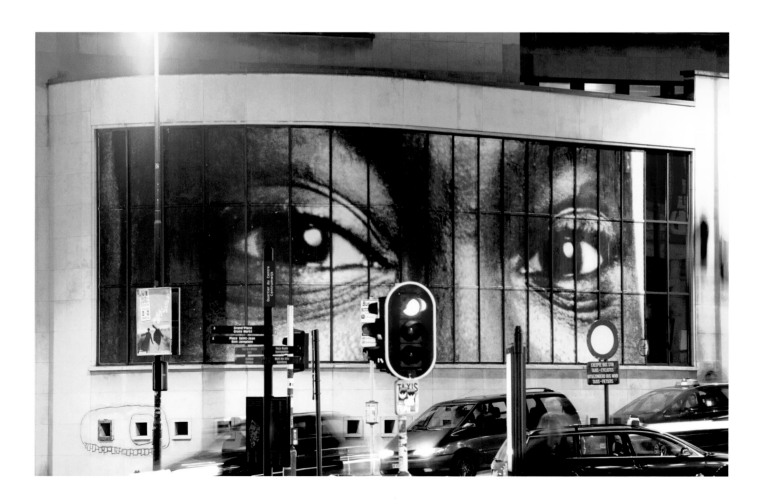

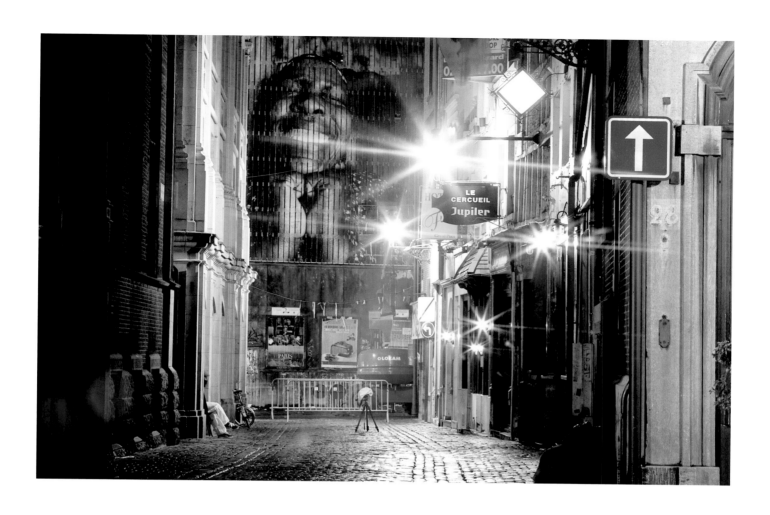

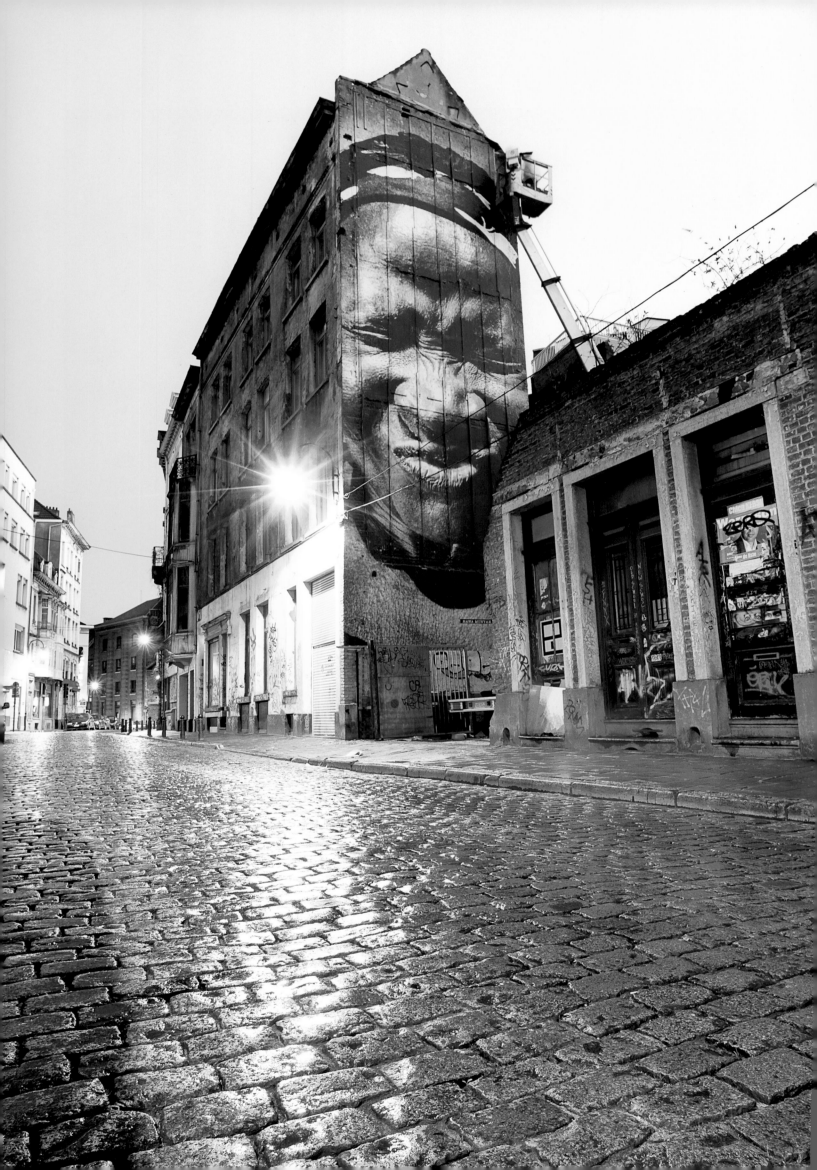

PARIS

September 2009: JR covered the walls of Paris's Île Saint-Louis, as well as both sides of Pont Louis-Philippe. The street audio guide was used once again to present the stories of the women from the project. Thousands of meters of posters were printed. The exhibition was accompanied by a multiscreen video installation in Pavillon de l'Arsenal, which also hosted Casa China (see page 348). Installed in the main hall of the Pavillon, this wooden shack became a historic monument of Brazilian favela architecture.

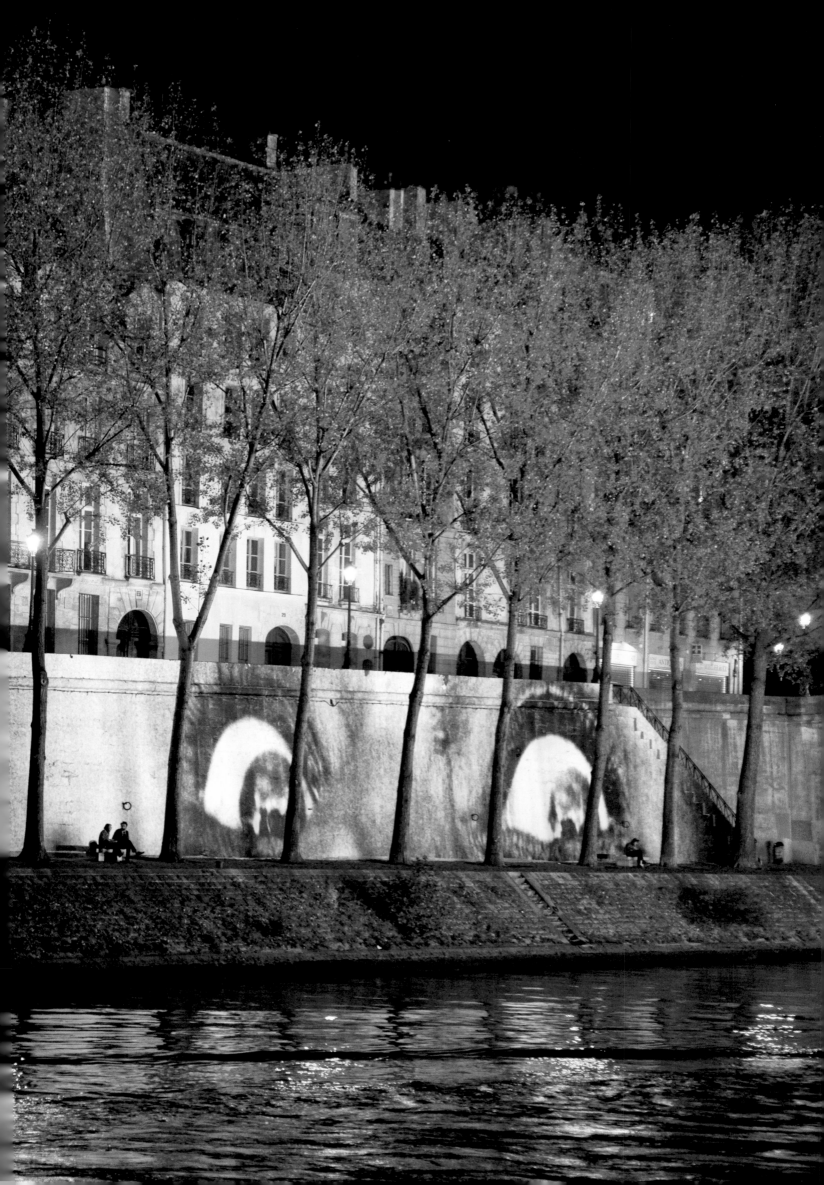

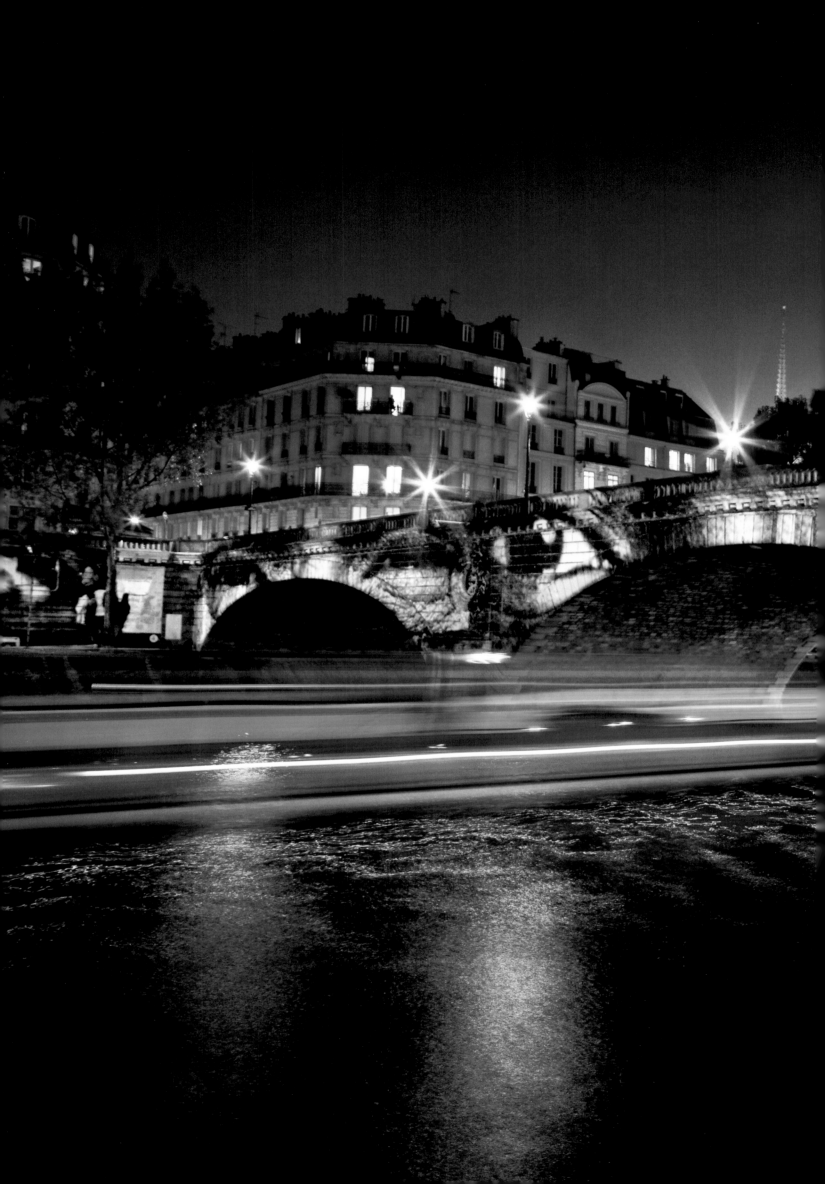

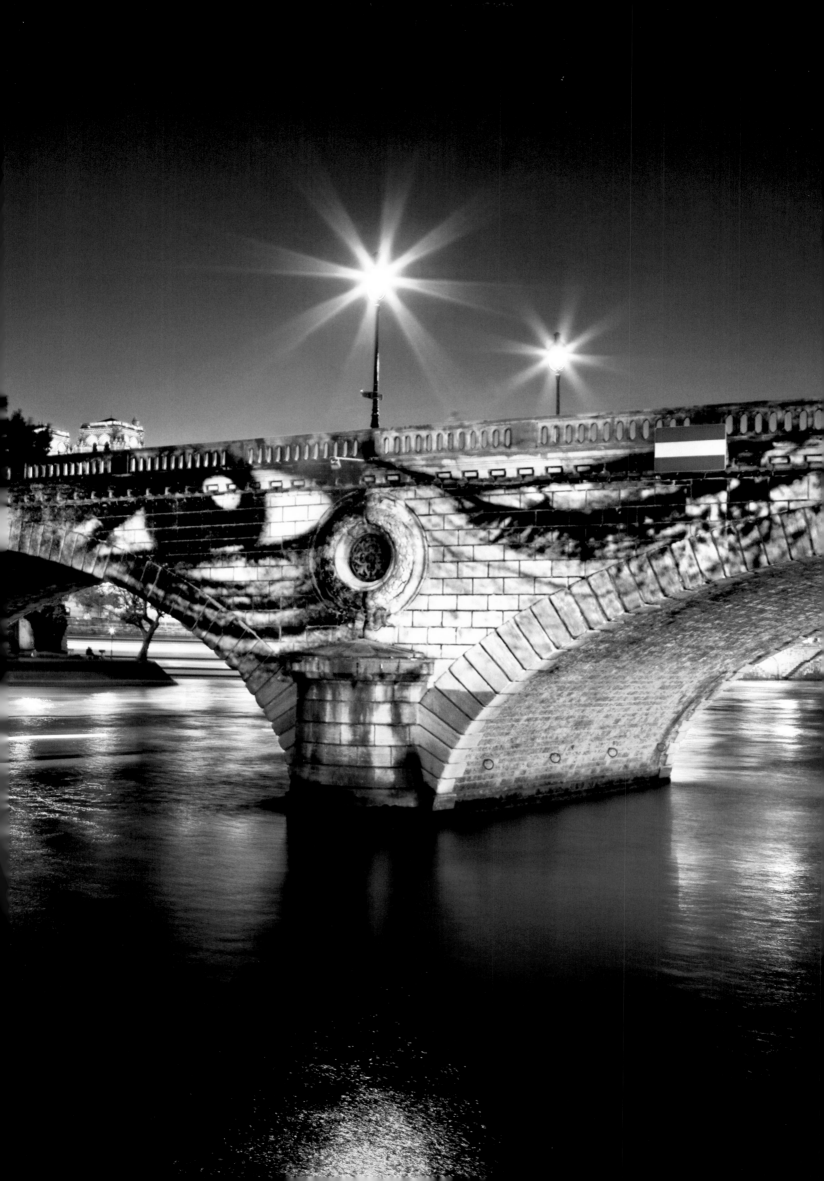

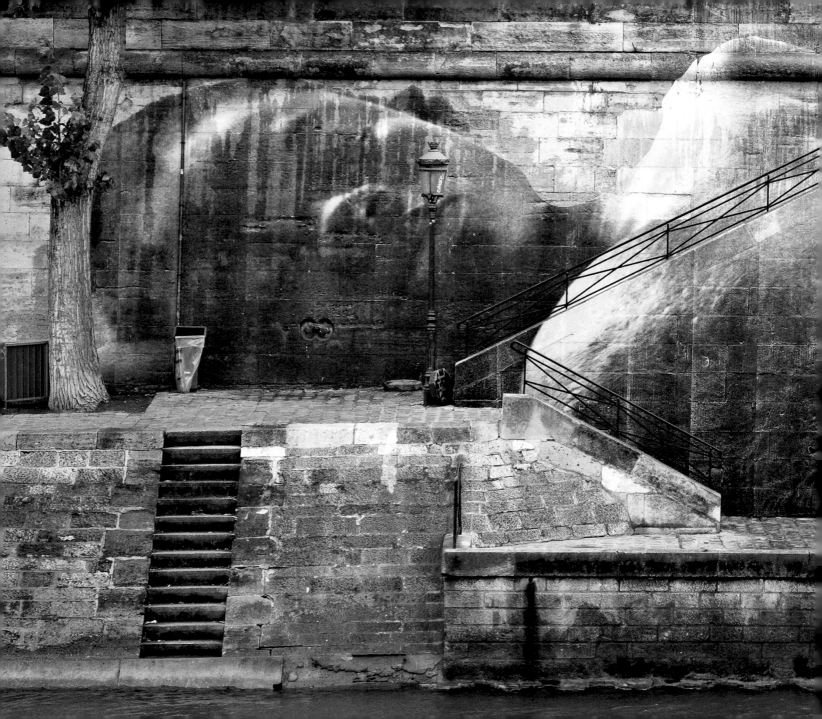

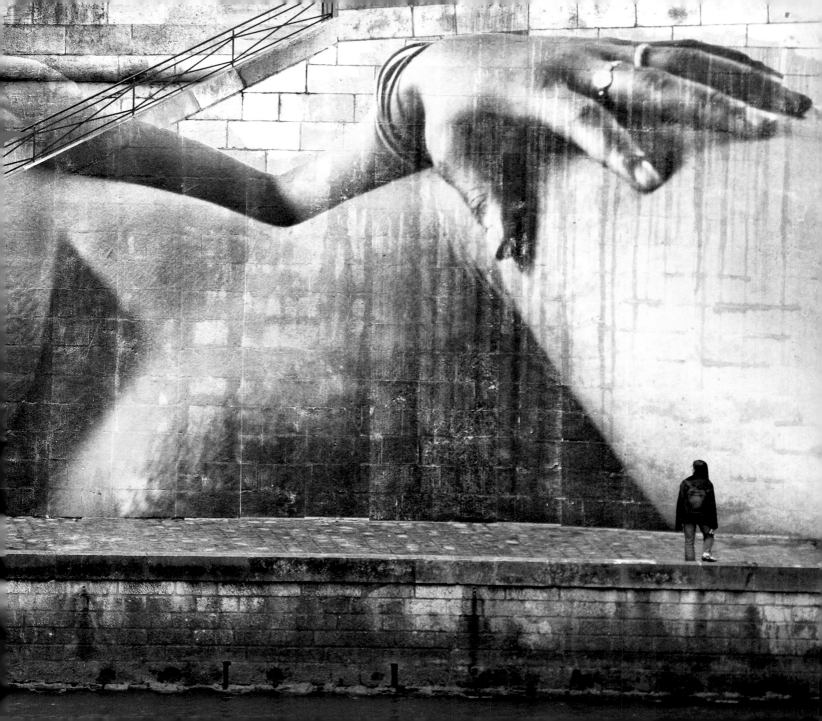

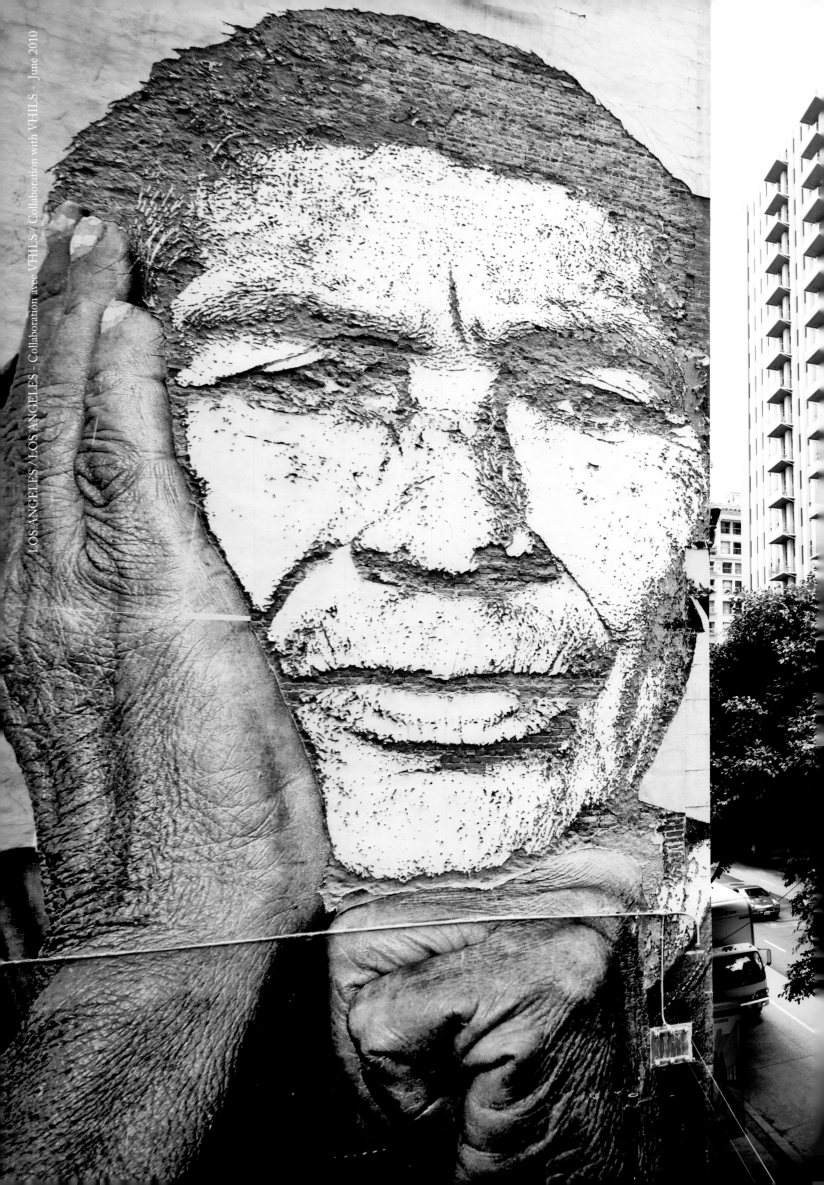

PROJECT FOLLOW-UP

CASA AMARELA

Children played a crucial role in the success of this project. Like children everywhere, they were fascinated by images. They were perfect models, always happy to pose in front of the lens, to make faces, smile, or jump up, again and again. JR taught them to use his camera and took shots of them with his digital camera, showing them the pictures and having fun enlarging their eyes and noses.

To make people understand what he wanted to achieve in the favela, he started by doing a little project with the kids. He chatted with them, taking shots of them in front of their houses and the places where they live and play, then made life-size prints of them and asked them to paste them up on their walls. He showed them how to cut out the strips of paper to trim the portraits, how to mix the glue powder with water, and how to use paintbrushes without getting glue all over their clothes. They all listened carefully and really tried their best in carrying out their work. Naturally the little artists brought their parents over to see what they'd done. After this first "exhibition," the inhabitants of the favela felt they could trust JR and understood how he wanted to collaborate with the women in the community.

JR set up the Casa Amarela, a cultural and social center in the favela heights, just for them. Although it's the oldest favela in Rio, Morro da Providência had no cultural facilities or social counseling infrastructure. When JR went there in August 2008, he promised to come back in April 2009 to open the center, which meant setting up an on-site team, buying a house, and going through all the administrative and legal formalities.

The children who learned to use a camera in 2008 were the ones who created the inaugural exhibition for the Casa Amarela. First, they went down to Copacabana. JR divided them into two groups of six kids, because it was hard to supervise larger groups. The young photographers had to introduce themselves with their given name, say they lived in Morro da Providência, explain that they were preparing an art exhibition, and ask if people would agree to be photographed.

During rehearsals in the favela, all the kids were very confident and played their parts as if they were onstage. But they were more reserved when they got to Copacabana. Lucas, ten, who had been part of the team from the very first day and never wandered very far from JR, felt a bit intimidated and hid in a tree for a long time. Young Anderson, twelve, listened very attentively to the instructions and tried to do a good job. But the passersby were afraid of these groups of kids who came up to them, and they refused to go along with it. Or maybe it was the kids who were scared. After talking it over, the kids came back saying: "We've got to stop saying we come from Morro da Providência. It's not working." Somehow JR tried to explain to them that the difficulties they were experiencing were interesting and rewarding, and that they shouldn't give up. In the end the solution was found with Thaïs, the little princess of the favela. She introduced herself first and impressed people with her politeness, diction, and nerve. Once a person had agreed to pose, the others would come and photograph them, too. Back in the favela, they put the photographs up inside and outside the Casa, which they had painted pale yellow for the occasion. The façade was decorated with the eyes of Giorgia, Rosiete's granddaughter. Everything was ready for the grand opening in the favela heights. A concert was organized and shuttle buses arranged for the Cariocas to come up from the city to attend the event.

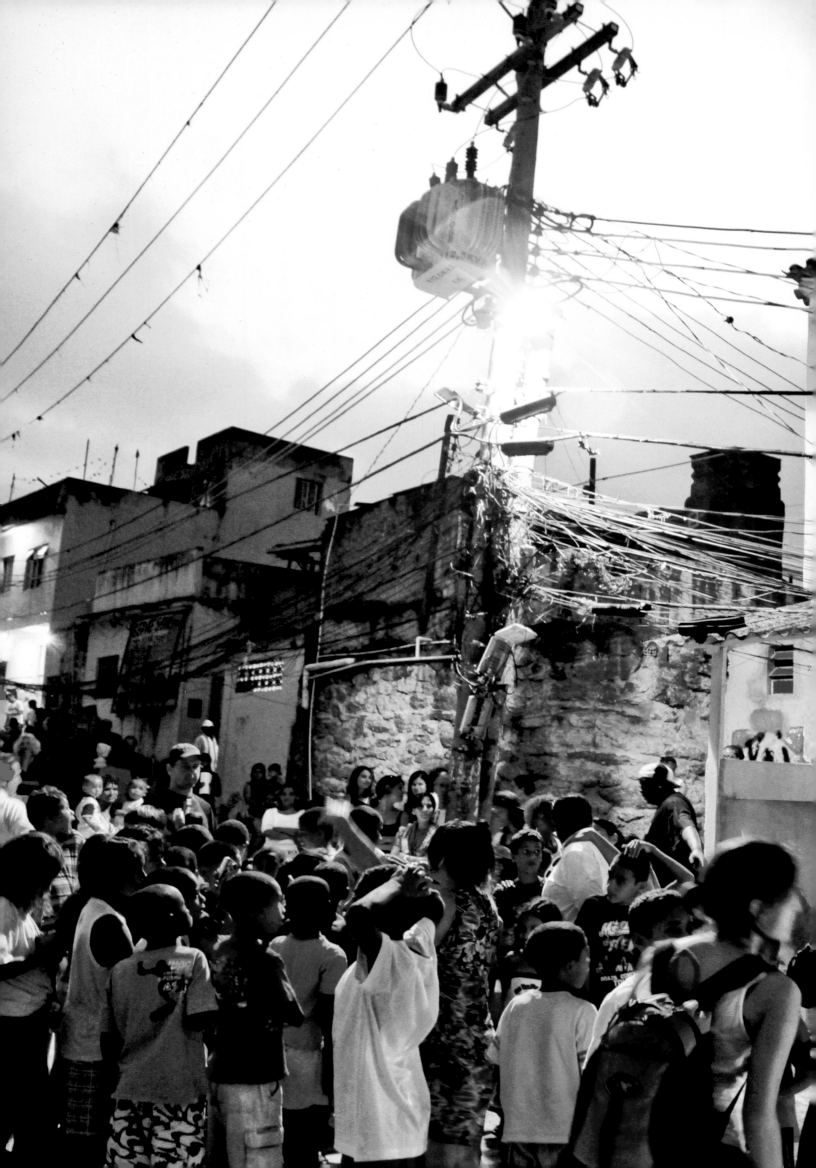

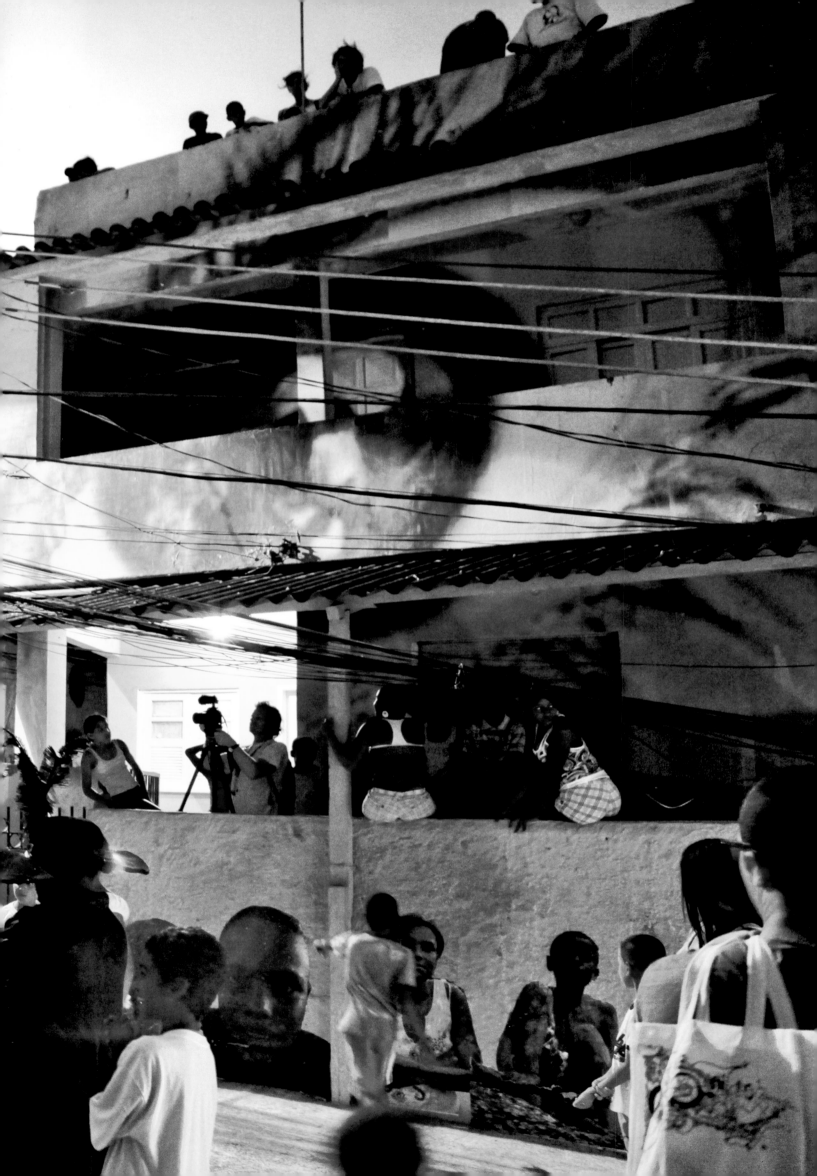

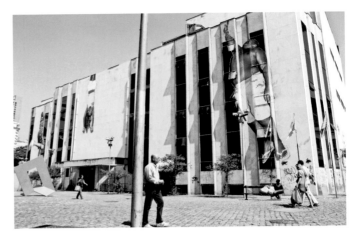

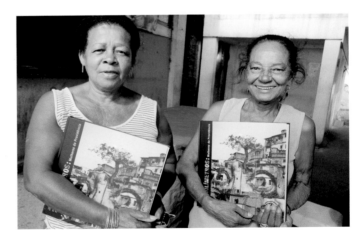

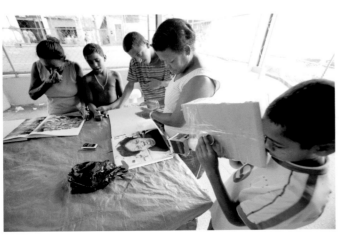

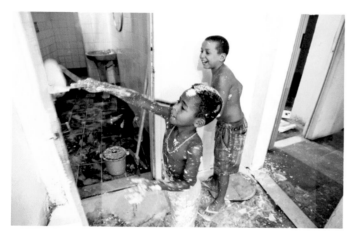

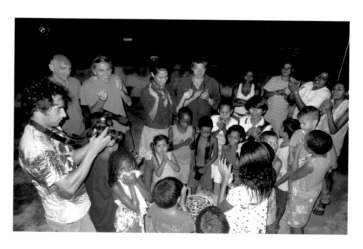

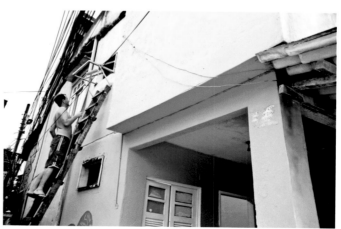

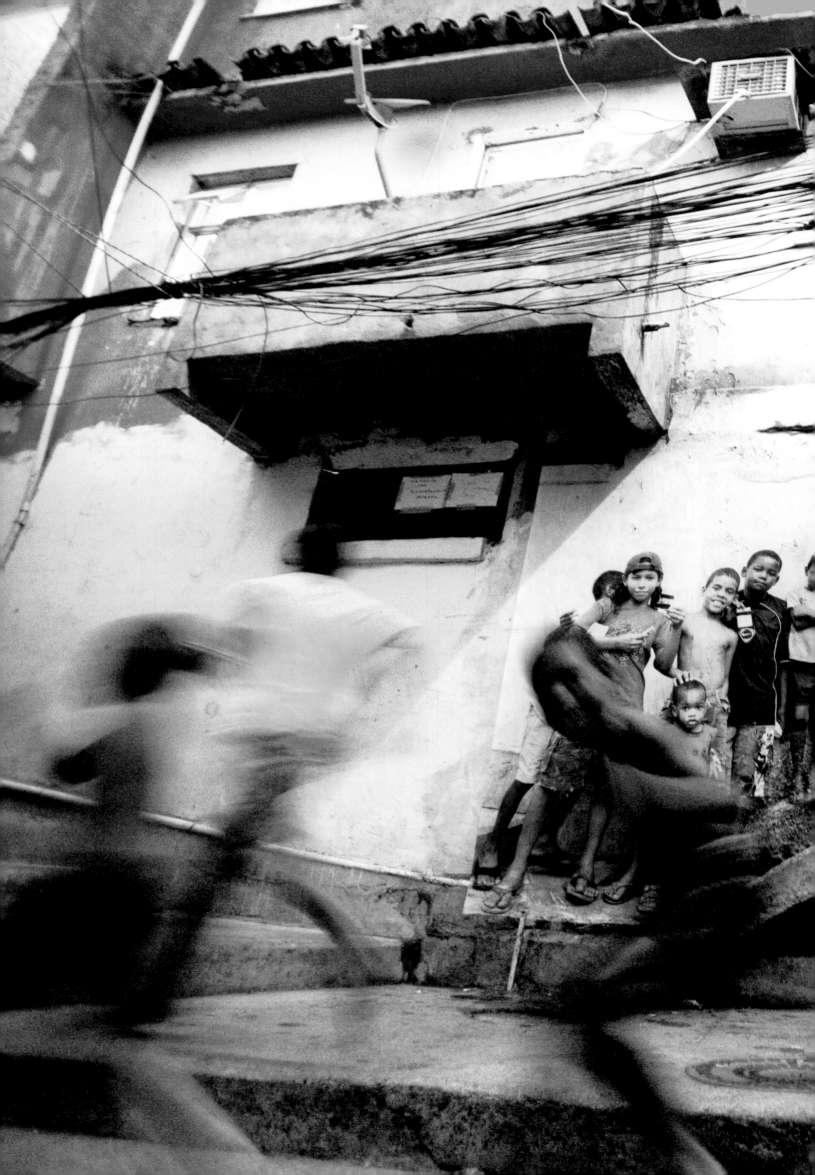

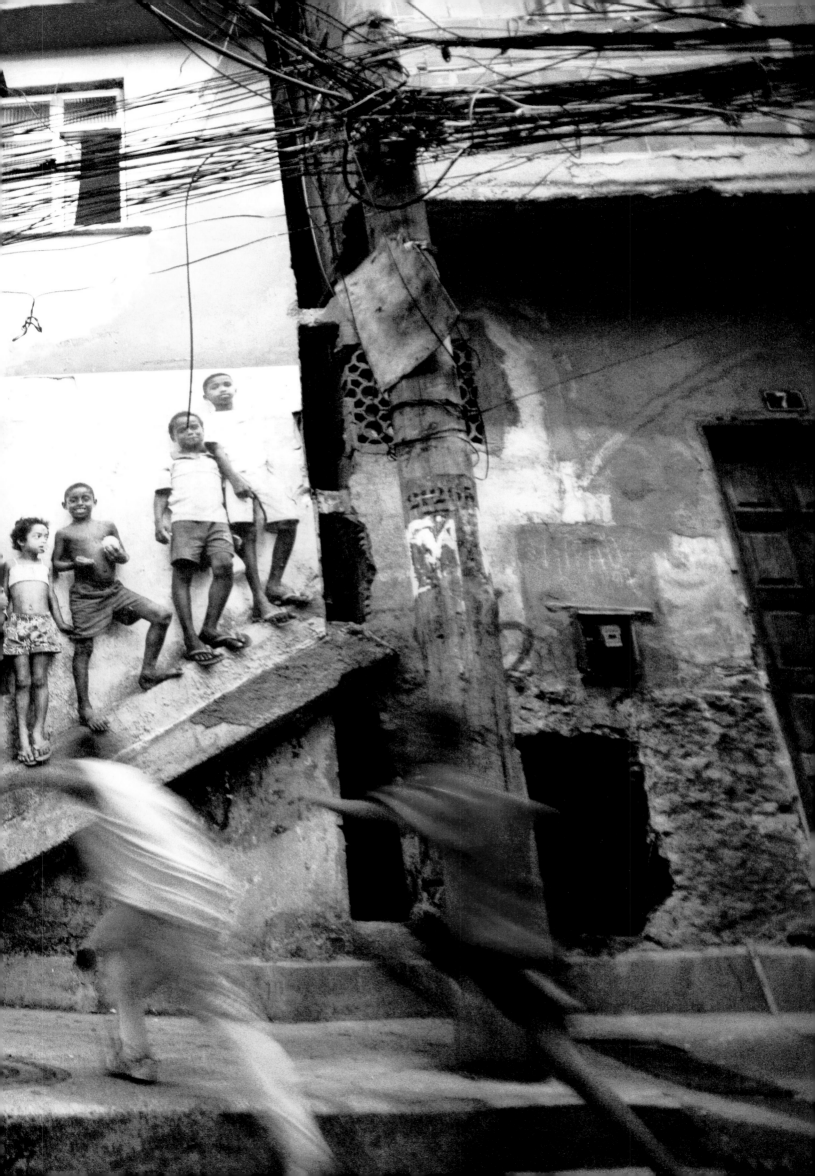

CASA CHINA

While campaigning to become mayor of Rio, one candidate put forward a project to consolidate and rebuild certain houses in the favela of Morro da Providência. The inhabitants soon realized that the only houses involved were those that could be seen from the road, on the first slopes of the favela.

During their first location visit, JR and his team met the family of Georgina, known as China. Nine people live on top of one another in the last wooden house in the favela, the lasting witness to an architecture of squalor that is sixty years old.

At the same time as they were setting up the cultural center at the top of the main steps of the favela, the idea was conceived of dismantling the China House and rehousing the family in a new "permanent" building on the same spot. According to the whole community, whose opinion JR sought, living conditions in the house were very difficult. They encouraged him to pursue the project.

Armed with this consensus, JR decided to dismantle the China House and turn it into an artistic center, using it as an empty shell in which he would set up a video installation for the exhibition at the Casa Franca Brasil (April to June 2009). Just as one can create art in strange places, one can try to create art from unusual objects . . . The idea of turning the oldest house in Brazil's oldest favela into a work of art amused those who lived there. They found it a bit odd, but having seen the walls decorated with the faces of women, they began to like these strange ideas. Some said: "These French are crazy!" But they also understood that the house would bear witness to the history of the favela and would be accessible to the people of Rio who would previously not have dared venture as far as that house.

In Morro da Providência, the new house was built within six months, with the aid of carpenters and residents of the community. So while the candidate was not actually elected mayor of Rio, the China House was rebuilt. After the first exhibition in Rio, the house traveled to Paris and beyond.

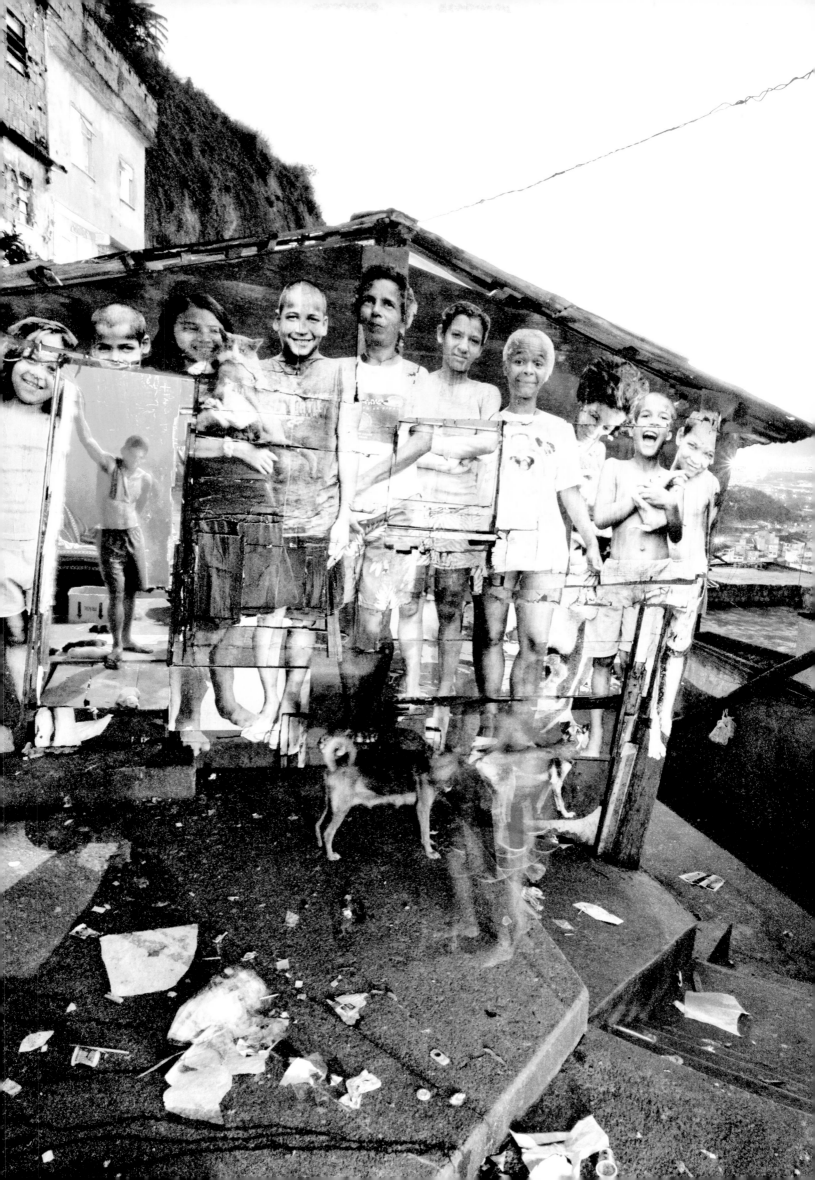

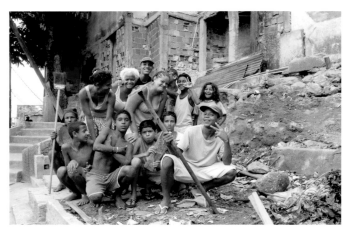

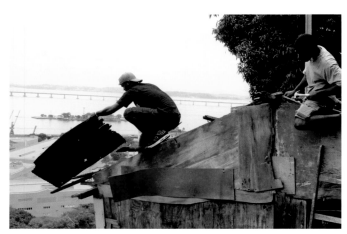

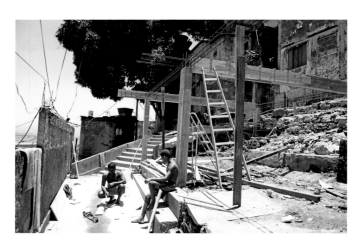

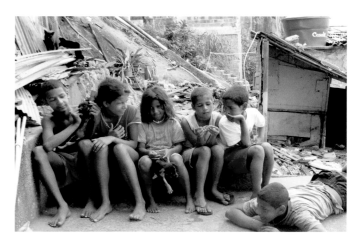

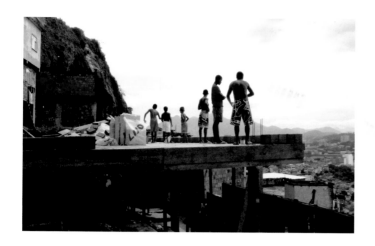

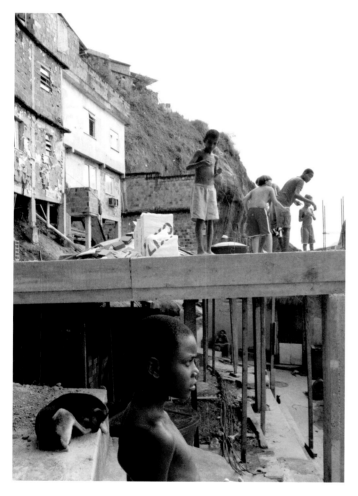

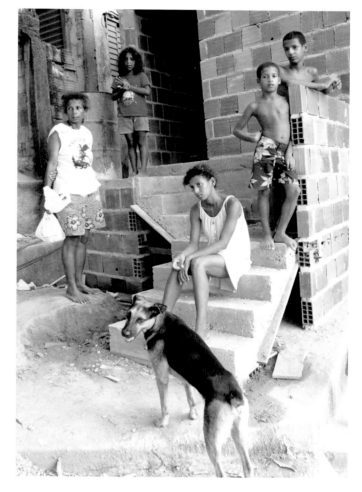

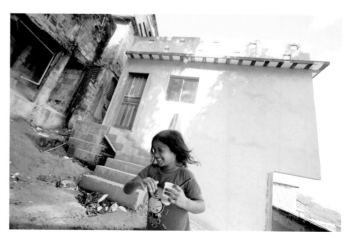

KENYA

SEVEN MONTHS LATER

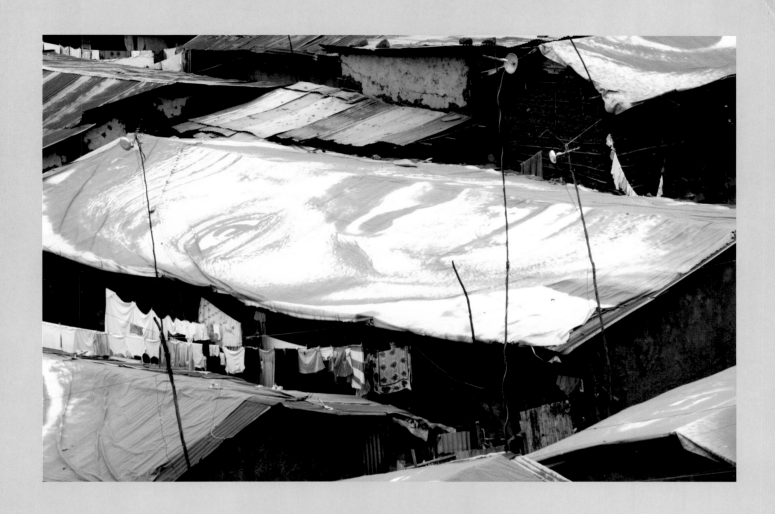

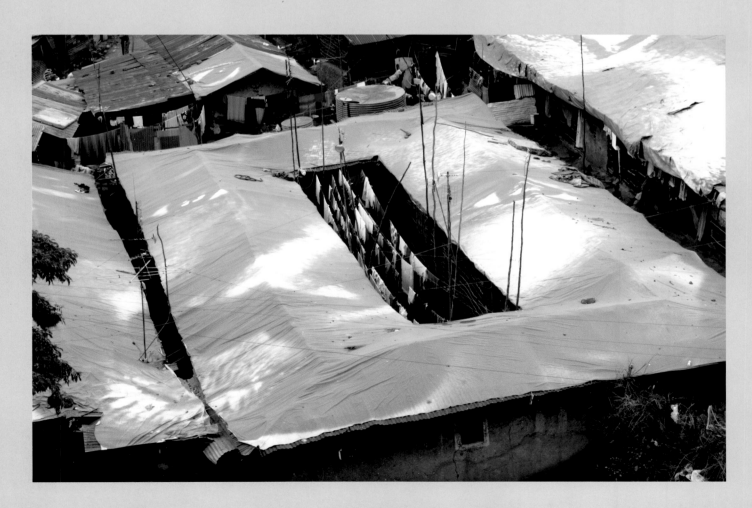

CAMBODIA

SEVEN MONTHS LATER

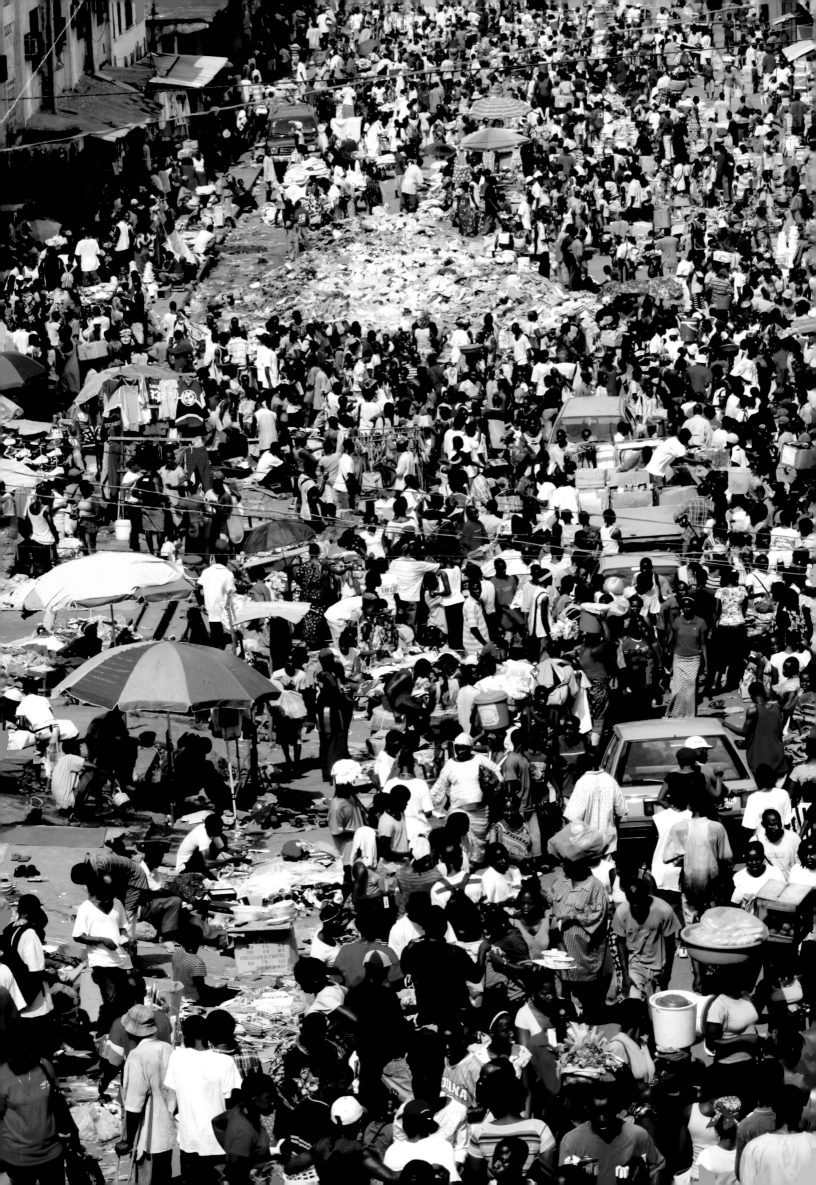

Women Are Heroes, a global project by JR

General coordination: Emile Abinal

Art direction of the book: Guillaume Cagniard, assisted by Marthe Svagelski

Mock-up: Marthe Svagelski

Editorial direction: Marco Berrebi

Texts: Marco Berrebi, Christian Caujolle, Françoise Docquiert, Emile Abinal, Damian Platt, and Mia Collis

Additional photos: Dan Lowe, Anthony Dickenson, David Boucris, Patrick Ghiringhelli, Alain Arnaudet, Philong, and Youssef Boubekeur

Translation: William Snow, Sophie Popieul, John Fisher, Myriam Rasiwala, Vicheth Hiep Chan, Mia Collis, Liane Khan Acito, Marc Azoulay, and Marco Berrebi

ACKNOWLEDGMENTS:

Steve Lazarides, Ralph Taylor, Jessica, Yvette, Alice, Victoria, Emily, Kim, Coralie, Adam, Tom & Alex, Hélène and François Meyer, Nathalie, Simon, Bilou and Emma, Maryse, Gérard, Julie and Elsa, MSF Belgique, Peter Casaer, Bettina Saerens, Valérie Michaux, Sara Laemens, Sandra Peiffer, Anne Misal, Henry Thuaud, Springmann gallery, Olivier Mouton, Martin Huisman, Dominique Bertinotti, Patrick Bouton, François Coen, Stéphanie Yvert, Didier Berthelot, Alexandre Labasse, Marion Dambrin, Dominique Alba, le Pavillon de l'Arsenal, Yael Reinharz Hazan, Leo Kaneman, Rony Braumann, Fabrice Bousteau, Laurent Joffrin, François Sergent, Didier Pourquery, Marie-Dominique Arrighi, Barak Obama, Jean-Baptiste Dumon, Serge, Laeticia and Naomie, Canon France, Culturesfrance, l'Agence VU, Sonetrans (Sabine and Patricia), Maurice Ephrati, Stephane Schinazi, Sir Ronald Cohen, Tatyana and Alexis, Brigitte Chouet, Edith Bizot, Olivier Brunisholz, Elle Driver, Vincent Maraval, Thierry Consigny, Marie Bazin and Olivier Dermaux, Sol Guy, Kim Chapiron, Jean-Gabriel Becker, Anthony Cheylan, Géraldine Gomez, Ben Ageorges, Catherine Philippot and Myrtille Beauvert, Rob 3D and Daddy G, Marie Nourry, Catherine Phillipot, Piero Borgel, Farida Cagniard, Thibaut Vieville and Marianne Ratier, Domoina, Angele, Steffen and Sophie, Dan and Olivia, Zevs, Blu, Yaze, Os Gemeos, Solal, Ladj Ly, Evelyne Soullier and Sandrine Debray, Sabine, Olivier, Prune, Marie, Katarina, Fina and Fia, Haribo, Maurice Grimbaum, Nabil and Hakeem, le Zink and Lisa, Stephen Schuster, Jean Claude and Béatrice, Romain and Ben-j, Lunik, Marc, Sara and Samantha, Scott Weber and le Jura, Xavier Faltot, Sébastien Kopp, Ludivine, Baba and Jean, Jay Smith and Greg, François Hebel, Jacob and Rosine, Mathieu Kassovitz, Laetitia, Esteban and Ayrton, Hélène, Françoise and Thierry, Charlotte Marmian, Iris and Laurent, Marie-Christine and Régis, Vincent and Squat, Patrick Baradel, Yvette Lamy, Christopher Shay, Vanessa, Valou, Timothée, Yvan and Matthieu, Otrad Services (Sebastien, Emma, Guillaume, Christian, Samuel, Mme Coler) and Martial & Co, Anthony Cheylan, Jerome Outlines, Etienne Rougery-Herbaut, Olivier Fleurot, Frédéric Rouzaud, and Michel Janneau

Éditions Alternatives: Gérard Aimé, Patrice Aoust, Catherine Paradis, Charlotte Gallimard, Sabine Bledniak, and David Ducreux

Collage team: Emile Abinal, David Boucris, Alexandre Guarneri, Christopher Irfane Khan Acito, Patrice Bart Williams, Youssef Boubekeur, Ulysse Moal, Constance Pentier, Charly Bassagal, Eric Salomon, Marco Berrebi, Alex Alabaz, Caroline Goutal, Prune Nourry, and Sophie Paumelle

Filming team: Agathe Sofer, Juliette Renaud, Patrick Ghiringhelli, Lazare Pedron, Nathalie Durand, Philippe Welsh, François Hamel, Dan Lowe, Anthony Dickenson, Prune Nourry, Alastair Siddons, Doctor Flake, Antoine Levi, Romain Alary, Fabrice Rouaud, Guillaume Saignol, and Mélanie Karlin

Sierra Leone, Liberia, Sudan: Médecins Sans Frontières / Doctors Without Borders, Cécile and Robert, Karl, Veronica, Barbara, Hiwet, Orange Base, and Black Base

Kenya: Special thanks to Remy and Isabelle Carrier, the community of Kibera, Hussein Musa, Nadir Abdi, Hezron Arunga, Awadh Ibrahim, Cletis Kasanyi, Otieno Goege, Ochieng Onyango, Jirus Agut, Viewfinders, Jean Hartley, Mia Collis, Kenya Grip, Ovidian, the Doctors Without Borders team of Kibera, Monique Tondoi Wanjala, Siama Abraham Musine, Cecilia Magdalene Achieng, Edwin Japaso, Anouk Delafortie, Alinur Adan, Georges Diener, Jesse Karp, Salim Mohamed, Shepard, and French cultural cooperation

Brazil: Mauricio Hora, Rosiete Marinho, Damian Platt, Debora Pill, Nele Harlans, Jorg Rohleder, Miliana Nakamura, Marcello Silva, Emmanuelle Boudier, Renato Rangel, Joao Guerreiro, Max Freitas, Pedro Strozenberg, Soluçoes Urbanas, Wallace Cardia, Worldbox Association, Alex Suliano, Romulo Sesh, Tulio Fiuza, Claudio, Baiano, Augusto Alex, Naltitude, and Patricia Oliveira

India: Jérôme Bonnafont (French ambassador), Philippe Martinet, Bénédicte Alliot, Nitin Chauhan, Elise Tassin, Marie Berst, Dhritobroto Bhattacharjya 'Tato', Ravi Kumar, Sukhi Singh, Mme Vandan, Sharma (Narirakshak), Aneesha Beri and Subhashree (Khushii), Gauri Chaudhary (Action India), Nandani Rao, Madhu & Sadaf (Jagori), Swami Vishalanand (Divya Jyoti), Yamini Kumar, Shaifali Jetli-Sury, and Alain Wuillaume

Cambodia: Alain Arnaudet, Marie de Pibrac, Lucile Charlemagne, Borin Kor, Neang Sam, Navy Tan, Julie Besson, Jean-François Desmazières (French ambassador), Jean-Luc Floch, and Paul Ouk and Me Mates Place Gang

Front and back cover: the Morro da Providência favela,
Rio de Janeiro, Brazil, August 2008

English-language edition
Editor: Laura Dozier
Typesetter: Darilyn Lowe Carnes
Production Manager: Anet Sirna-Bruder with Ankur Ghosh

Cataloging-in-Publication Data has been applied for
and may be obtained from the Library of Congress.

ISBN: 978-1-4197-0333-1

Printed and bound in Hong Kong, China
10 9 8 7 6 5 4 3 2 1

Abrams books are available at special discounts when purchased in quantity
for premiums and promotions as well as fundraising or educational use.
Special editions can also be created to specification. For details, contact
specialsales@abramsbooks.com or the address below.

THE ART OF BOOKS SINCE 1949
115 West 18th Street
New York, NY 10011
www.abramsbooks.com